My total conscious search in life has been for a new seeing, a new image, a new insight. This search not only includes the object but the in between place. The Dawns & the Dusks. The objective world, the heavenly spheres, the places below the land & sea.

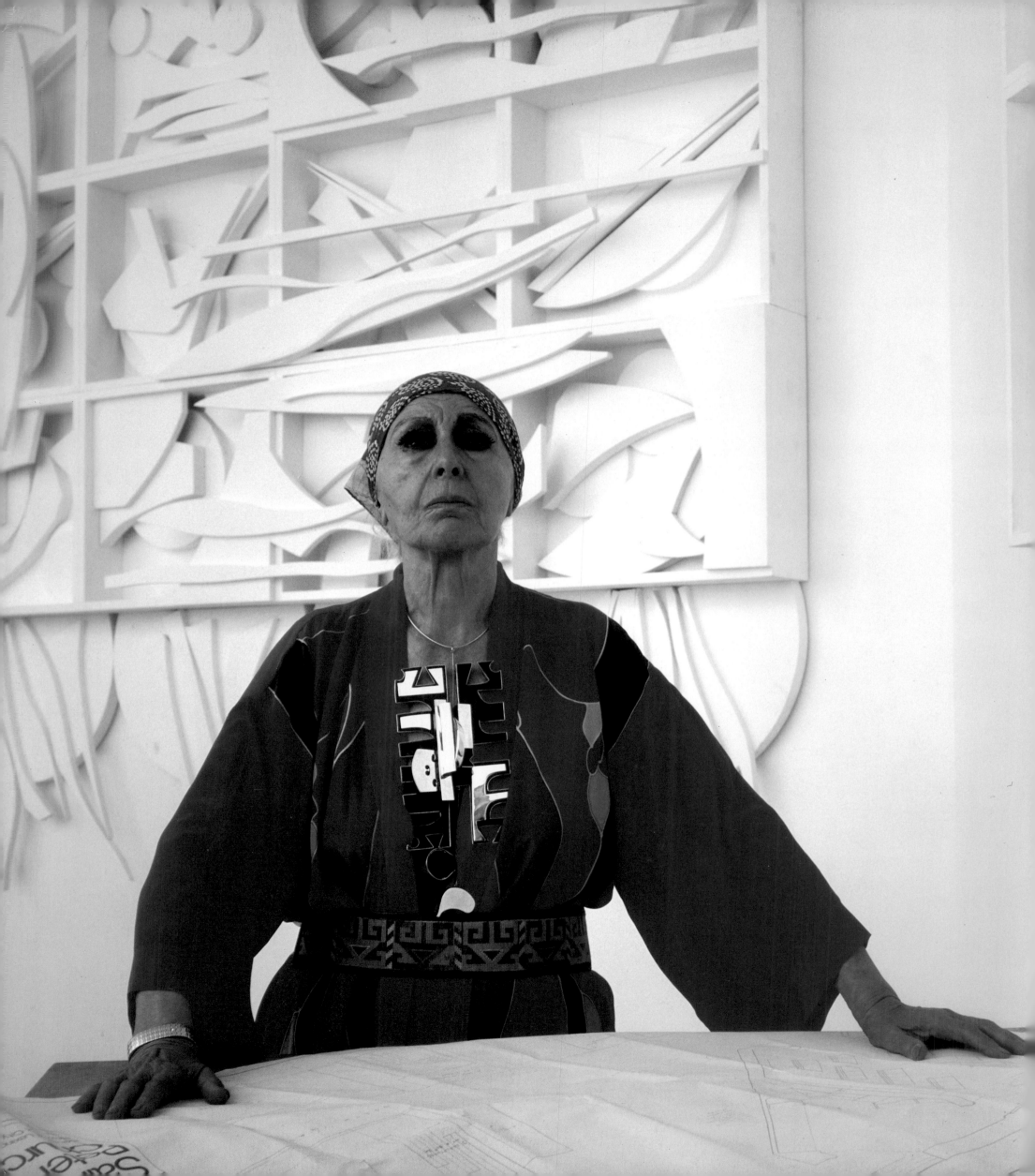

NEVELSON'S WORLD

by Jean Lipman

INTRODUCTION BY HILTON KRAMER

HUDSON HILLS PRESS, NEW YORK
in Association with the
Whitney Museum of American Art

FIRST EDITION

©1983 by the Whitney Museum of American Art
Introduction ©1983 by Hilton Kramer

Published in the United States by Hudson Hills Press, Inc., Suite 301, 220 Fifth Avenue, New York, NY 10001.
Distributed in the United States by Viking Penguin Inc.
Distributed in the United Kingdom, Eire, Europe, Israel, the Middle East, and South Africa by Phaidon Press Limited.
Distributed in Australia, New Zealand, Papua New Guinea, and Fiji by Australia and New Zealand Book Co. Pty. Limited.

Editor and Publisher: Paul Anbinder
Assistant to Jean Lipman: Margaret Aspinwall
Copy Editor: William Dyckes
Designer: Philip Grushkin
Composition: U.S. Lithograph Inc.
Manufactured in Japan by Toppan Printing Company

Library of Congress Cataloguing in Publication Data
Lipman, Jean, date–
　Nevelson's world.

　Bibliography: p.
　Includes index.
　1. Nevelson, Louise, 1899–　　. I. Title.
N6537.N478L56 1983　　709.2'4　　83-8476
ISBN 0-933920-33-4
ISBN 0-933920-34-2 (deluxe)

Excerpts from *Dawns + Dusks: Louise Nevelson*, taped conversations
with Diana MacKown, are reprinted by permission of Charles Scribner's Sons.
Copyright ©1976 by Diana MacKown.

CONTENTS

INTRODUCTION

by HILTON KRAMER

As much as I feel I have struggled, I never for a moment in my whole life felt that I questioned my art.

Certain experiences in the realm of art remain forever associated in our minds with the places where the art was first fully revealed to us. Subsequent experience may augment our knowledge, alter our perspective, and deepen our understanding, but it can never quite eradicate the impression made upon us by the quality of that initial encounter. If only for that moment, something central to the spirit of the art seemed to belong to the very atmosphere that enclosed it. Thereafter, the art itself seems to us to carry the spirit of that atmosphere with it, no matter what the actual physical circumstance in which it is seen.

Anyone lucky enough to have seen the sculptures of Henry Moore reposing in the gray-green winter light of the cozy meadows surrounding the artist's studios in Herefordshire, for example, is unlikely ever again to conjure them up in his mind's eye in any other setting. Likewise, to have seen the constructions of David Smith arrayed like magic sentinels in the open fields of the Terminal Iron Works at Bolton Landing, above Lake George, or to have glimpsed the fugitive figures of Alberto Giacometti emerging from the crushed plaster and

grisaille light of his cell-like Paris studio was to have experienced something essential to the inner life of the art itself. At such times we are made to realize that, whatever the nature of its material realization, there is a world of mind, feeling, and spirit at the core of every work of art that captures our imagination, and that world is often coextensive with the place where the art is created.

As a young man in the 1950s, when I was just beginning to write about the visual arts, the visits I made to the studios of Moore, Smith, and Giacometti were among the experiences that meant the most to me, and they remain today among my most precious memories of that very rich period. Yet in some respects the most extraordinary of all my encounters with artists and works of art in those days occurred on a sunny spring day when I paid a visit to a tall townhouse on East 30th Street in Manhattan. This house, which has since been torn down, was then the residence and workshop of Louise Nevelson—a sculptor virtually unknown to the art public, unexhibited in the museums, and scarcely ever written about by the critics.

From the street, the house hardly looked like the sort of place where an artist, especially a sculptor, might be engaged in serious work. For one thing, the neighborhood—though already a little rundown in anticipation of the wrecker's ball—was distinctly bourgeois. It was certainly far removed from the ambience of 10th Street and the Cedar Bar or, indeed, from any social milieu one associated with the art life of the time. The New York art scene was, it must be remembered, a very different place in those days. Among other things, it was smaller. There were fewer artists, fewer galleries, fewer collectors, fewer critics, and fewer museums that took an interest in the new art of the day. It was also less chic. And word of its activities reached the "outside" world—the world of money and the media—at a much slower rate of speed. Artists' lofts had not yet come to be featured in the home-decorating pages of our newspapers and magazines. For an artist to live in comfort and luxury seemed almost a contradiction in terms.

But there was also another reason why one did not expect to find a sculptor at work in a townhouse on East 30th Street. This was the heyday of welded sculpture, and there were many practical considerations that made a townhouse in midtown Manhattan an unsuitable environment for the welder's torch. In those days there was much talk—and with ample reason, too—about "The New Sculpture," and it was more or less assumed that this new sculpture would be welded sculpture. The new sculpture tended to be "open" in its forms. It was often spoken of as "drawing in space," and welding was deemed the most appropriate means of achieving its artistic objectives. No one, as far as I know,

had laid down any laws to that effect, but it was a commonly held belief among those who were interested in new sculpture. Welded metal was therefore considered avant-garde. The use of wood—like the use of stone and bronze in this respect—was identified with "tradition," despite the fact that many (indeed most) of the major modern sculptors had employed these materials. And "tradition," it will be remembered, was not in good odor in the fifties, especially among the sculptors who wished to be associated with the Abstract Expressionist movement in painting.

It was painting, moreover, that dominated the scene—dominated, indeed, our very notions of what art was, and what it might be. It was around this time, as I recall, that André Malraux observed that while painting was the art we had inherited, sculpture was an art the modern world had been obliged to reinvent. And although this project of reinvention had been launched decades earlier and achieved spectacular results, it had not yet met with the kind of acceptance and understanding that much of modern painting had already received. In the fifties, neither Paris nor New York had yet seen the bulk of the sculpture that Picasso had been producing for half a century, and it was not until the mid-fifties that New York saw its first museum retrospective of the work of Julio González. Even to devotees of modern art—still, in those days, a minority among those who took a serious interest in art—much of modern sculpture remained unknown, and was in any case looked upon as ancillary and marginal. It was painting that was assumed to represent the mainstream of creative endeavor. Those interested in new sculpture, especially abstract sculpture, thus constituted a minority within a minority.

I mention all this because it is essential to any understanding of the art of the fifties, to the place that sculpture occupied in the art of that period, and to the role that Louise Nevelson came to play in the evolution of that art. It may also help to explain why it was that my visit to the house on East 30th Street proved to be such an extraordinary experience.

Nothing that one had seen in the galleries or museums or, indeed, in other artists' studios could have prepared one for the experience that awaited a visitor to this strange house. It was certainly unlike anything one had ever seen or imagined. Its interior seemed to have been stripped of everything—not only furniture, rugs, and the common comforts of daily living, but of many mundane necessities—that might divert attention from the sculptures that crowded every space, occupied every wall, and at once filled and bewildered the eye wherever it turned. Divisions between the rooms seemed to dissolve in an endless sculptural environment. When one ascended the stairs, the walls of the stairwell

enclosed the visitor in this same unremitting spectacle. Not even the bathrooms were exempted from its reach. Where, I wondered, did one take a bath in this house? For the bathtubs, too, were filled with sculpture. Somewhere, I suppose, there were beds that the occupants of the house slept on, but I never saw them. There were, I remember, a plain table and some unremarkable chairs in the basement kitchen, and a glass coffee table in the "living room," which was otherwise designed less for living than for the storage and display of the sculpture that was the overwhelming raison d'être of the whole interior.

Once inside this enchanted interior, one quite forgot that one had entered a townhouse in mid-Manhattan. One had entered a new world. It was a very mysterious world, too, very far removed from the sunshine and traffic of the street. Here one entered a world of shadows, and it required a certain adjustment in one's vision simply to see even a part of what there was to see. The separate sculptural objects were mostly painted a uniform matte black, and they seemed to absorb most of the available light. The light itself seemed to be a permanent and unrelieved twilight—gray, silvery, and shadowy, without color or sharp contrast. It was austere without being bleak. It was also, as one came afterwards to realize, intensely theatrical. Emerging from that house on this first occasion, I felt very much as I had felt as a child emerging from a Saturday afternoon movie. The feeling of shock and surprise upon discovering that the daylight world was still there, going about its business in the usual way, was similarly acute.

Yet there was another aspect to this experience that stood in sharp contrast to this feeling of poetic enchantment. This was the sense one had, whenever and wherever one paused to examine a particular object, of a mind that was extremely tenacious and remarkably fertile in its command of a certain mode of sculptural form. One was constantly being reminded that, in some odd and unexpected way, Nevelson's sculpture, however much it may have attached itself to the impulses of fantasy and however often it seemed to produce a private landscape of dreams, belonged nevertheless to the Constructivist tradition. While the rationalism and idealism of Constructivism, with its tendency to sublimate the passions in favor of an unearthly perfection, appear never to have interested her much, Nevelson nonetheless brought to each of her wood constructions the kind of clarity, precision, and order that Constructivism made an integral part of its aesthetic vision. One of the things that made her work so strange—even when seen in the cold light of a museum exhibition, and thus removed from the twilight atmosphere she favored for her sculpture —was the way she employed the syntax of Constructivism for expressive pur-

poses that did not conform to Constructivist goals. Yet her employment of that syntax was never marginal or incidental to the work itself. It became an integral part of her vision as well—one term, but an absolutely essential term, in the dialectic that governed her art.

This became vividly apparent when Nevelson burst upon an unsuspecting world with the first of her full-scale sculptural walls. For without this Constructivist syntax, with its architectural rigor, the walls would scarcely have been imaginable. Consisting of stacked and extended modular enclosures, each containing a compressed, miniature variation on Nevelson's by then characteristic dream construction, the walls have surely been her most original contribution to modern sculpture. The first of the walls was conceived and executed in the house on East 30th Street, and it was there that I saw it soon after its completion. It was an unforgettable experience—a revelation not only of a new and powerful work of sculpture, but of a new way of thinking about sculpture and about the scale governing its conception. The Nevelson wall gave us, in fact, a new sculptural genre.

Only later did I come to realize that there was an important connection between the creation of this genre and the 30th Street house—between, that is, the original walls and what Nevelson had made of the interior of the house. For the experience afforded by the interior of the house, with its pell-mell profusion of forms, its architectural divisions of space, and its twilight atmosphere, served as both a model and a given—the content, as it were, for which the form of the walls had, perforce, to be created. The walls were, in other words, versions of the house itself. And so completely had the experience of the house been absorbed into the creation of the walls, and so profoundly transformed by that creation, that when Nevelson left East 30th Street and established herself in a taller, narrower house on Spring Street, where she has lived ever since, this new habitation became, in effect, not an attempt to recreate the 30th Street interior but quite simply another, ampler, more commodious and quintessential version of the wall itself.

As everyone knows, a great many elements—some consciously intended, some not—enter into the creation of a work of art, and it is an illusion to suppose we can ever identify all of them. It is also illusory to suppose that their identification somehow "explains" the work of art or accounts for its power. At the same time, it is always salutary in confronting a truly original work of art to remember that art belongs to the realm of culture as well as to the realm of

experience, that it may owe as much to precedent and convention as to the promptings of the individual psyche, that it is an artifact of history as well as an expression of feeling. If, indeed, we know anything about art, we know that it is in these collisions of convention and imagination, of tradition and the individual talent, that the most vital artistic events tend to occur. In the life of art, there are no virgin births.

How, then, are we to account for the art that emerged so unexpectedly in the fifties from that very strange house on East 30th Street?

If we attempt to answer this question strictly in terms of form and technique, the answer is not hard to come by. I have already mentioned Nevelson's debt to Constructivism. Beyond this lay a deeper and more comprehensive debt to Cubism, both to its general vocabulary of form and to the specific technical innovations of the collage medium and the kind of constructed sculpture that directly derived from the methods of collage. Nevelson has always acknowledged—in fact proclaimed—her debt to Cubism, and it is not to be doubted. Everything she has produced for the last forty years confirms it. For her, as for so many artists of her generation, Cubism marked the birth of the modern age, and it was upon its foundation that she based her style and her vision.

All of this is unquestionably true, and it tells us something important about her work. But as often happens with explanations of art based on matters of form and technique, it does not take us very far in accounting for what is most individual in the art in question. In Nevelson's case, for example, it does not account for either the scale of the art as it evolved in the creation of the great walls or the element of the theatrical that is so much a part of our experience of them. It does not account, either, for the psychological texture of the work —the curious quality of inwardness and subjectivity that lives on such easy terms with the formalities of its architectural structure. We must look elsewhere if we are to penetrate the mystery of what are some of the salient qualities of Nevelson's art.

Take the matter of scale. Historians of modern sculpture tend to ignore it. The fact is, it did not loom as a very compelling artistic issue in most of the sculpture—and I mean most of the best—that was produced in Europe and America in the first six decades of this century. (That it became an issue in the sixties and has remained one ever since must surely owe something to Nevelson's work of the late fifties.) It was a very big issue for painting, however, especially for the Abstract Expressionists. Whether Nevelson was directly influenced by the scale of the "big picture" that came to dominate Abstract Expressionist painting in the fifties, I do not know. I rather think that she was.

What we know for certain is that she was the first sculptor of the period to produce something that could be compared to the scale of Abstract Expressionist painting, and the result changed our whole notion of scale in contemporary sculpture. This, incidentally, was but one of the reasons why Nevelson was never in any danger of becoming a casualty of the changes in sculptural taste that occurred in the sixties. She had already anticipated these changes in her own work.

The scale she introduced into sculpture was a mural scale, and this surely owed something to her experience as Diego Rivera's assistant in the early thirties. The Mexican mural movement has long been acknowledged to be one of the sources of the altered sense of scale to be found in the painting of the Abstract Expressionists, and I think it must be counted among Nevelson's sources as well. Like the Abstract Expressionists, she had to get rid of the figure —get rid of the whole moribund tradition of explicit social commentary in art—before she could do anything significant with this source. She had to find a way of wedding it to the world of private feeling, to subjective emotion, to the realm of myth and abstraction.

Crucial to this process, I believe, was Nevelson's encounter, in the early fifties, with the ancient art and architecture of Mexico and Central America. This was a world in which art and myth were one and inseparable—a world of primitive mystery and heroic form. Important, too, was the fact that it was a world of *sculptural* form projected on an architectural scale. To say that she felt a profound affinity with this world of primitive form, and with the subjective emotions it symbolized for her, would be understating the case. It proved to be an inspiration and a model for everything that followed. The myriad sculptures that filled her house on East 30th Street in the late fifties, the sculptures that she exhibited in those unforgettable exhibitions at the Grand Central Moderns gallery in those years, were all, in a sense, an imaginative gloss on what she had seen in Yucatán and Guatemala. Like so many modernists before her, Nevelson had found in the expressive conventions of primitive sculpture and architecture a grammar of feeling that answered to the world of her dreams. It is worth recalling that the exhibition she mounted at Grand Central Moderns in 1955 was called *Ancient Games and Ancient Places*.

One of the things that struck the visitor to those exhibitions of the fifties so forcefully—most especially the exhibition called *Moon Garden + One* in 1958—was their sheer theatricality. The entire gallery was turned into what we would now call an "environment," and like the interior of that house on East 30th Street—which served as a prototype—it was a realm of enchantment.

Not everybody liked it, of course. Art exhibitions tended in those days to be somewhat austere occasions, and the theatricality of the Nevelson shows violated the sense of solemnity then associated with the exhibition of serious art. Yet the impression that these "environments" made on the spectator proved to be irresistible, and provided one of the keys to Nevelson's art.

Theater, dance, music, films—the whole world of theatricality had long been one of Nevelson's passionate interests. In the twenties she had studied drama and voice, and in the thirties—and for many years thereafter—she studied modern dance. It was to be expected, then, that she would sooner or later come to look upon exhibitions as a mode of performance, and upon the gallery space as a stage. This was what she commenced to do in those exhibitions of the fifties. Interestingly, in this endeavor too she had to eliminate the figure in order to realize the idea. The "drama" she staged in these exhibitions was an interior drama—a drama of the psyche—but its metaphors were entirely visual. Yet the primitivist forms that governed this visual drama had certain affinities with actual performance—most especially with the dance-dramas of Martha Graham, with their obsessive exploration of dark emotions and primitive mysteries and with the radical priority they gave to the life of the psyche, in all its inwardness, over the demands of the workaday world. The psychological texture of Nevelson's work from the fifties onward has many obvious parallels with the psychological intensities we find in Graham's dramatic choreography and even in her technique. It has not been the least of Nevelson's achievements that she has been able to bring this mode of feeling into sculpture without recourse to the kind of symbolism that properly belongs to arts other than her own.

Sometime after Nevelson had moved from East 30th Street and established herself in the house on Spring Street—this was in the early sixties—I brought an English painter to see her. He was visiting from London, and was eager to meet her and see her work. She was now beginning to be famous, and people were beating a path to her door. She gave us a complete tour of the house, with its sculpture-filled rooms. She gave us drinks, and talked at length about her life and her work. I could see that my English friend was in a state of excitement and bewilderment. I had seen people go through the whole thing before, and the result was always the same. They hardly knew what to make of it all, for nothing that they saw or heard there seemed to conform to their notions of the way artists lived and produced their work—especially sculpture. And when we finally left the house and were riding uptown in a taxi, we sat in silence for a long time

until my friend finally said: "You know, when I get back to London and tell people about this, no one is going to believe it. I don't blame them, really. I'm not sure I quite believe it myself."

Well, for a long time there were many people here, too, who could not quite believe their eyes when they came to the sculpture of Louise Nevelson. There was so much of it, and it was all so different from what everyone was doing. Yet once she emerged as a major figure in the late fifties, she could never again be ignored. She turned out to be one of those artists who changed the way we look at things.

When you project a world, the world is yours.

Louise Nevelson has summarized the concept of her lifework in half a dozen words: "I wanted to build a universe." As she freely admits, "I am not very modest; I always say I built an empire." Nevelson's universe is a personal world of form and space, with suns and moons, land and sky, light and shadow. The magical "empire" she built is as multileveled as her personality; her lifelong interests—music, drama, voice, film, poetry, dance, drawing, painting, print-making, sculpture, architecture—join in her visionary, theatrical world. She has deliberately integrated the ancient past, the present, and dreams of the future—with emphasis, always, on what will be *next* in her work: "What I did yesterday isn't today; what I did today isn't tomorrow." Dorothy Gees Seckler, in an interview-article written for *Art in America* in 1967, remarked, "How exhilarating is this forward momentum that disdains the backward look.... Even when she invoked the past, she was talking about the present."

"My world is my creation," Nevelson stated in an interview in the mid-sixties. A decade later she added to this in conversations with Diana MacKown, her assistant and biographer (whose book of taped talks, *Dawns + Dusks*, must be gratefully credited by all who write about Nevelson's attitudes toward her art and life). "Almost everything I had done," she said, "was to understand this universe, to see the world clearer." And then, "I have taken everything out of this world, everything that I could, to become more aware of what it is."

Whatever Nevelson does and says is intensely personal; she has had ever since early childhood an obsessive sense of self: "I recognized that the most important thing in my life was to claim myself totally." (She has given the Archives of American Art 21,000 items about herself, from watercolors saved from high-school years to the most recent interviews, reviews, and honorary degrees.) Her use of the word "personage" in titles of works—*First Personage, Moon Personage*—is significant; she obviously sees herself as a personage rather than just a person. The various titles of her works clearly signify her basic attitudes. The word "totality" is important: "Mine is a total life.... I had to have totality. Night and day." Nevelson visualizes a total environment, and the individual works always suggest the whole rather than a part—*Totality Dark, Night Totality*. Each of her sculpture walls, made up of cellular box units filled with wood scraps, adds up to a whole world of content; every major work becomes an anthology of all her ideas, of her universe. In the most exact sense, Nevelson's lifework is both personal and universal: "My whole work constitutes a total world." This world of hers is one of grandeur, of magnificence; she has only contempt for anything shoddy or even ordinary. She has repeatedly stated that she abhors the idea of compromise; she always plans on doing the very best work she is capable of, and then tries for one more *plus*. Her perfectionist stance calls to mind Winston Churchill's standard of excellence: "Only the best is good enough, and that will scarce suffice."

Consider other suggestive titles—all rich, personal, dramatic. *Royal Tide, Royal Game*: "There is such a thing as royalty of mind." And the words "royal" and "voyage" provocatively joined—*Royal Voyage*: "My voyages have been in my work." "Plus" is a key word and a key concept for Nevelson's work—an

I felt that my great search was for myself.

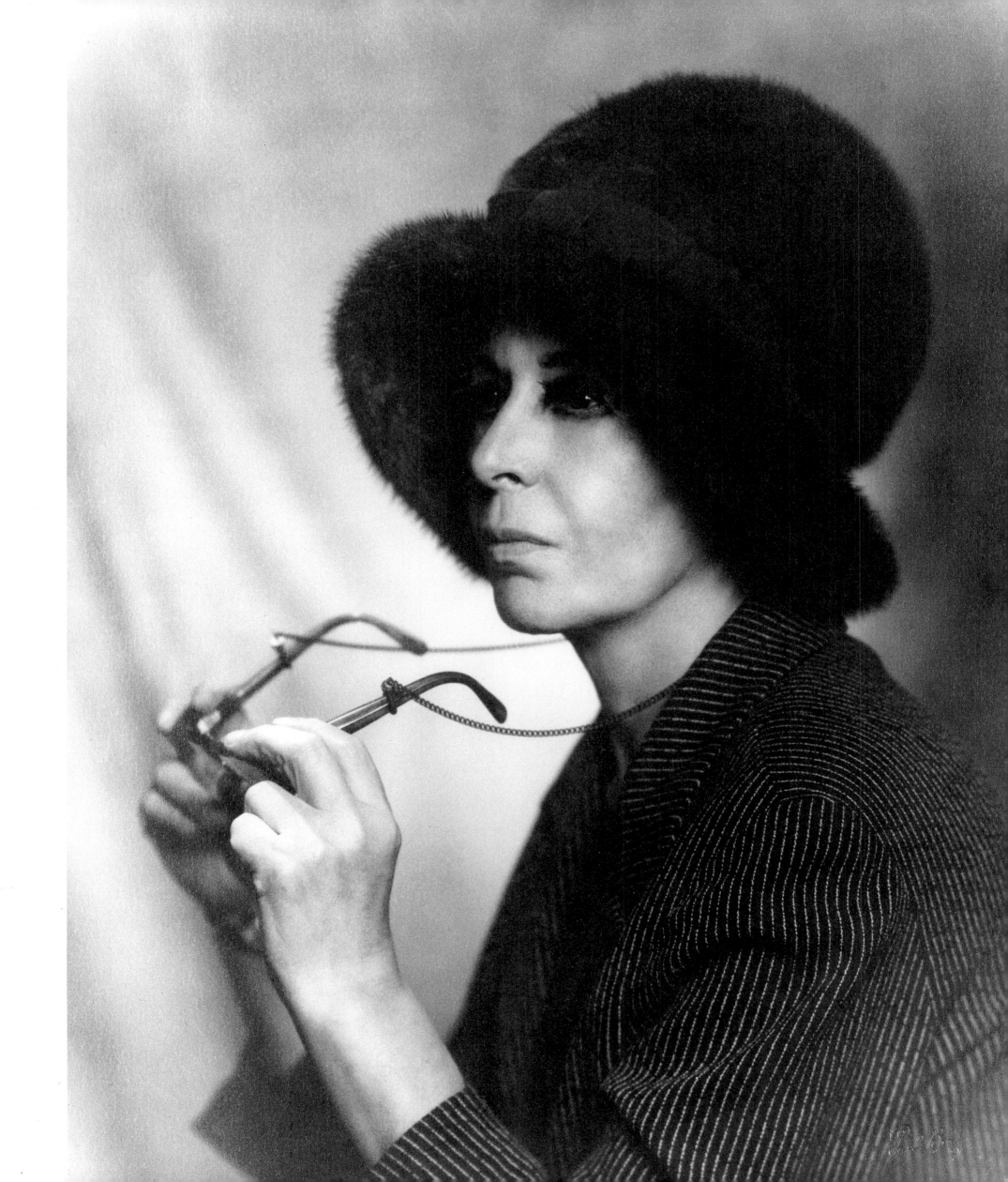

9

There's something beyond the three dimensions. I call it the fourth dimension, and this is what art is.

exhibition titled *Moon Garden + One*, the lithograph *Thru A–Z +*—always the maximum, superabundance. "Presence," like "personage," is significant—an exhibition called *Sky Columns Presence*, and *Sky Cathedral Presence*, sculpture, like the sculptor, a presence. "Feast"—Nevelson describes her collections as a feast, her own works as a feast, for herself and for us. *Dawn's Wedding Feast* is one of her masterpiece assemblages. The word "dawn"—connotations of rebirth, joy, light—is especially significant; "night" and "black" are even more so— *Night Presence, Night Music, Black Majesty*, many others. Titles often fuse concepts of dark and light, night and day—*Night—Focus—Dawn, Nightsphere-Light*. Black is Nevelson's primary color—"Black seemed the strongest and clearest"—but there is also white, festive, filled with light; and gold—she speaks of "its splendor. And an abundance." (The word "abundance" occurs often: "Let there be abundance. I want nothing skimpy.") The richness of gold relates to a favorite word, "exotic"—*Exotic Landscape*. Other lush-sounding titles, such as *Rain Forest, Tropical Tree*, seem to describe both the work and the artist's personal preferences and focal ideas. The word "essences," featured as the serial title of the *Essences* etchings, is often heard in her most serious conversation: "Art is the essence of awareness"; about Picasso's *Guernica*: "Its content and what it told about humanity was an essence of all times and of all places."

Nevelson's titles read as capsule comments on each work. Her landscape titles, for instance, never suggest anything arid or minimal, rather a luxuriant sweep and lavish scale. She has created a series of abstract scenes, many kinds

of "scapes"—landscape, dawnscape, cityscape, nightscape, moonscape, garden-scape, even a gatescape, a work titled *Undermarine Scape*, and a series of eighteen sculptures called *City-Space-Scape*. There is a frequent echo of urban architecture: the grids of city streets, details of office buildings, and churches —for example, the great series of *Sky Cathedrals*. Her white wood environment for the Chapel of the Good Shepherd in Saint Peter's Church, New York, can be seen as the epitome, the logical culmination, of Nevelson's cathedral concepts. It is her finest work of sculpture as architecture—or the other way round: "In a way the end is architecture." The *Dream House* series and the fairy-tale wood environment, *Mrs. N's Palace*, are variations of the house idea that also relate to her boxes and architectural wall sculptures.

Nevelson, royal personage, empress of her art world, naturally lives in a palace. She once said that her mother was "a woman who should have been in a palace," and added, "I think that's my idea for myself." Her New York house, for those who know it, becomes a tangible afterimage when viewing *Mrs. N's Palace*. Her house is the container of her work and of her dreams, her world in microcosm. In the five-story house on the corner of Mott Street and Spring Street (she assembled two adjoining houses and a large garage to create an astounding multilevel architectural labyrinth), her sculpture surrounds her, over-laying walls, enclosing rooms—as if each were a Nevelson box, the whole house a prodigious Nevelson assemblage. At one time the rooms were crammed with her collections, but sixteen years ago she disposed of all but a few treasured pieces, such as a single painting by Louis Eilshemius, selected from over a

You see, you can buy the whole world and you are empty, but when you create the whole world, you are full.

hundred she once owned. The house is now bare except for her own sculptures and stacked collages, with a minimum of furniture—spare wooden pieces painted black—just enough to seat and serve the few special friends invited to share for an evening her private world.

Edward Albee, famous playwright and Nevelson's close friend, contributed an introduction to the catalogue of the exhibition *Louise Nevelson: Atmospheres and Environments*, organized by the Whitney Museum to celebrate her eightieth birthday. He wrote that "from the middle 1950s all of Nevelson's work has been one enormous sculptural idea—or world, if you will," and added that "to those who know what a Nevelson looks like, the world is beginning to resemble her art."

Nevelson has said, "I wish to own my time and to claim it." And, "If you can live in the present, recognize the past, and project a bit into where we're going, that's great." She wanted to build an "empire" of aesthetics and she knows that she has done it: "The essence of living is in doing, and in doing, I have made my world." No reason for modesty: "I do like to claim that my being here has shaken the earth a bit."

The specific way Nevelson has shaken the earth is the content of this book. The enormous work of a lifetime is illustrated here in a small number of examples, critically selected from close to a thousand pieces to represent the best work in each of the media that the artist has chosen for her sculptures and graphic work. (Some additional works that seemed important to record are listed in the Chronology.) Each major section of illustrations is introduced with a close look at one or two outstanding examples. It is rewarding to enjoy any Nevelson work first at an overall glance, then to close in on its structural details to see how they add up to the immediately exciting experience that the artist has created for the viewer. The illustrations do not adhere to strict chronological sequences or styles, but are arranged to suggest the evolution and interrelationships of Nevelson's major series of works. It is hoped that in turning the pages the reader will sense the inner rhythms that determined the order of the pictures and comments.

The quotations that accompany each illustration—to allow the artist to speak directly to the reader—were chosen from hundreds of thousands of Nevelson's words, heard in the art classes she has taught and panels she has participated in; published in books, articles, and catalogues; taped in interviews and recorded in conversations with the author. The text also features Nevelson's

pithy comments about her work, making it as much hers as mine. I believe that a publication about an artist should present, as much as possible, the artist's point of view. Relatively few artists want to—or can—use words to communicate their ideas about art, but Louise Nevelson is a rare exception. She is eager to tell her audience exactly how she lives and thinks and works, and she does it with an extraordinary combine of courage, panache, and passion. In describing her personal world as an artist she seems to speak not only for herself, but for all artists, not only of her time, but of all times.

Marcel Duchamp, Frederick Kiesler, Alberto Giacometti, Jean Dubuffet, Willem de Kooning, Mark Rothko, Jackson Pollock, Franz Kline, Max Ernst, Jasper Johns, Diego Rivera, and Hans Hofmann.

Her son Myron (Mike), who is also a sculptor, was born in 1922; his early years were the only ones in which she focused on family life. In 1928 and 1930 she worked at the Art Students League under Kenneth Hayes Miller. In 1931 she separated from her husband and traveled to Munich to study painting with Hans Hofmann, who she had heard was the greatest art teacher in the world. She also worked as an extra in films in Berlin and Vienna. Her mother took care of her young son and gave her an allowance while she was abroad. Back in New York in 1932, she met Diego Rivera and became an assistant for his series of murals, *Portrait of America*, done in the New Workers' School on 14th Street. She then worked as a full-time painter, studying at the Art Students League with Hans Hofmann, by then living in New York, and with George Grosz. She also studied modern dance with Ellen Kearns. In the sixties she told Colette Roberts, one of her first dealers, "I started modern dance in 1930 and

have never stopped since. I felt a body discipline was essential to harmonious creation and to help me solve the plastic problems, as I saw them both made of alternative equilibrium and tension."

After the final separation from her wealthy husband in 1933, she gave up without regret the luxuries that her marriage had provided. (Much later she described her work as "a marriage with the world" and said, "I am closer to the work than to anything on earth. That's the marriage.") At that time she began to work in sculpture, exhibiting in group shows at various New York galleries for the next few years. In 1937, as part of the Works Progress Administration, she taught art at the Educational Alliance School of Art. Her first gallery showing, where she exhibited several paintings, was at the Secession Gallery in New York. Her first museum exposure was the inclusion of one of her terra-cotta figures at the Brooklyn Museum.

In the 1940s she worked in plaster, terra-cotta, tattistone, marble, aluminum, bronze, and wood. Her first one-artist show was held at the Nierendorf Gallery in New York in 1941. Reviewing this exhibition, Emily Genauer, art critic for the *New York World Telegram*, wrote that the sculpture was "completely personal and original...full of the suggestion of flux and movement...one might say like a coiled spring would be." In 1944 her first exhibition of abstract wood sculpture was held at the Nierendorf Gallery. After traveling in Europe (England, France, Italy), she returned to New York and began to work at the Sculpture Center. She made two trips to Mexico, where she was much moved by the ancient art and architecture.

In the early 1950s Nevelson practiced etching at Stanley William Hayter's Atelier 17. In the mid-fifties she began to make wood assemblages, which were shown at the Grand Central Moderns gallery until she became affiliated with the Martha Jackson Gallery in 1959. The first piece to enter a museum collection was *Black Majesty*, given to the Whitney Museum of American Art in 1956, and the first major work, *Sky Cathedral*, was given to the Museum of Modern Art, New York, two years later.

Throw off your environment and rebuild.
You must remain free.

At 29 Spring Street

*I have been a collector
all my life. You name it,
I have collected it....
Marvelous American
Indian pottery...
African sculpture...
silver, pewter...
Chinese lacquers.
Other artists' work.*

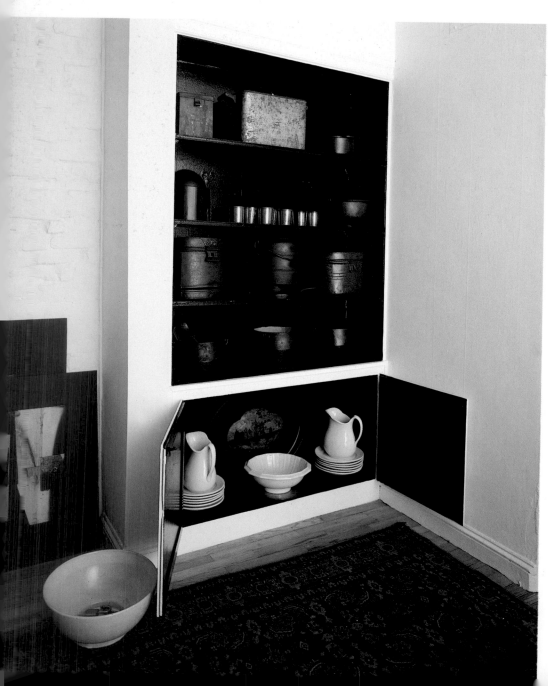

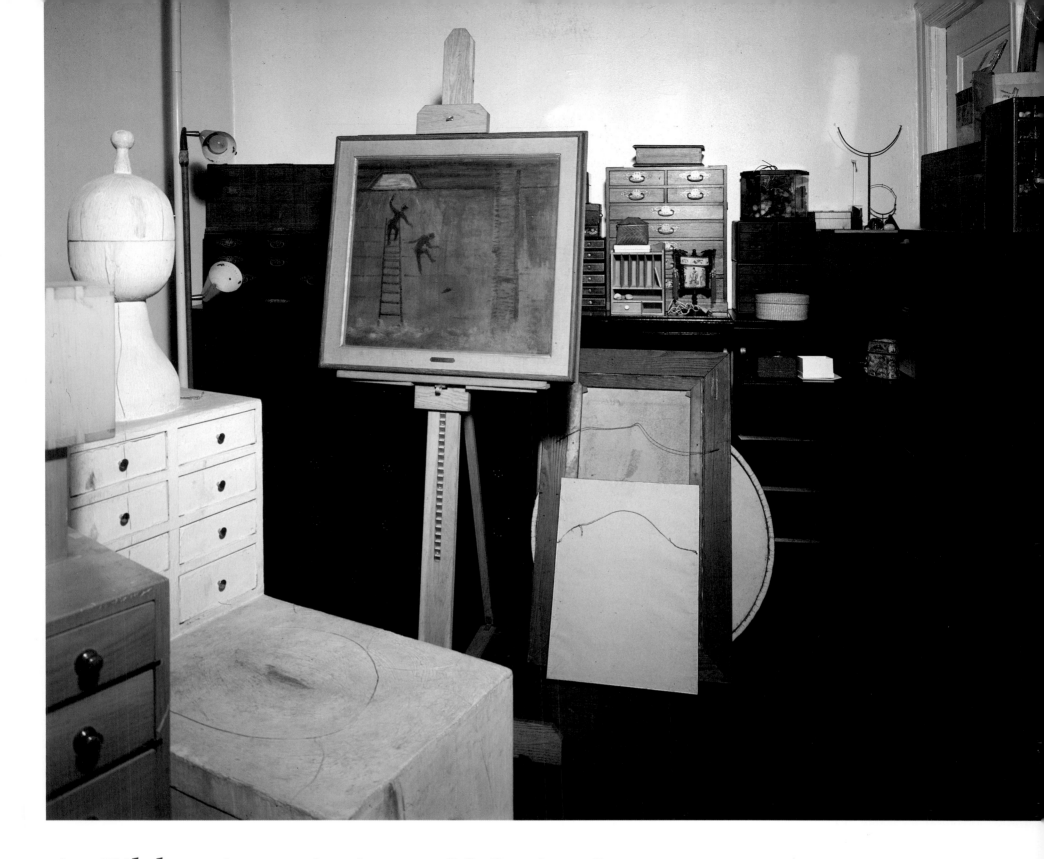

An Eilshemius painting at 29 Spring Street

Just as I recognized the power of African and Indian relics, I also knew the value of the American artist Eilshemius. . . . I was overwhelmed by these paintings. And of course I bought a piece right away. I thought the color and the vitality were great.

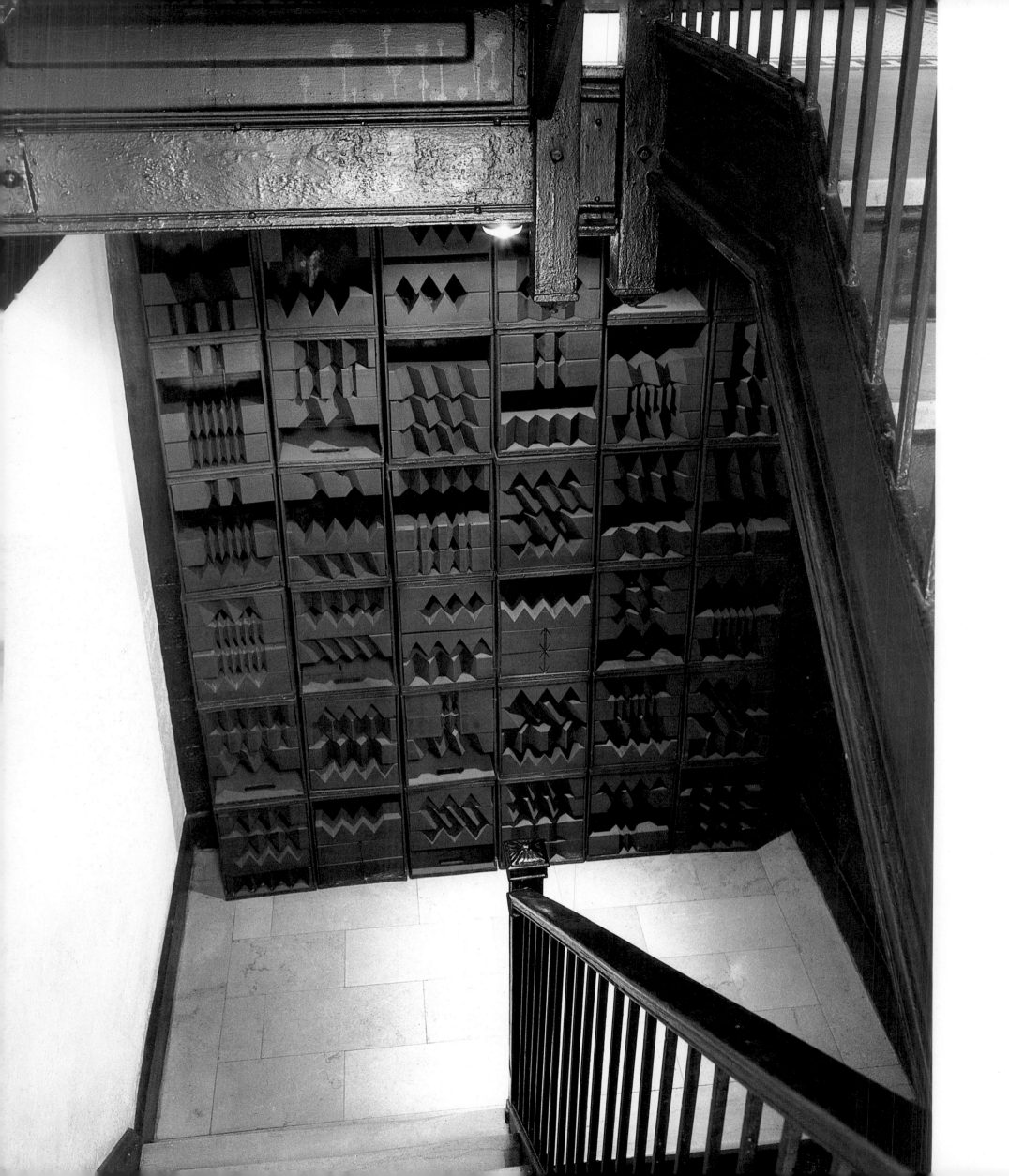

◁ <u>Stairwell, 29 Spring Street</u>

Basically it's like architecture.

<u>Reception room, 29 Spring Street</u>

I love an empty house. I love the luxury of space.

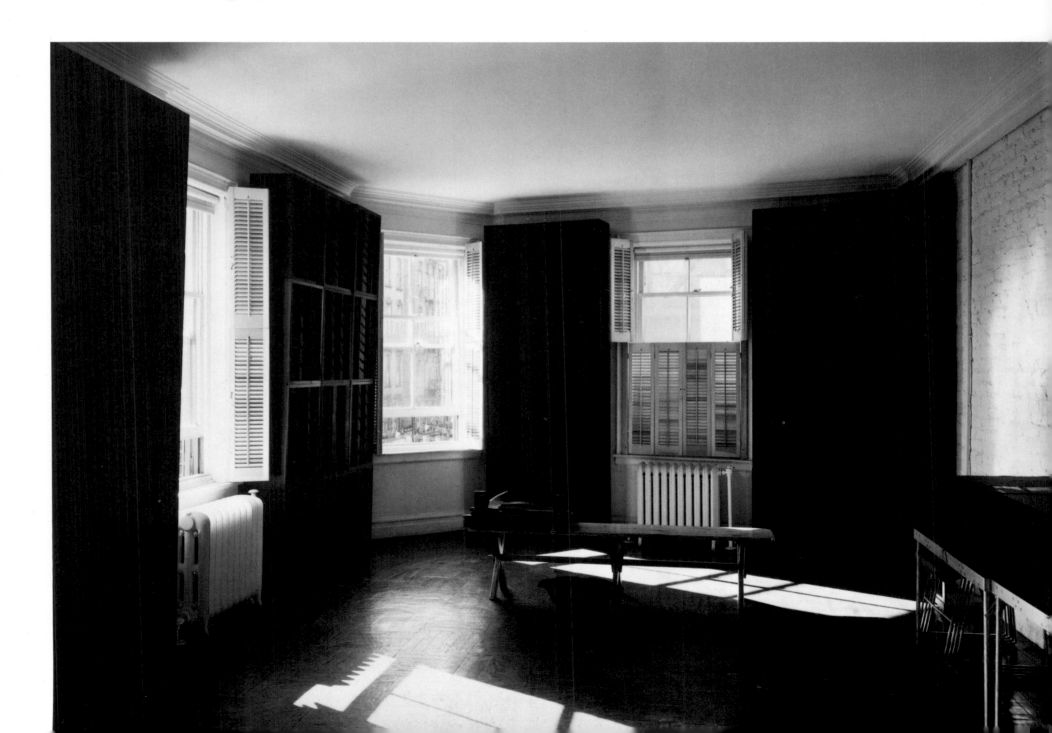

Living room, Spring Street, before 1967

*I collect for my eye. . . . A feast
for the eye. A banquet for the eye.*

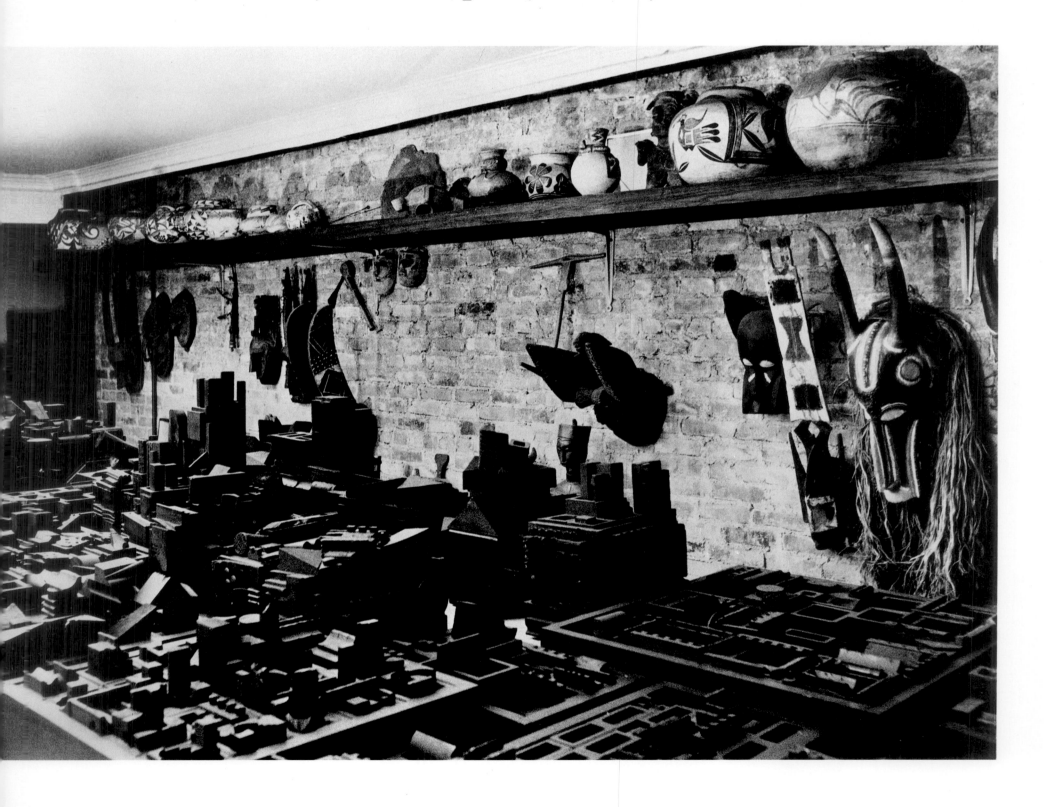

In the 1970s Nevelson reached some new peaks in the scale and grandeur of her work, and in the enormous annual production. She has said, "I want a lot of quality in a lot of quantity." She was granted numerous honors: a Brandeis University Creative Arts Award in Sculpture, a Skowhegan Medal for Sculpture, an honorary Doctor of Fine Arts degree from Rutgers University, membership in the American Academy of Arts and Letters. Major works were acquired by museums and private collectors, and commissioned by churches, cities, and public institutions; prominent examples are the Louise Nevelson Plaza in lower Manhattan, which features a group of black painted Cor-ten steel sculptures titled *Shadows and Flags*, and the wonderful white wood sculpture interior of the Chapel of the Good Shepherd in Saint Peter's Church. Important traveling exhibitions were organized by a number of museums, including the Walker Art Center in Minneapolis and, in celebration of her eightieth birthday, the Farnsworth Library and Art Museum in Rockland, Maine (her home town), the Phoenix Art Museum in Arizona, and the Whitney Museum in New York.

Nevelson, now internationally famous, generally considered the greatest living American sculptor, is an extraordinary personification of the rigor and pain, ambition and elation of a dedicated life. Books, catalogues, magazine and newspaper articles have recorded her work, pictured her in her invariably dramatic dress and trademark double eyelashes, quoted from her rich flow of comments on her life, ideas, and work. She is admired by the world, respected by her colleagues, loved by her friends. John Canaday, former art critic of the *New York Times*, has described her as "a woman whose presence in a room enhances everyone else's sense of his own life."

The passionate and prodigious work continues in splendor, and Nevelson glows with the triumphant pride of realized and recognized achievement. *Celebration* is the title of a series of joyous, colorful prints made in her eightieth year.

Nevelson once quoted Picasso as always saying that he was searching, never that he was finding. She herself has said innumerable times that a continuing search has always been the motivation for her work, which is her life. In the interview with Barbara Braun she talked about this, adding: "When I work, I'm not searching for perfection, I'm searching for life. I'm always searching, always questioning. England has the lion, we have the eagle, and my emblem is the question mark."

Self-Portrait, *1922*

I felt like an artist. You feel it—just like you feel you're a singer if you have a voice. I have that blessing, and there was never a time that I questioned it or doubted it.

the canvas in a way that could be seen as painting about structure, a prelude to her architectural sculpture. Dorothy Seckler has remarked (again in her *Art in America* article) on the painterly effects in the early wall sculptures—"a rough board serving as a broad impasto stroke, a series of slats providing crisp linear accents." Concepts of painting, drawing, sculpture, and architecture are variously blended in all of Nevelson's work, both early and late.

The early sculptures in various media—plaster, terra-cotta, wood, marble, and metal—were based on figurative concepts (often influenced by Nevelson's fascination with American Indian, African, and pre-Columbian arts, all of which

she collected), but they became strongly abstract in her execution. The plaster figures, in retrospect, seemed very much alive to her: "Some years ago I was working in big pieces, of plaster, and they were not realistic as we understand figures. Still, they had some part of the figure concept. And at night I could sleep with them and I could see them as if electricity was in them, lighting them up, and I could see all of them moving. While they were static in daylight, they were moving in their world of reality."

In the early 1940s she began to make small wood assemblages, almost by accident, because after a brief illness she lacked the strength to execute heavy stone and ceramic pieces. In the following decade she embarked on the large compartmented structures that have been her distinctive contribution to modern sculpture. A show titled *The Circus: The Clown Is the Center of His World*, held in the Norlyst Gallery in New York in 1943, was clearly reaching in that direction. Two major shows at Grand Central Moderns, *The Royal Voyage* in 1956 and *The Forest* in 1957, were true progenitors of the series of dramatically staged Nevelson shows. Two of the large sculptures in these exhibitions are the outstanding masterpieces in the early Nevelson oeuvre: *Indian Chief* and *First Personage* mark the transition from figurative sculpture to abstract wood constructions and foretell much of the great work that was to come—found pieces of wood assembled to create dynamic sculptures in large scale, presented in exact frontality, painted matte black.

A dramatically feathered chieftain is the subject of *Indian Chief*, but the one large and thirteen small pieces of wood that are assembled to form him could as well have been material for one of her later wall pieces–assemblages of wood that have nothing to do with representation, except for occasional vestigial remnants suggested by the titles. *First Personage*, a spare silhouette —but with double impact when seen from the front and then the back—is a marvelous sculpture, monumental in its powerful presence. Dore Ashton described it, when it was first shown, as "a primordial image."

All of Nevelson's work creates a strong impression of spontaneity, partly because of the seemingly casual content, partly because of the seemingly casual way the materials are assembled. Her instinctive flair for dramatic design, however, controls every choice, every decision. The pieces of wood she found for her Indian and *First Personage* were selected, not shaped. For *Indian Chief*, the big slab was chosen as exactly the right recipient for the abstract feathers that fit as if they were darts thrown accurately along its edge. The large, curved form firmly fixed on its base is the perfect counterpoint for the staccato rhythm of the sharp-feathered fringe.

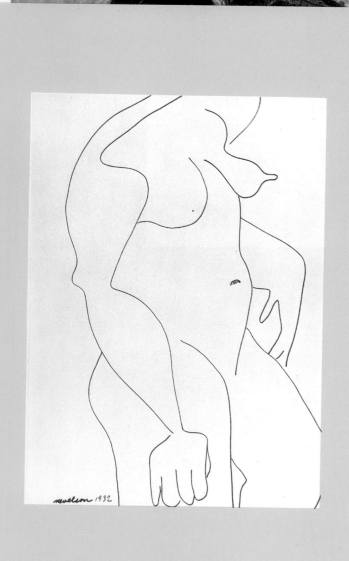

Untitled drawing, 1932

I didn't have to study African sculpture. I immediately identified with the power.

Lovers II, *1946*

I relate to or feel close to certain cultures and I don't demand authenticity....

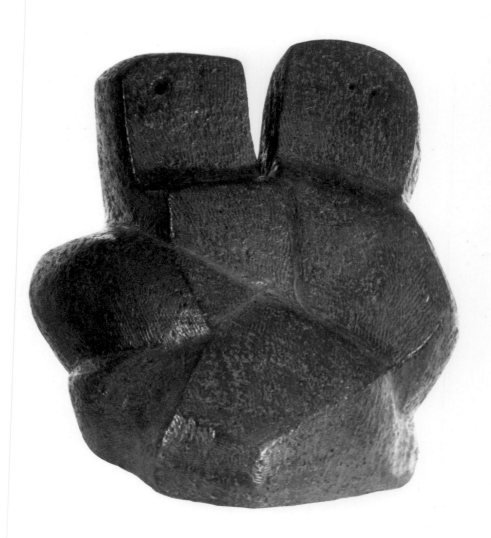

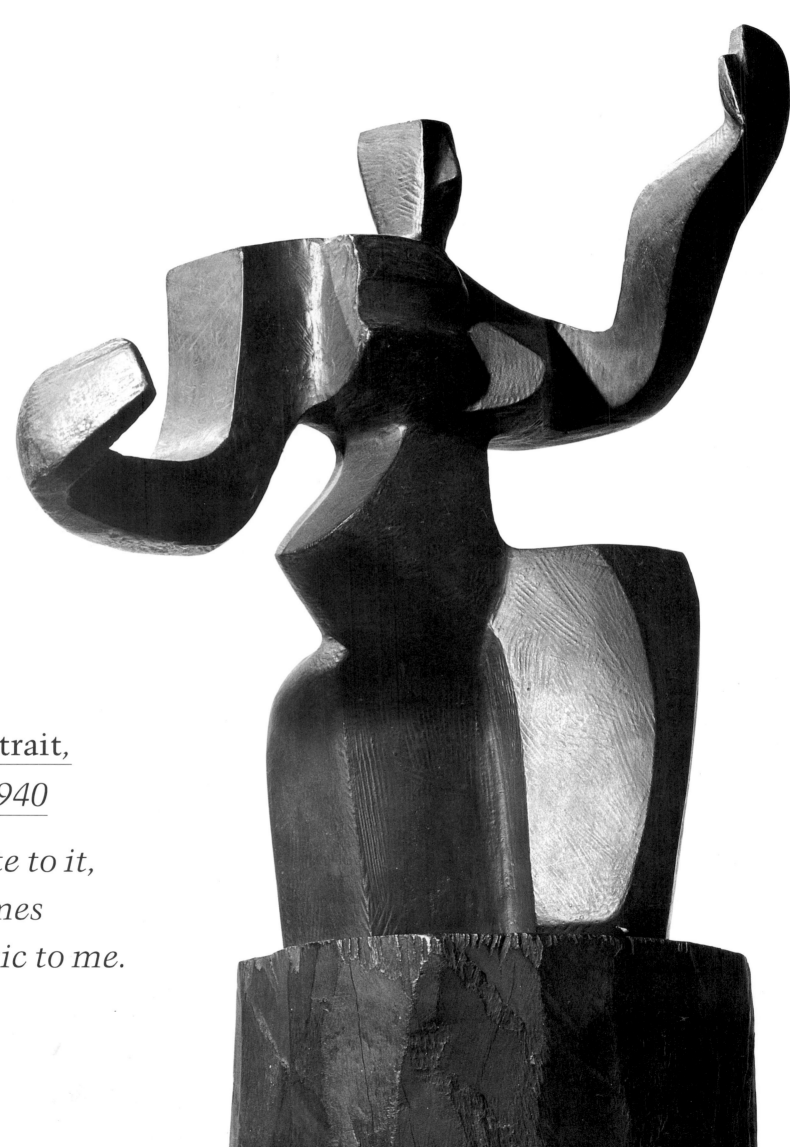

Self-Portrait, about 1940

*If I relate to it,
it becomes
authentic to me.*

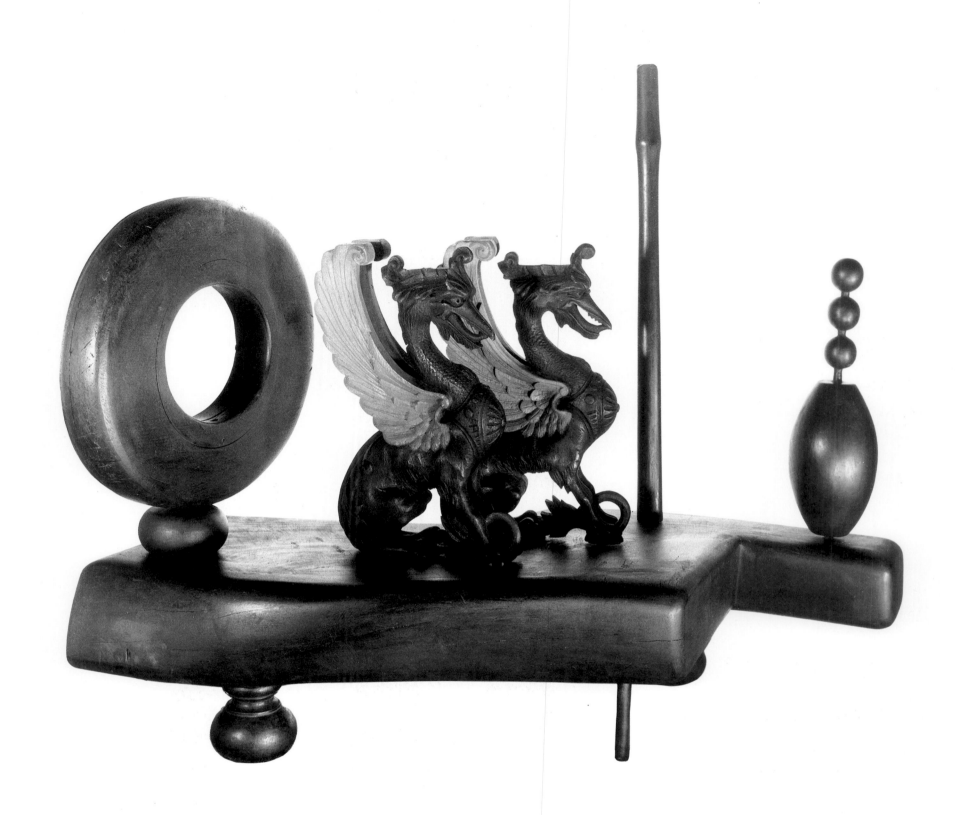

Ancient City, *1945*

The griffins I have used as our worldly symbols for flight. The round object in back represents the sun.

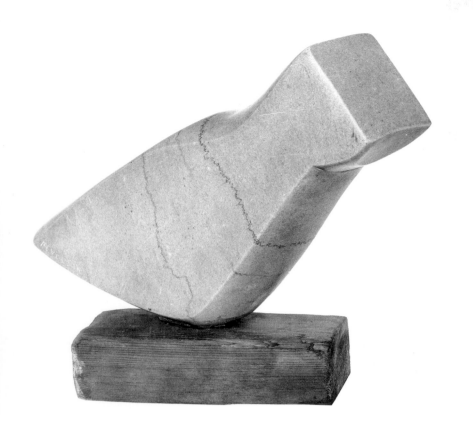

Bird Form, *about 1945*

There was a courtyard to work in. . . . I could sit out there in the sun with my shoes off and let the stone decide the form.

The Circus Clown, *1942*

I had a circus exhibition at Norlyst called "The Clown Is the Center of His World." It was partly inspired by a clown's head that I bought in a Third Avenue junk shop.

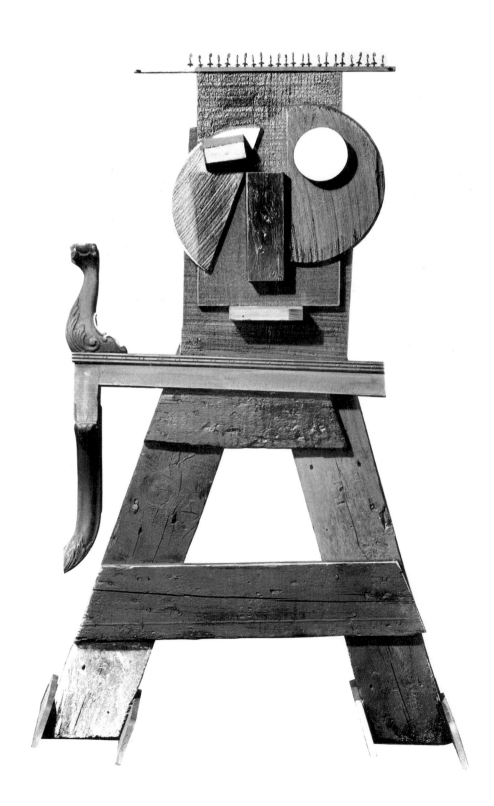

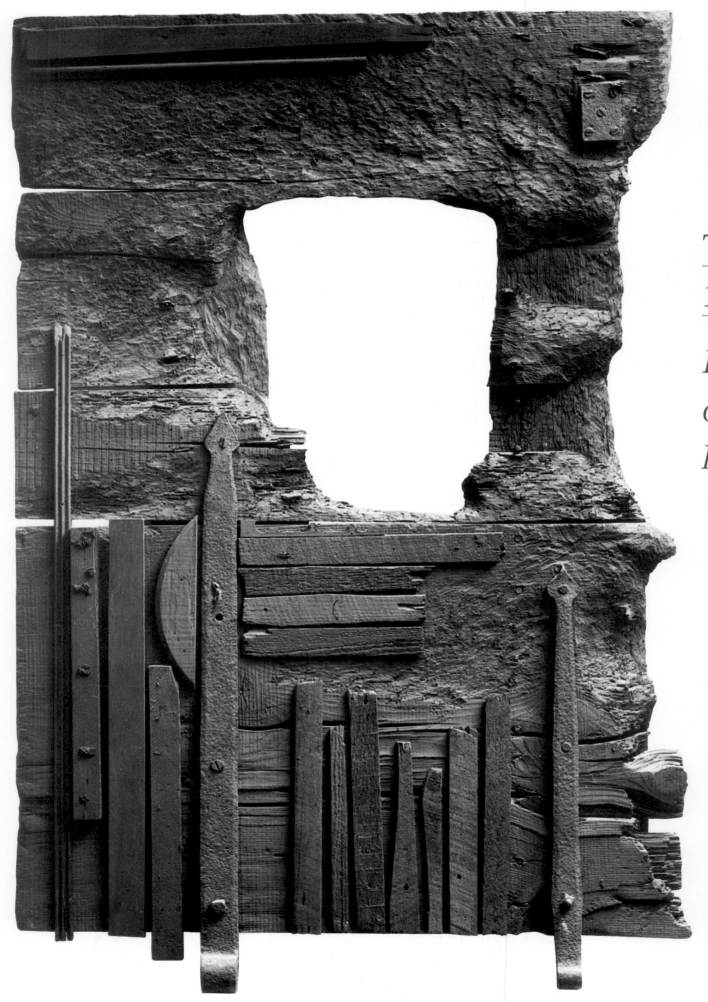

The Open Place, 1958

*I pick up
old wood that
had a life.*

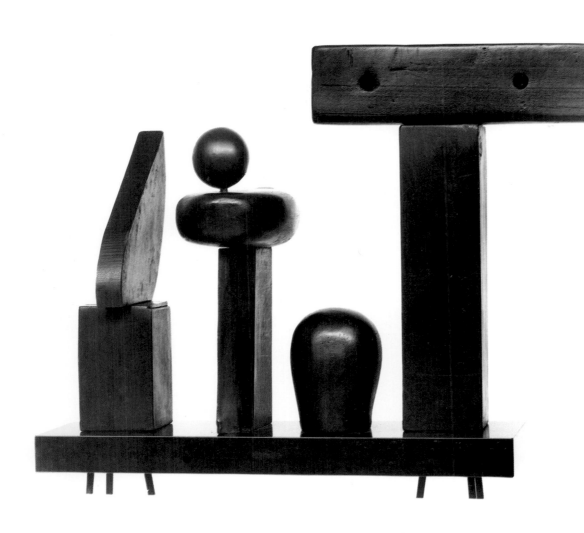

Black Majesty, *1955*

*It was always a
relationship—my
speaking to the
wood and the wood
speaking back to me.*

Night Presence VI, *1955*

*In art . . . I suppose you might say
I'm not frightened. I'll try anything.*

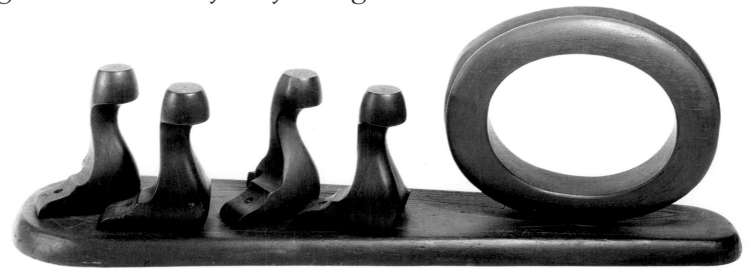

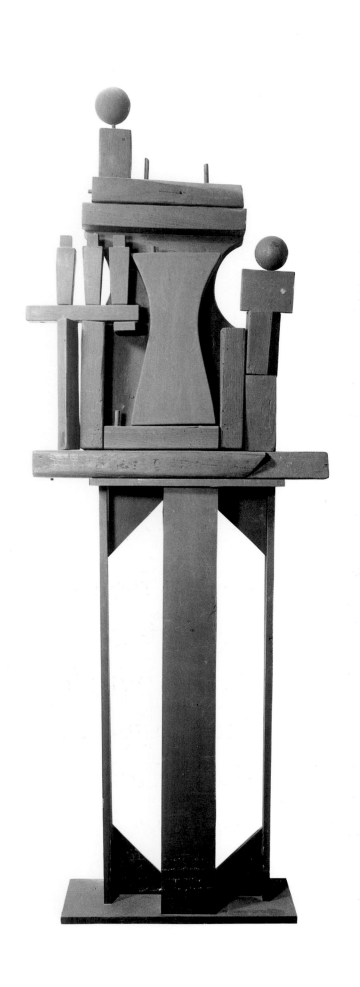

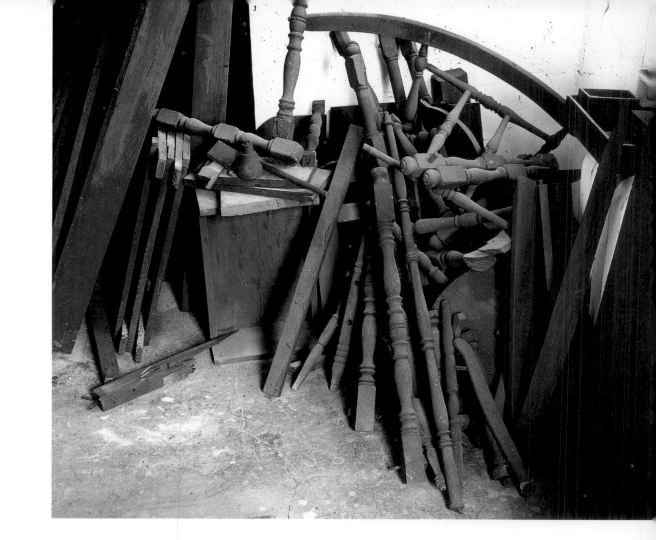

Studio, 29 Spring Street

*I will use anything
to fulfill what I want.*

Forgotten City, 1955

*You can't just put woods
together . . . they have to be related,
just like human beings.*

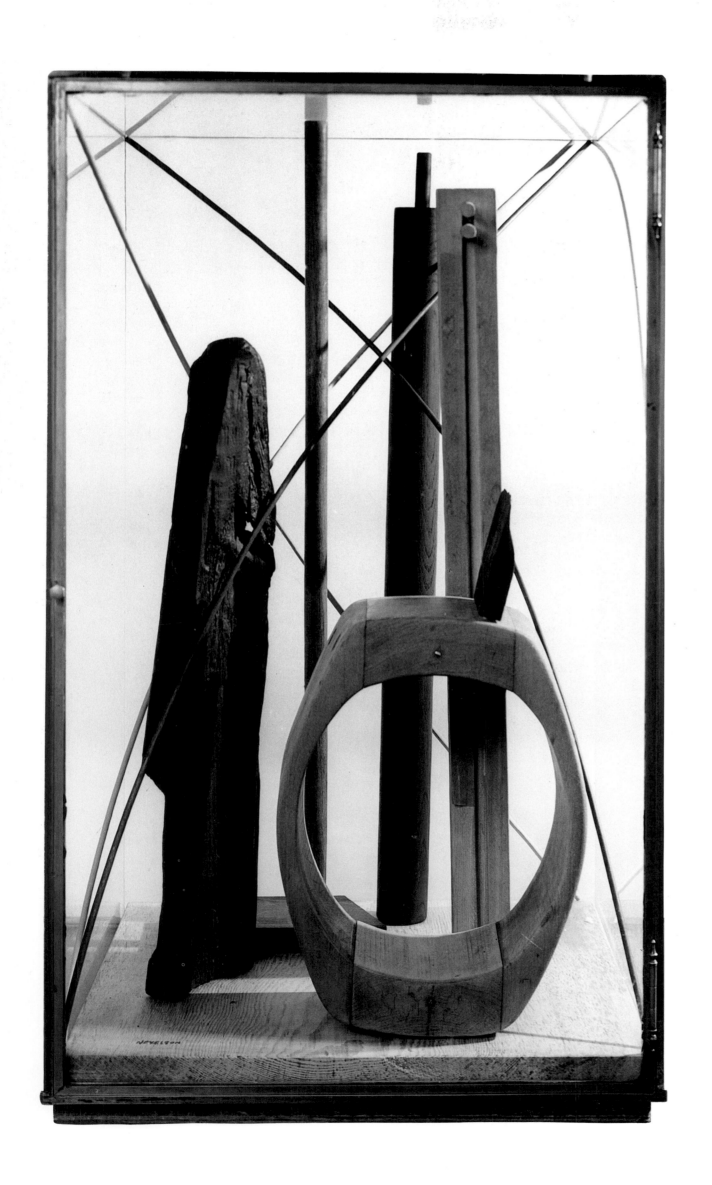

Undermarine Scape, *1956*

When I begin composing... I know which piece to pick with which other piece.

Indian Chief, *1955*

I love American Indian things, and I wanted them around me.... If I had to choose a reincarnation I probably would say I'd like to be an American Indian.

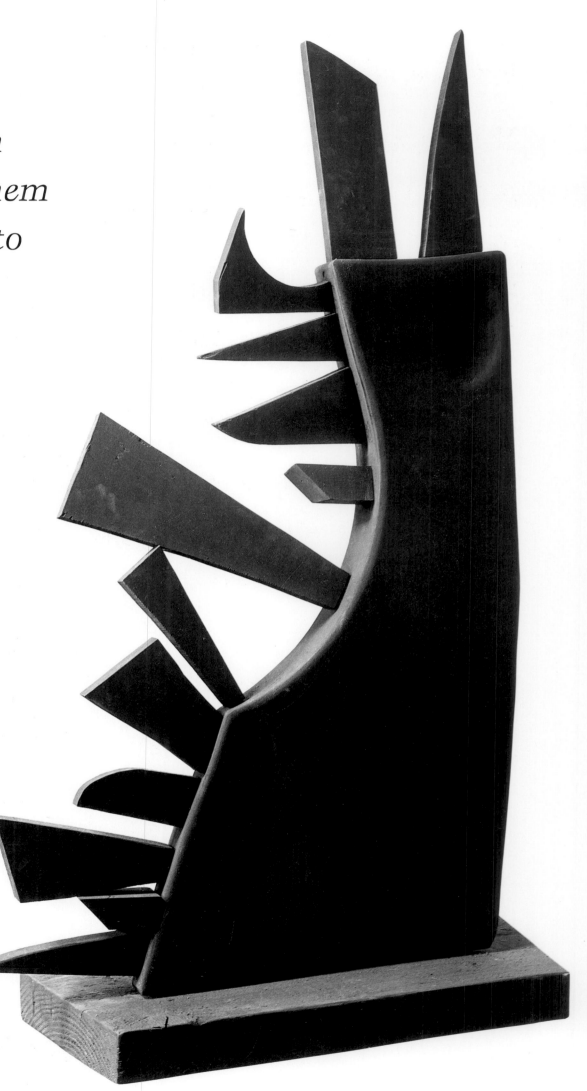

First Personage, *1956*

You know that great big piece that's in the Brooklyn Museum? That's one of the first major pieces. . . . I acquired those planks and things, and I got so involved in my work that I really was creating a novel, because I had myself being the bride . . . it was my autobiography in that sense.

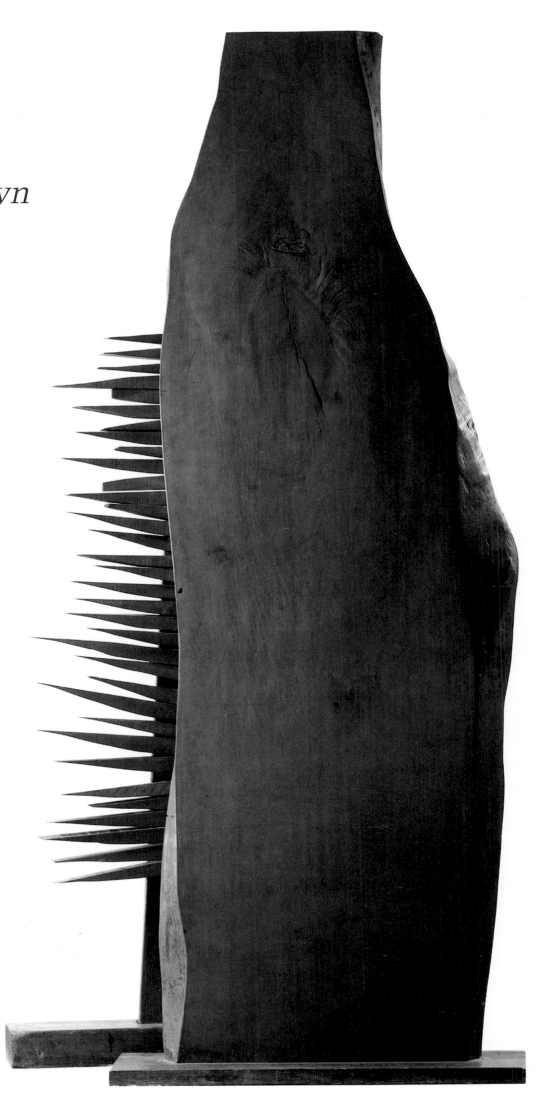

WOOD CONSTRUCTIONS AND ENVIRONMENTS

BLACK WORKS

Actually, I think that my trademark and what I like best is the dark, the dusk.

"Nobody did until I did," Nelson said, "make a whole environment. It was *Moon Garden + One*, 1958, at the Grand Central Moderns. . . . My shows always had themes." For this exhibition she created a total environment of the assemblages she called *Sky Cathedrals*—stacked boxes filled with newel posts, balusters, finials, moldings, and other found objects and scraps of wood. These were her first sculpture walls. They were painted flat black and, under the dim illumination that she arranged, revealed themselves only slowly to the viewer. (She still likes her black wall pieces to be shown in a blue light that suggests the sky at dusk.) The *Sky Cathedrals* feature wildly varied content, composed in daring, surprising ways. But ordering her wood-scrap collections, their light and shadow, shapes and spaces, was from the start the primary requirement for her sculpture, and it is also the function of the individual box frames that add up to an orderly architecture. The taut balance between the skeletal structure and its opulent content is at the heart of Nevelson's sculptural style.

Shortly after this landmark exhibition, Hilton Kramer wrote an extraordinary article for *Arts*, "The Sculpture of Louise Nevelson." Then the editor of the magazine, his was the first presentation of Nevelson as a major artist of our time and the first in-depth critical appraisal of her rich personal style—exactly

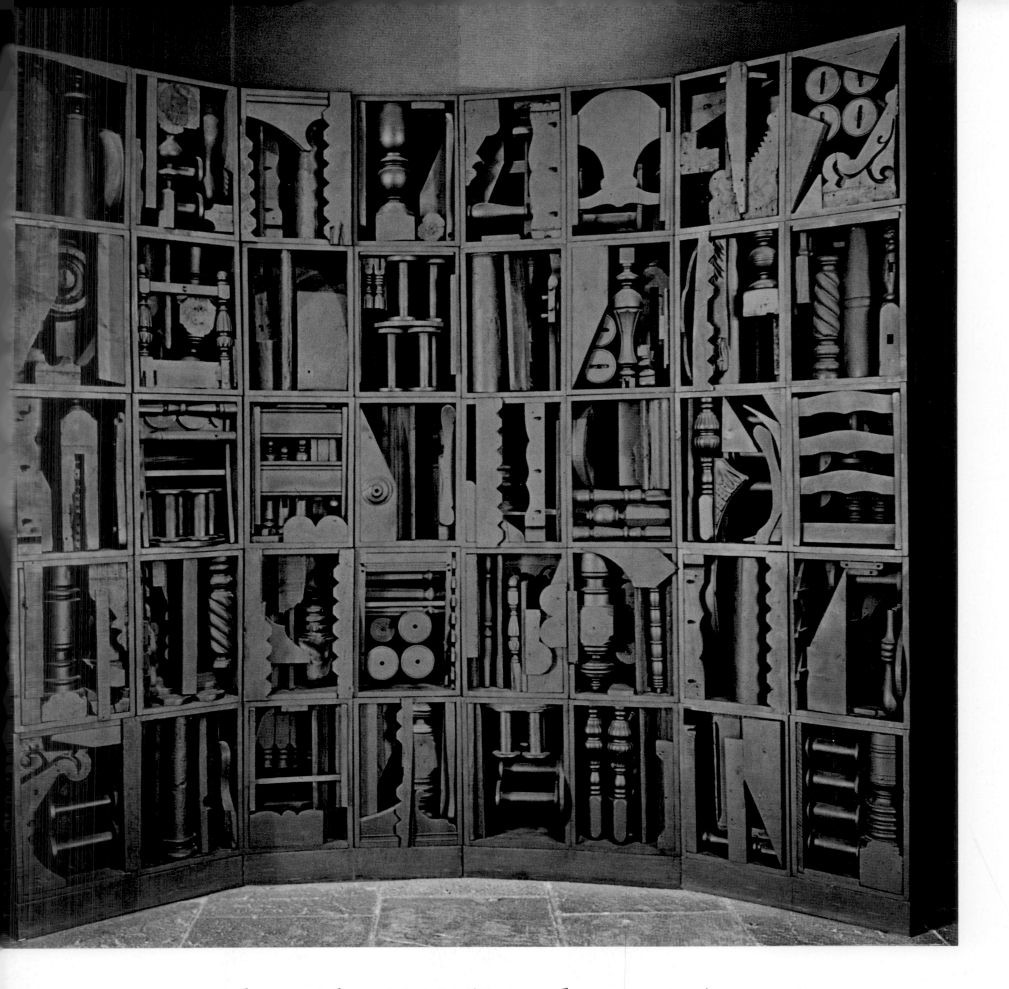

Tide I Tide, *1963. (Detail opposite)*

There is great satisfaction in seeing a splendid, big, enormous work of art.

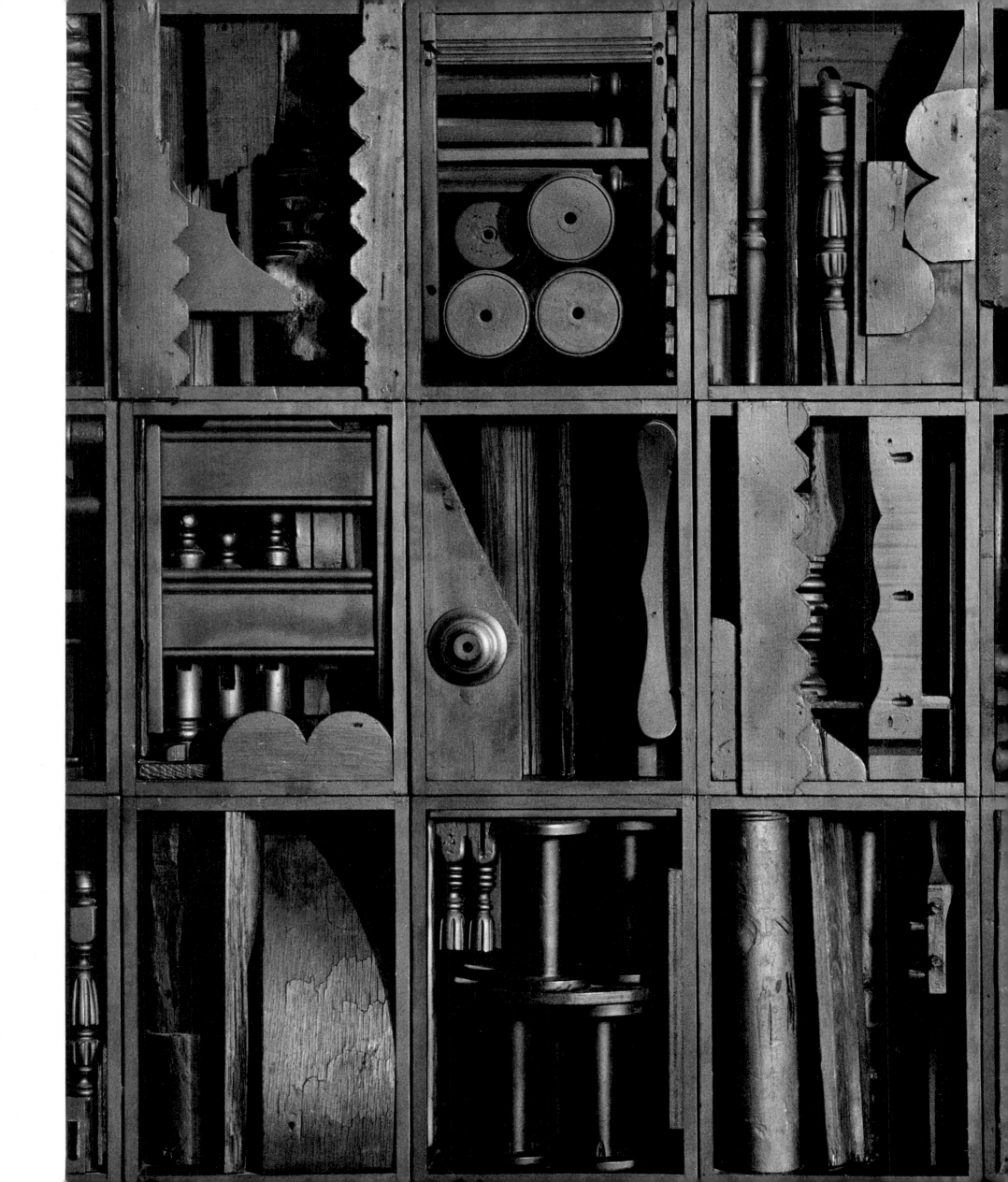

as if he knew just how the prodigious Nevelson oeuvre was to develop during the next quarter-century. He cited her affinity with drawing, collage, and architecture; her innovative materials and color; the complex mind that produced "an art characterized by precision and extravagance." The illustrated essay of several thousand words can't very well be summarized, but here are a few telling excerpts:

Like a great deal of modern sculpture, the recent work of Louise Nevelson is neither carved nor modeled—it is *constructed*. It is made of wood which is cut, nailed, glued, joined and otherwise *put together*. Its tradition is thus no longer the monolithic figurative mode in which the artist worked some years ago; it is instead the more radical heritage of the Cubist wood-construction which Picasso, Lipchitz, Laurens and others created during the First World War and after, the heritage of construction-sculpture which derives directly from the concept and the method of collage....

It has affinities also with the history of Dadaist construction, which followed on the Cubist period, often investing the austere syntax of Cubist collage with wit, poetry and erotic fantasy. At the same time, her work profits from the new open-space sculpture which has flourished for the last quarter-century and which has come to a stunning fruition during the last decade in New York. Its emphasis on the silhouette, on drawing in space, and on the radical use of materials, has given strength to her vision....

[Hers] is a sculptural mind both exact and extravagant in its mode of expression, aspiring toward—and achieving—an art of precision which is yet a form of Expressionism. I doubt if Mrs. Nevelson's achievement can be understood without an appreciation of these antiphonal qualities, for its overriding impulse is to release a sculptural energy which is audacious and spendthrift in its overall force but very exactly stated in its details. Both the force and the exactitude are essential elements in the sculptural dialectic. The one establishes the artist's affinities with the Expressionism of our time, with the aspiration for an esthetic emotion which is unbridled and deeply felt; the other reveals a sense of design which is nearly Mondrianesque in precision and discipline.

Kramer concluded that Nevelson's works "violate our received ideas on the limits of sculpture...yet...open an entire realm of possibility....The *Sky Cathedrals* seem to promise something entirely new in the realm of architectural sculpture by...postulating a sculptural architecture."

A few of the walls have been made or adapted for specific places, beginning with the *Sky Cathedral* Nevelson created for her brother's Thorndike Hotel in Rockland, Maine. In the early walls each shallow compartment of the large cellular structure, filled with accretions of found wooden objects, is unique and independent, yet rhythmically related to the others by the multiplication of similar elements across the surface of the sculpture. She planned and explained this relationship in terms of living, cellular organisms: "Each niche lives and

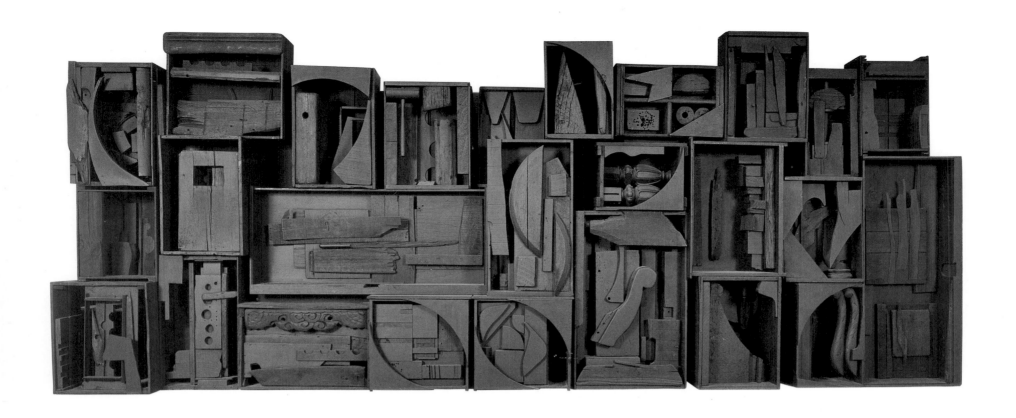

Sky Cathedral, *1957*

These pieces of old wood have a history and drama.

encloses its own life...[they] are colonies in which each cell strengthens and supports its neighbors....Life is both in the parts and in the whole."

Her individual sculpture boxes clearly reflect this idea of a living cell. She has made a great many black-painted boxes that open to show the black wood-scrap treasures they contain. One is only eight inches long and has a plain sliding lid exactly like a child's pencil box, but it is filled with exciting bits of "Nevelson" wood. More typically, the boxes are quite large, elaborately ornamented outside and filled inside. Some of the sculptures are closely related to the house idea, opening at the front like dollhouses, and there is also a series of thirty-seven *Dream Houses*. These are progenitors of the climactic black house sculpture called *Mrs. N's Palace*. This enormous work, made of pieces done over a period of a dozen years, assembled and built in two weeks, is a stage-set summary of Queen Nevelson's major interests. The mirror base that is the palace floor creates a kaleidoscope of reflections. The richly varied, dramatically shaped reliefs that cover the palace walls, inside and out, hold startling, rhythmic shadows. As one enters the open doorway, there are two

"figures" at the right, a king and a queen. At the rear, in the "garden," tall slats and poles grow out of barrel tubs to build a sculptural line drawing. And although Nevelson had created the great series of white and gold sculptures long before she finished her palace, it is all done in her primary color—black.

"I think," she has said, "there is something in the consciousness of the creative person that adds up, and the multiple image that I give, say, in an enormous wall, gives me so much satisfaction." In the tripartite *Tide I Tide*, a marvelous wall piece, recurring motifs of spools, circular disks, and turned or carved furniture parts give the whole composition a baroque richness that is a feature of her gilded pieces but rare among her great black sculptures. The compartments are held together by gravity, without nails, and so neatly are they aligned that it is impossible not to respect the rigorous architecture of the overall structure at the same time that we are lured into the mysterious shadowed substructures of each of the forty boxes. These are literally shadow boxes. "I had given myself the title 'Architect of Shadows,'" Nevelson said.

Because Nevelson's walls are always intended to be seen from the front, they relate to painting as much as to sculpture, especially to the large, mural-like works of Clyfford Still, Barnett Newman, and Mark Rothko—who once likened his paintings to facades. The contents of her boxes are reminiscent of Picasso's collage works of the Cubist period, and it is worth noting that from the late fifties on she produced series of collages and collage-based prints. The positive and negative forms of her sculpture also imply the shallow space of Cubism. Her utilization of objects dissociated from their original context and juxtaposed in unexpected ways goes back to Dada.

Nevelson has always been a collector; for her wall pieces the collectibles are bits of wood that interest her, and she installs them in their boxes in the same way that she plans the installation of her sculptures in museum galleries. For some later reductive works that required a uniform grid, Nevelson had the boxes made to order, and occasionally she now buys some of the ingredients; mostly, however, they are found by her or Diana MacKown, or given to her by the many friends who salvage "Nevelson scraps." She was delighted to accept, and promptly used, a dozen large sculpture bases that we had stored in our barn in Connecticut (they had come from the old Brummer Gallery in New York, and had been used by my husband, who was a sculptor for some years). Once a friend told her that there were 200 old typesetters' font boxes available for salvage, and Louise used most of them. Another find: she and Diana dragged home from a nearby street junk pile a number of huge crates (piano-sized) that they took apart in the garage and combined with smaller scraps to make an

enormous low-relief mural. Another wonderful black wood mural—briefly gracing the house, now stored—features a rhythmical series of large turned bedposts, discards from a woodworking shop, standing out boldly against a flat facade of packing-case parts. Sometime ago she mentioned still another windfall: "There were some old organ pipes stored in St. Mark's Church-In-The-Bowery. They said that only Nevelson could make any use of them, so they gave them to me, and I'm thinking of something wonderful to do with them." The organ pipes inspired a series of dramatic and lyrical sculptures titled *Cascades Perpendiculars*, shown in 1983 at the Pace Gallery.

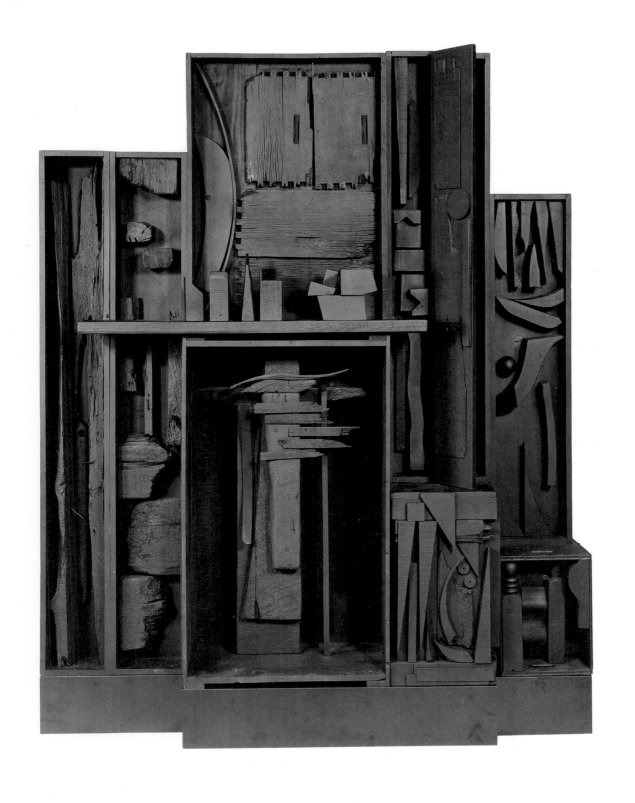

Sky Cathedral—
Moon Garden Wall,
about 1956–59

I took wood from the streets, boxes, old wood with nails, and all sorts of things.

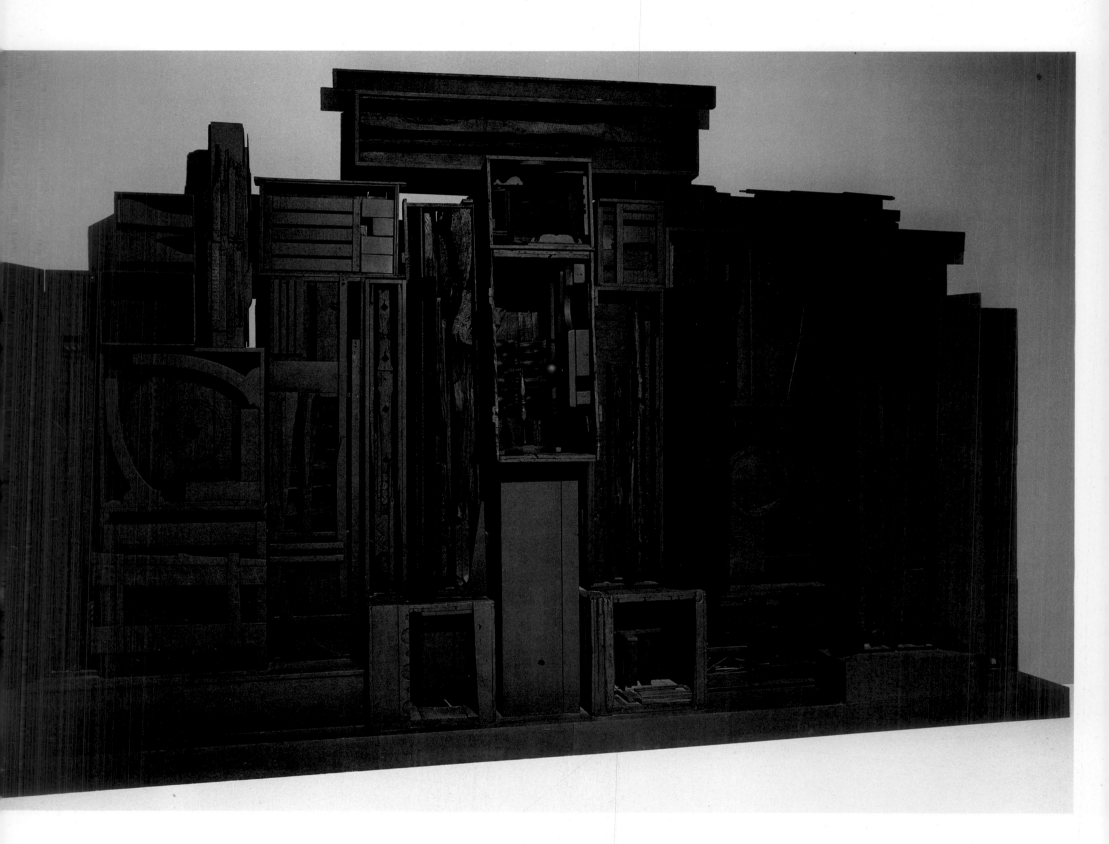

Sky Cathedral Presence, 1957–64. *(Detail opposite)*

The dips and cracks and detail fascinate me.

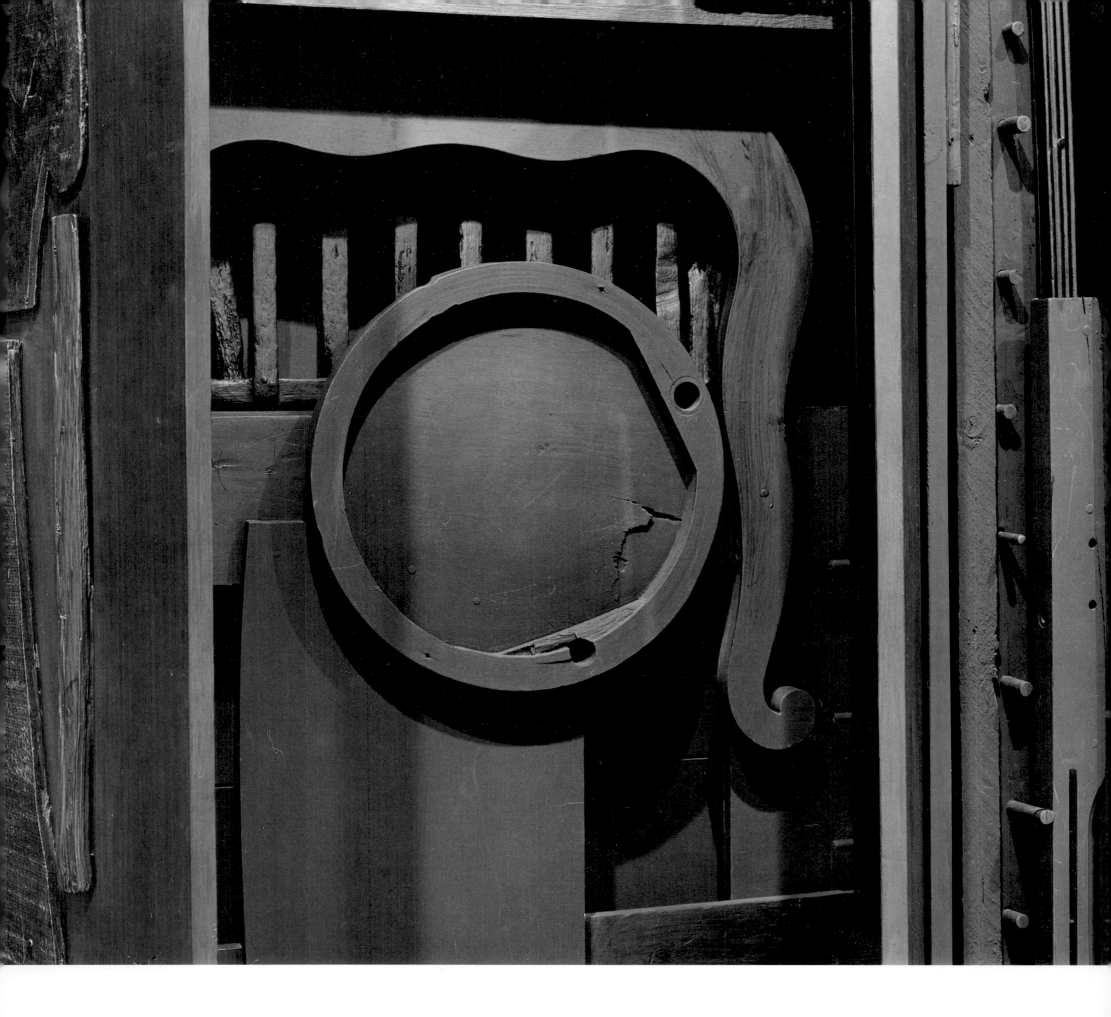

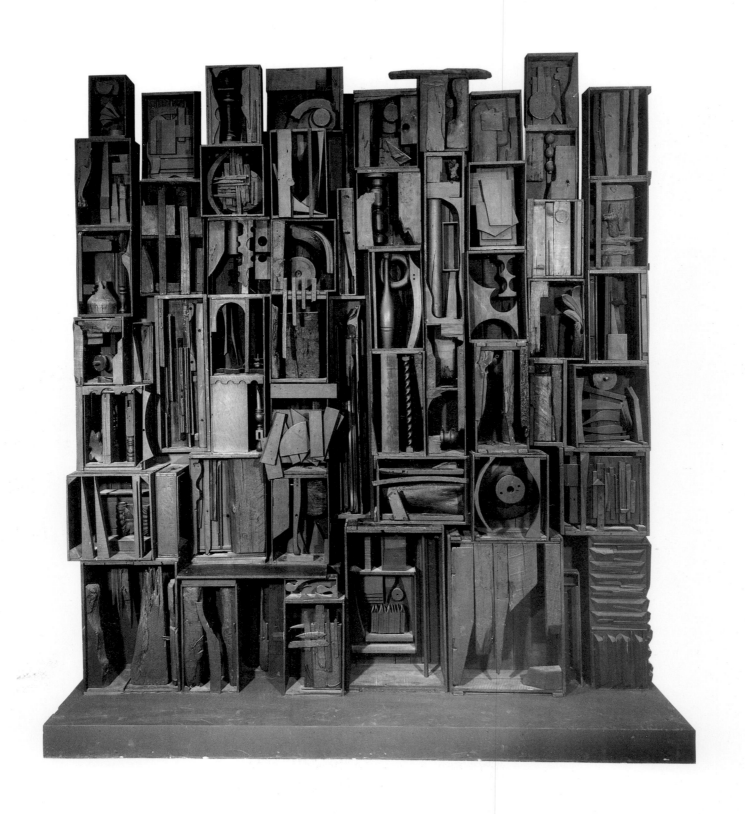

Sky Cathedral, *1958*

When Arp was in New York for the opening of his show
at the Museum of Modern Art, he saw my wall,
Sky Cathedral, . . . he stood in front of the wall and said,
"This is America, and I will write a poem to the savage."
Then later he wrote a poem to my sculpture.

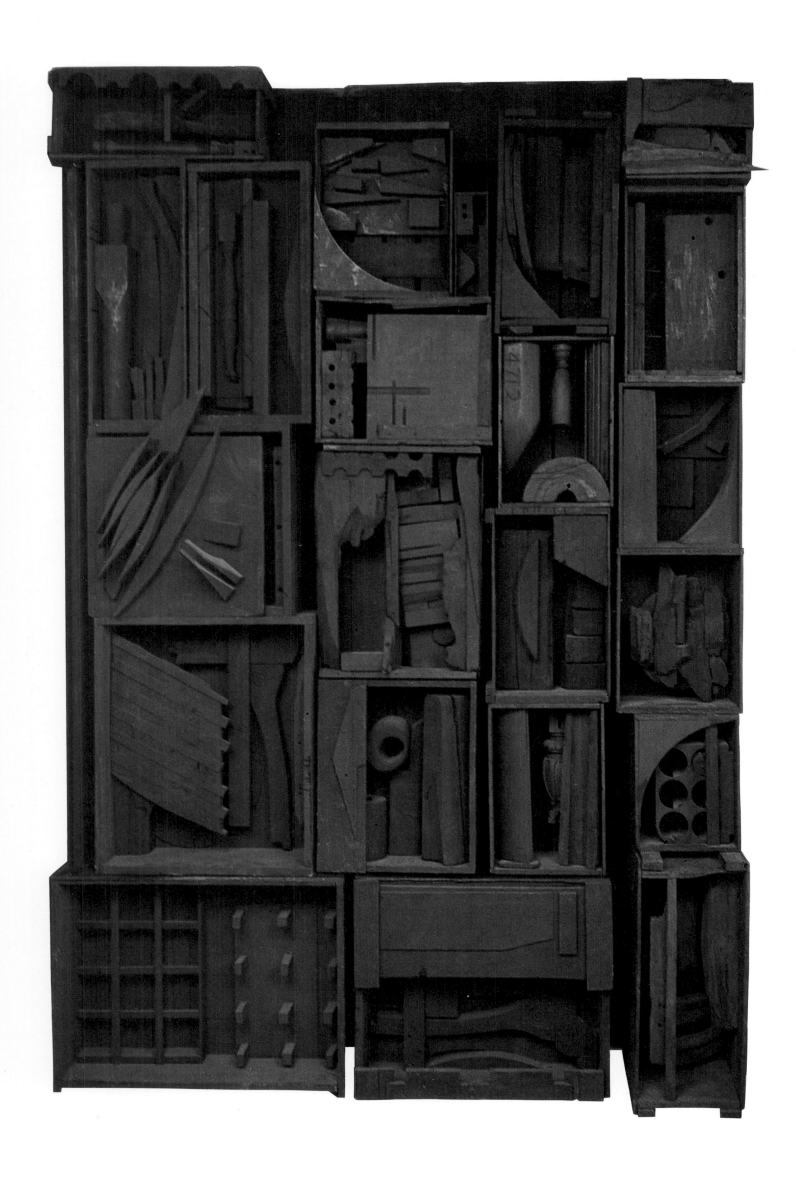

Sky Cathedral
Variant, *1959*

*In my inner
being I'm
a builder.*

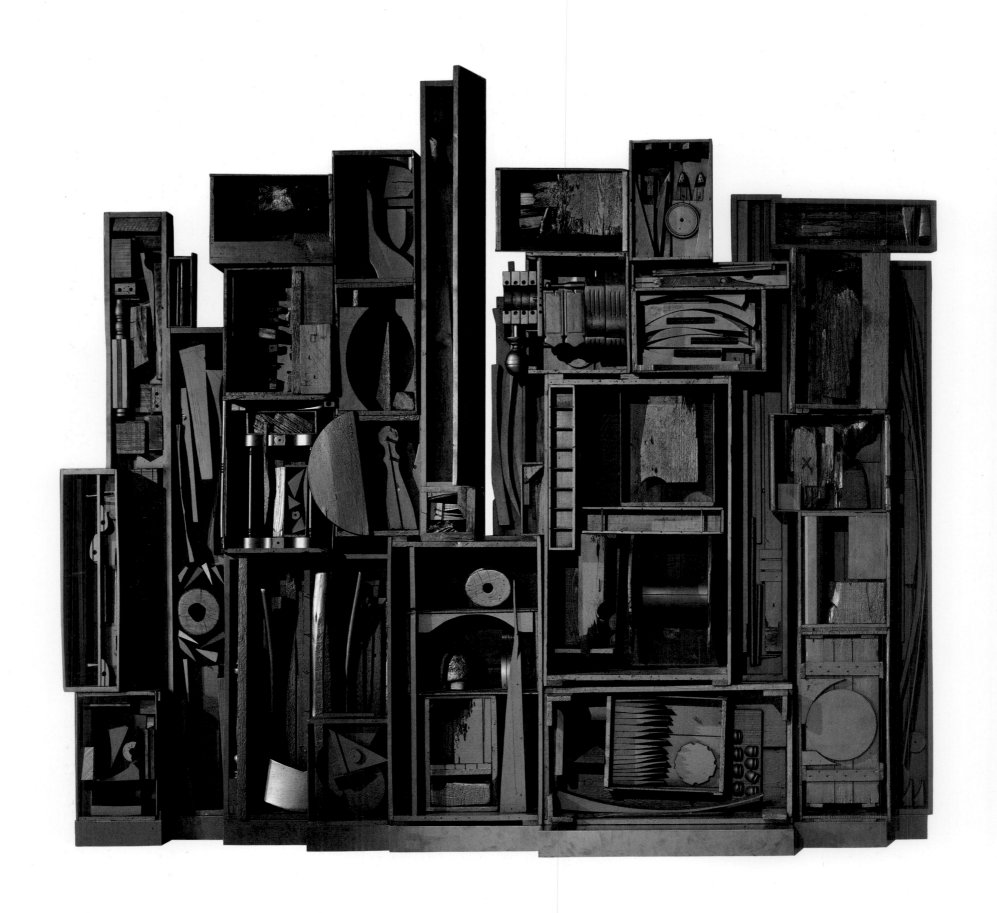

Sky Cathedral—Moon Garden + One, *1957–60*

For me, the black contains the silhouette, the essence of the universe.

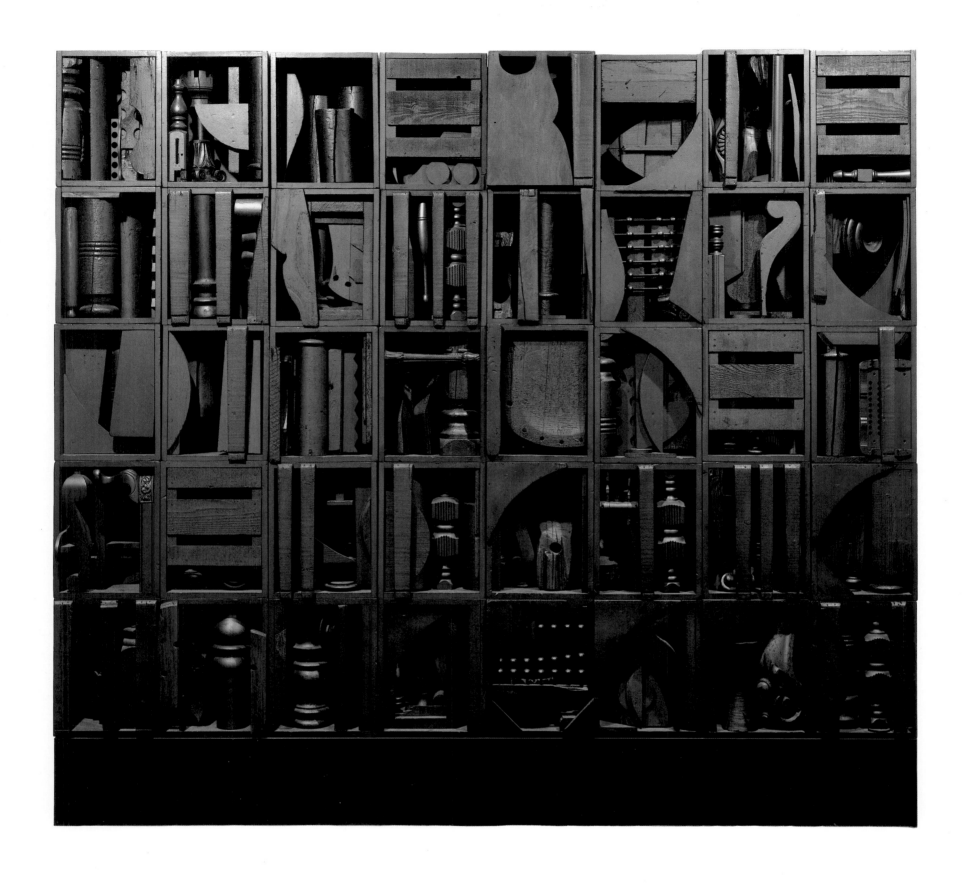

Black Cord, *1964*

Black is not anticolor, it is what it is. It's a definition. . . . Black encompasses all colors.

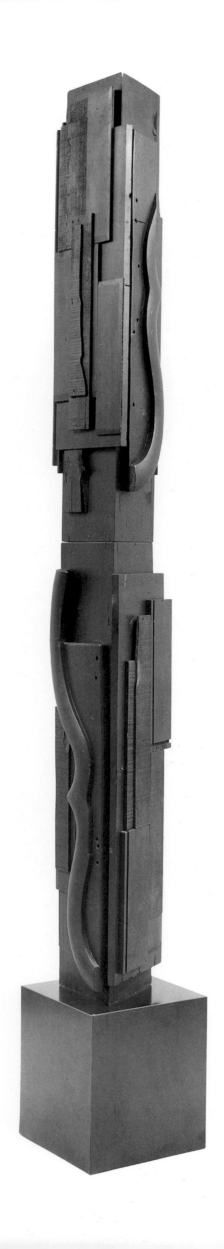

Rain Forest Column VII, *1962–64*

*I would go in the subways
and see the black supporting
columns and recognize
their power and strength
standing there.*

Sky Columns
Presence, *1959*

*The columns in the
subway had
as much meaning
as many of the things
that are in museums.*

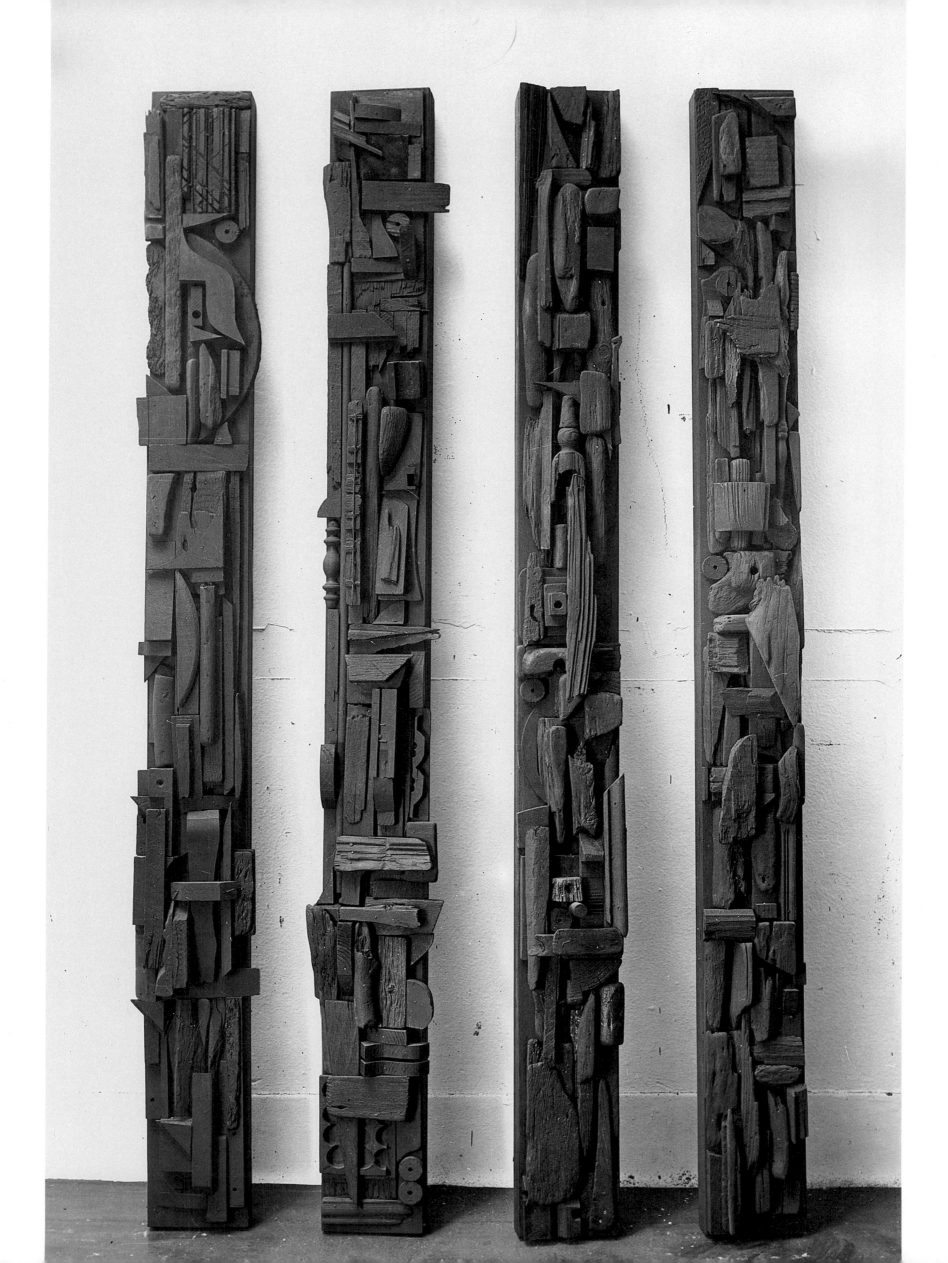

At the Caccamo woodworking shop in New York

I had all this wood lying around and I began to move it around. I began to compose.

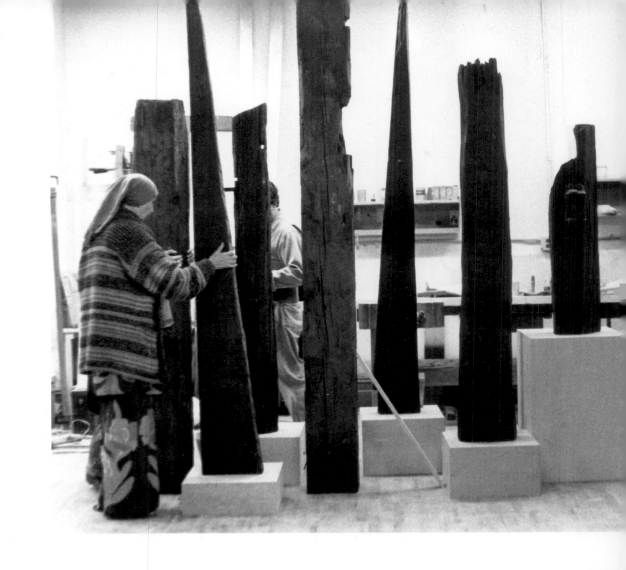

Spring Street studio

Anywhere I found wood, I took it home and started working with it. . . . I always wanted to show the world that art is everywhere, except it has to pass through a creative mind.

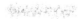

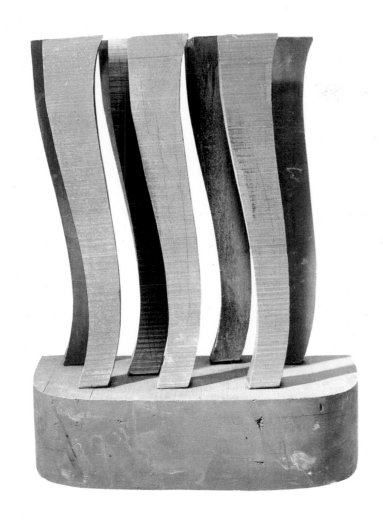

Standing Wave, *1955*

I don't want the safe way....

Dark Reflections, *1959*

The safe way limits you.

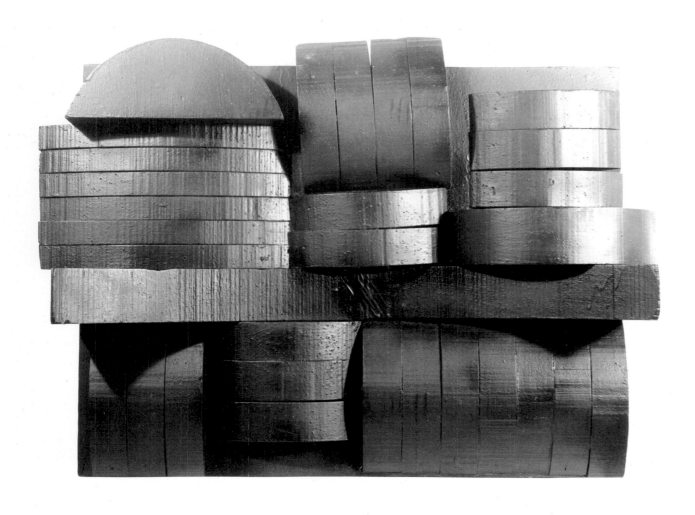

Tropical Garden, *1960*

There is in every human being a desire for order.
But the artist doesn't have it ready-made.
That is the search.

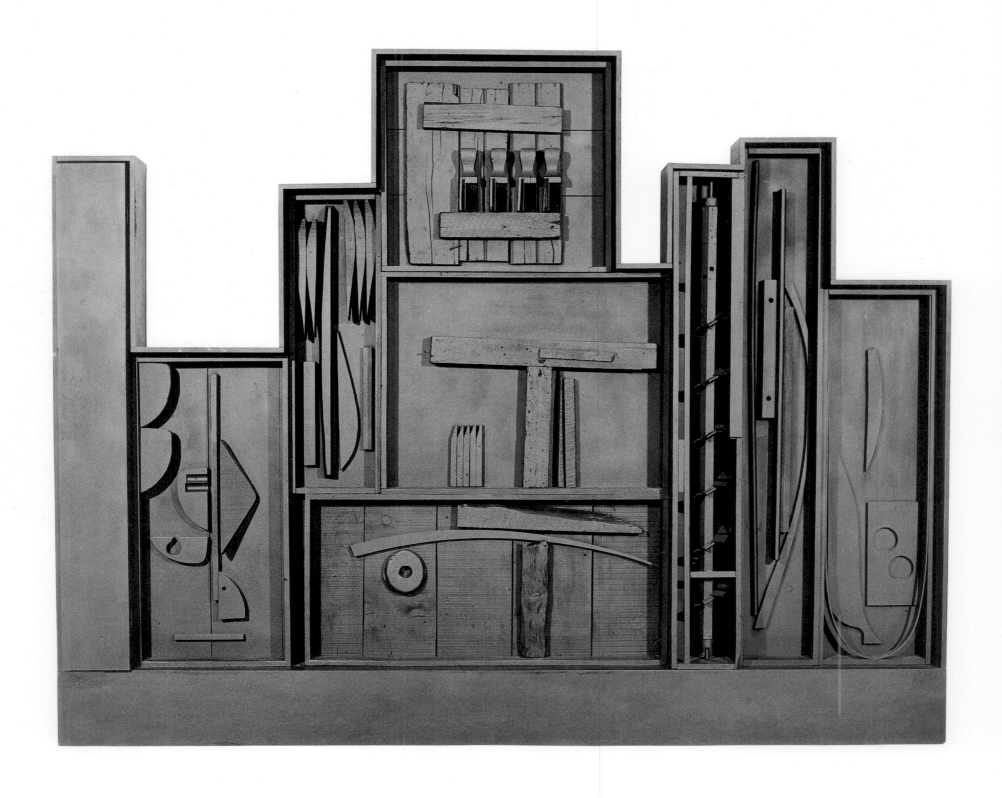

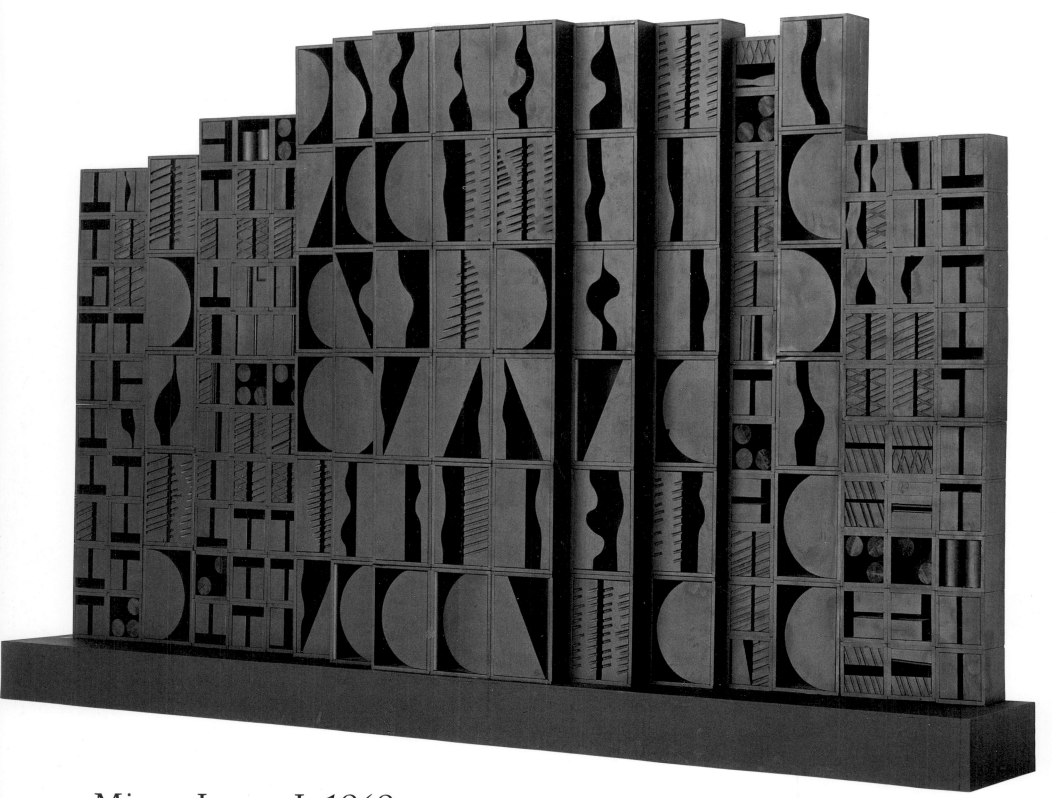

Mirror Image I, *1969*

*Creation basically is that you are searching
for a more aware order.*

Night—Focus—Dawn, *1969*

Art is as alive as our breathing, as our own lives,
but it's more ordered.

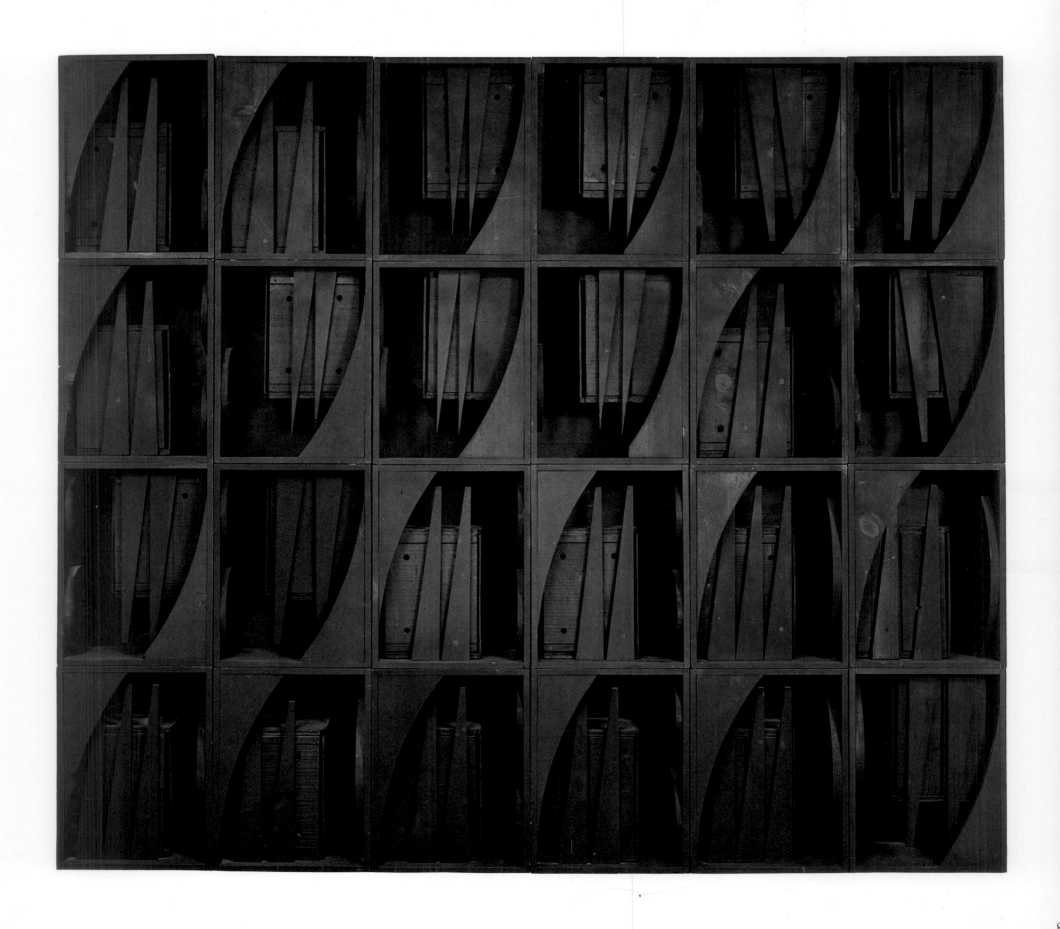

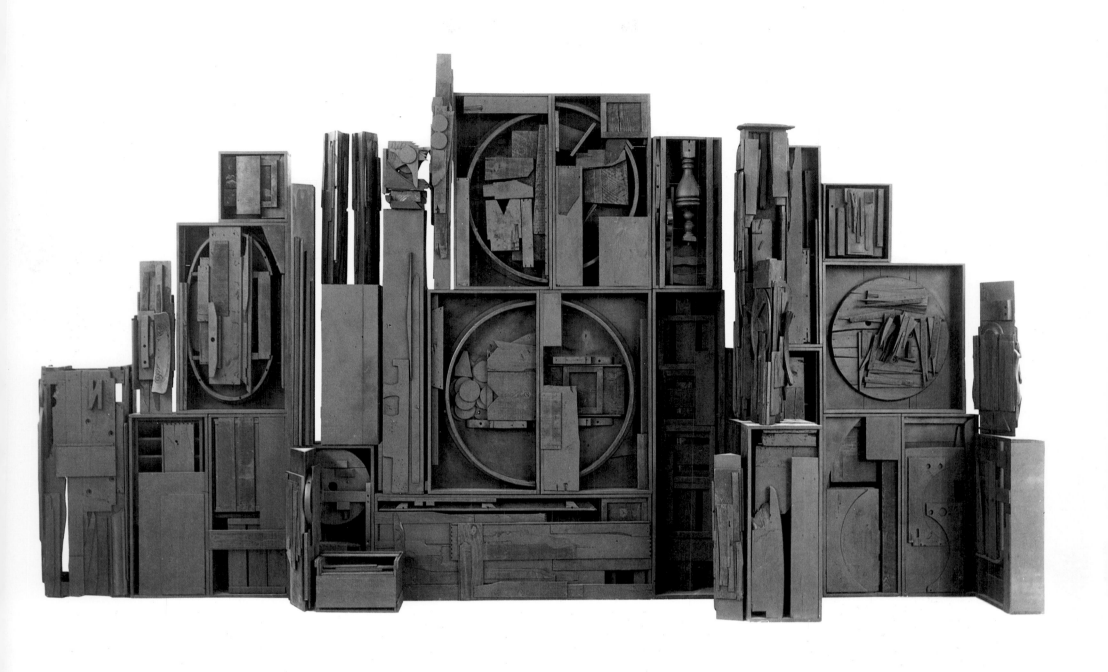

Homage to 6,000,000 II, *1964*

I wanted every line to really build into the other.

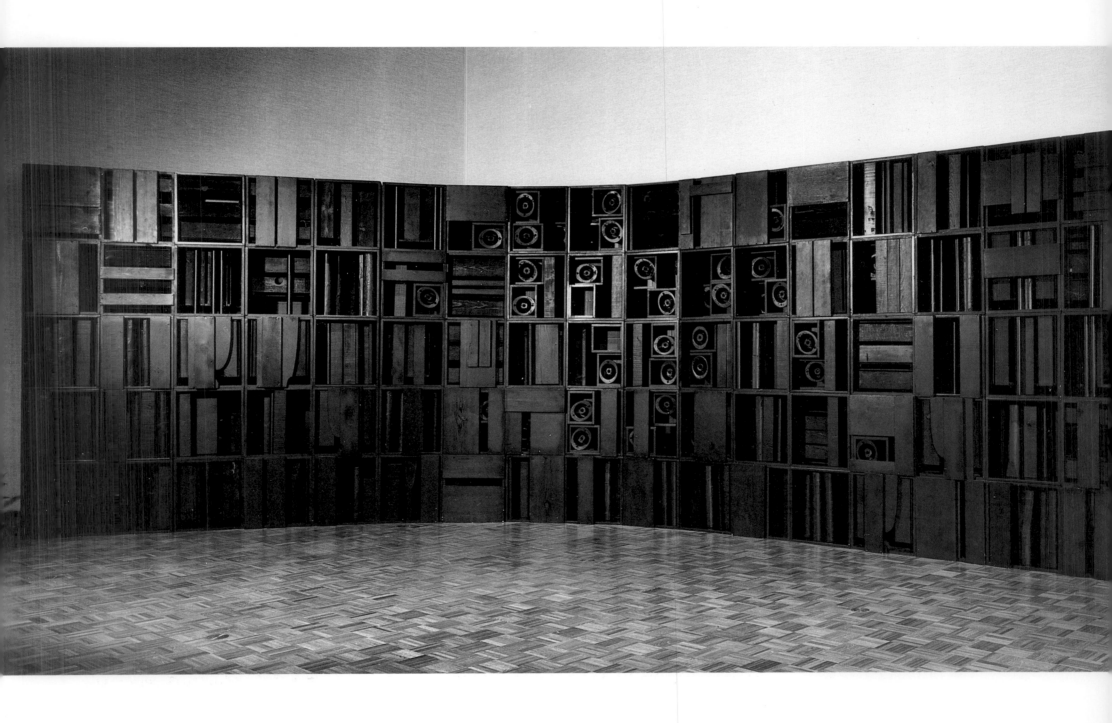

Homage to the World, *1966*

It is not only sculpture, it is a whole world.

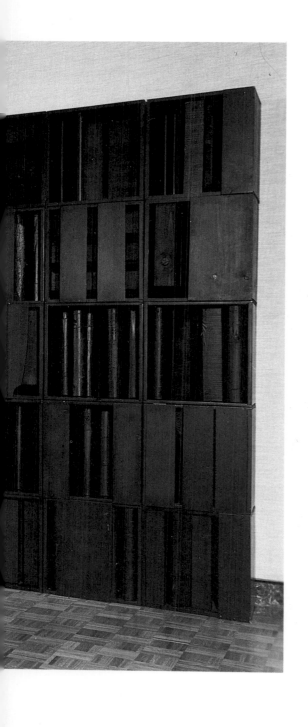

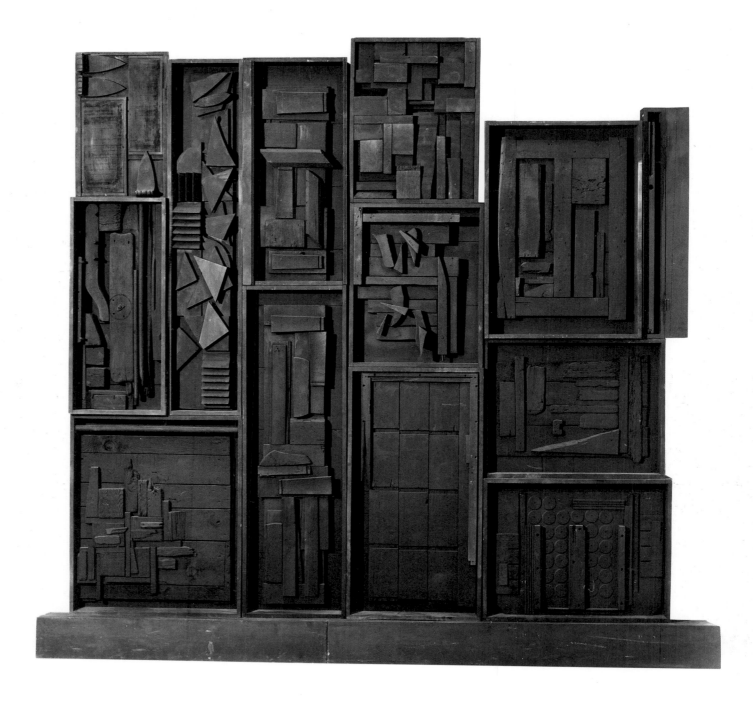

Young Shadows, *1959–60*

The shadow, you know, is as important as the object. . . . I arrest it and I give it architecture as solid as anything can be.

Nightsphere-
Light, *1969.*
(Details on
four following
pages)

I use
action and
counteraction,
like in music,
all the time.
Action and
counteraction.

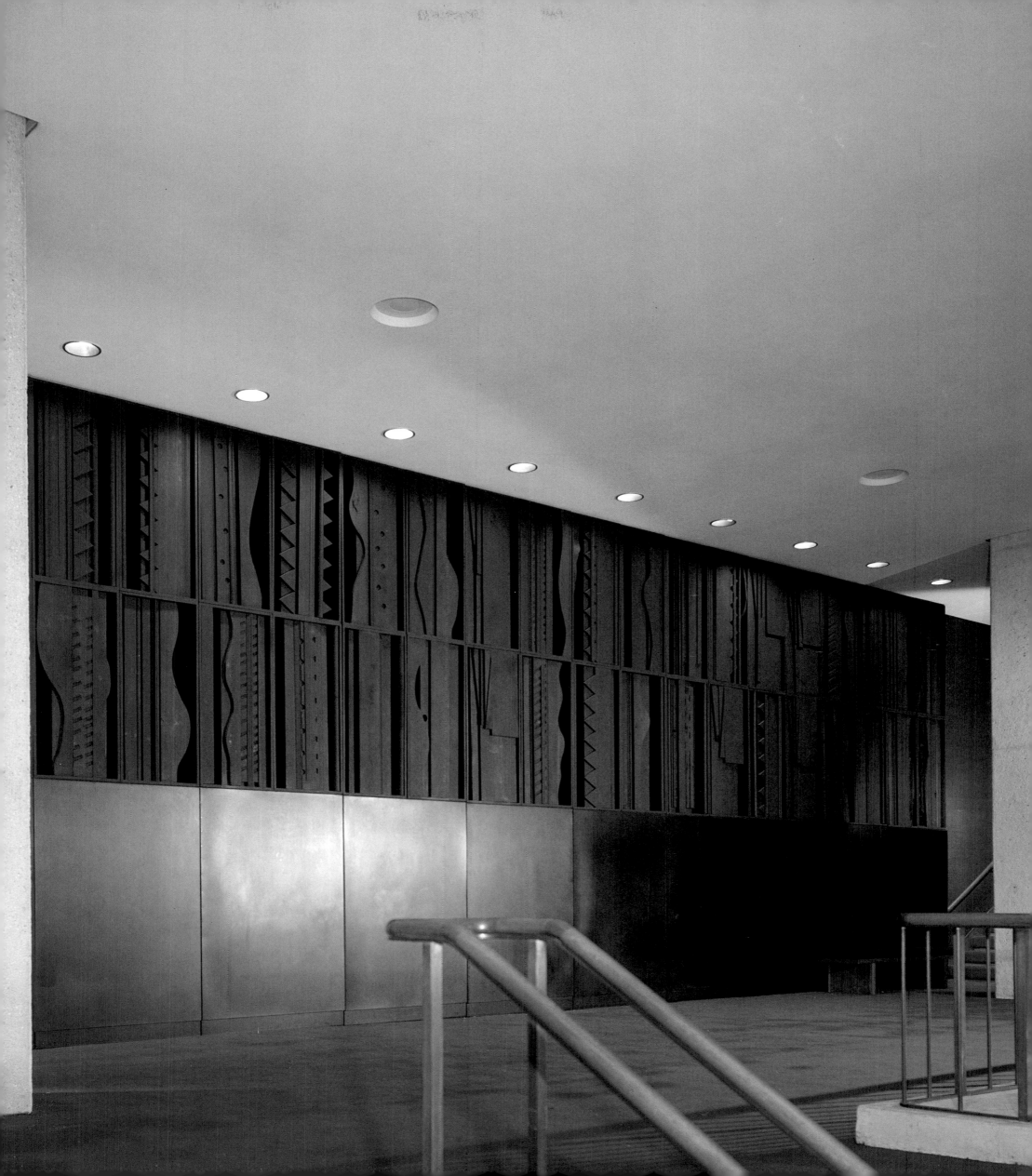

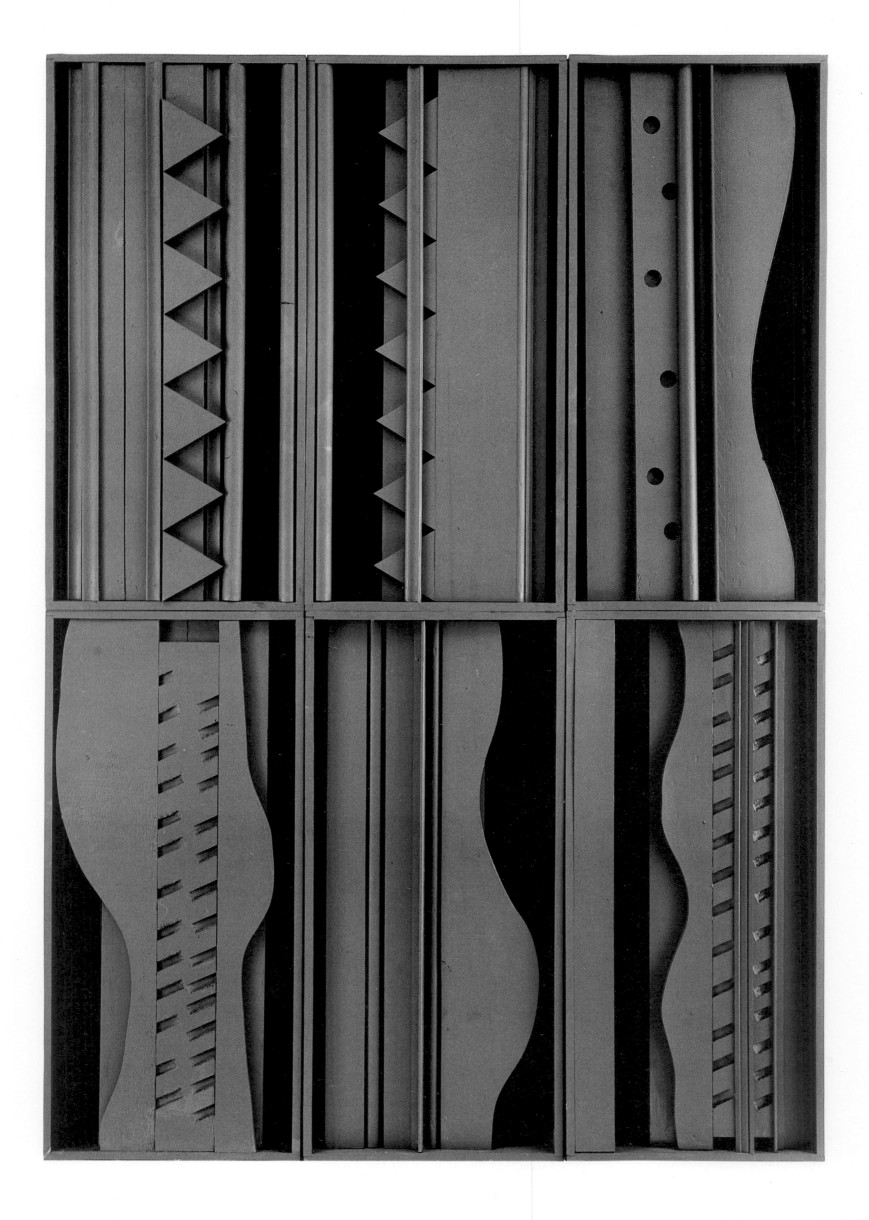

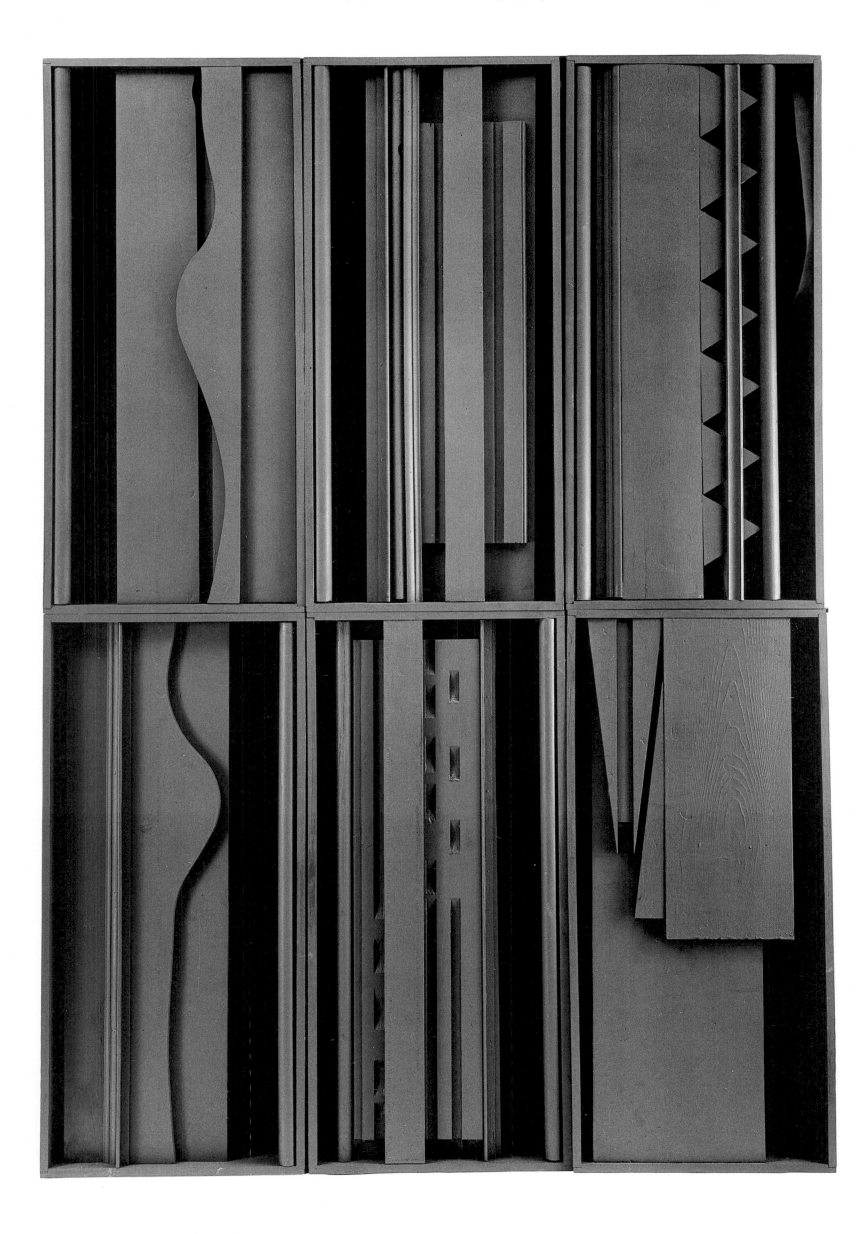

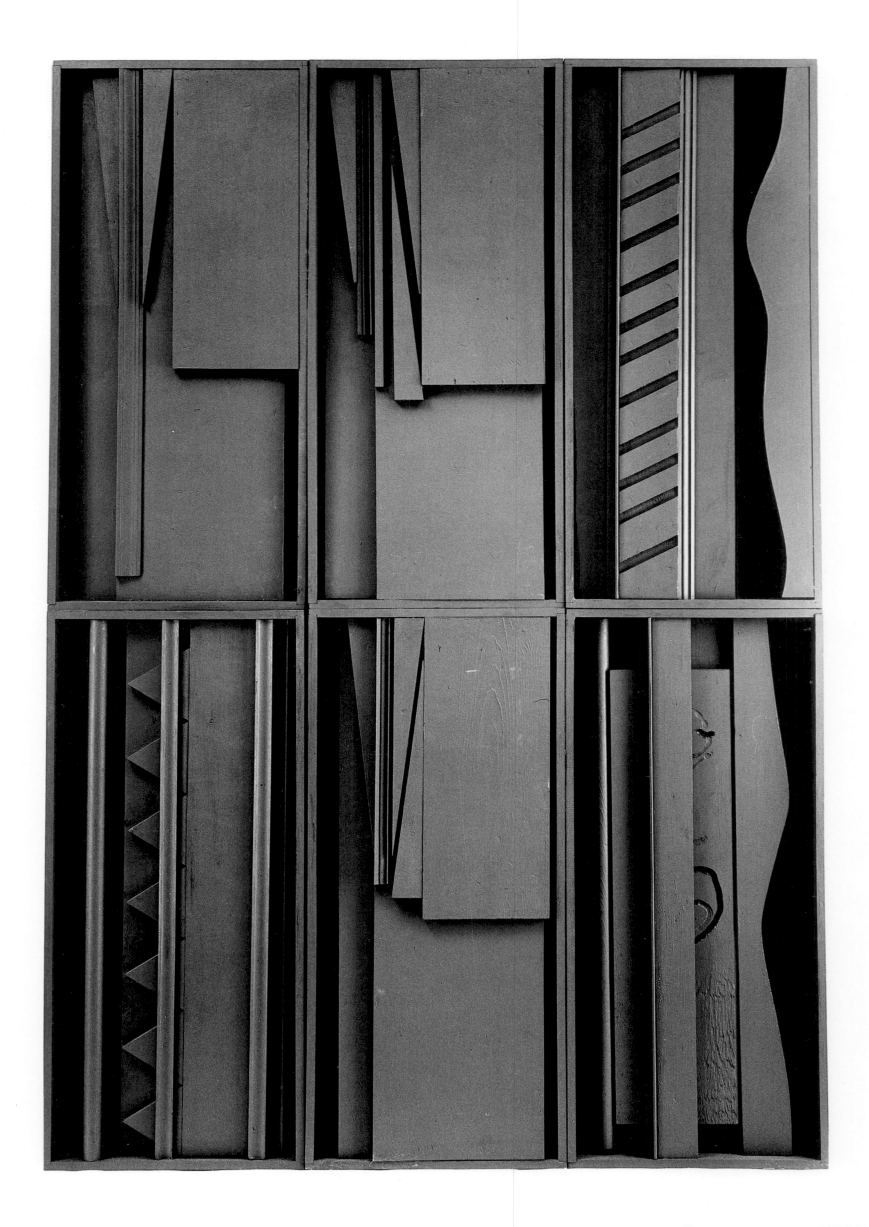

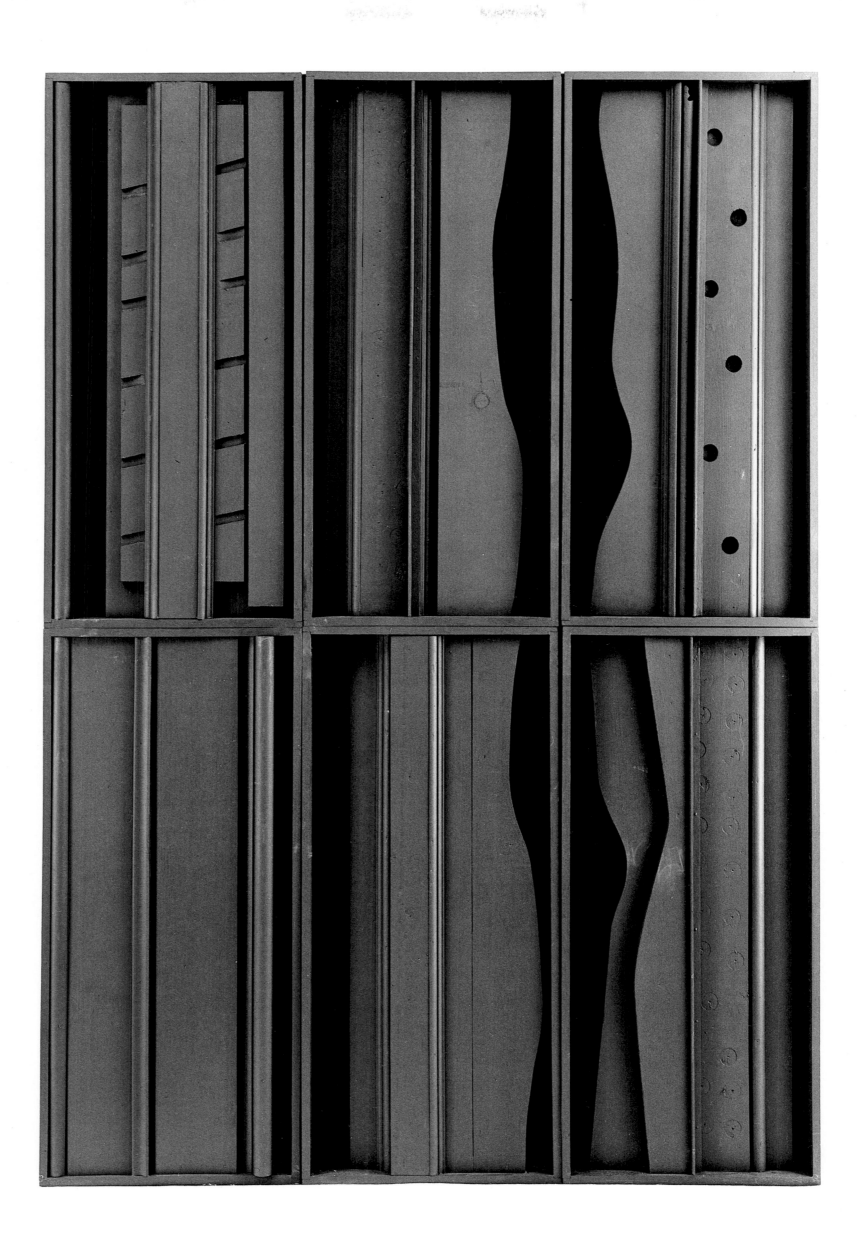

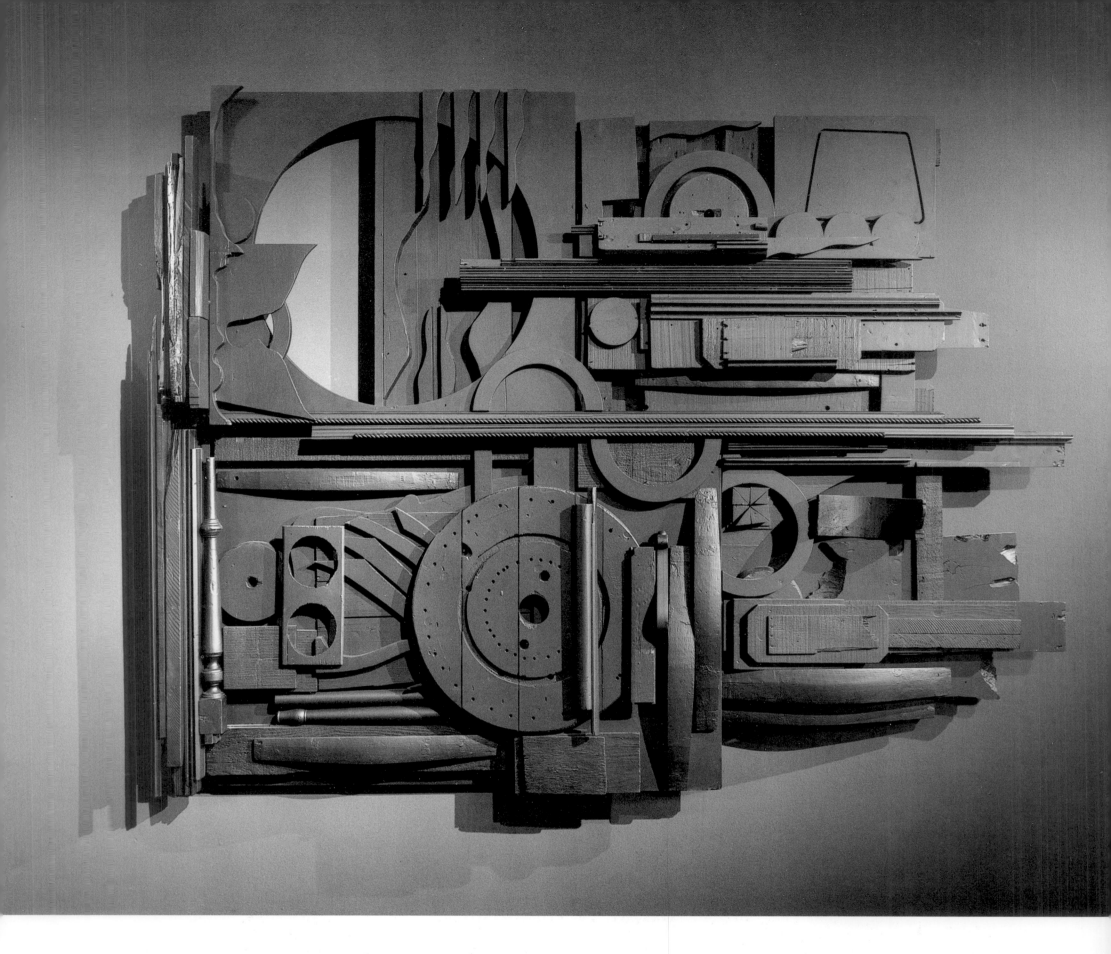

Moon Gardenscape XIV, *1969–77*

My work is delicate; it may look strong,
but it is delicate. . . .

Rain Garden Spikes, *1977*

True strength is delicate. . . . A whisper
can have more strength than loud shouting.

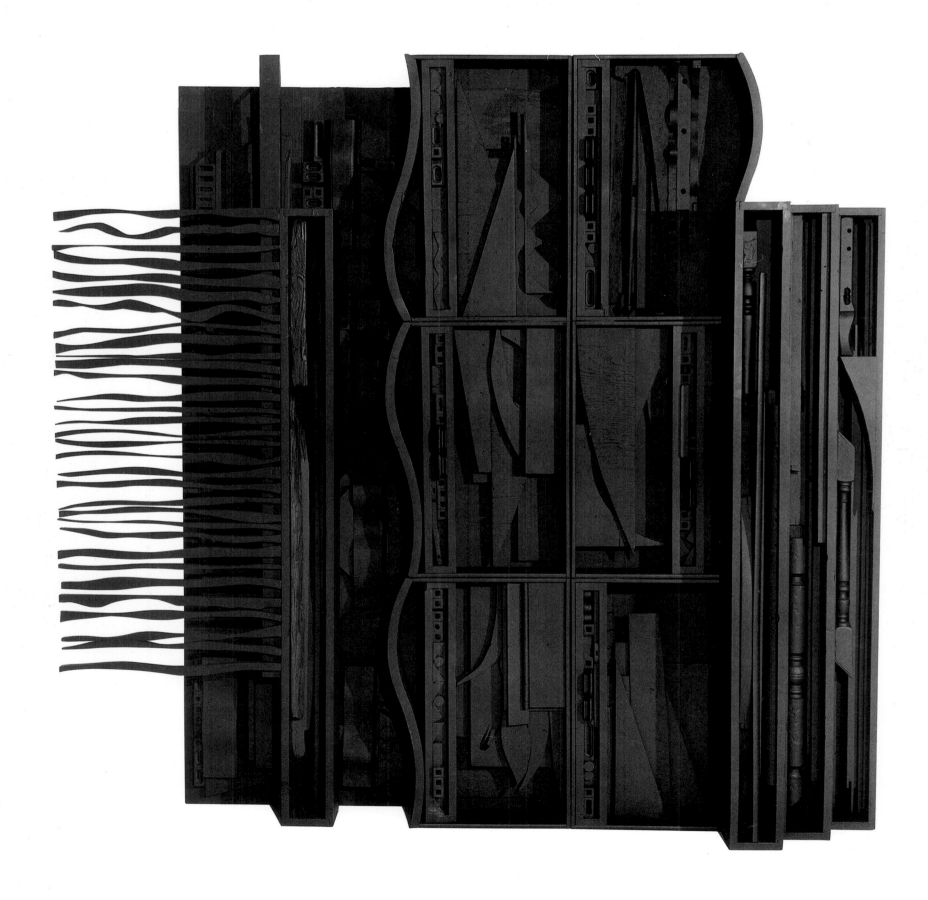

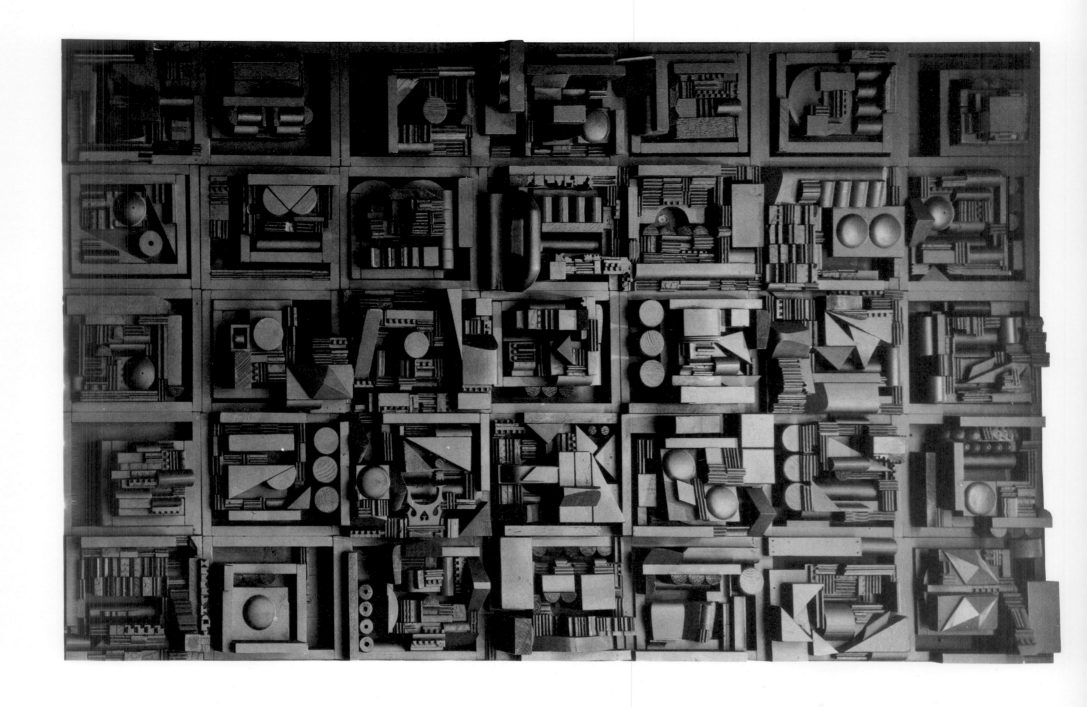

Night Zag III, *1965*

I feel that my works are definitely feminine....

Night Zag I, *1969–73* ▷

*A man simply couldn't use the means of, say, fingerwork
to produce my small pieces. They are like needlework.*

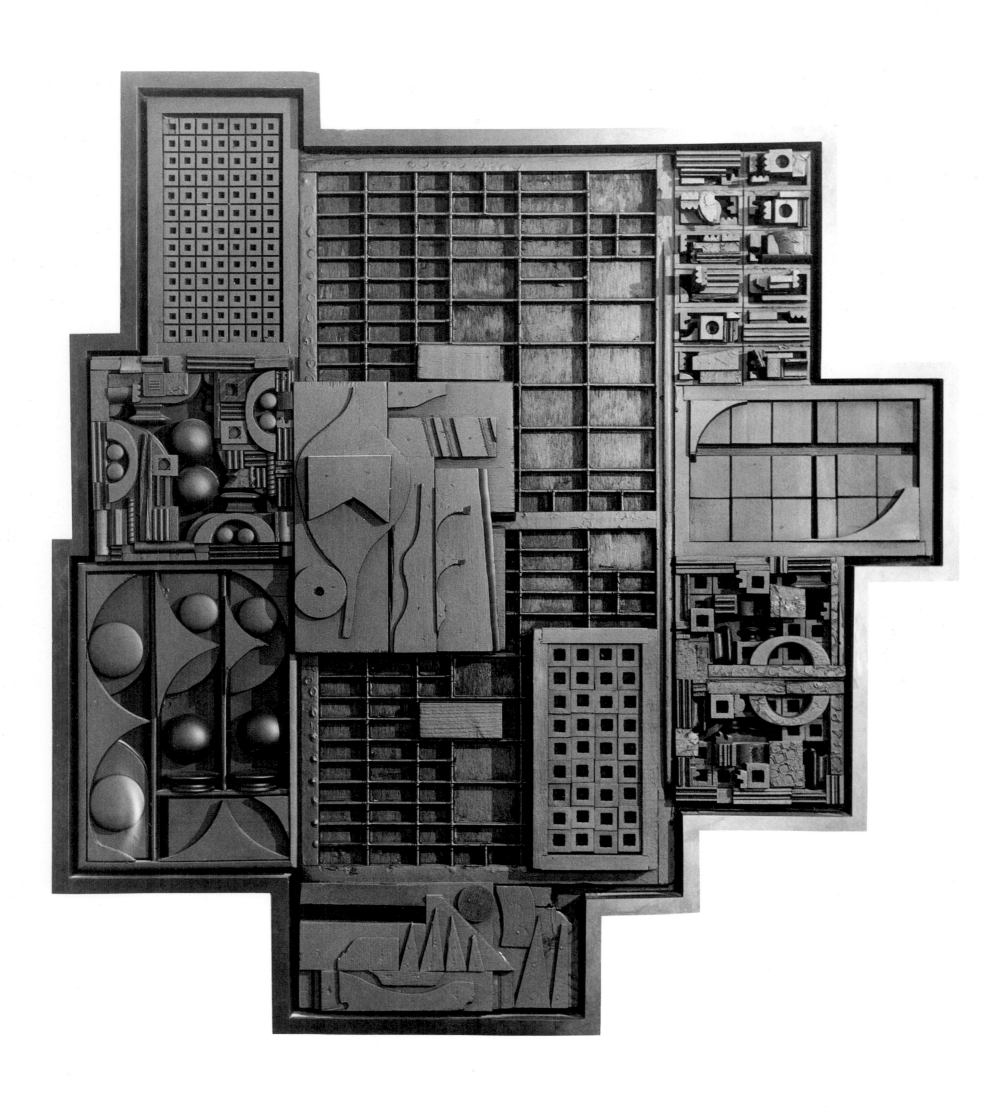

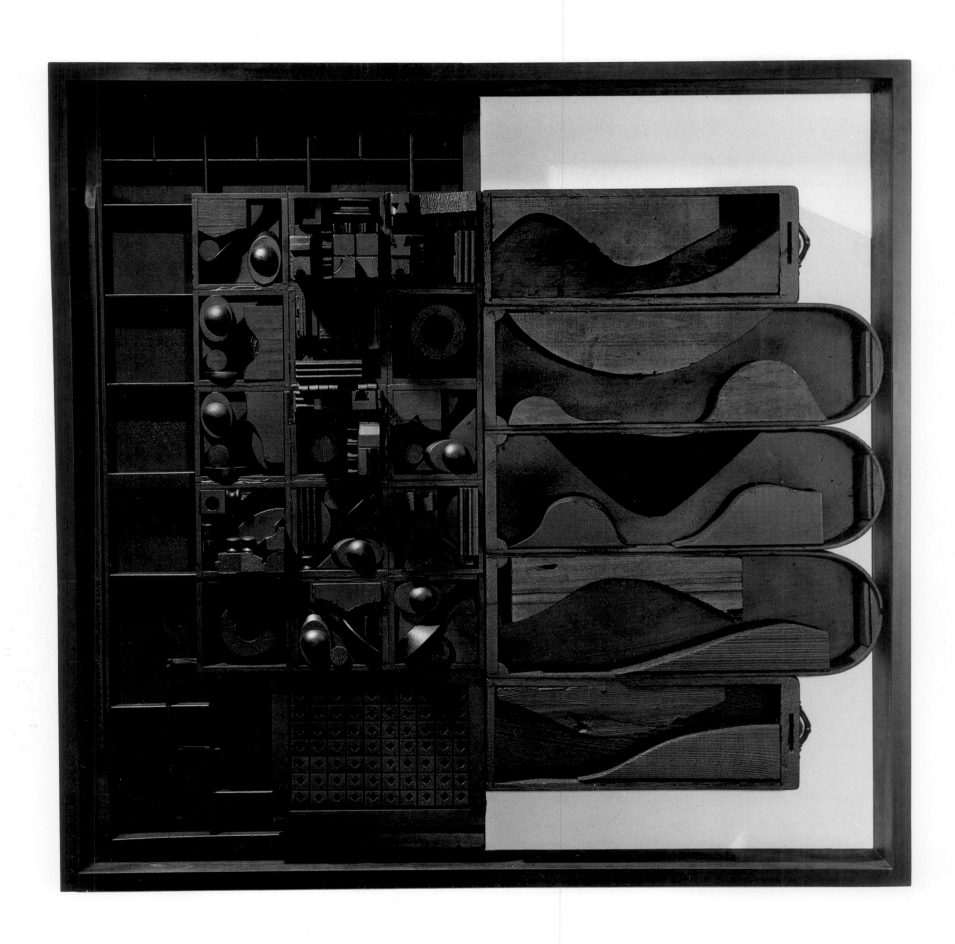

◁ Hudson River Series V, *1971*

They have a movement. . . .

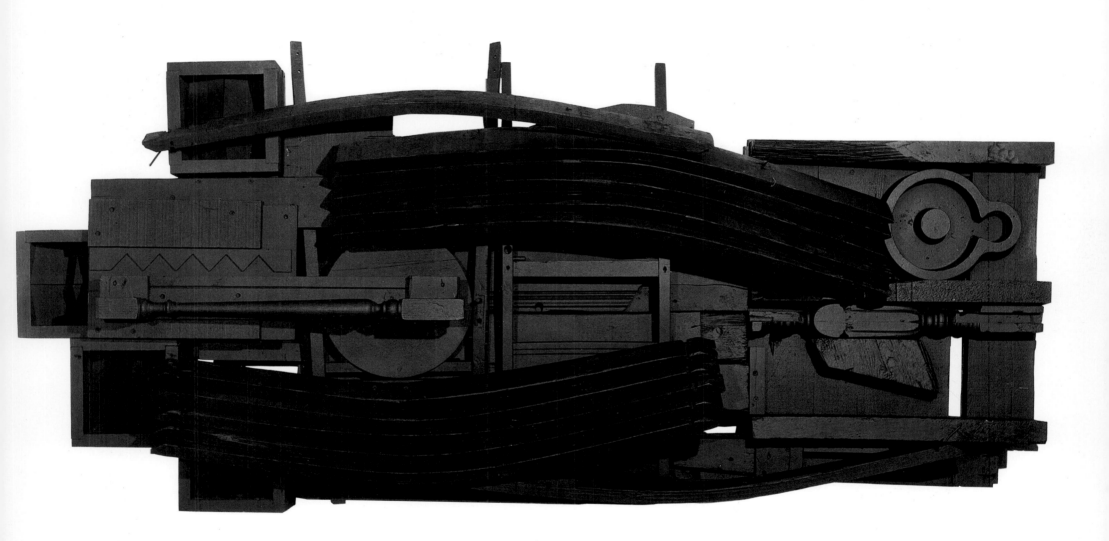

Moon Star Zag VII, *1981*

They really soar.

Spring Street garage

*My garage is full
of black wood.
This is what I
call my stock,
my raw materials.*

Studio,
29 Spring Street

*Sometimes it's
the material that
takes over;
sometimes it's me
that takes over.*

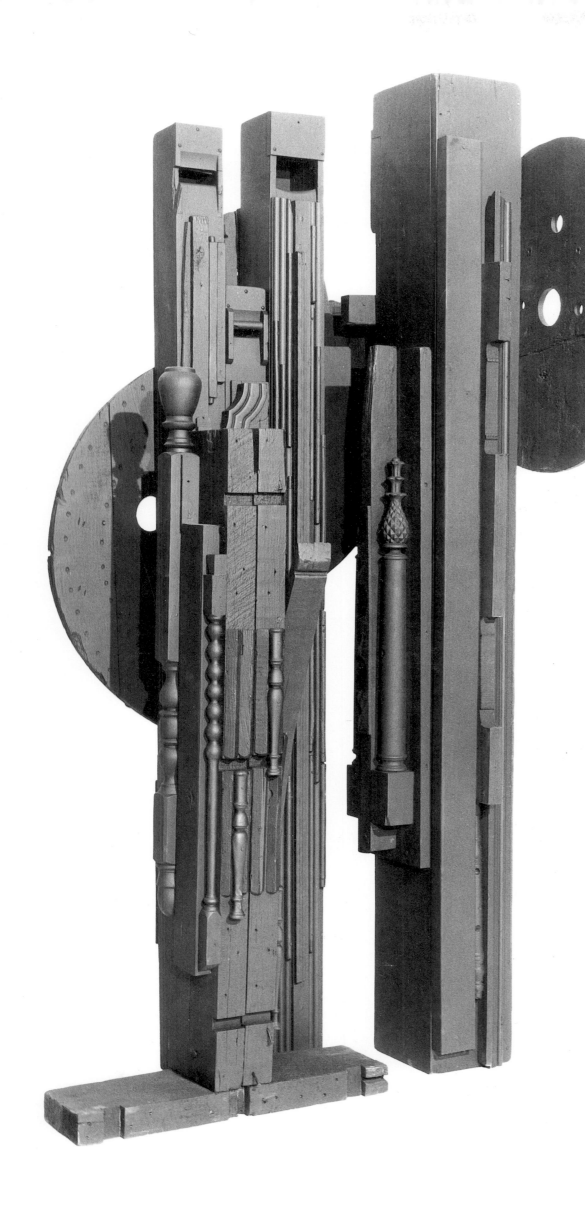

Cascades
Perpendiculars II,
1980–82

*Some old organ pipes
from St. Mark's Church-
In-The-Bowery
were offered to me, and
of course I knew I
could use them.*

**Silent Music I,
1964**

*I had always
identified
with Cubism
from its
earliest stages.*

Black Zag Y, ▷
1969

*Cubism gave
me law.*

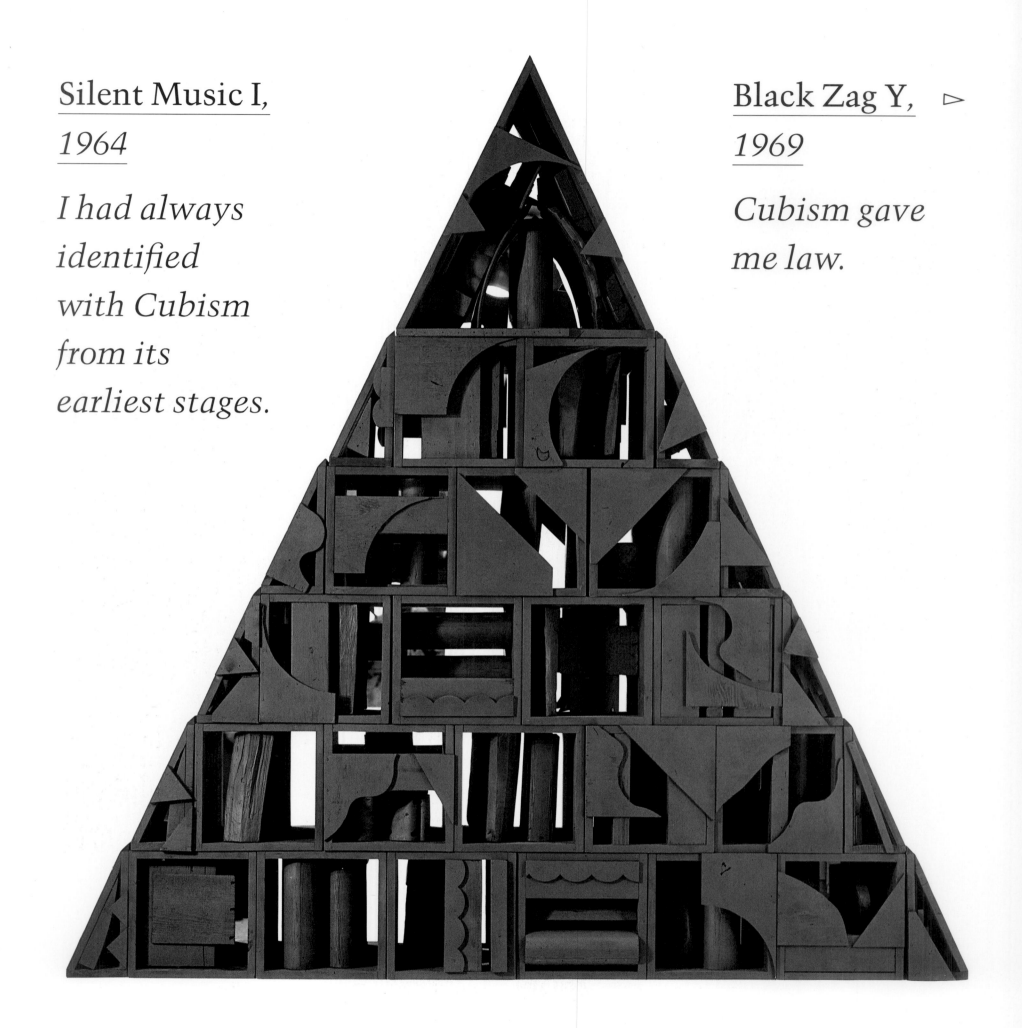

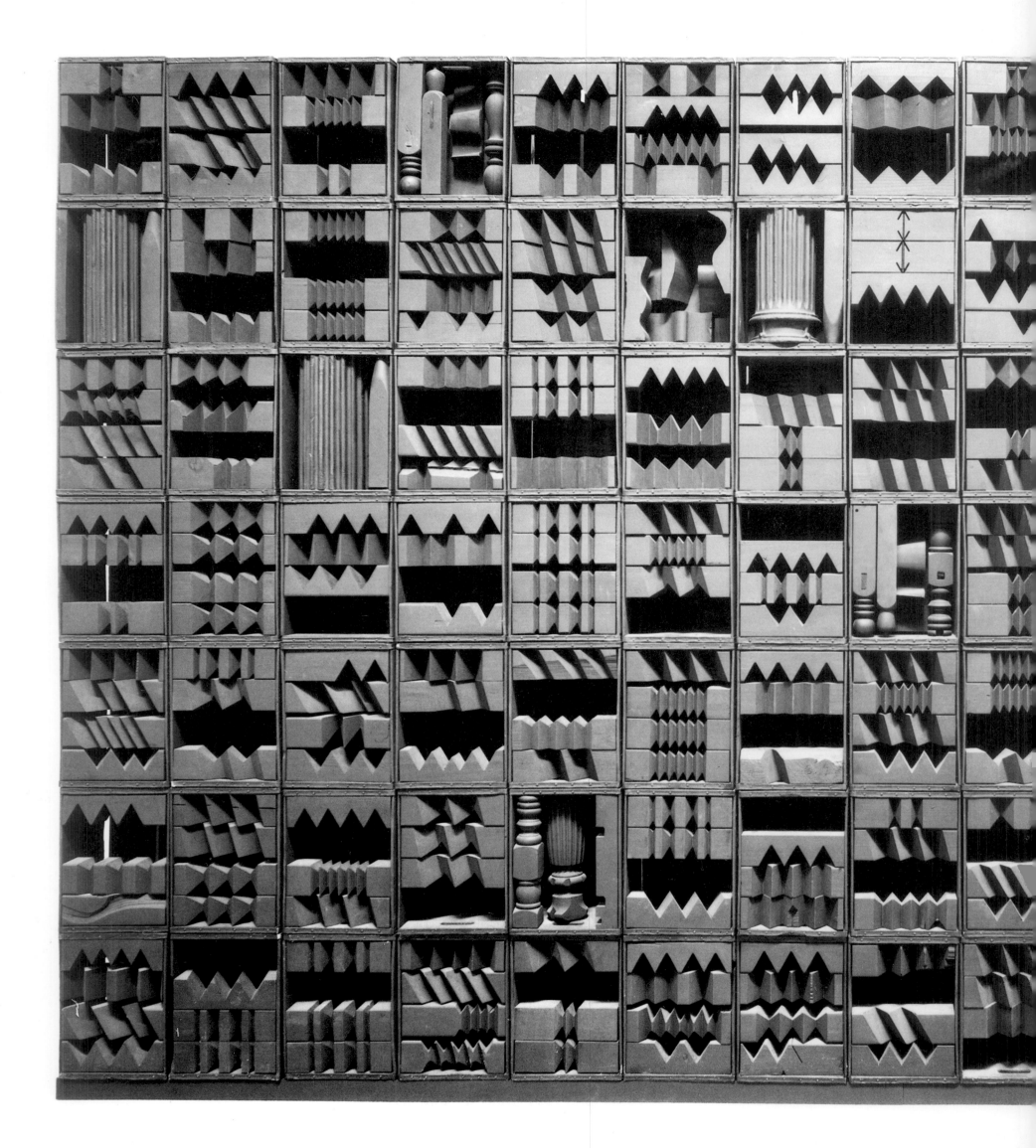

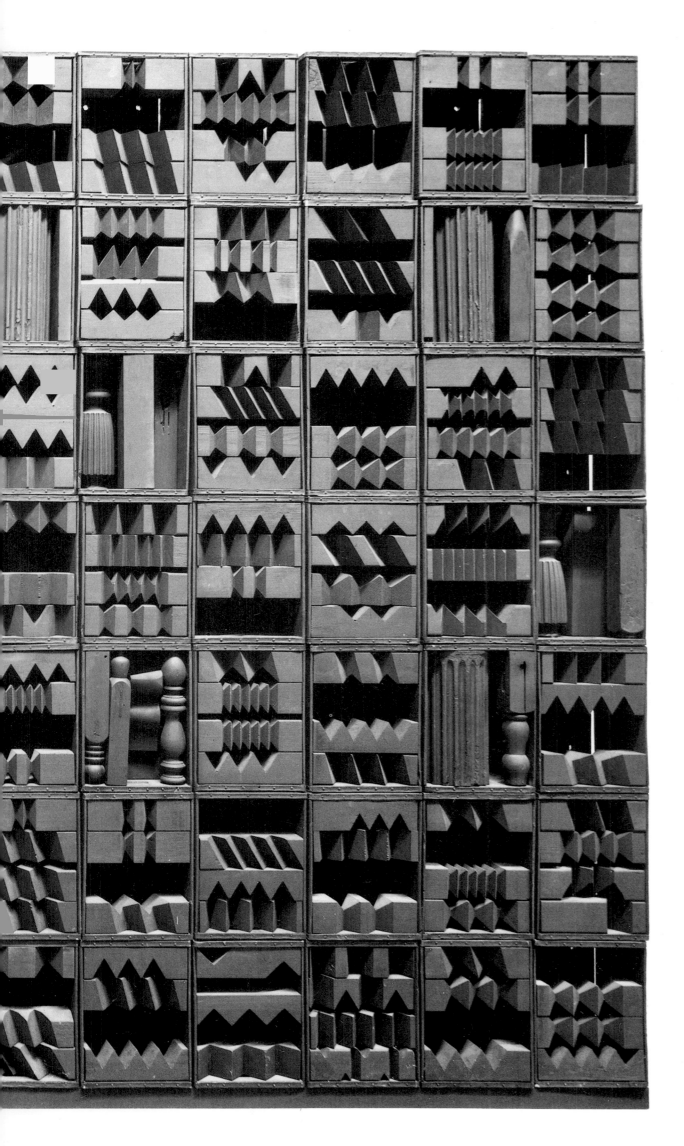

Luminous Zag: Night, *1971*

I felt that the Cubist movement was one of the greatest awarenesses that the human mind has ever come to.

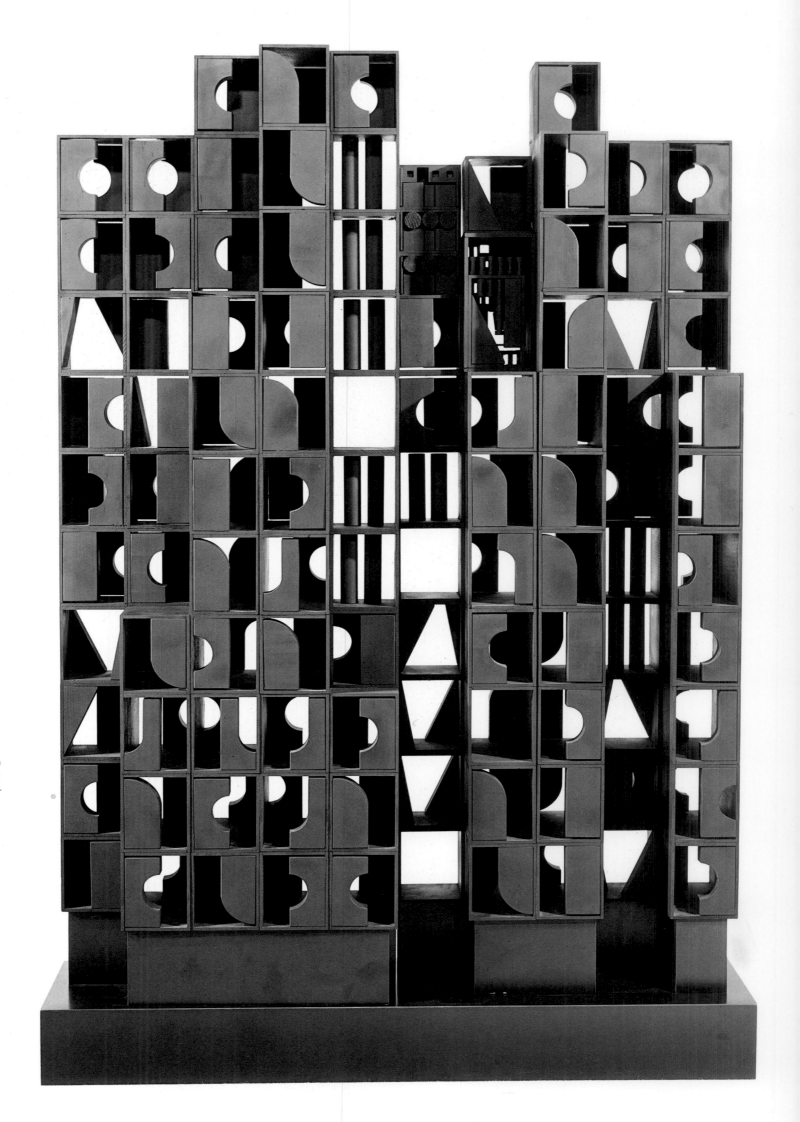

Moon—Homage, *1968*

The purity and clarity of Cubism fit perfectly.

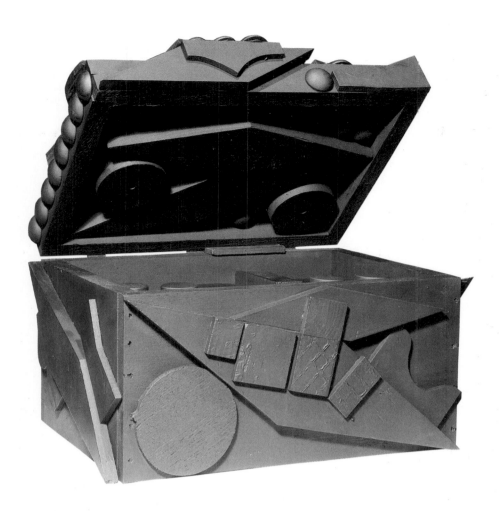

Large Cryptic II, *1969*

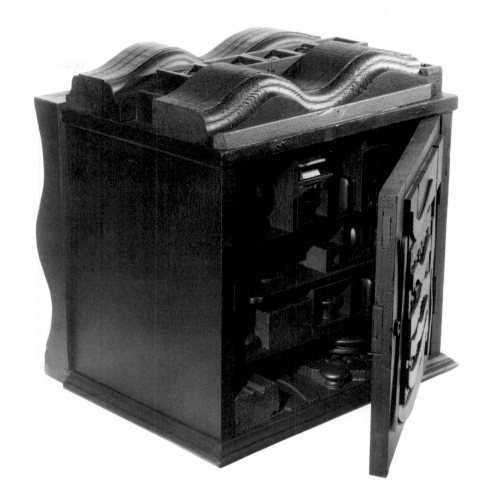

Rain Garden
Cryptic XVI, *1970*

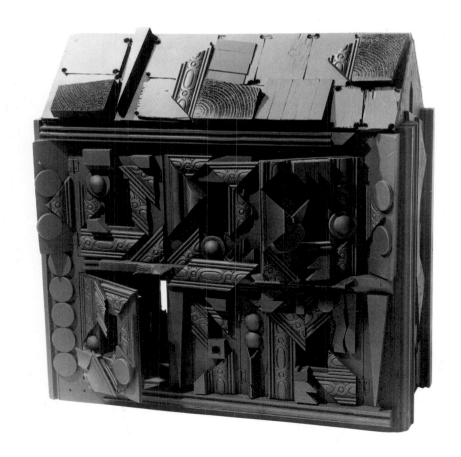

Dream House II, *1972*

*The box is a cube . . .
the cube transcends
and translates nature
into a structure.*

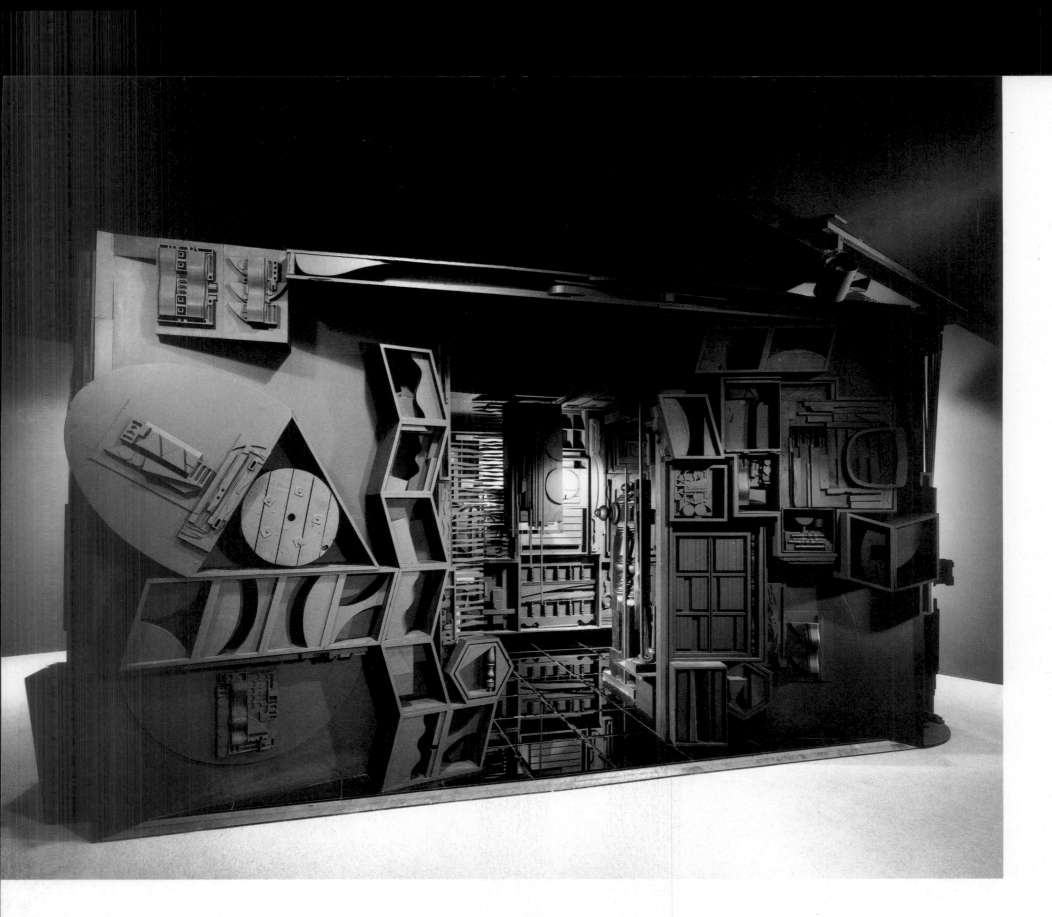

Mrs. N's Palace, 1964–77

*And think of the Colonial houses where I grew up
in Maine. Every room was squared off,
and then the whole house was box-shaped.*

Interior of Mrs. N's Palace ▷

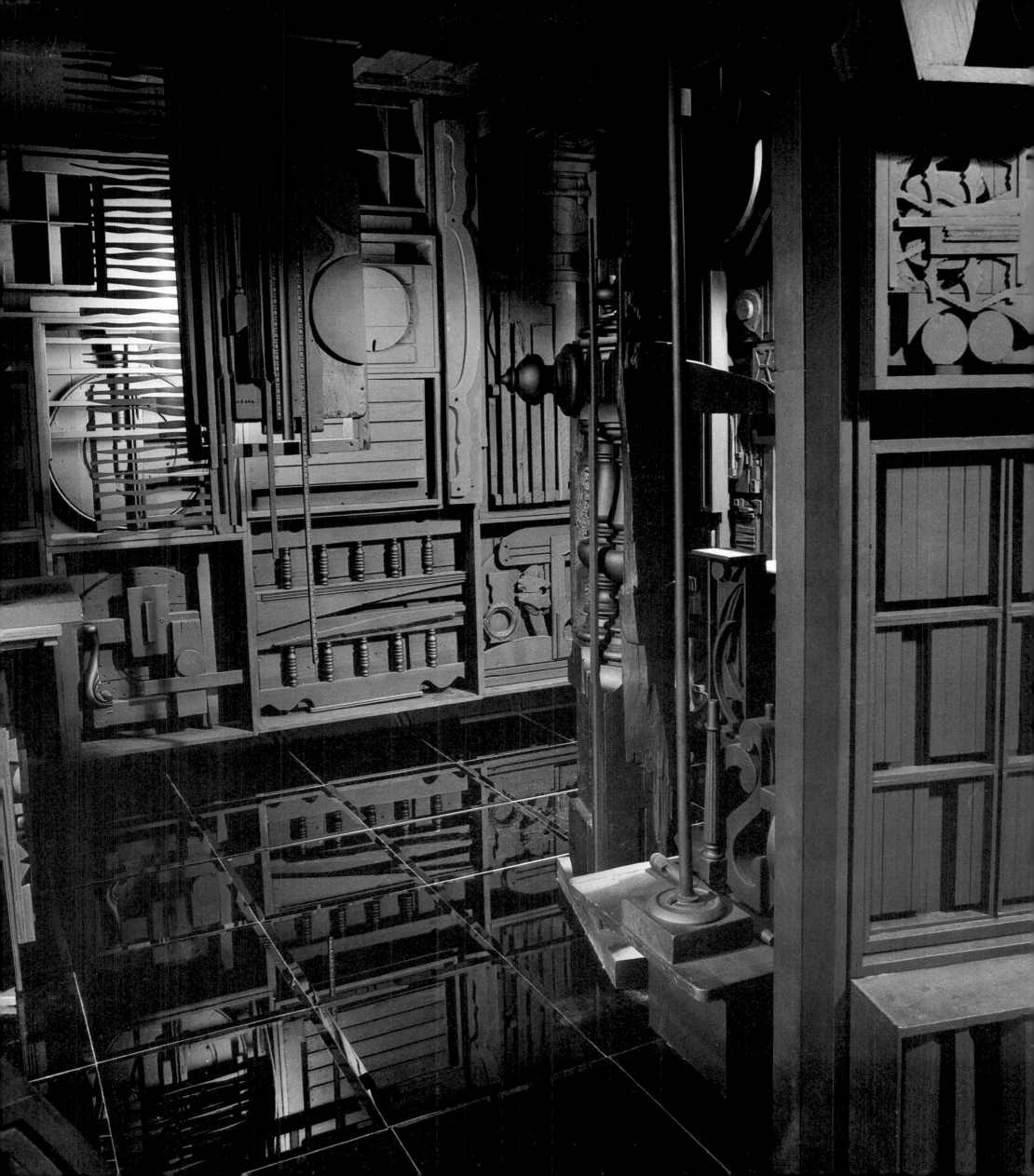

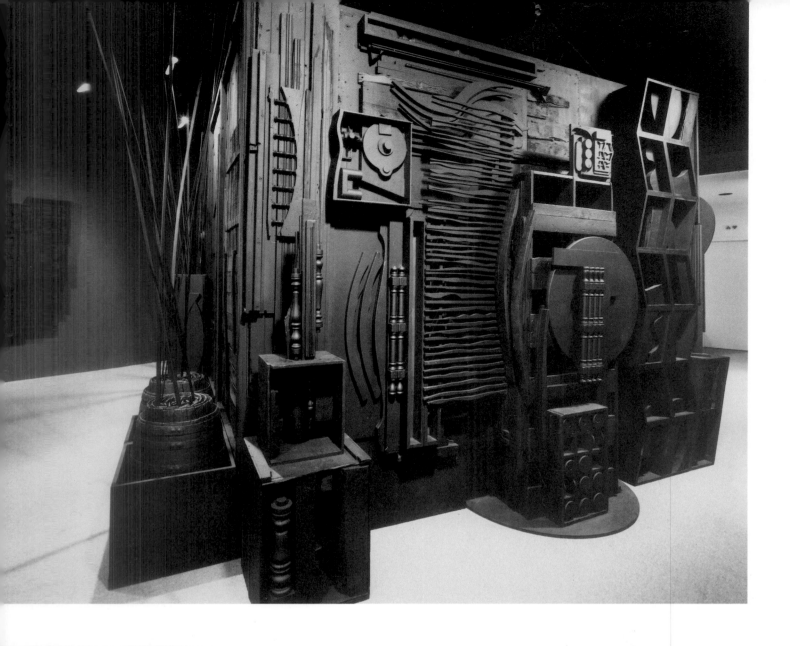

Side view of
Mrs. N's Palace

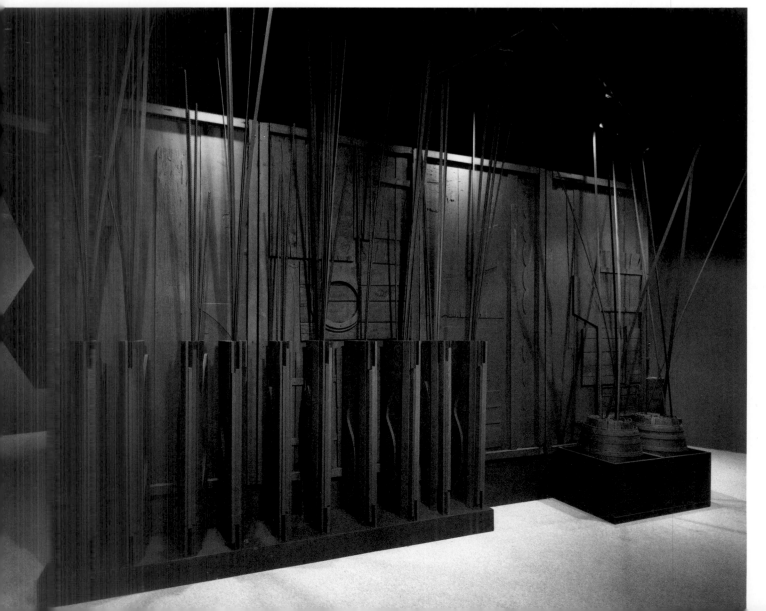

Back view of
Mrs. N's Palace

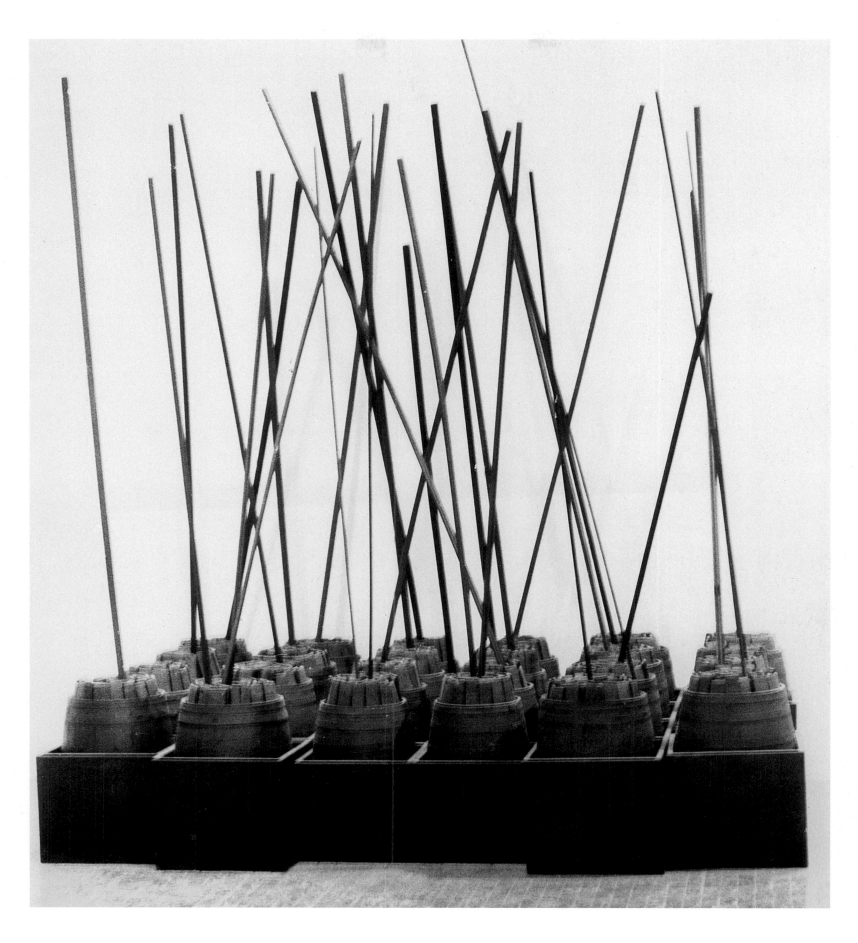

Winter Garden, *1976*

All objects are retranslated—that's the magic.

WOOD CONSTRUCTIONS AND ENVIRONMENTS

WHITE WORKS

If you paint a thing black or you paint a thing white, it takes on a whole different dimension. A state of mind enters into it. Now, white was in my mind.

The exhibition that established Nevelson's reputation as an important artist was *Moon Garden + One*, the black wood environment shown at Grand Central Moderns in 1958. In addition to the critical response it received from Kramer and other writers, it attracted the attention of Dorothy C. Miller, the chief curator at the Museum of Modern Art in New York. She decided to invite Nevelson—who at sixty had not yet had a major museum showing—to be one of the *Sixteen Americans* in her forthcoming exhibition. According to Miller, who recently told me, with total recall, the story of the planning, creation, and installation of the show, she broached the subject at dinner one evening. Nevelson didn't even bother to answer yes or no. She simply said, "Dear, we'll do a white show. Don't tell anybody. It will be a surprise."

The response struck the curator as a totally spontaneous one, but in a recent taped conversation the artist told Diana MacKown that *Dawn's Wedding Feast*, the great environment she created for the 1959 MoMA show, had been "a wish fulfillment, a transition to a marriage with the world." The new color

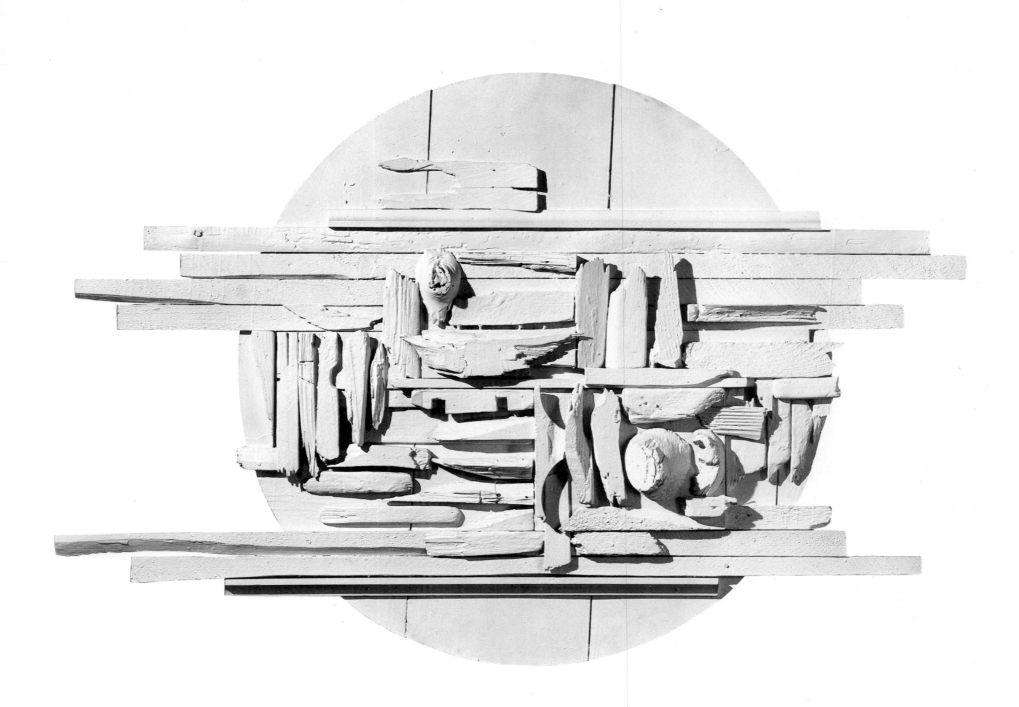

Sun Disk, *1959*

Black Moon II, *1961* ▷

The white and the black invited different forms.

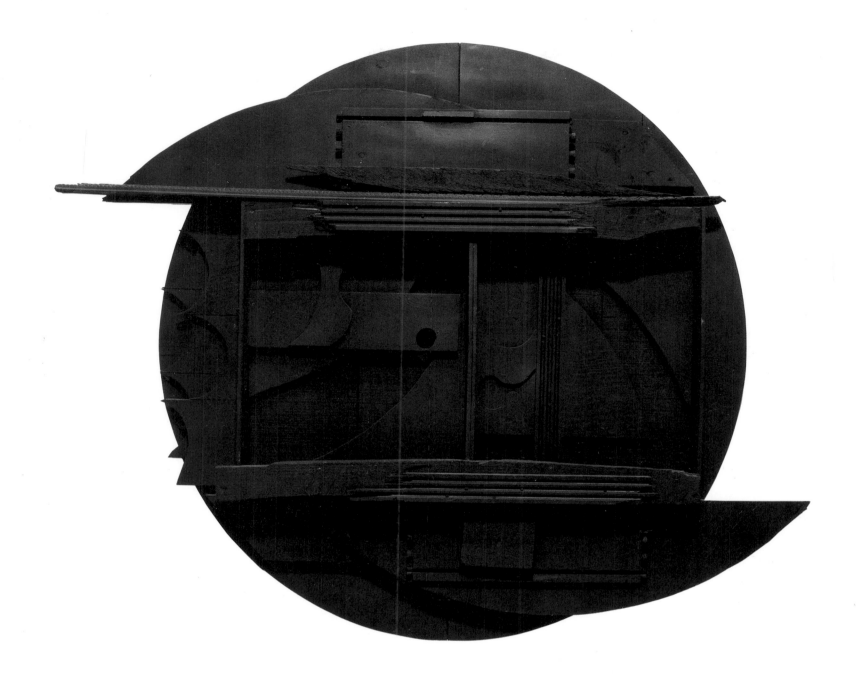

signaled a new start. Where black held connotations of dusk and night, white was dawn—joyous, festive, and emerging at the same moment that Nevelson's career emerged after a lifetime of struggle. The title of the show, Dorothy Miller said, grew out of the fact that Louise had so often talked about her work as a feast and that the white was both festive and radiant with light, like the dawn— and, like the dawn, offered a new beginning. As for the wedding, Miller added, "and weddings used to be white, remember?"

For some months Nevelson worked secretly on the white show, renting the

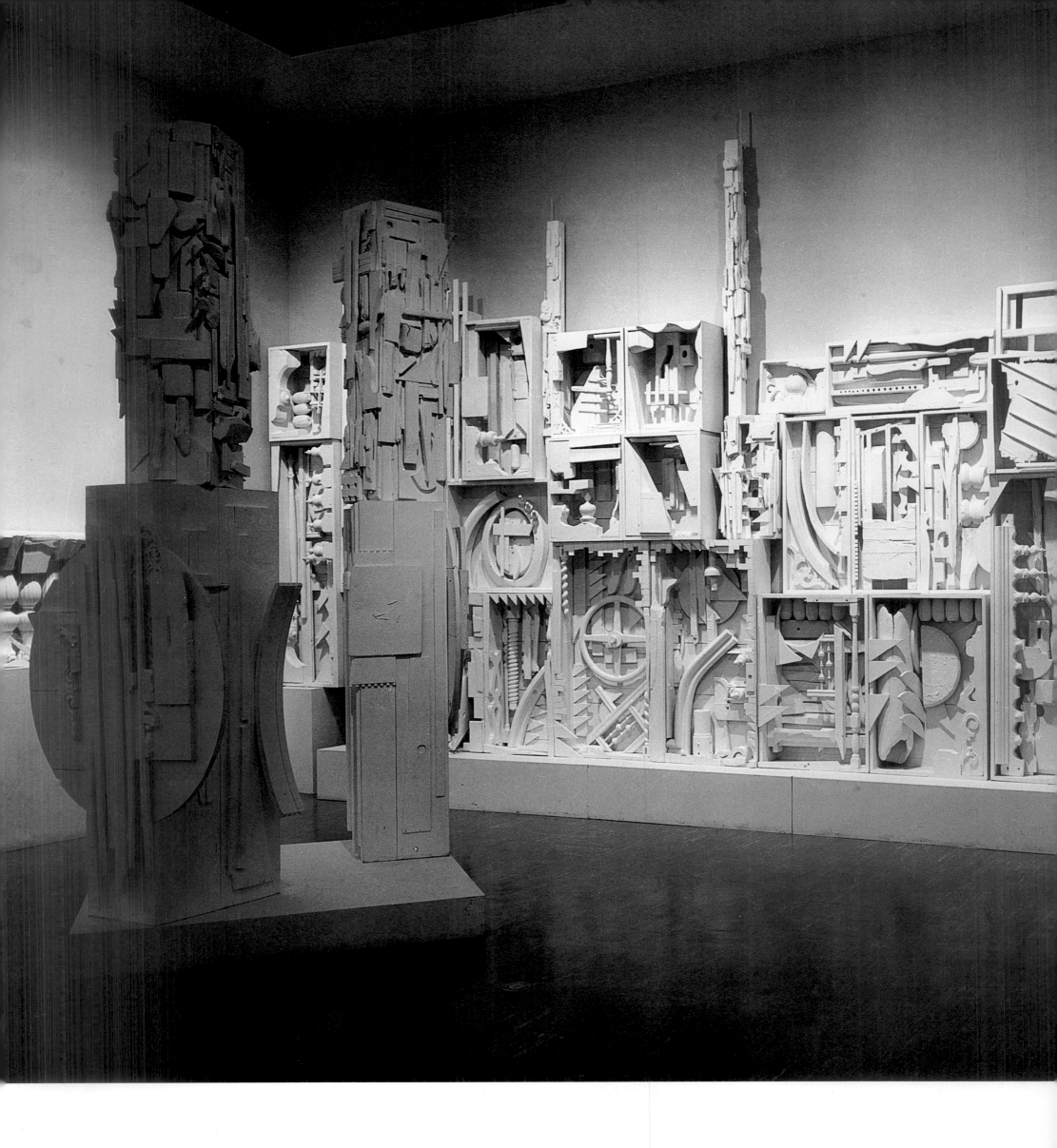

11

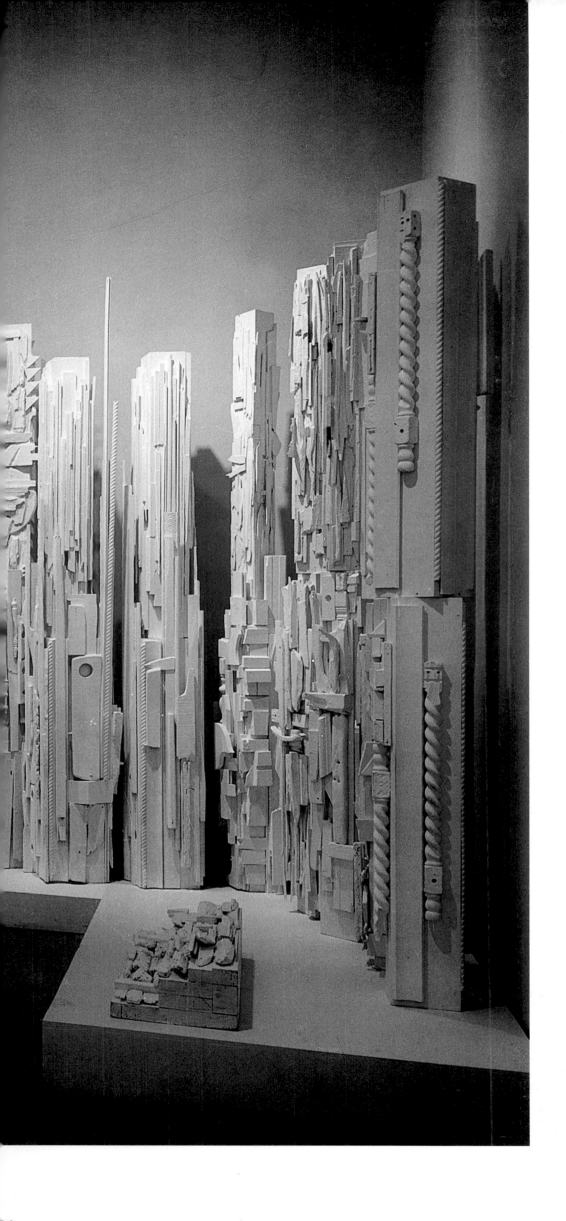

Installation of
Dawn's Wedding Feast
at the Museum
of Modern Art,
New York, 1959

Forms have to speak,
and color. Now the
white, the title is
Dawn's Wedding Feast,
so it is early morning
when you arise. . . .
When you've slept
and the city has slept
you get a psychic
vision of awakening.

garage next to her house on Spring Street in order to have room to plan and construct the show and keep it secret, working entirely by herself. Preparing for her black environment at Grand Central Moderns she had filled a couple of rooms in her house with pieces of wood, all painted black, from which to choose. Now she filled the Spring Street garage with found pieces and painted them all white. She also painted the interior of the garage white because, she said, "When I am thinking black or thinking white, I don't want to be confused."

After the work was completed, she assembled the wall pieces and the standing and hanging sculptures in the garage exactly the way she wanted them in the museum, and Miller had them photographed there so that they could be installed exactly as Nevelson had planned them. Something like eighty-five pieces were sent to the museum, and the installation shots vary only slightly from the Spring Street photographs that were published in the exhibition catalogue.

The reaction to the Nevelson section of the show at the opening could be summed up in one word—excitement. Among the artists in the show were Jasper Johns, Robert Rauschenberg, Jack Youngerman, Frank Stella, Alfred Leslie, and Richard Stankiewicz, all of whom were excited by Nevelson's creation, as was Alfred H. Barr, Jr., the museum's great director. Like Nevelson, they were certain that the white environment would be remembered. When Mrs. Barr said at the opening, "It's a colossal success," Miller asked how she could tell. "The air is electric!" she answered. Before that time the world had scarcely heard of Louise Nevelson.

The day before the opening Nelson Rockefeller came to see if there was anything he wanted to buy, as he always did before museum openings, and bought an entire large wall for the Governor's Mansion in Albany and several pieces for his private collection. Nevelson had wished that the entire environment could be kept together as a permanent installation, possibly at the museum. But, as Miller pointed out, "We were all, to quote Alfred Barr, 'institutional beggars' at that time in the museum." A great black wall, *Sky Cathedral*, from the Grand Central Moderns show, had already been given to the museum by Louise's sister. But of the whole *Dawn's Wedding Feast* assemblage only two slim hanging columns were acquired by MoMA, with funds from the Blanchette Rockefeller Fund. Some of the major pieces were later reassembled, with some variations, and are now in museums and private collections, but most of this great work was dismantled and reused by the artist in other sculptures.

The creation of *Dawn's Wedding Feast* can be seen, in retrospect, to have been the single most important event and achievement in Nevelson's life. From

that point on she was recognized as one of America's major artists. Her never-failing confidence in her career was publicly confirmed, and all her work since then has been carried out with optimism and joy.

Rather than mourning the demolition of the great white assemblage after the exhibition, Nevelson proceeded to plan a resurrection. The pieces were reconstructed, during the next years, and even into the seventies, with many variations. Some of the white pieces and a great deal of new material were used to make a monumental white environment for the 1962 Venice Biennale, where Nevelson, one of the three artists in the United States Pavilion that year, also had a huge black room and a small circular gold one. Italian workmen installed the pieces according to Nevelson's instructions, and though they couldn't communicate in a common language, it went along splendidly. As Miller, who had gone along, described it: "Nevelson would pick up a piece, say, 'Put it there, dear,' and point. Then, 'Let's move it over a few inches to the right,' and point." Alberto Giacometti, who was chosen as the honored international artist at the Biennale that year, was so impressed with Nevelson's whole show, and with her, that he spent hours looking at her rooms.

The Biennale works were in turn dismantled and, like the *Dawn* environment, recycled into other works that, in some cases, resulted in greater sculptures than the original ones. *Dawn's Wedding Chapel II*, first seen in *Dawn's Wedding Feast*, is a notable example of the way slight changes and additions add up to a major difference in the impact of the revised composition. Architectonically stabilized with a new symmetrical grid, soaring skyward with the new double tower of staccato slats, it could stand as a sculptural surrogate for the facade of Notre Dame. Another of Nevelson's great white works is *Dawn's Presence—Two*, based on ideas and some bits from that vintage year of 1959, begun in 1969 and finalized in 1975. As with other works that she has revised over the years, the freshness and sense of immediacy are not lost, but her obsession with ordering her most random-seeming work has disciplined the complex assemblage to achieve remarkable serenity and stability.

The white interior of the Chapel of the Good Shepherd in Saint Peter's Church in New York, completed in 1977, is unquestionably the masterwork of Nevelson's architectural sculpture. The low-relief murals—reductive, minimal sculpture compared to her more typical work—create an environment both aesthetically exciting and psychologically serene. The only comparison that comes to mind is Matisse's Chapel in Vence, for which the artist designed, as Nevelson did, a total environment that included even the vestments for the attending clergymen.

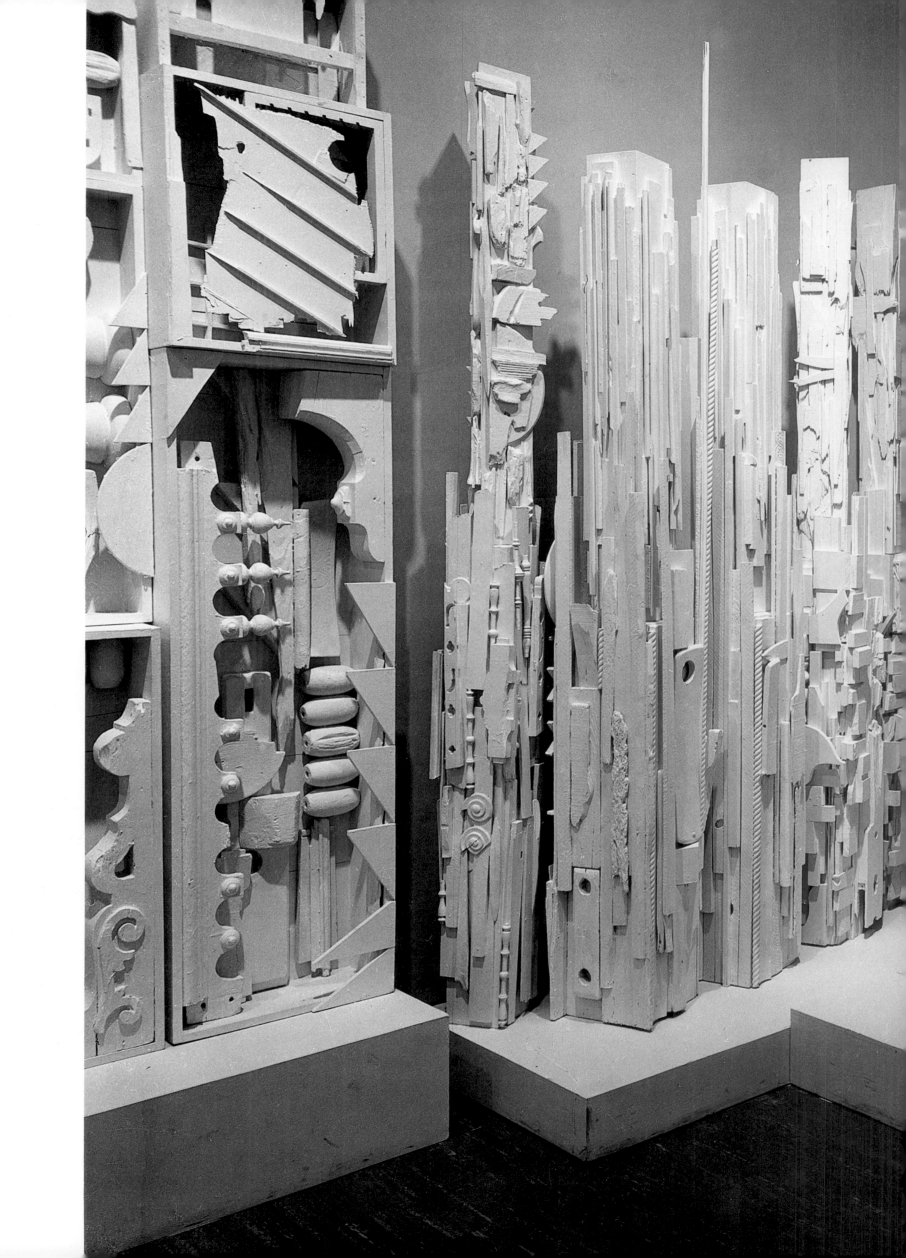

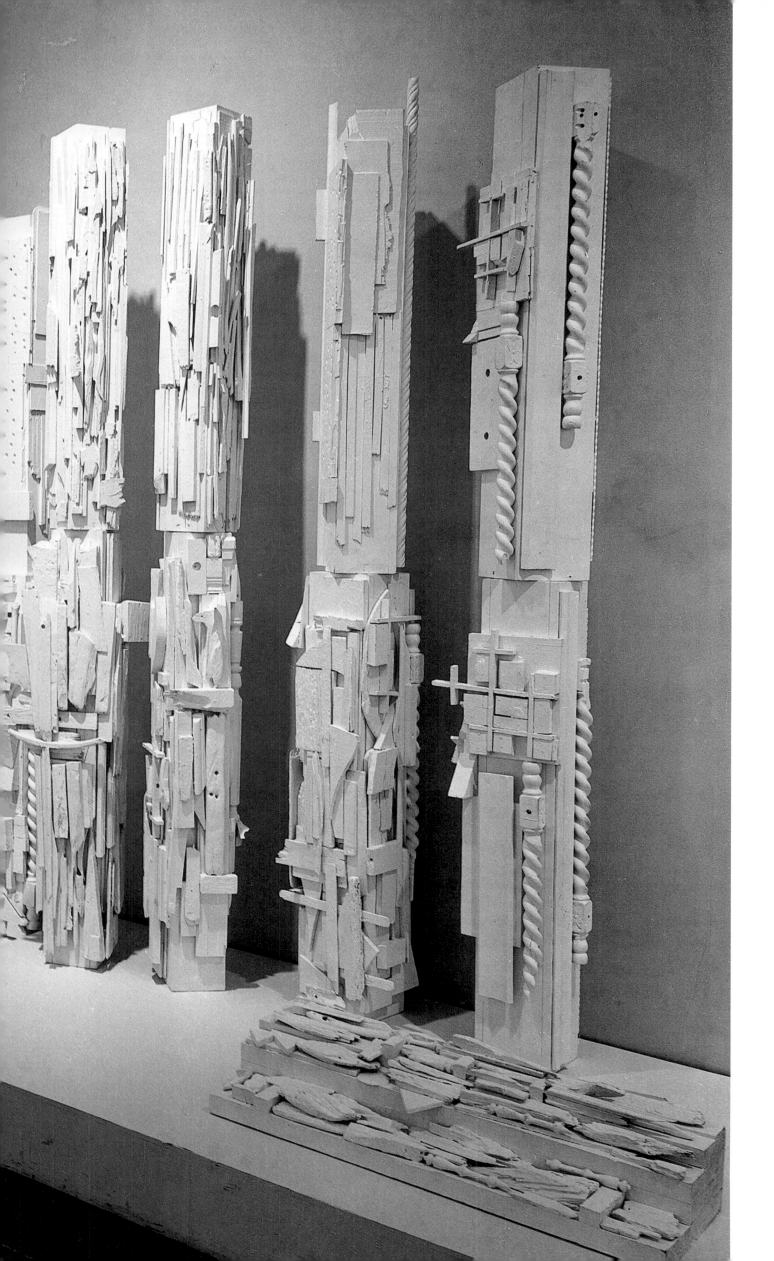

Installation of Dawn's Wedding Feast *at the Museum of Modern Art, New York, 1959*

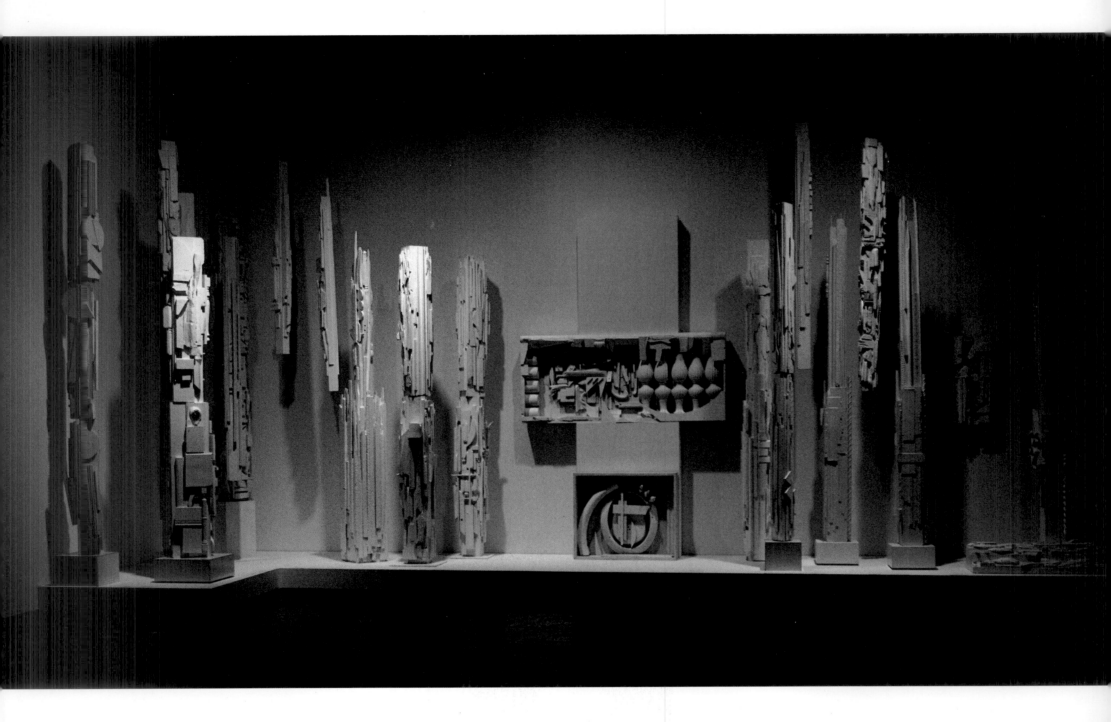

Installation of works from Dawn's Wedding Feast
at the Whitney Museum of American Art, 1980

Dawn's Wedding Mirror, *1959*

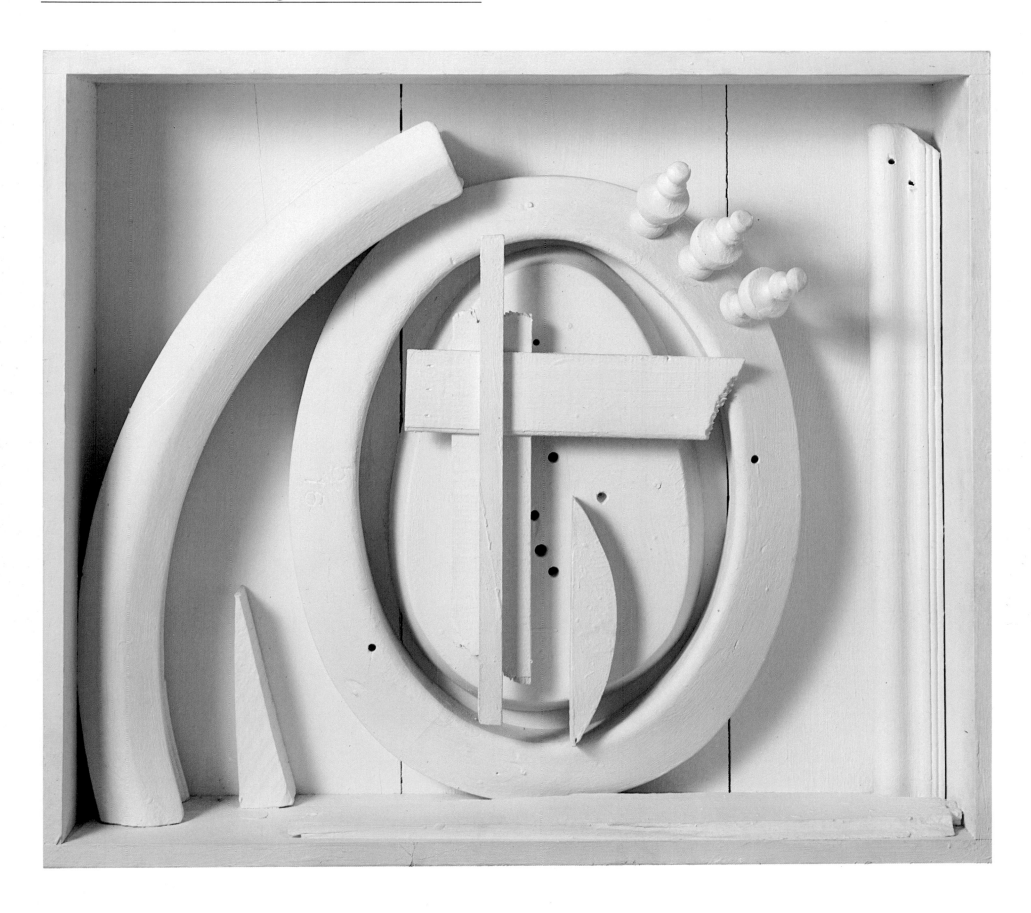

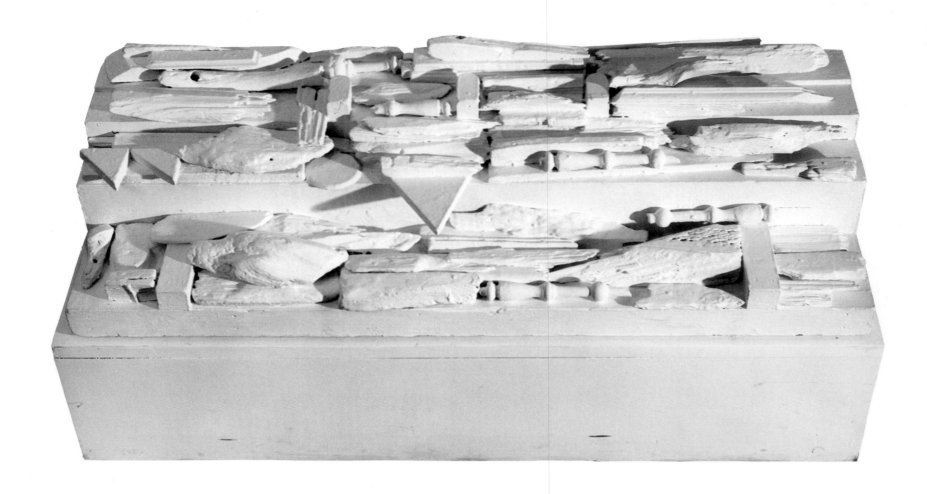

Dawn's Wedding Pillow, *1959*

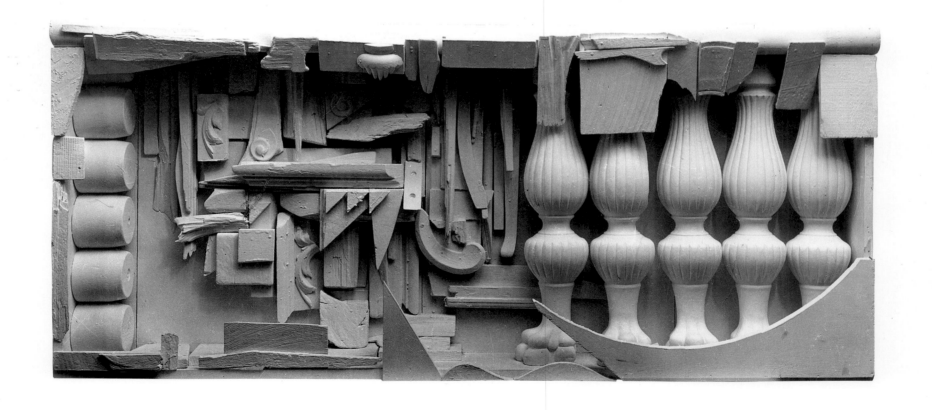

Case with Five Balusters, *1959*

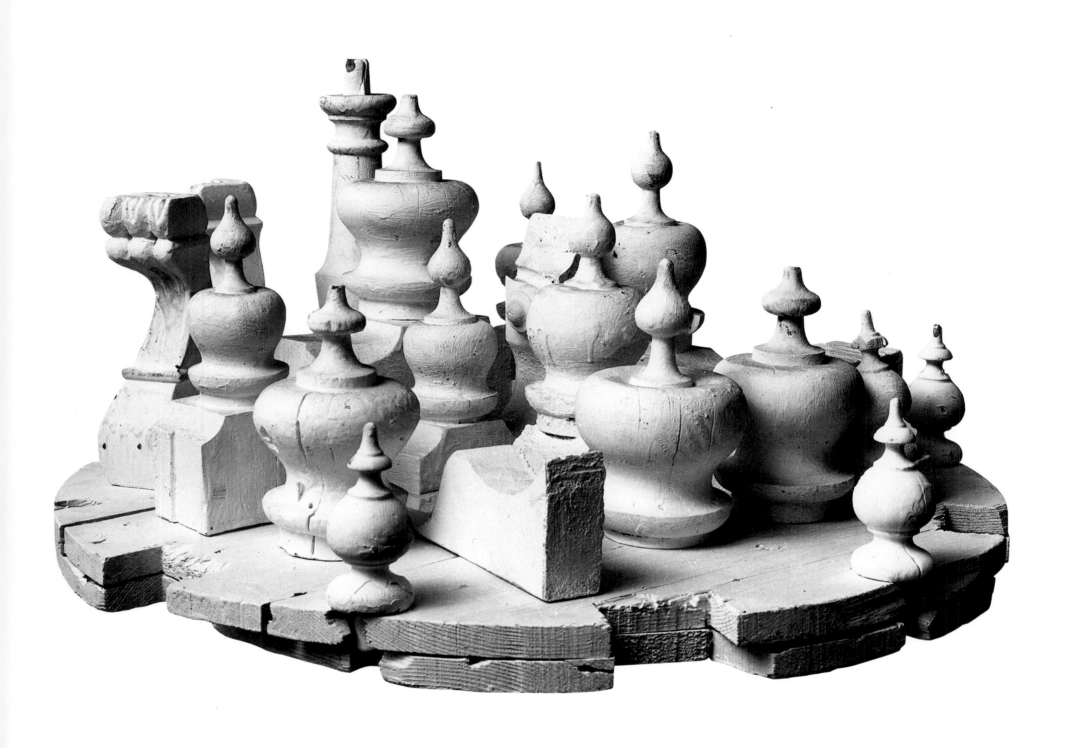

Dawn's Wedding Cake, *1959*

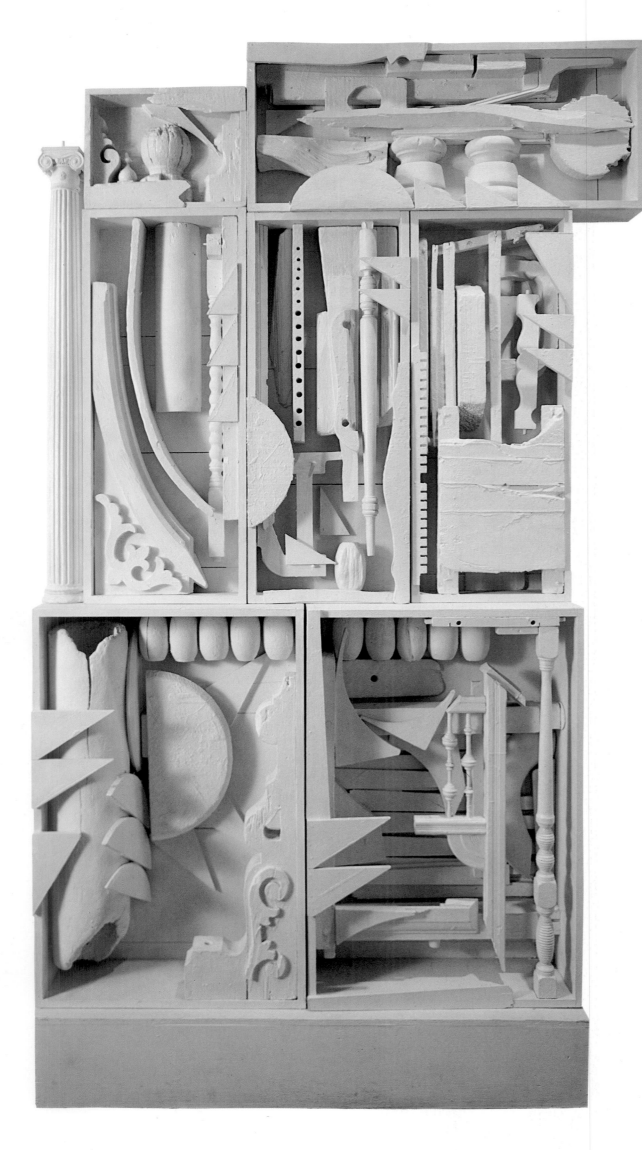

Dawn's Wedding
Chapel I, *1959*

Dawn's Wedding
Chest, *1959* ▷

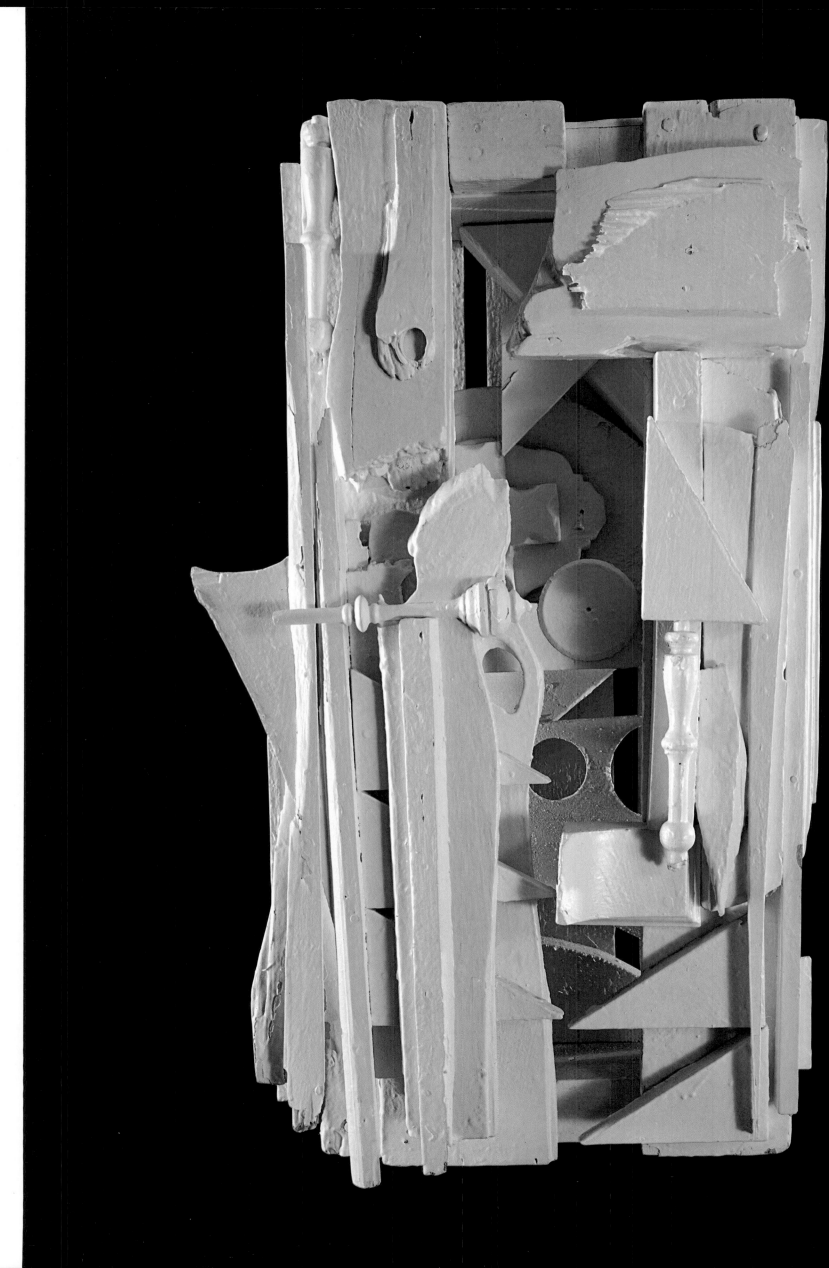

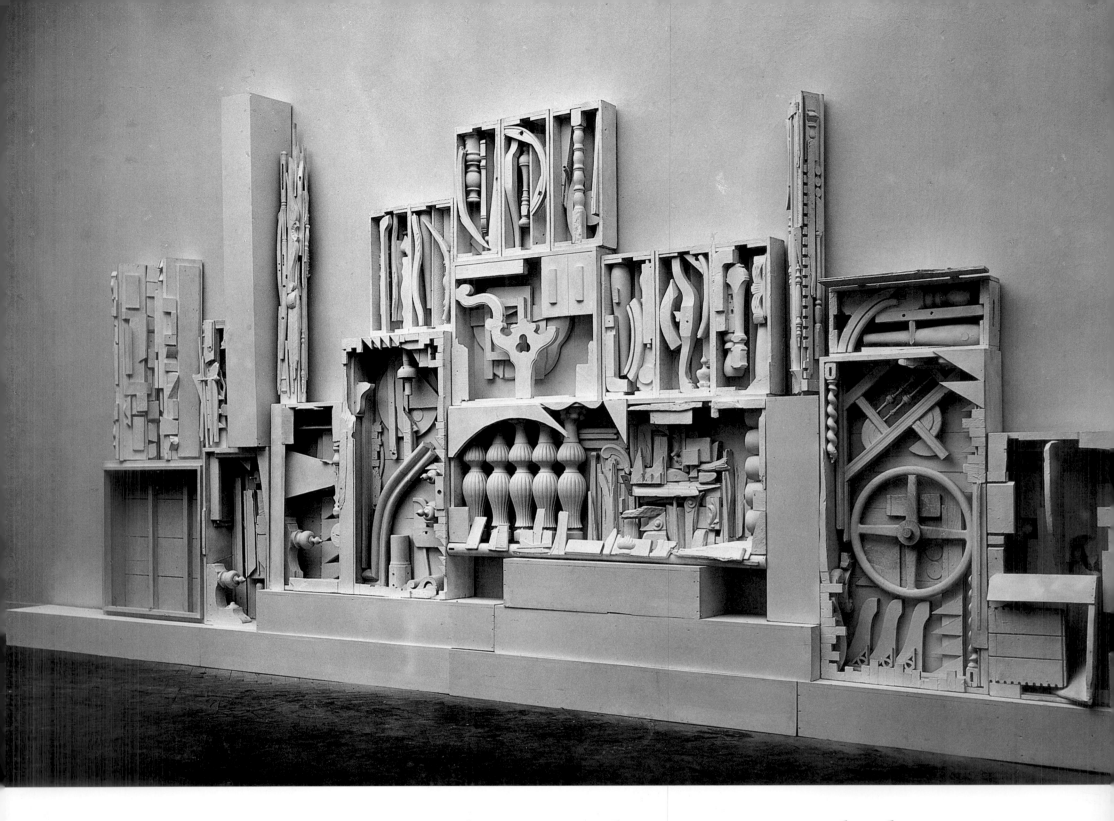

Voyage, 1962, in the Biennale Internazionale d'Arte, Venice

*Some of the pieces had been in other shows,
the white included parts of Dawn's Wedding Feast.*

Dawn's Wedding Chapel II, 1959–63 ▷

The white was more festive.

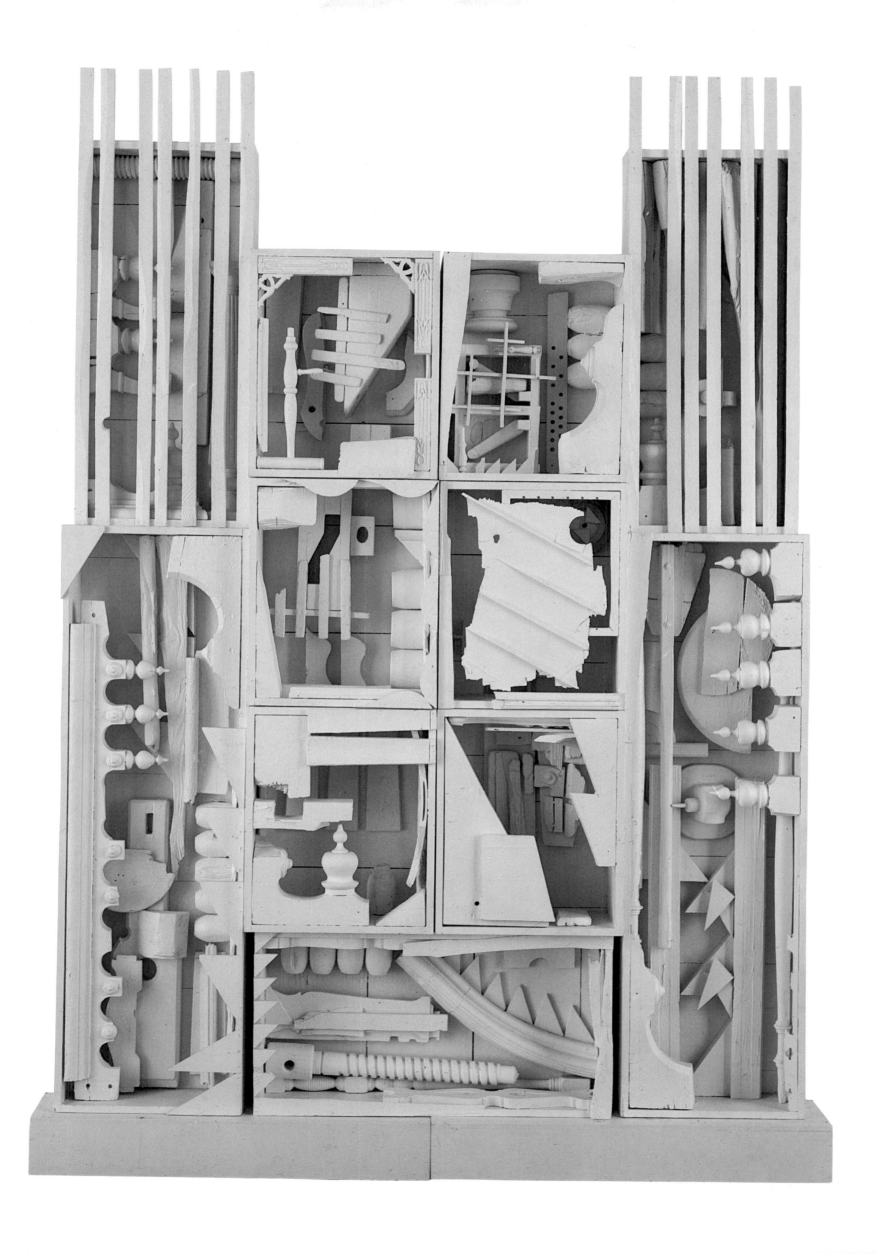

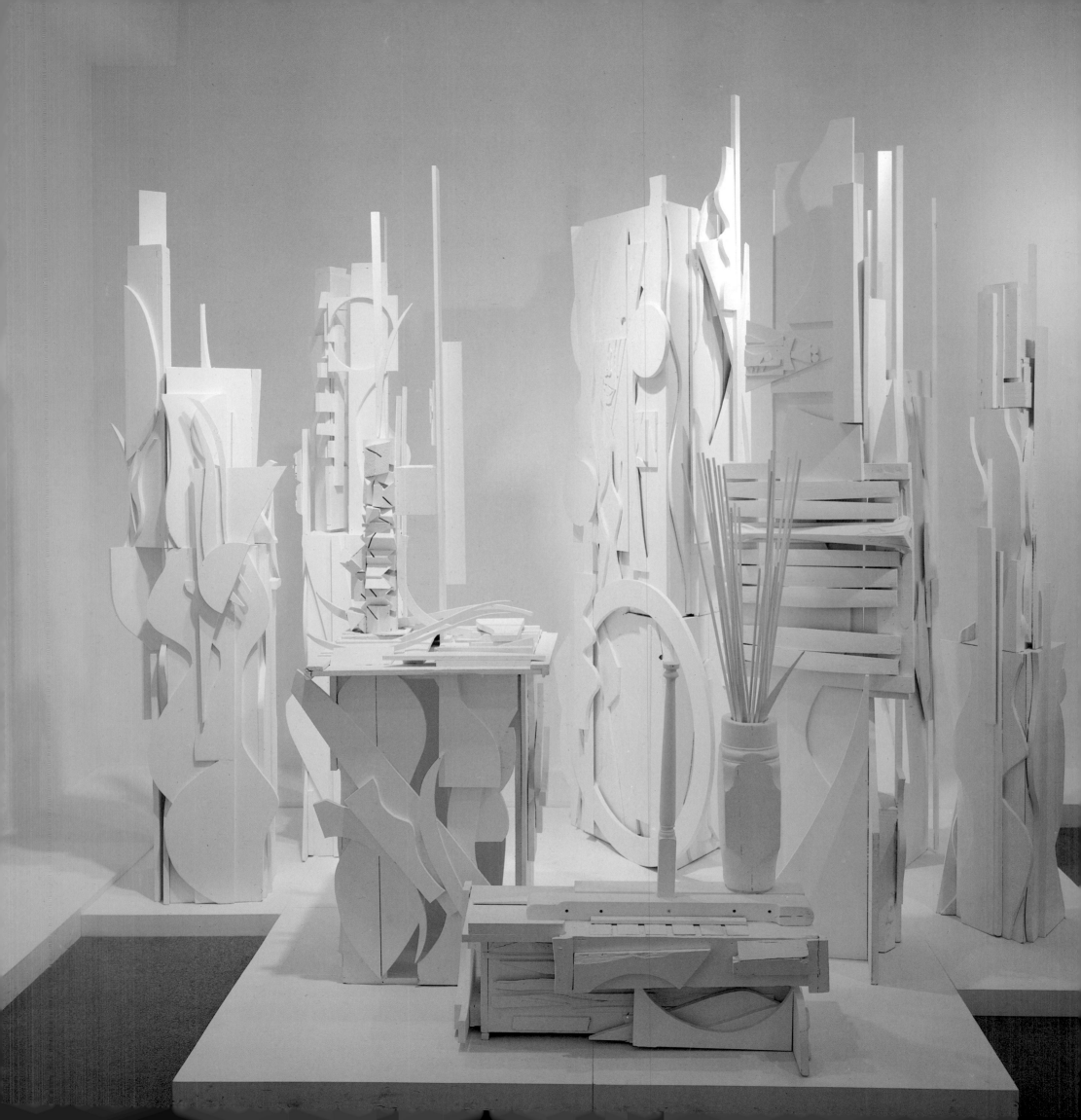

◁ Dawn's Presence—
Two, *1969–75*

*I feel that the white
permits a little
something to enter . . .
probably a little more
light. . . . It moves
out a little bit
into outer space.*

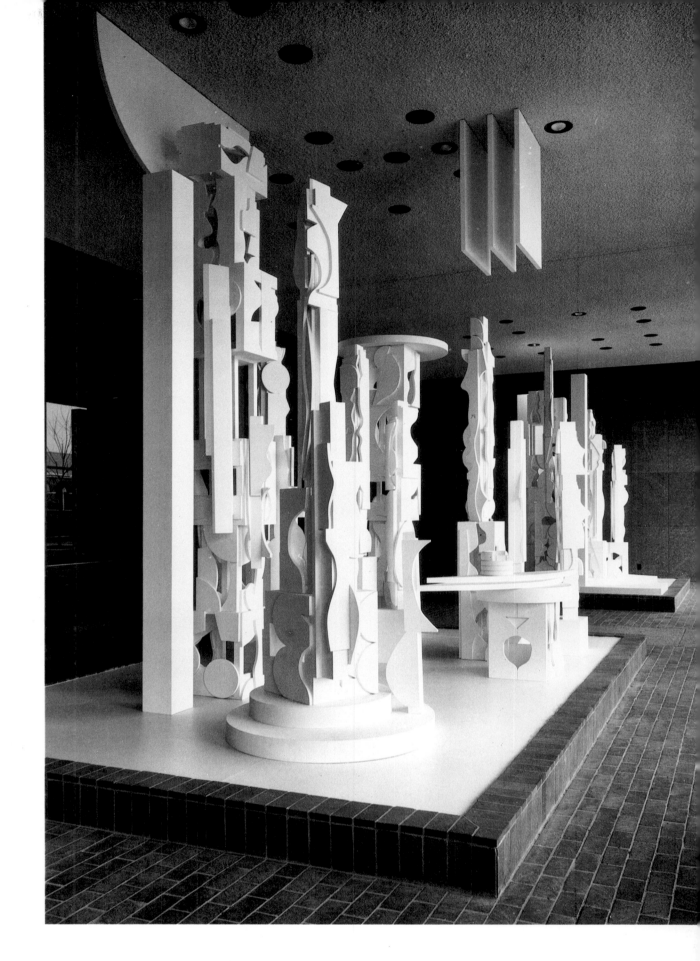

Bicentennial Dawn, *1976*

It becomes very surrealistic.

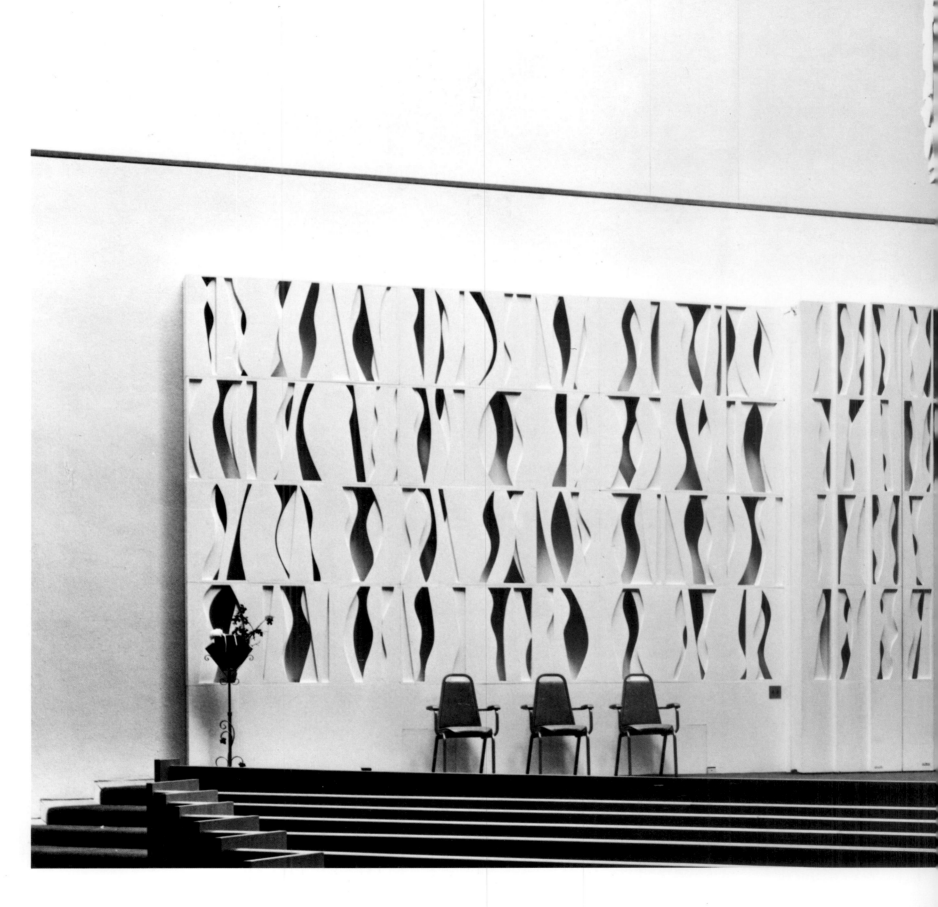

Temple Beth-El, 1971

Religion, if you feel it, belongs to the world.
My sculpture in the Vatican? Why not?

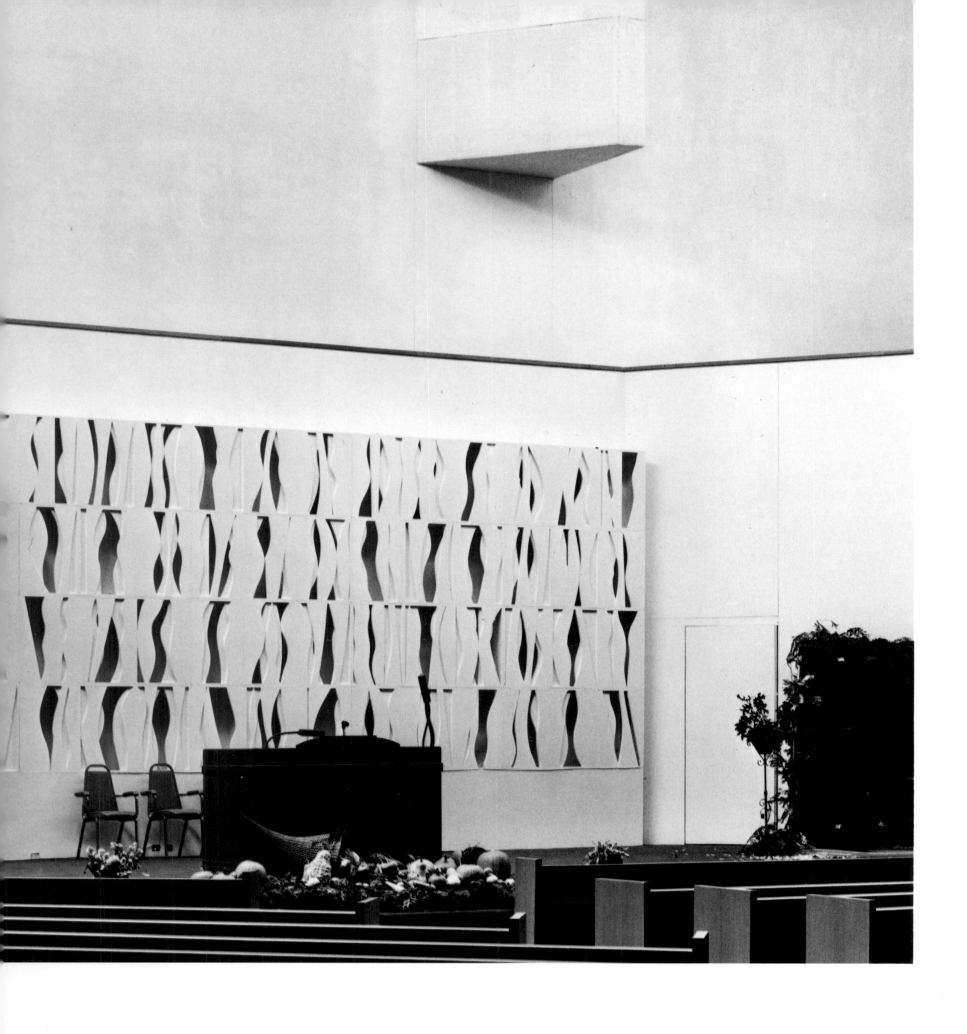

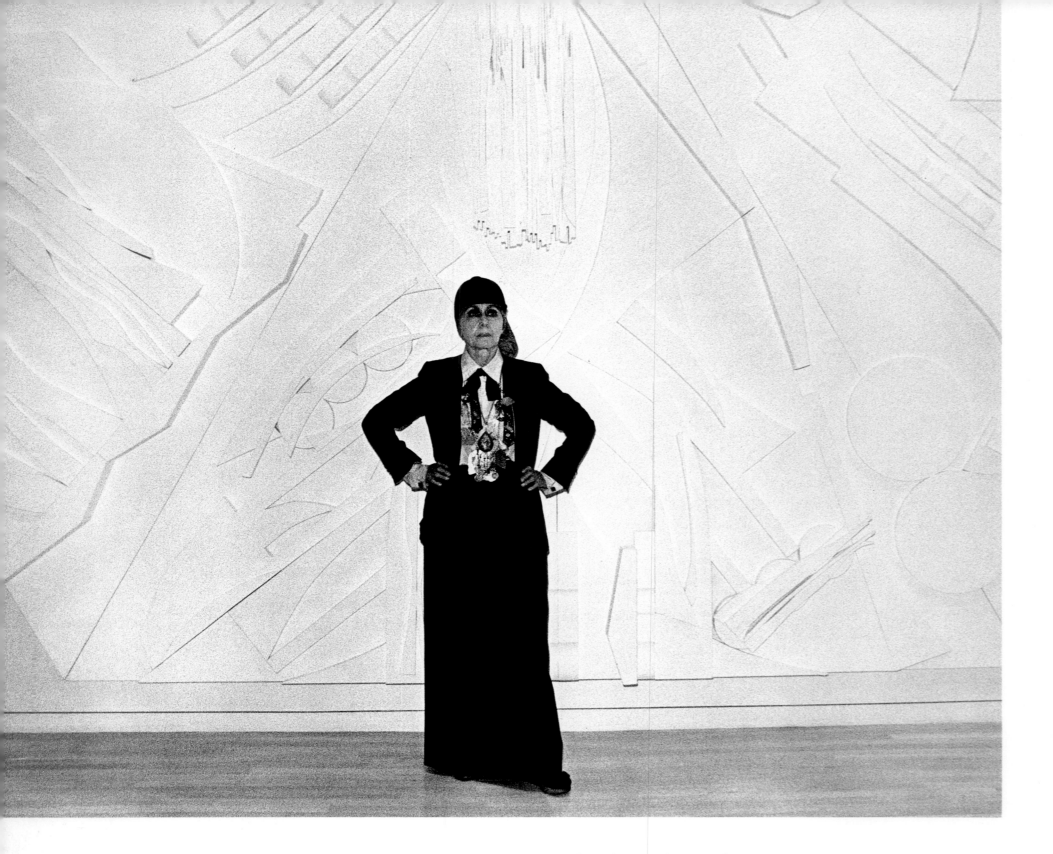

In the Chapel of the Good Shepherd

The Chapel was designed to be universal; it's a symbol of freedom. It has attracted every denomination. . . . If people can have some peace while they are there, and carry it with them in their memory bank, that will be a great achievement for me.

Grapes and Wheat Lintel,
Chapel of the Good Shepherd,
1977

View of the east and southeast walls
of the Chapel of the Good Shepherd,
1977, showing the Frieze of the Apostles
and the Cross of the Resurrection

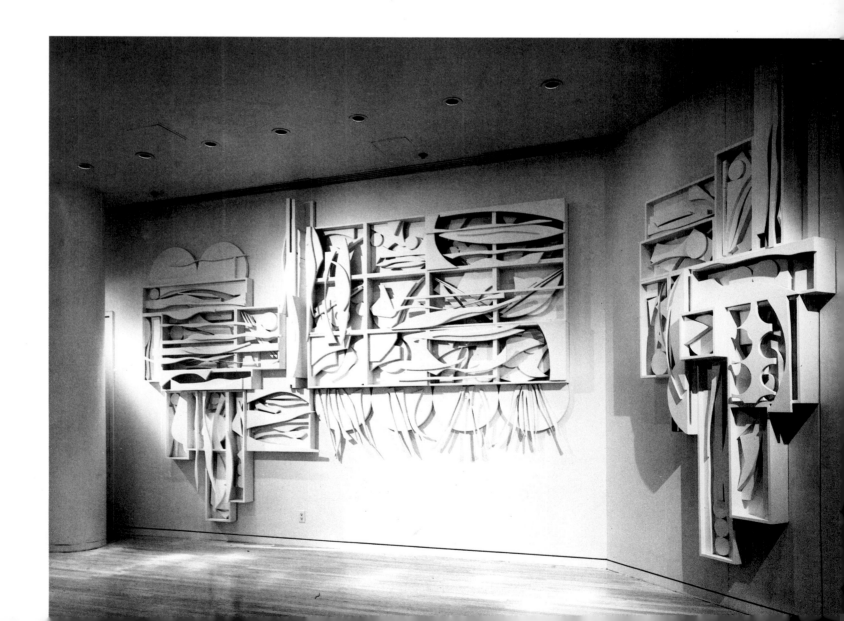

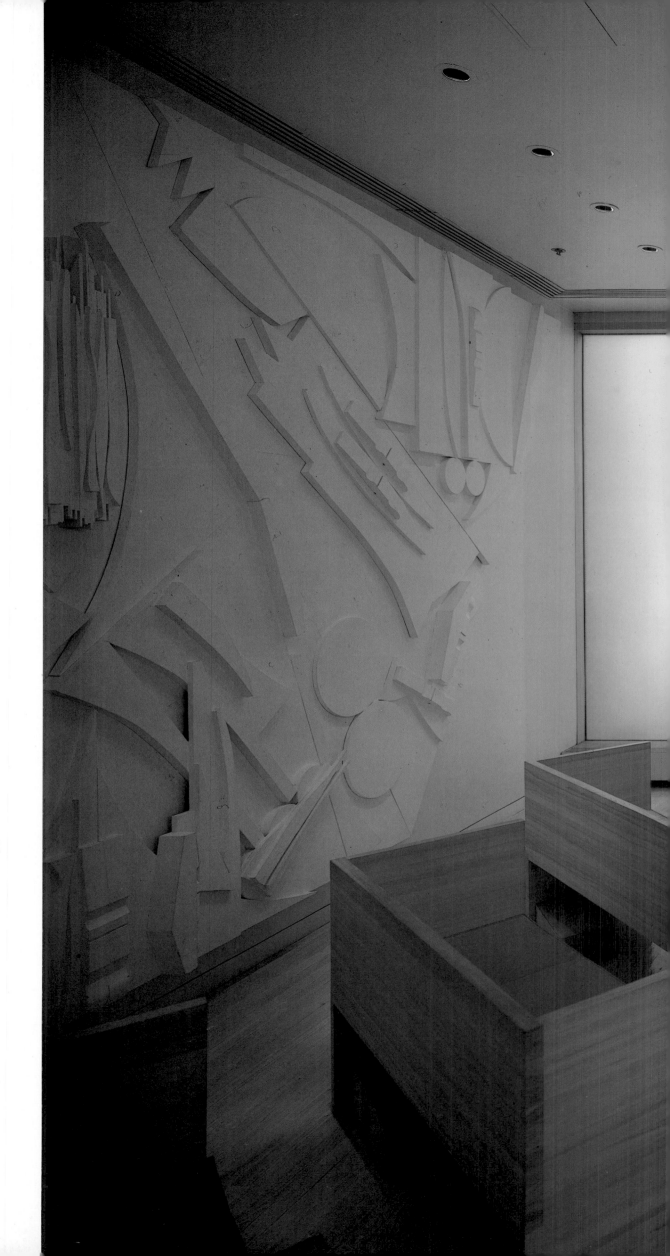

In the Chapel
of the
Good Shepherd

I meant to provide an environment that is evocative of another place, a place of the mind, a place of the senses.

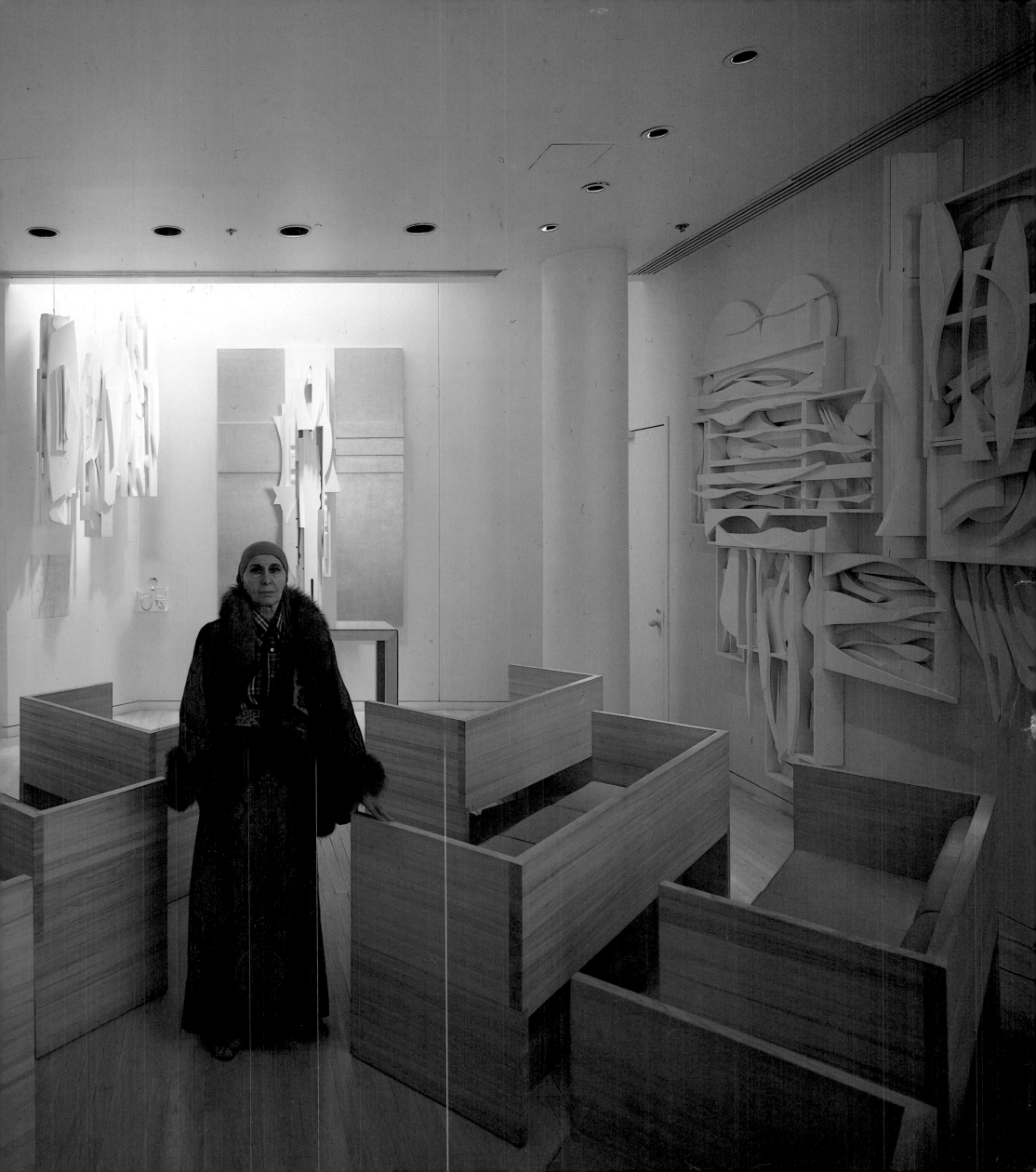

WOOD CONSTRUCTIONS AND ENVIRONMENTS

GOLD WORKS

I do think of gold in two ways. One is that the world is shining. Then I also think it symbolizes so much—the sun and the moon.

In his book *Louise Nevelson*, Arnold Glimcher says of the gold pieces:

Interesting formal innovations take place in the gold works. Nevelson abandoned the staccato composition of angular forms for new harmonies of volumetric roundness and curvilinear flatness. The optical density of the color intensifies textural richness or lack of it in the component forms, and a driftwood chunk assumes the visual weight of a solid gold nugget. The sculpture assumes optical weight and seems to be made of gold rather than surfaced with the color.

Vivien Raynor reviewed for *Arts Magazine* the first assemblage of gold works, *The Royal Tides*, shown at the Martha Jackson Gallery in 1961. She too sensed a definite change of direction:

Whether it is because her latest constructions are sprayed with gold paint, or whether the ingredients are becoming more ornate, she seems to be entering a baroque phase, and seems also to be working on a larger scale. The pigeonholes of the "walls" are perhaps fuller, and one thought there were more claw-and-balls among their contents, all of which seem to have started out in the statelier homes. But they could never have looked as august and glistening as they do now, transfixed by the Nevelson spell.

Royal Game I, the first of the series of that name, provides a fine opportunity to see how Nevelson assembles ordinary—and extraordinary—found objects to create her splendid golden wall sculptures. The parts are recognizable as bedposts and other furniture parts, toilet seats, barrel staves, and various scraps

of wood, all fitted into and framed by rough crates; the whole might suggest the entrance wall guarding a royal palace.

Each of the panels has been constructed as an independent sculptural collage but the three are organically related. The progression from bottom to top is determined by both the left-to-right diagonal of the three ovals and the right-to-left placement of the vertical strips of wood in their crate frames. The lowest panel is firmly rooted by the curved pedestal. This element is repeated in reverse in the second panel, where it leads the eye upward to the barrel staves that form a sweeping final arc. The whole sculpture has great stability, but

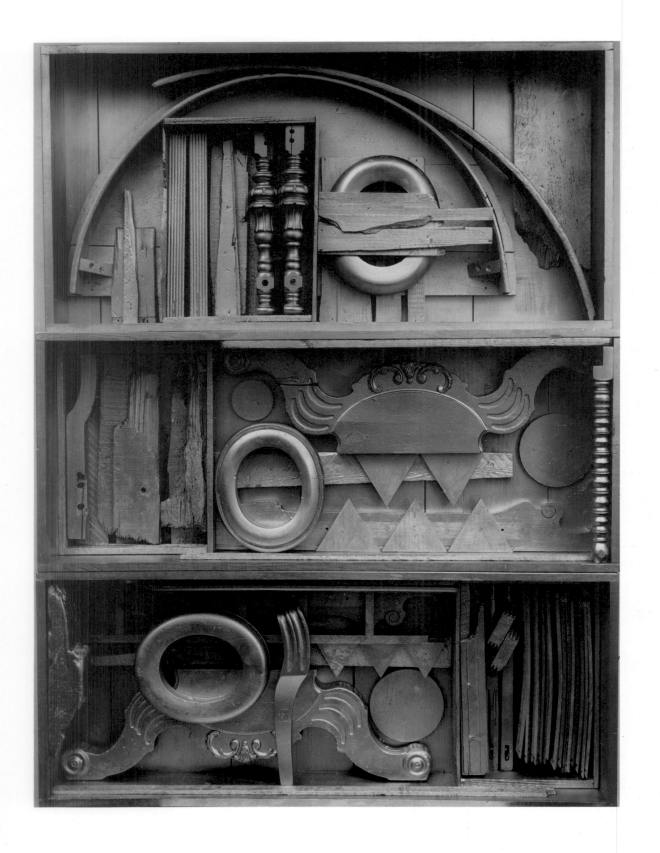

Royal Game I, *1961*

I think the gold enhanced the forms, enriched them.

there is a suggestion of lighthearted activity throughout: for instance, in the central tier the various ovals and circles play around the interlocking triangles, and the three open ovals seem to leap from one tier to the next until they are stopped at the top by the horizontal boards.

The rich surface of gold paint is, of course, the element that holds it all together. Our attention can shift back and forth, up and down, in and out, but the glowing surface constantly urges us to scan the complex whole. *Royal Game I* is well named; it is both a rich, treasure-filled wall and a playful, challenging sculptural game.

Royal Tide I, another wonderful example of the gold sculptures, is totally different in its design. William Seitz, in the catalogue of the Museum of Modern Art exhibition *The Art of Assemblage*, wrote about this piece with a balance of intuitive admiration and critical analysis that is a model of how to look at a Nevelson sculpture:

Each gilt-sprayed compartment of *Royal Tide I* is complete, and absolute in its clarity, yet each functions as a unit in a poem of eighteen stanzas. Those qualities that Schwitters loved—traces of human use, weather, and forgotten craftsmanship—still exert their magic here, but their color and dispersiveness is formalized by the gilding. Depth is flattened, but the reflecting surfaces delineate each block, sphere or volute, dowel hole, slot or recess, with scholastic thoroughness and precision.

This authoritative work resembles a reredos, an altar; but its dedication is not to a spiritualized divinity. The immediacy, clarity, and tangibility of its form and surface muffle and control, though they do not obliterate, an atmosphere of mysticism and romanticism. The gold is as much that of Versailles as of Burgos.

For this splendid wall sculpture, Nevelson collected all sorts of interesting wood scraps, selected for their range of textures and patterns. There are two antique hat forms (she had bought an entire collection of them), a mallet, furniture parts, bits of carved cornices, strips of ornamental moldings, chunks of weathered wood, and dozens of other fascinating fragments of unidentifiable —now seeming mysterious—origin. All these bits are placed in scrupulously unrandom ways so that the observer's eye is guided horizontally and vertically to see patterns of form and line, light and shadow, exactly as the artist planned them. Each of the eighteen compartments is a complex sculpture-collage; they are subtly connected by related elements that take the eye from box to box, by the uniformly shallow recession, the horizontal-vertical grid, and finally the dazzling golden skin. Looking at any of the black walls, one is constantly lured deep into the shadows; all the gold constructions are designed to move us briskly out to the shining surface.

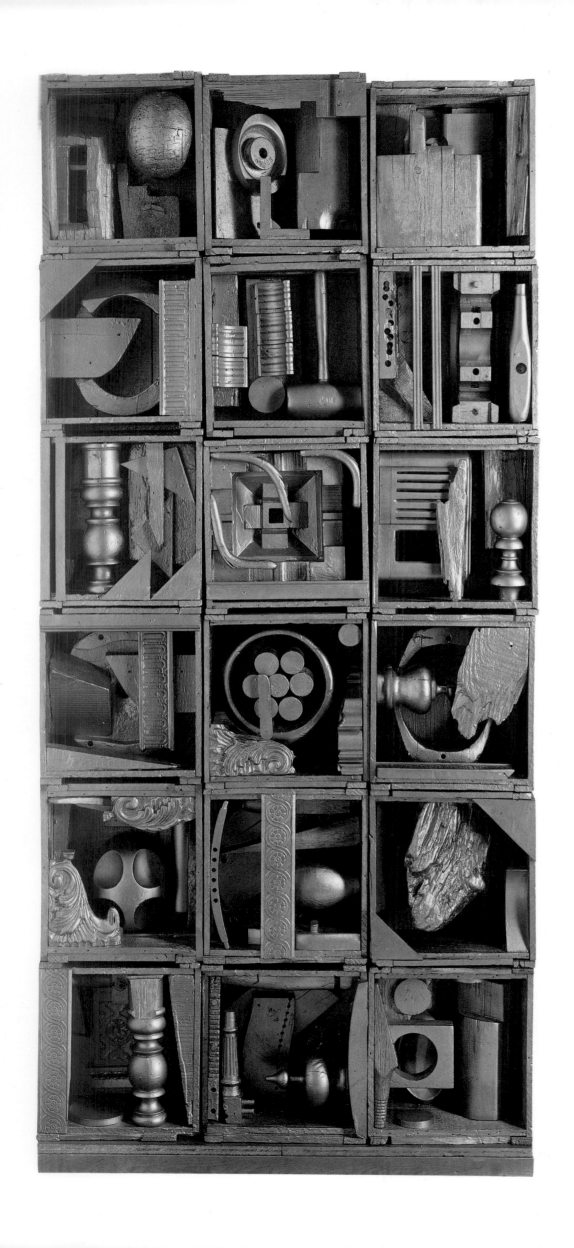

Royal Tide I, *1961.*
(Detail opposite)

*I wanted to show that
wood picked up on
the street can be gold.*

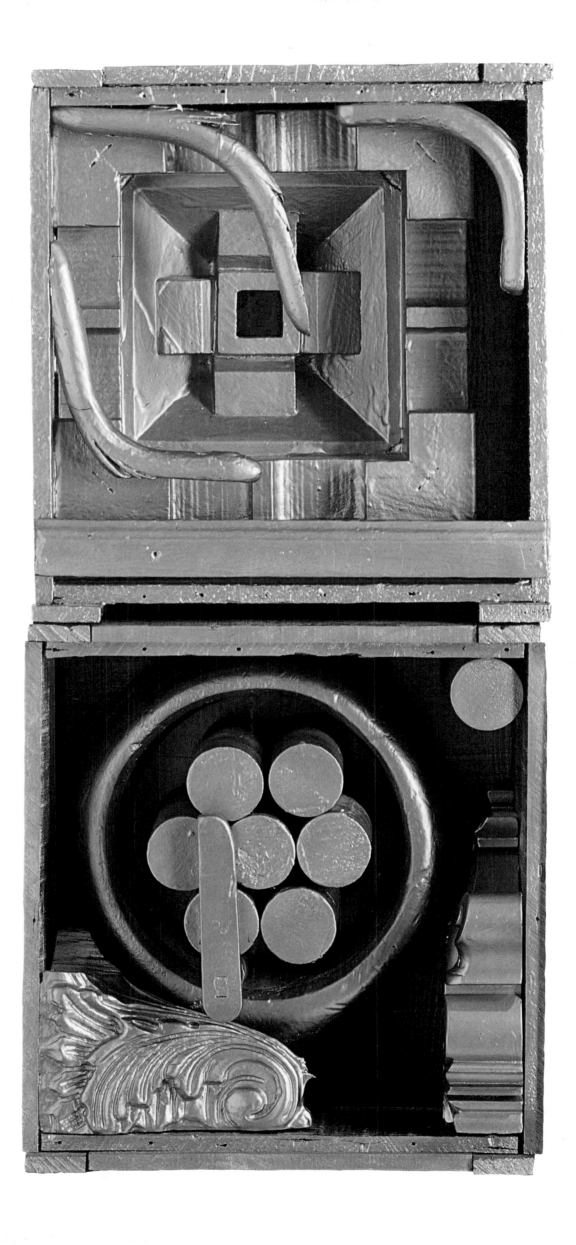

Royal Tide IV, *1960–61*

You could write a book about gold.

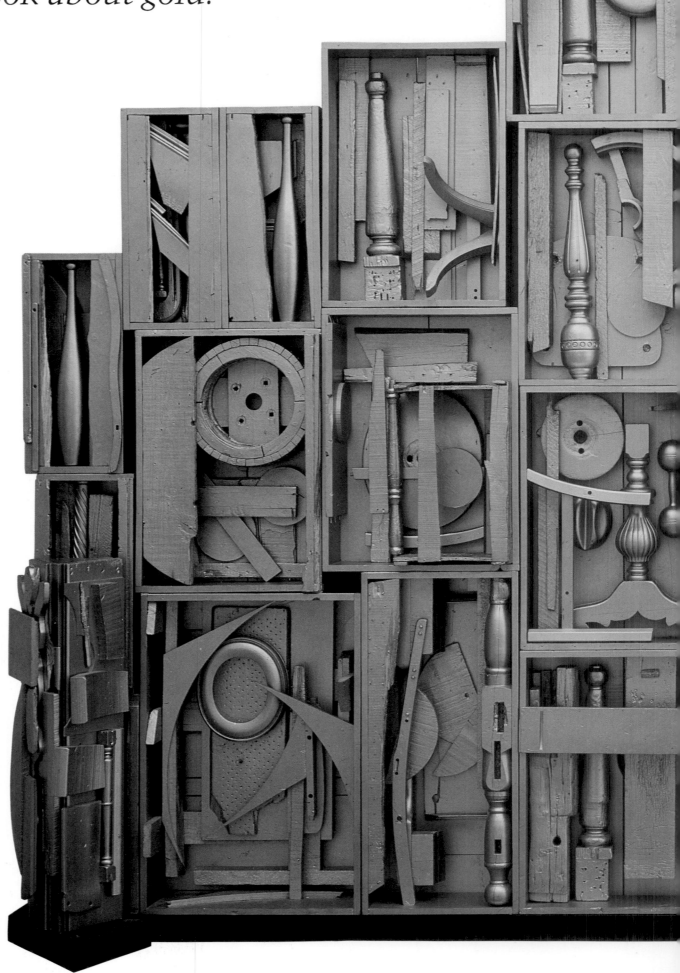

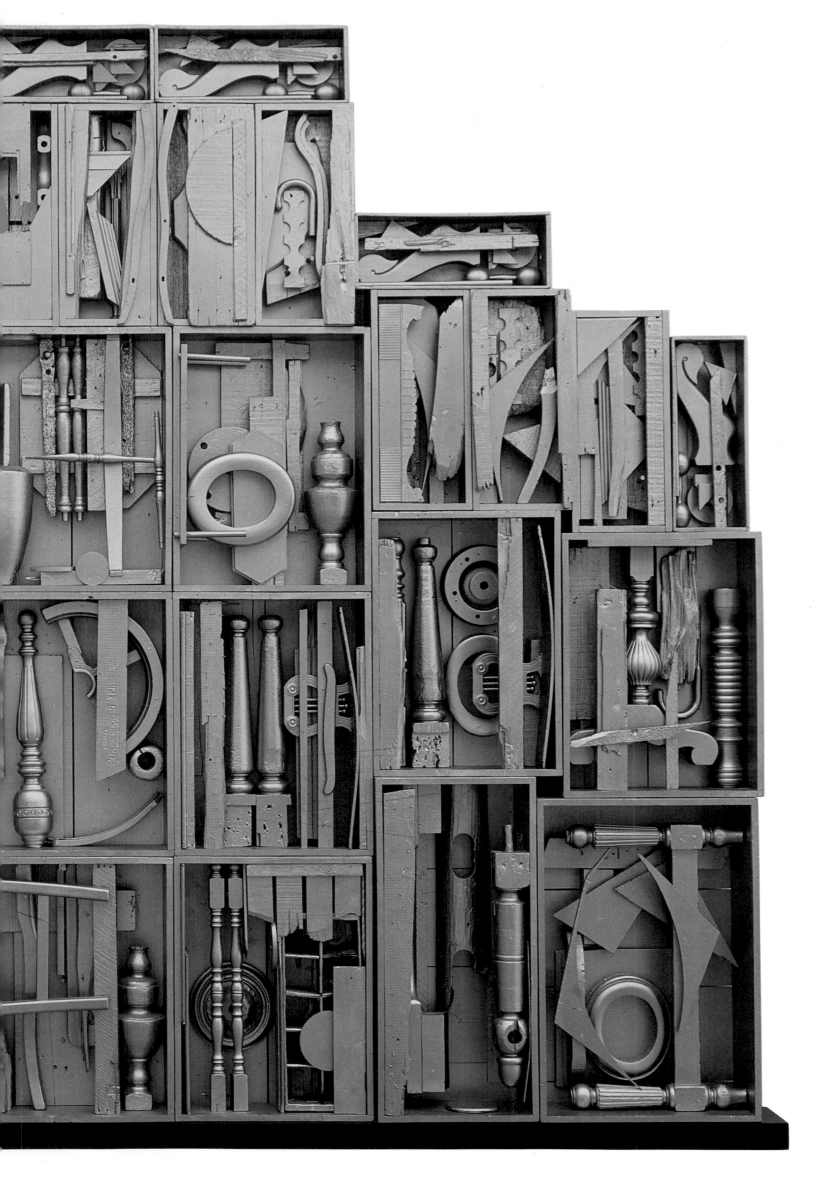

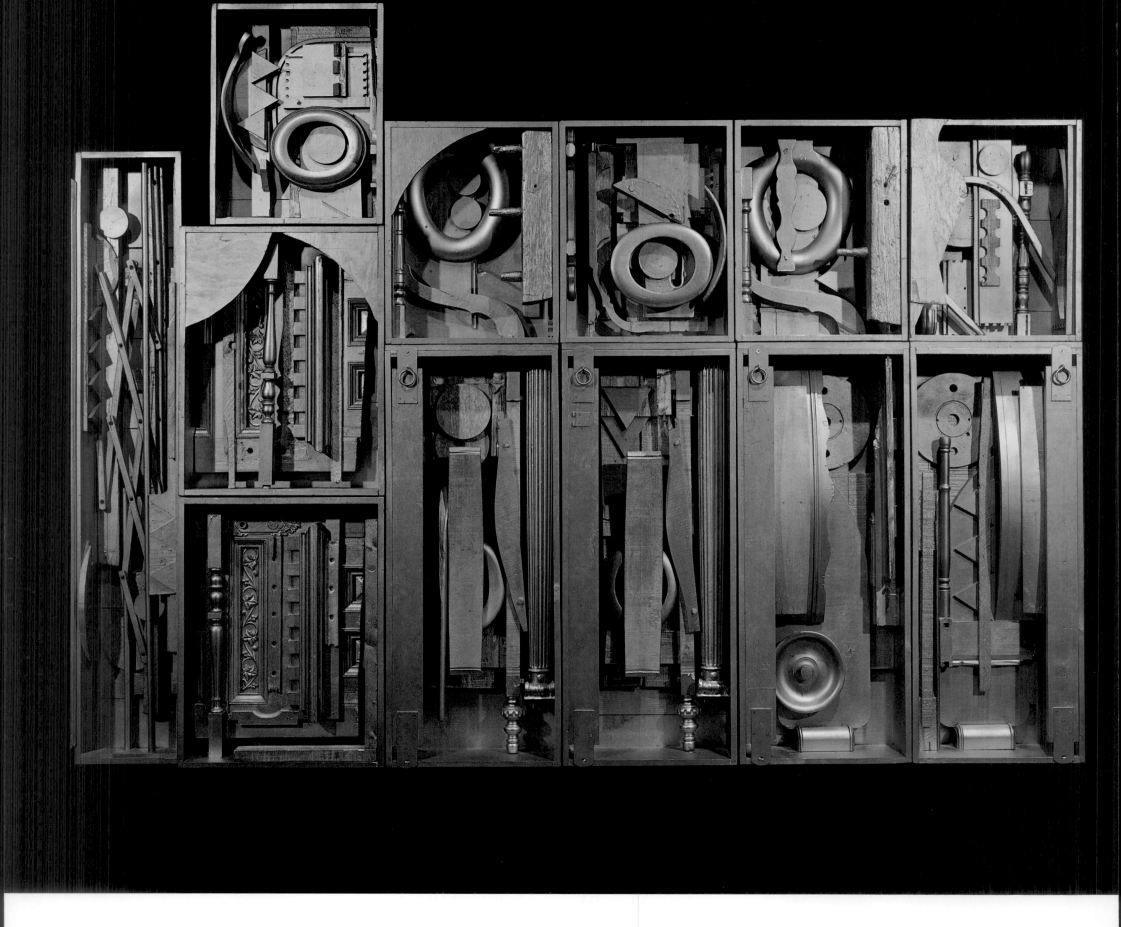

Royal Tide II, *1961–63*

This is a golden world.

Nevelson with <u>Royal Tide II,</u> *wearing her own black wood jewelry*

The good artist is the one that knows how much to put in and how much not to put in. That is the weights and balances we are always working with. . . . I try playing with light and shade, the different sizes and mediums and weights.

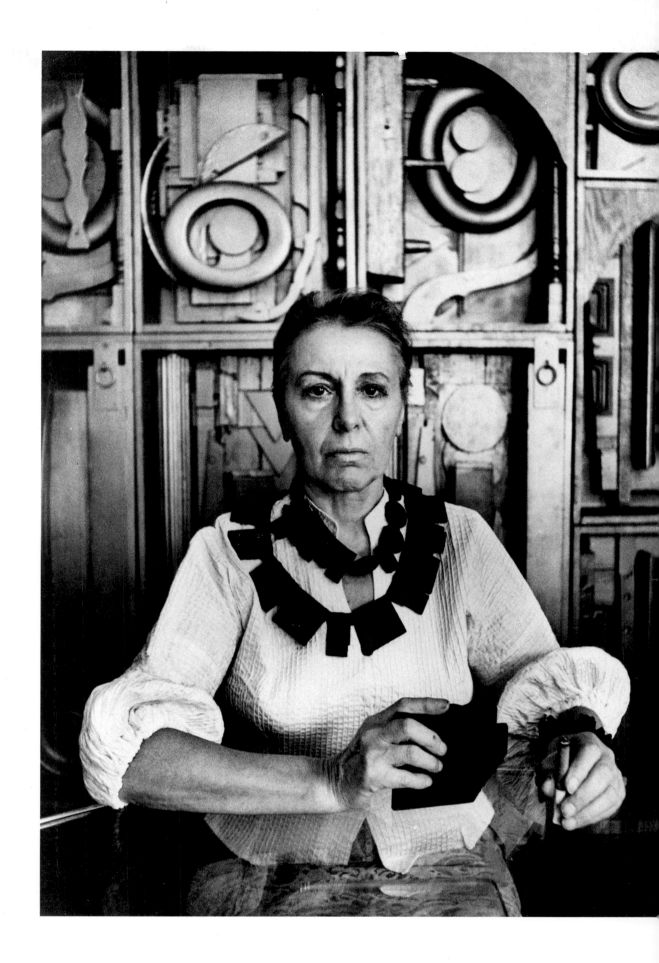

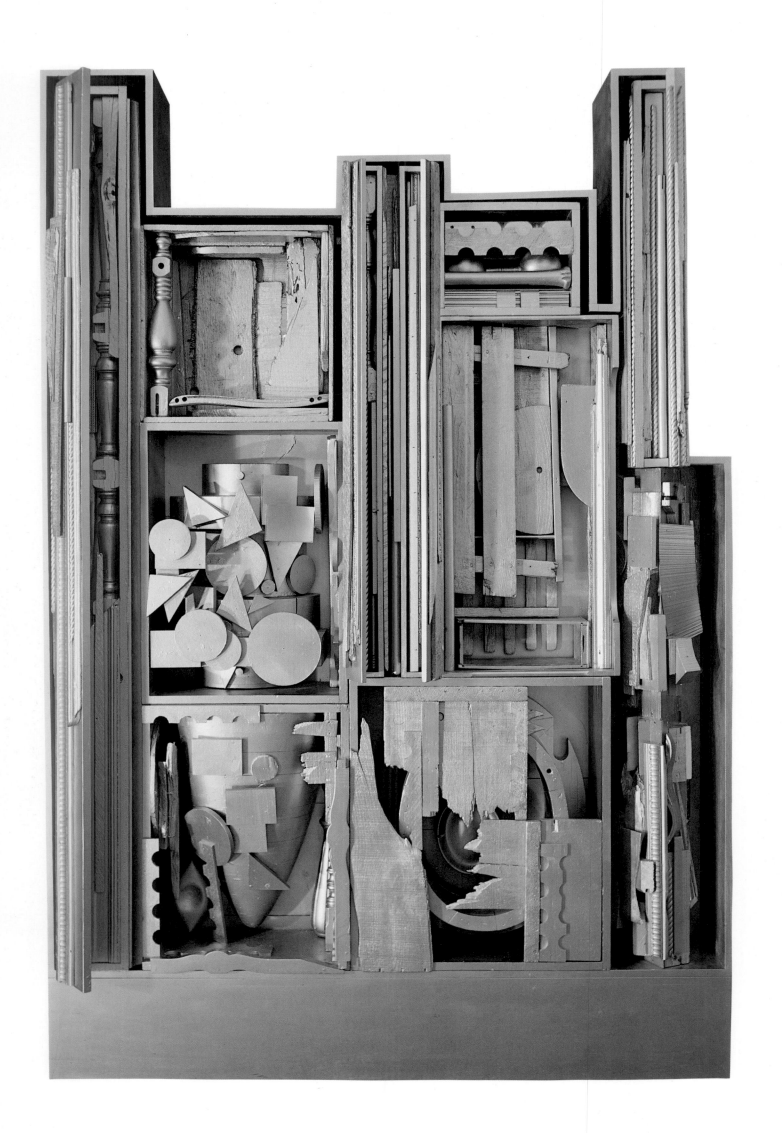

Golden Gate, *1961–70*

The minute you have gold, it takes over. It's splendor. And an abundance.

Royal Tide Dawn, *1960* ▷

Gold has been the staple of the world through the ages; it is universal.

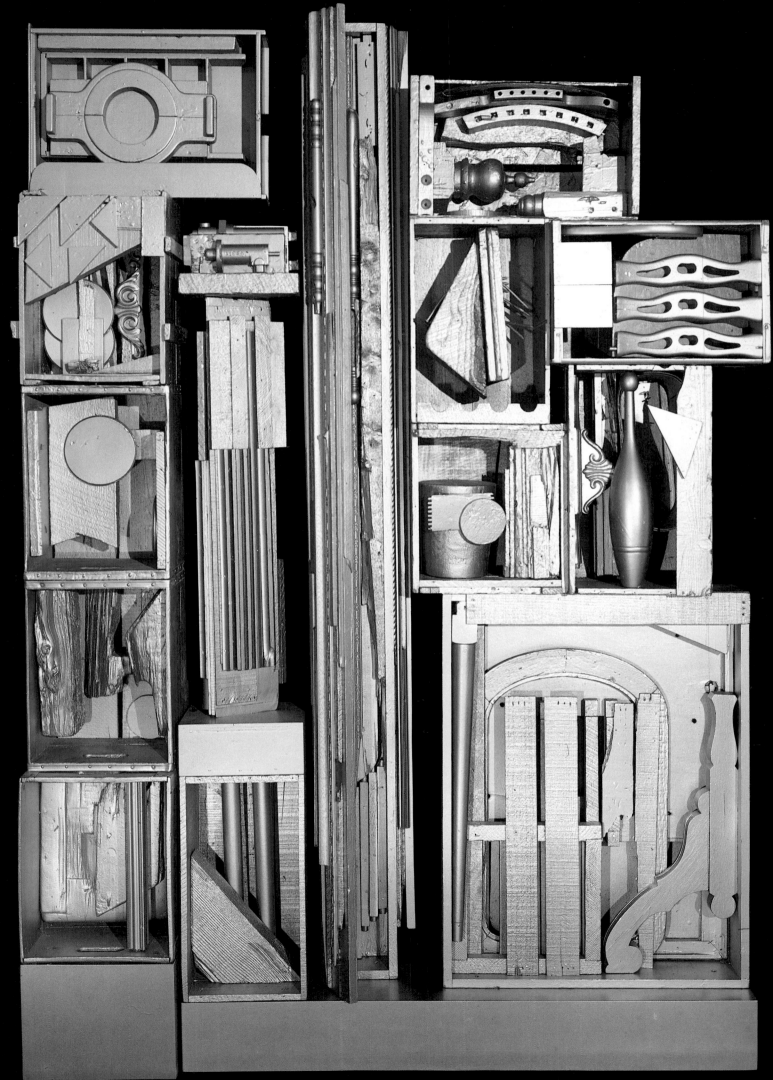

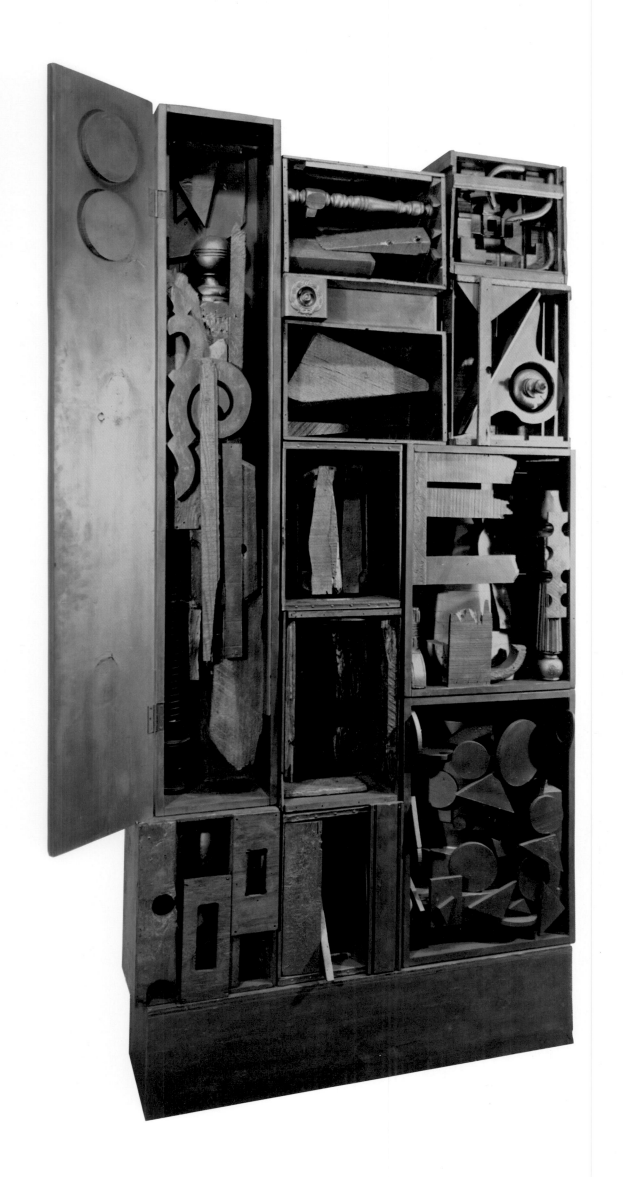

Royal Winds I, *1960*

My whole work in wood was enclosure, an enclosed or interior environment.

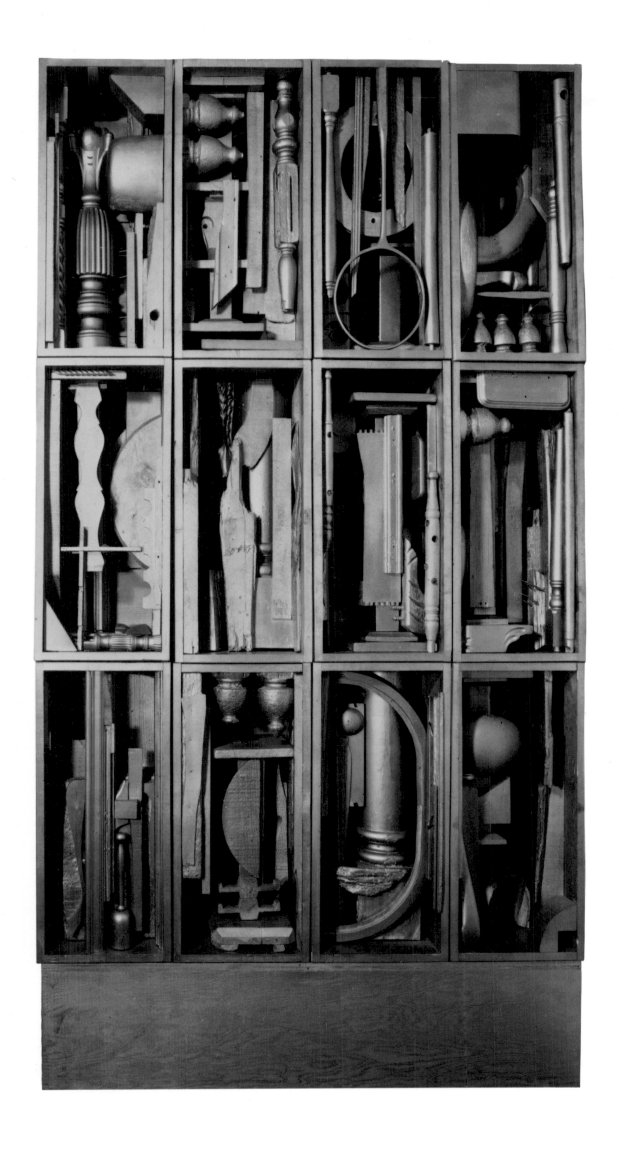

Night Music A, *1963*

*I think why, in
my particular case,
gold came after
the black and white
is natural. Really
I was going back
to the elements.
Shadow, light,
the sun, the moon.*

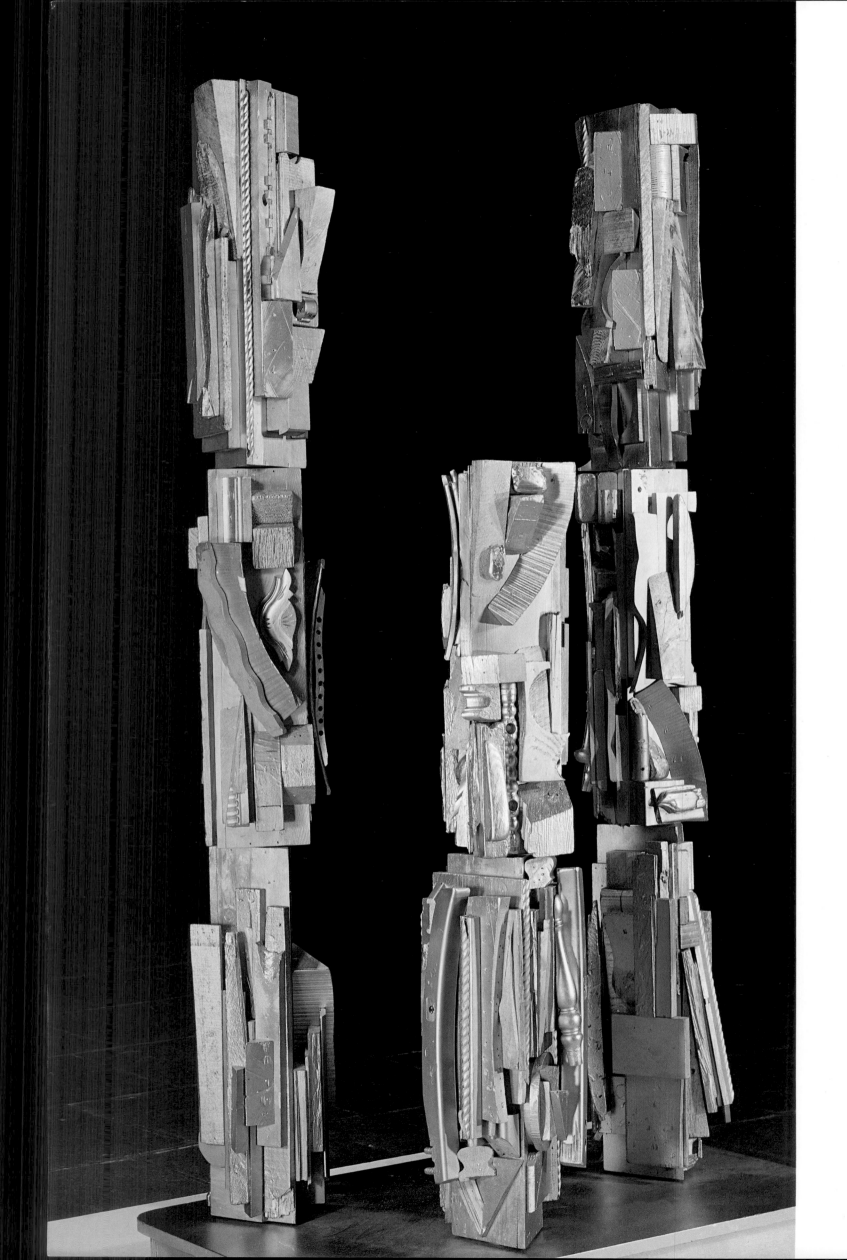

Sun Garden I, 1964

It's like the sun, it's like the moon— gold.

Dawn, 1962 ▷

The reality of gold is alchemy.

148

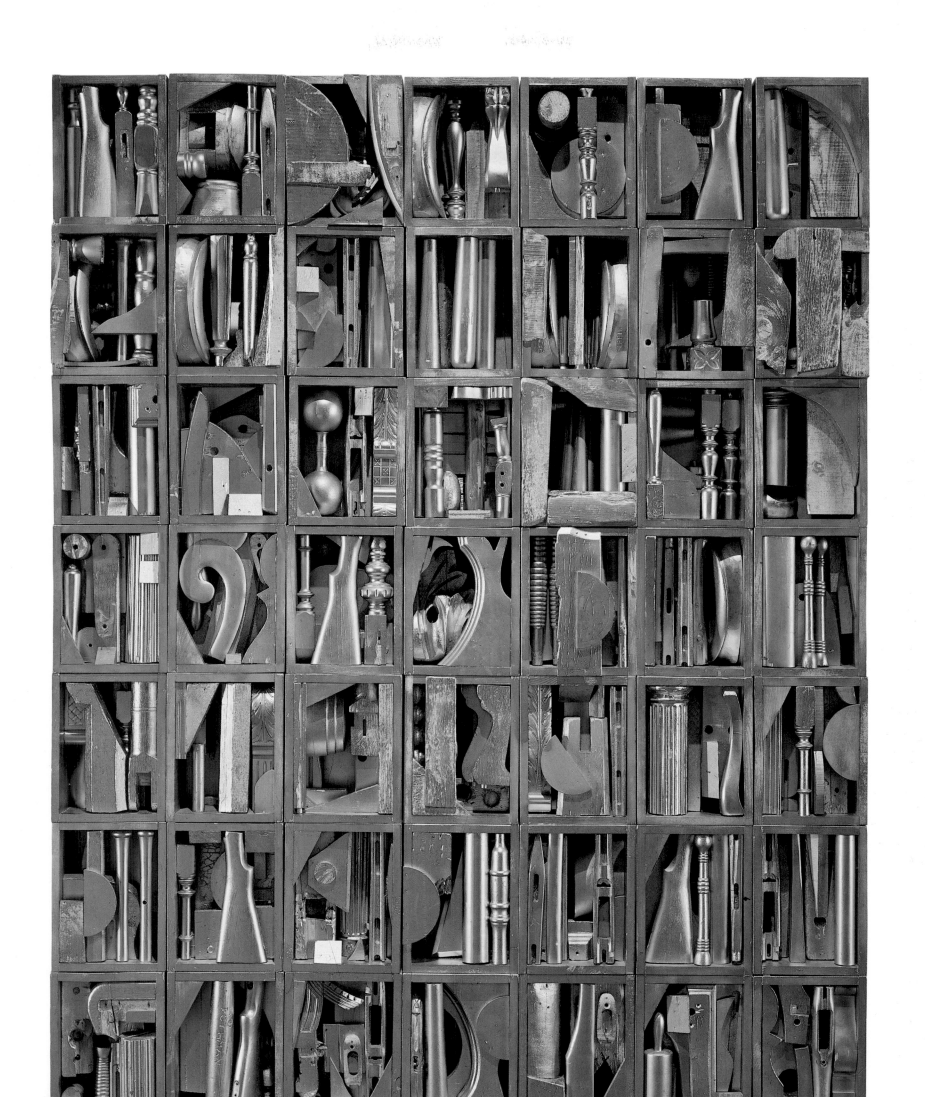

An American Tribute to the English People, *1960–65*

An enormous gold wall was my gift to the British people.

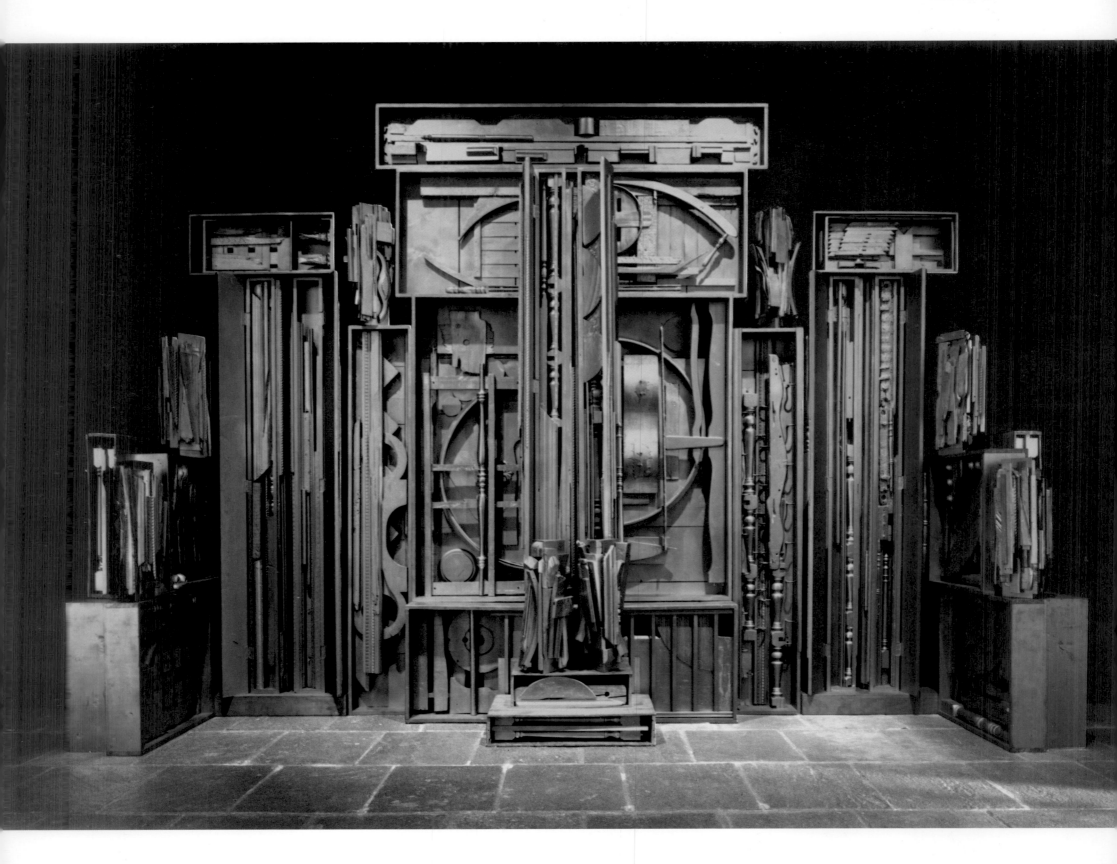

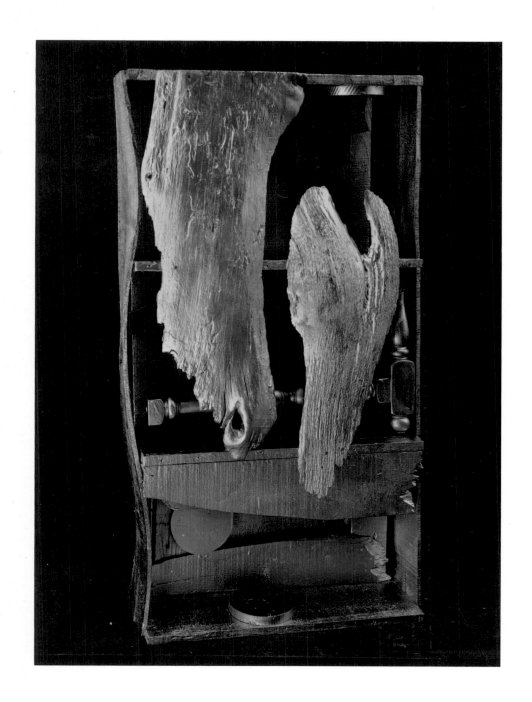

Royal Fire, *1960*

*When I'm working with wood,
it's very alive. It has a life of its own.*

Royal Winds, *about 1960*

*When I worked on the white
and the gold sculpture I
had two separate studios.*

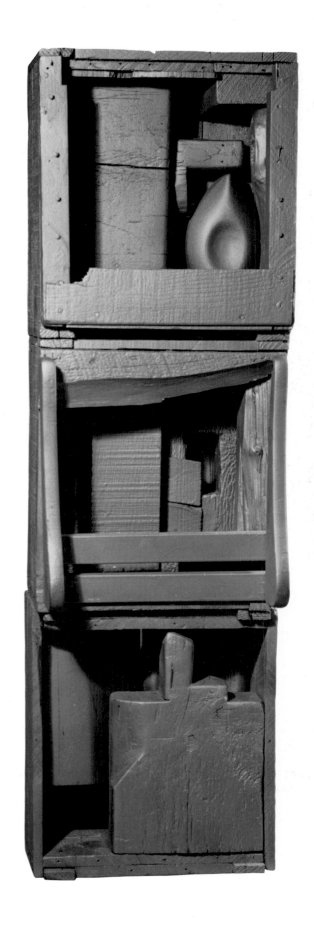

TRANSPARENT
SCULPTURE

I have given shadow a form and I give reflection a form. I used glass for reflections, then I used mirror. Then the Plexiglas. There you have a transparent material which gives us the ultimate light.

Always innovative and eager to discover the possibilities offered by different materials, Nevelson became interested in making fabricated works in 1965, when she visited the company in Saint Louis that was producing Ernest Trova's *Falling Man* sculptures. She began to explore the lightweight and reflective properties of black-enameled aluminum and of black and clear Plexiglas. Instead of blocking the viewer's vision with a solid wooden wall divided into compartments with shallow recessions, she chose to create transparent, skeletal structures that are open to the space beyond the work. She wanted the open spaces to assume significance equal to that of the solid shapes, and she decided that certain geometrical forms—concentric arcs and squares—were most appropriate for the new medium—and dramatically different from the found objects which Jean Arp had called her "monstrous bibelots."

Nevelson's sculpture is generally thought of as dark and solid, but the ideas of transparency and reflection are equally important to her, and not only when

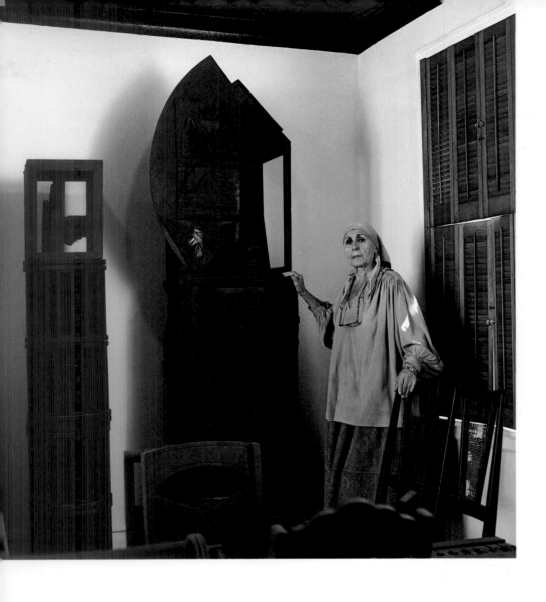

With two untitled black wood and glass sculptures made in 1980

I found an antique glass bird house, and glass boxes.

she uses transparent material. Some of the early drawings have see-through overlapping lines, and her prints have titles such as *Solid Reflections*, *Reflected Cathedral*, *Mirrored Figure*, *Mirrored Wheel*. Names of various wall sculptures and reliefs make this key interest in light, shadows, and reflections very obvious: *Diminishing Reflection*, *Black Light*, *Black Mirror*, and *Young Shadows* among others. The monumental black steel sculpture at M.I.T. is titled *Transparent Horizon*, and the Cor-ten sculpture made for the city of Scottsdale in Arizona, which features open rectangles, is called *Windows to the West*.

Martin Friedman, in the catalogue for the Nevelson show he organized for the Walker Art Center in Minneapolis in 1973, wrote that

her art is expressive of fragile metamorphosis, not monumentalism. She regards herself as "an architect of shadows" and ponders the city's transformation at night, when solids and voids become interchangeable, and familiar objects lose their contours in shadows and reflections. Derived from such attitudes, her sculpture is wholly atmospheric.

It is interesting to note that Friedman was writing about Nevelson's wood sculptures. Clearly the transparent sculpture is not a departure from but rather an extension of a central aspect of her wood sculpture. The *Transparent Sculpture* series comes as no surprise.

In an interview with Arnold Glimcher in 1971, Nevelson said: "The glass, the transparency, and the mirrors played and do play such an important part in my thinking." After working with glass and mirrors in the mid-sixties, she began a series of sculptures that were made of transparent material. The Plexiglas sculptures were constructed in a Saint Louis workshop during 1967–68 under Nevelson's direction. She designed the transparent box parts, then went there to direct the assemblage. The chrome-plated nuts and bolts were placed to look, as she said, like a drawing. About the new material, Plexiglas, she said: "I'm blessed that I can use it, but it isn't giving me a new thought. It is permitting me to execute my kind of thinking in a more complete way."

These frontal Plexiglas sculptures, totally abstract, represent Nevelson's most

Homage to Dame Edith Sitwell, *1964*

I used glass for reflections. . . .

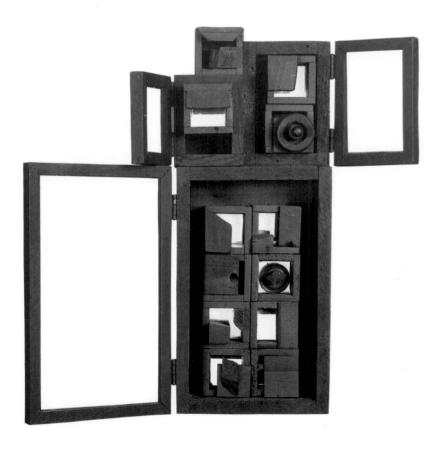

Silent Motion, *1966*

Then I used mirror.

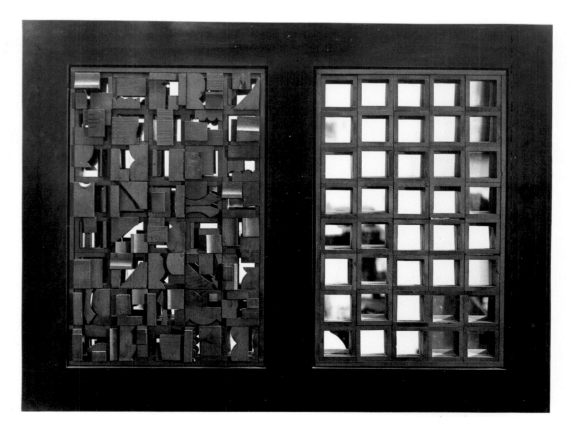

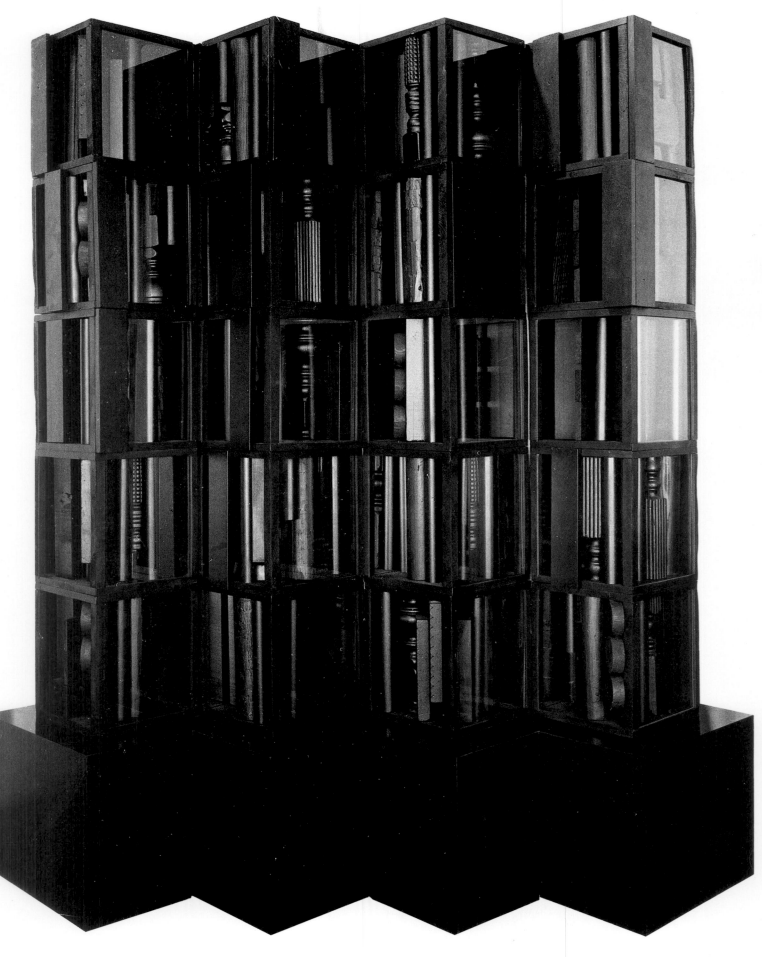

Night Zag IV, 1965

I am an architect of shadow, and I'm an architect of reflection.

sophisticated and original departure from traditional Cubism. She had been experimenting with both mirrors and Plexiglas to create complicated reflections, a counterpart to her concern with the subtle internal shadows in the wood constructions. She has said many times that shadows and reflections are as important to her work as their source. "I will never give up shadow because I'm in love with shadow. I'll never give up reflection because I'm in love with reflection."

Once, when she was shown a rare black comb-back Windsor rocker—she particularly likes chair backs and collects broken chairs as material for her sculpture—Nevelson walked all around it and then said, "I couldn't care less about the chair, but look, dear, at that shadow!"

The clear Plexiglas sculptures were designed as elegant, formal, decorative objects. The shallow recessions, the lively pattern of overlapping circles, arcs, and rectangles that are activated by the changing light, and the stabilizing rows of bright bolts add up to complex but brilliantly clear geometric compositions. The color of the background against which a transparent sculpture is placed, the angle at which it is viewed, and the time of day all affect the quality of the light that is in and around it. The material Nevelson chose for these handsome pieces is Plexiglas, but they are really made of light.

With Royal Voyage, *1965, a mirrored assemblage*

I didn't use the mirror or the glass lightly— I feel they paralleled my kind of thinking.

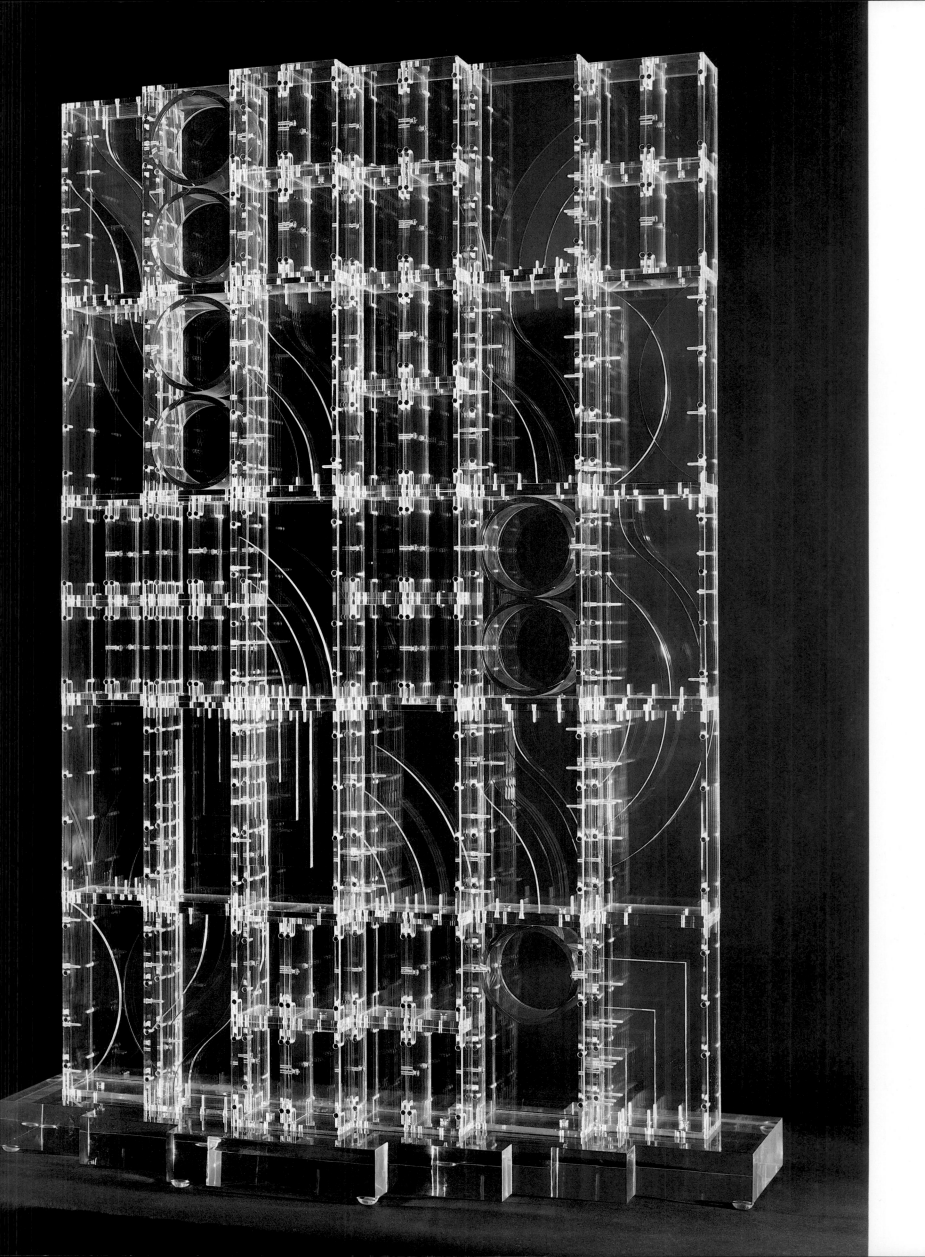

Canada Series V, 1968

I first wanted to give structure to shadow—now I want to give structure to reflection.

Transparent Sculpture II, 1967–68

After living with the shadow for so many years—and through art I was able to give shadow form—I've come to the point where I can give reflection form.

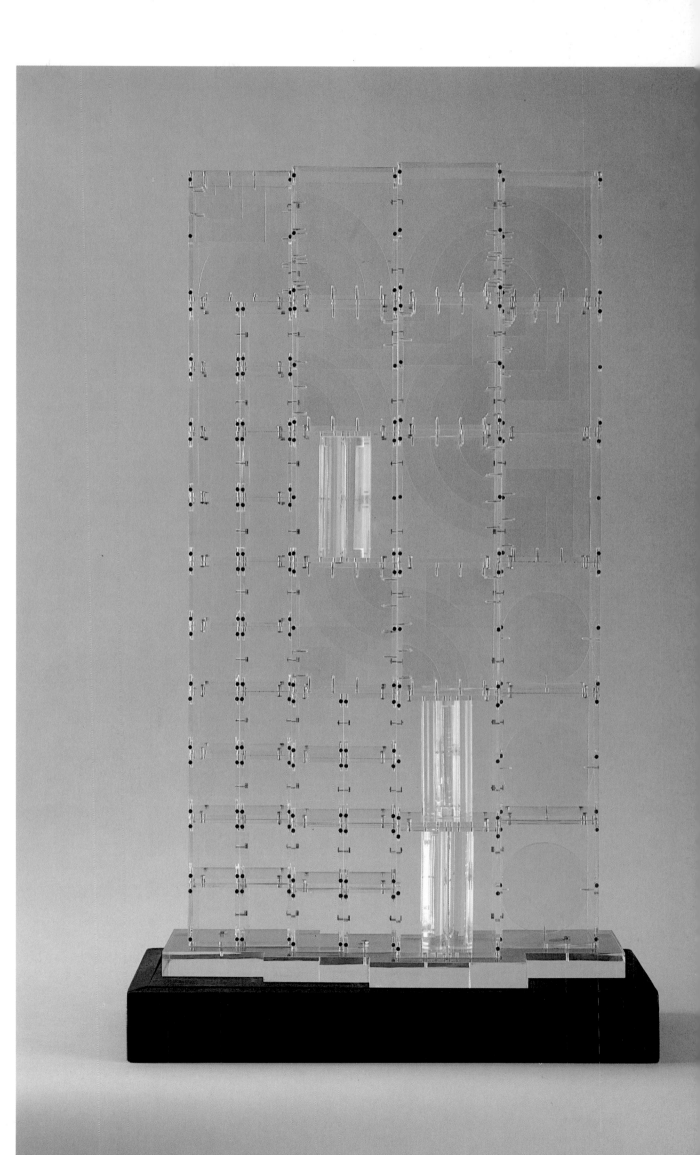

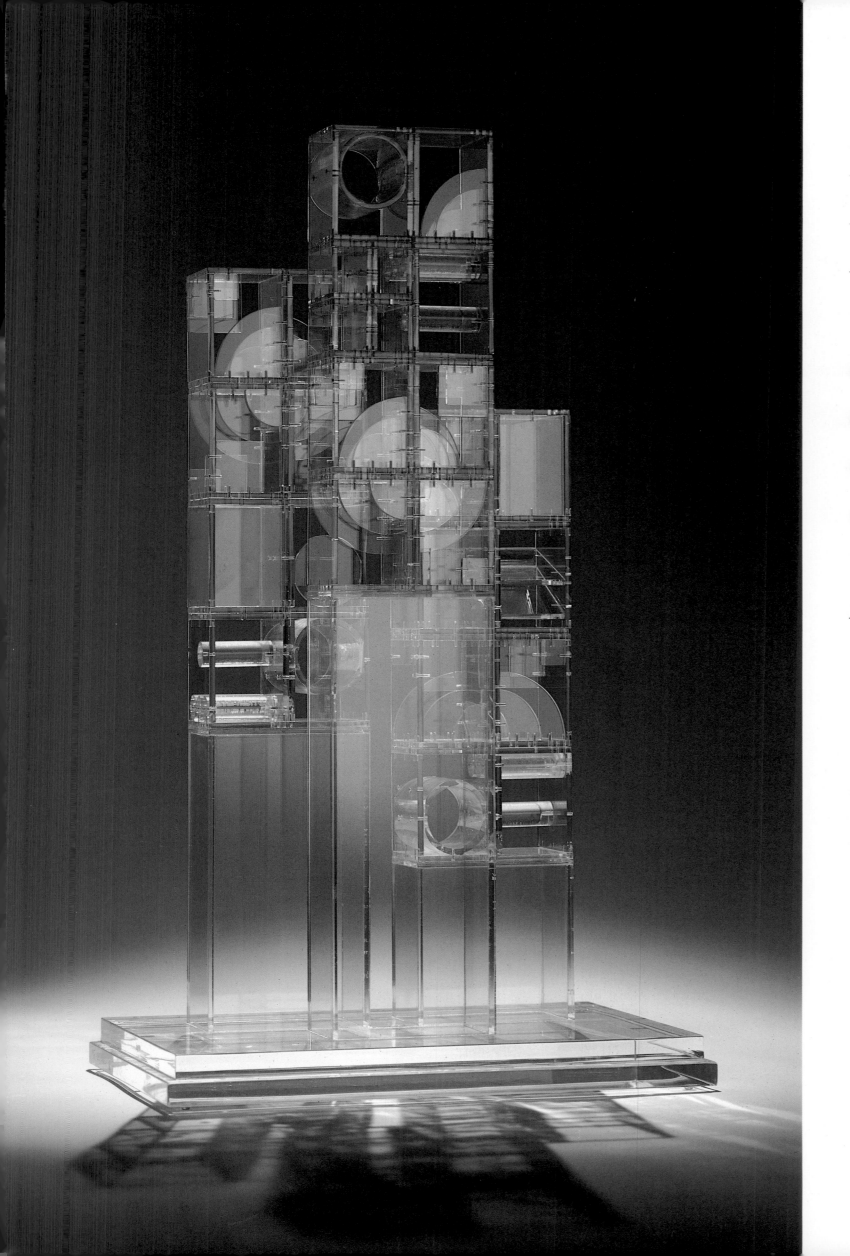

Transparent
Sculpture VII,
1967–68

*Through the
day and night,
color is
constantly
changing.
We arrest it,
not Nature.*

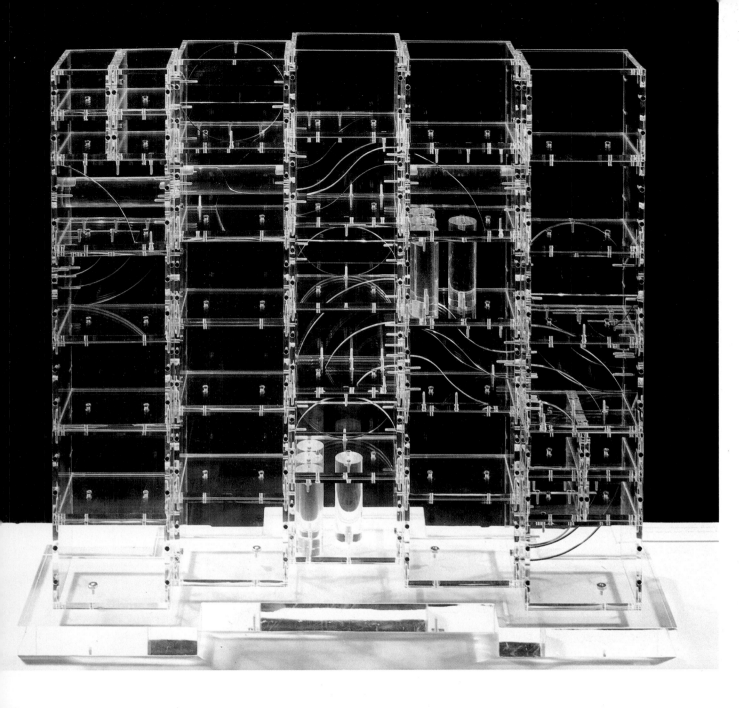

Transparent Sculpture VI, 1967–68

My kind of thinking includes reflection.

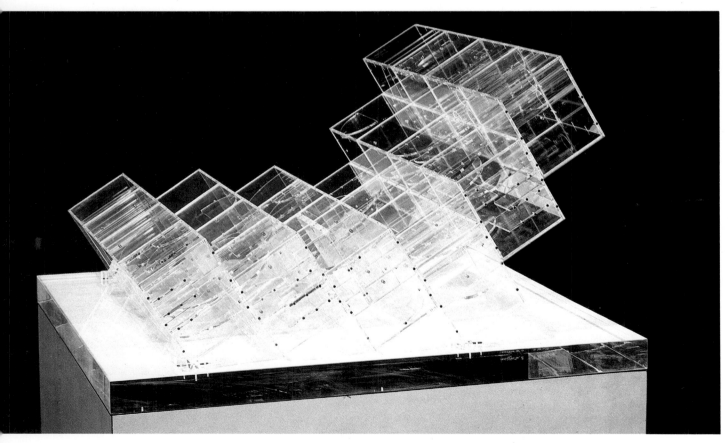

Transparent Sculpture IV, 1967–68

I take light which is fleeting but I give it solid substance. I give it architecture.

METAL
SCULPTURE

In our time, the new materials like Plexiglas or Cor-ten are just a blessing for me—because I was ready for them and the material was ready for me.

The transparent sculptures were small in scale, but Nevelson has favored monumentality in her metal works ever since she designed the first large *Atmosphere and Environment* piece in 1966. That one, fabricated in aluminum and finished with black epoxy and enamel, was created for the Museum of Modern Art in New York. Three years later Princeton University commissioned her first large outdoor piece in Cor-ten steel, and other works in this material followed. She also began to make large welded-aluminum sculptures painted black or white, cut and assembled and welded piece by piece under her direction, and to design monumental steel pieces painted black, for public places.

In 1971 Nevelson created a surprising series of welded sculptures: a group of ten black-painted aluminum pieces about seven to nine feet high which she called *Seventh Decade Garden* (to mark the flowering of her own seventh decade). On a routine visit to Lippincott, the Connecticut manufacturers of her steel sculptures, she saw a room in the foundry filled with aluminum scraps left from the production of another sculptor's work. With her consistent "scavenger instinct"—as Arnold Glimcher describes it—she impulsively claimed the scraps and completed the entire series of "plants" in two days.

Nevelson constructs directly with discarded metal, exactly as she does with wood. Even for the largest welded-steel sculpture the process is surprisingly

similar, though for these works she also has the workmen cut shapes—circles or rectangles or arcs, whatever she feels she needs—to combine with the found materials.

The monumental *Windows to the West*, the culminating masterpiece of the series called *Atmosphere and Environment* (and probably the greatest of all her outdoor works), was inspired by the smaller fabricated pieces. Nevelson has explained the generic title of this Cor-ten sculpture, made for the city of Scottsdale, Arizona, in 1972: "The landscape is the *atmosphere* that fills the spaces of the steel *environment*; the two together are the sculpture." The relationship between the atmospheric landscape and the steel environment is in constant flux. The entire complex structure appears to change as the light changes, breaking and shading the forms, and casting shadows seemingly as solid as the steel plates. As the viewer walks past the sculpture, the interlocking arcs seem to rotate, the rectangular "windows" to slide open or to close. Only the staccato pattern of the bolts remains constant. Arnold Glimcher noted that in this piece, "Nevelson extends her vocabulary of found forms to include the surrounding landscape. Unlike the closeted secrecy of her wooden 'walls,' she opens these boxes to focus on the ritualization of natural forms subject to constantly changing light and shadow." Nevelson has described how she arrived at this concept of open scaffolding: "There had been the principle of the enclosed box, the principle of the shadow boxed in; with the mirror, the principle of the reflection boxed in. Well, at the end of that, you had to push out into the open. Now I'm boxing in the outdoors."

Surprise has always been important to Nevelson: in her walls it is found in the rich content of the individual boxes and their formal relationships. Here it is the fluidity of the geometrically structured forms and their unexpected interaction with the landscape.

Atmosphere and Environment XIII: Windows to the West, *1972*

We look through the inside mass to see a multitude of paintings and photographs. The mountains, the trees, and the skies of Arizona.

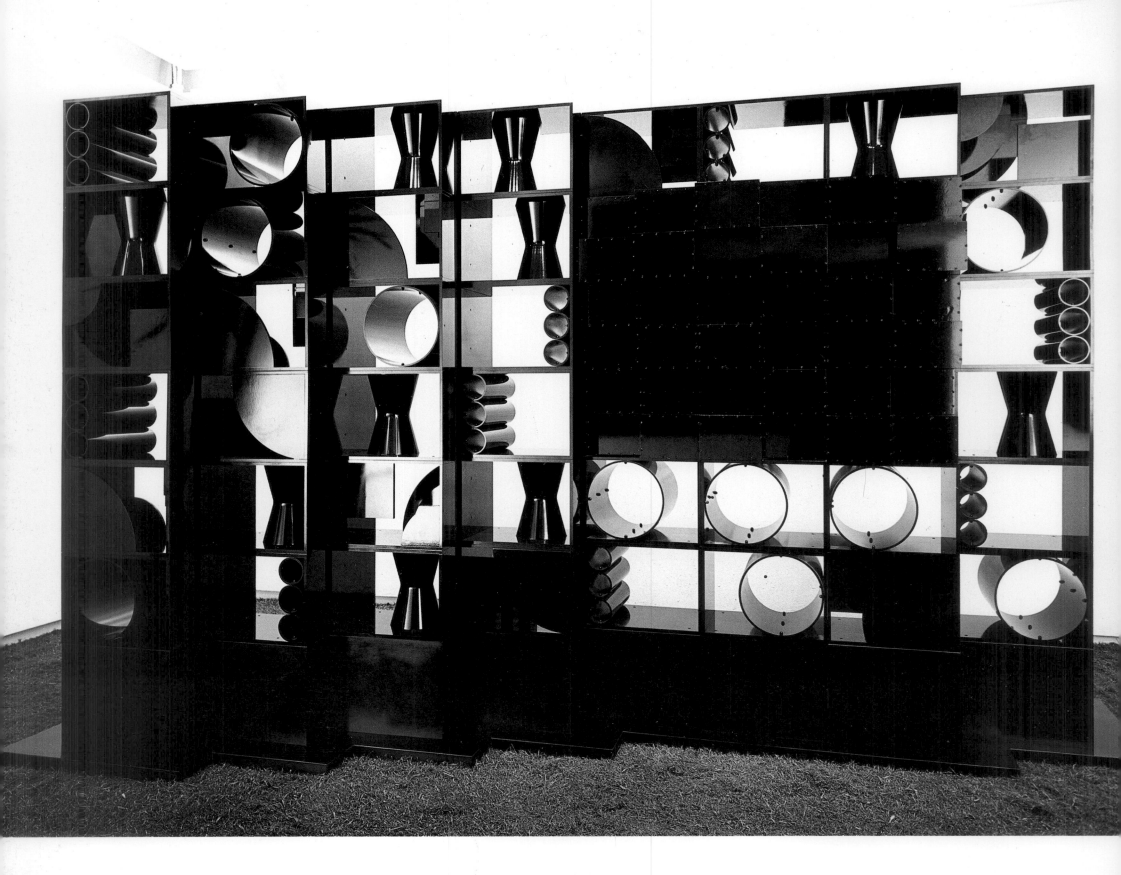

Atmosphere and Environment I, *1966.*
(Detail opposite)

*Space has an atmosphere, and what you put
into that space will color your awareness . . .
the environment becomes its frame.*

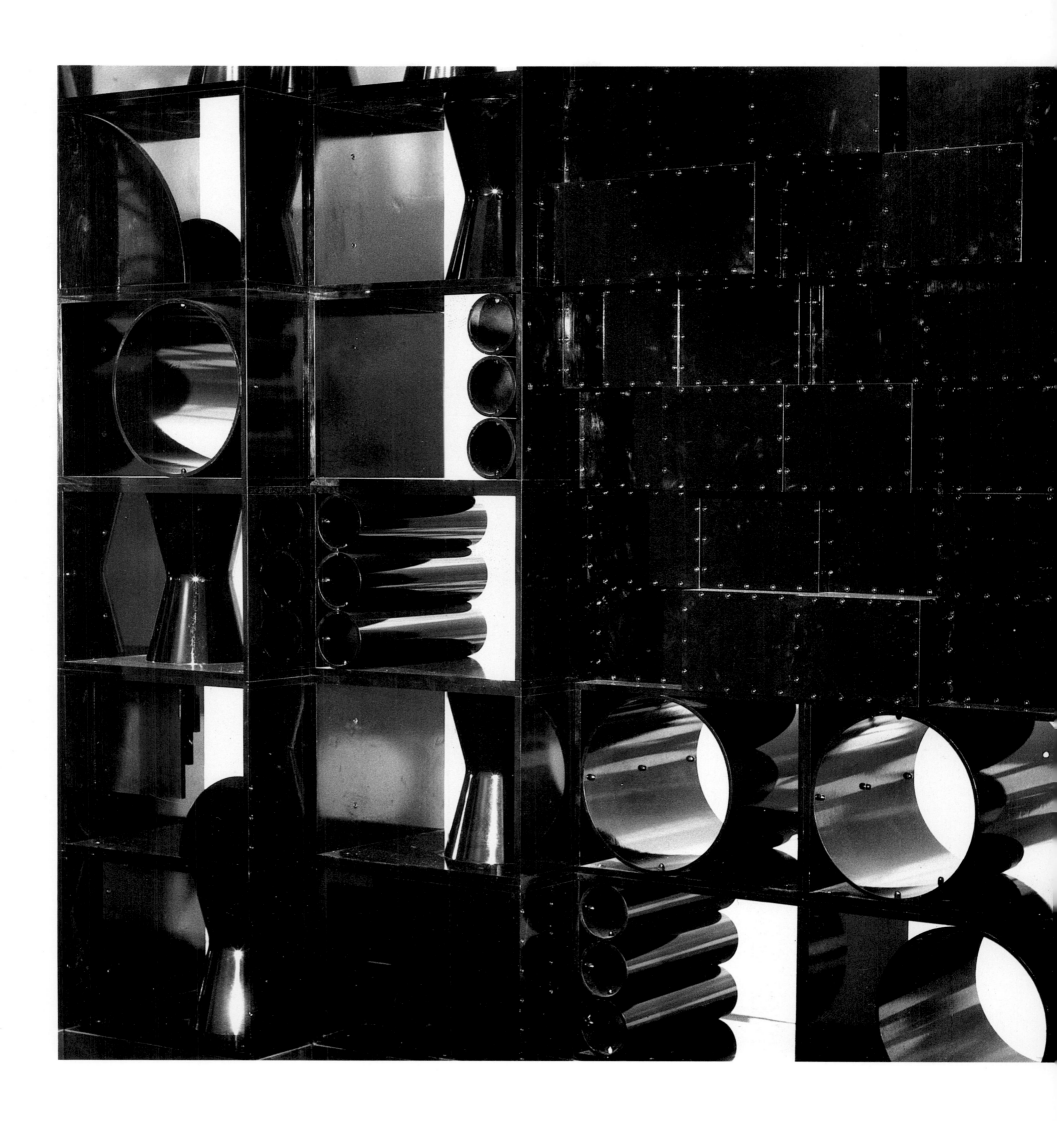

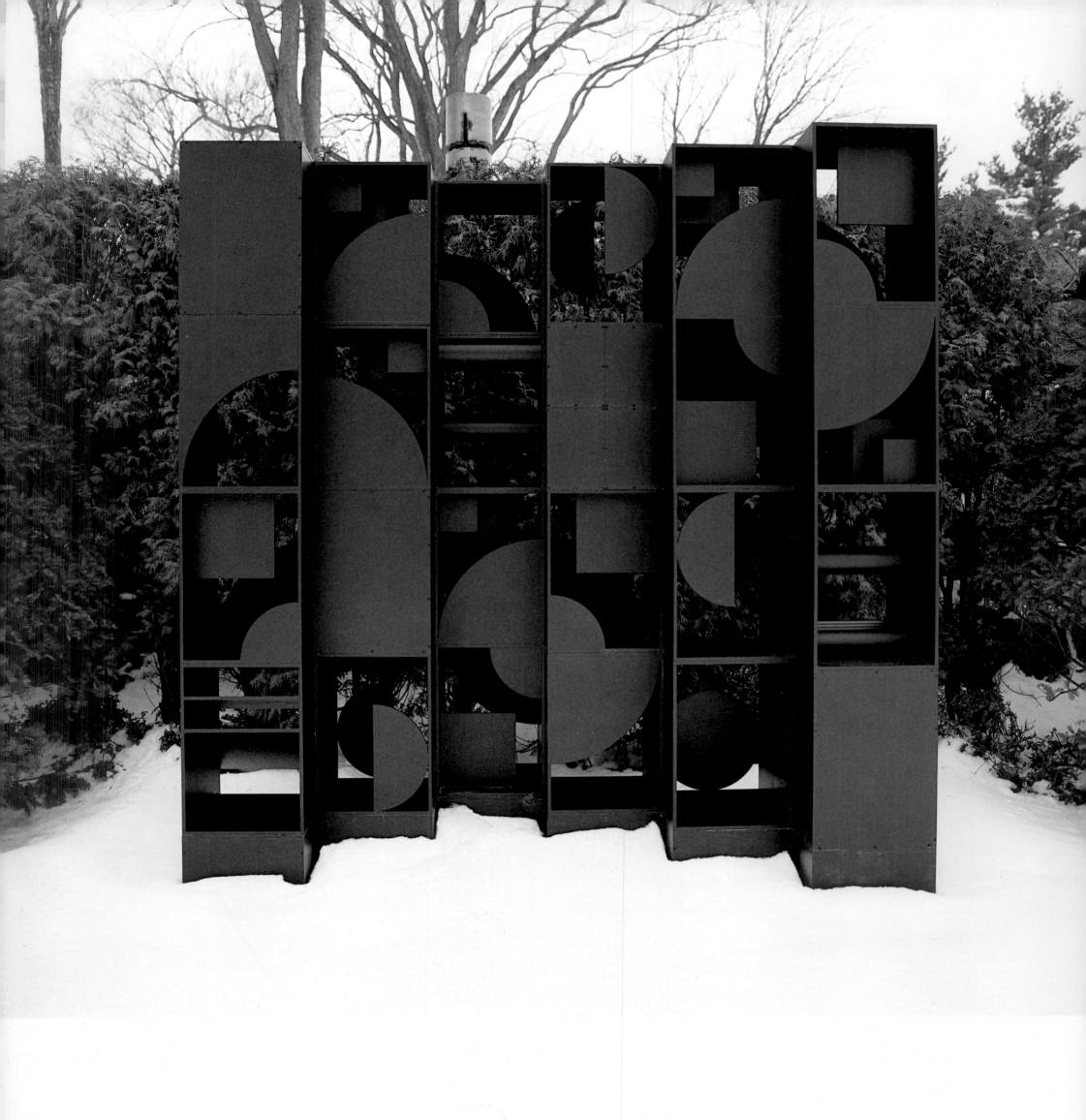

Atmosphere and Environment VI, *1967*

How I feel about outdoor sculpture.... I felt that I had to claim spaces.

At the Lippincott foundry in North Haven, Connecticut

I was using steel as if it was a ribbon made out of satin.

At the Lippincott foundry

When I go to the foundry to work, the whole place is at my disposal. It is geared for the artist to work— with materials, with the men who assist me.

I never had a day when I didn't want to work.... The work and you are one.... It's your reflection.

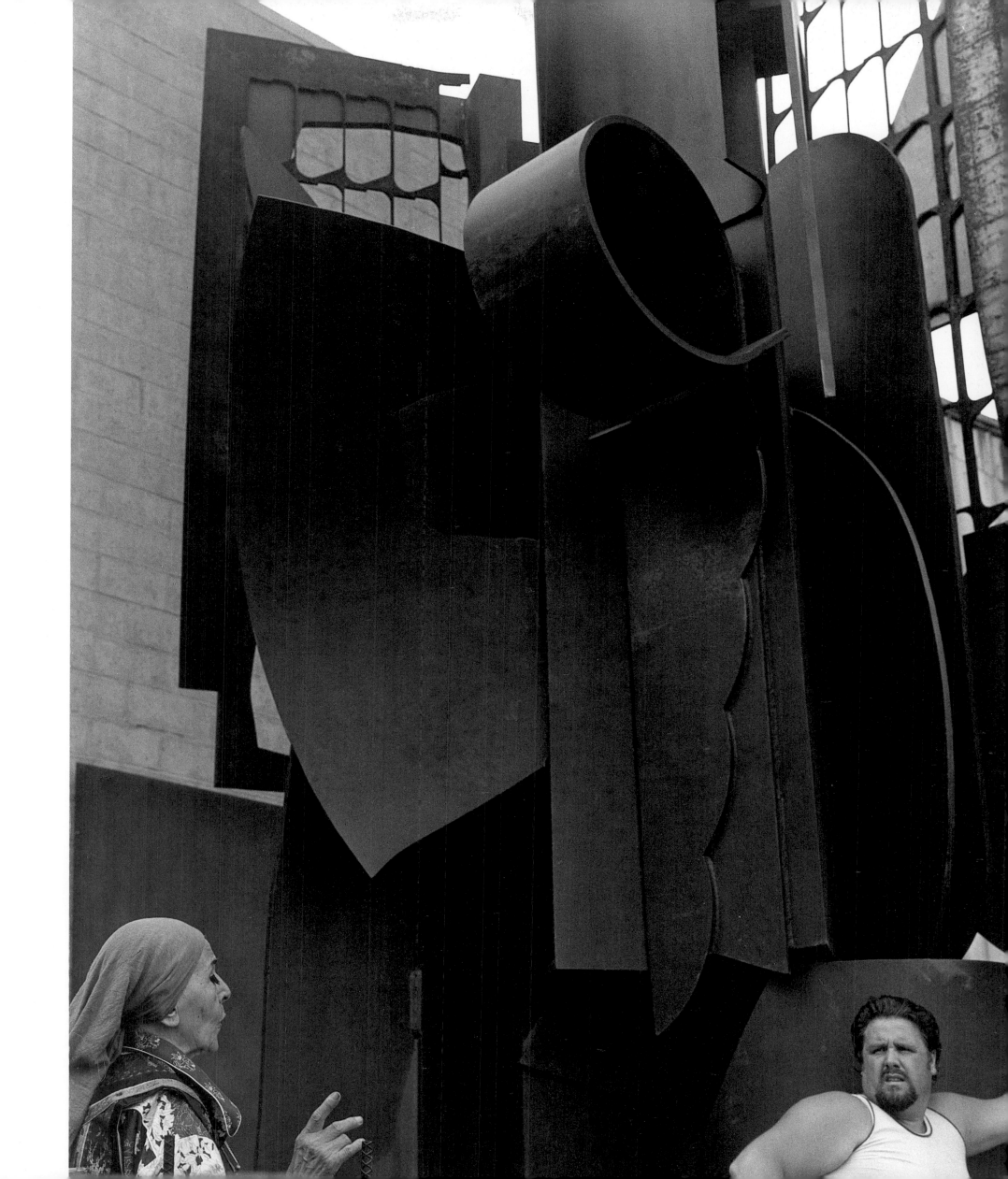

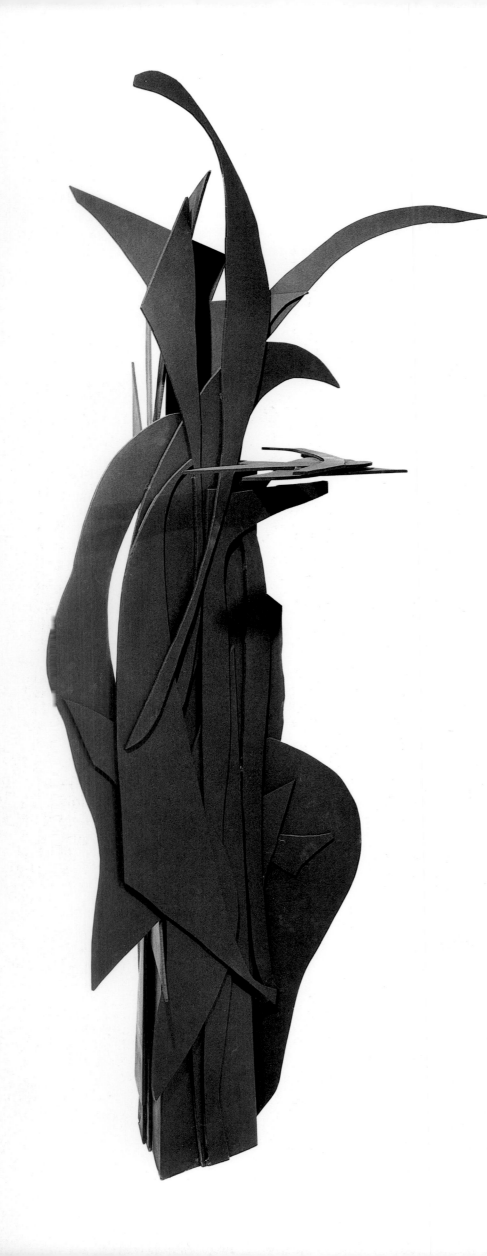

Seventh Decade Garden VII, *1971*

*I started with aluminum.
And I'd make my sculpture,
I call them sculpture-collage.
I would compose and the men
would work with me—direct.*

Transparent Horizon, 1975 ▷

*I like that piece as well as
I ever liked any of my public
pieces. The placement of
the piece is right in its
environment. . . . It wasn't as
if we placed a piece there,
but rather that we built an
environment. . . . There are two
"personages." The small figure
is the female and the tall one
is the male. Not a man or a
woman, but the male principle
and the female principle.*

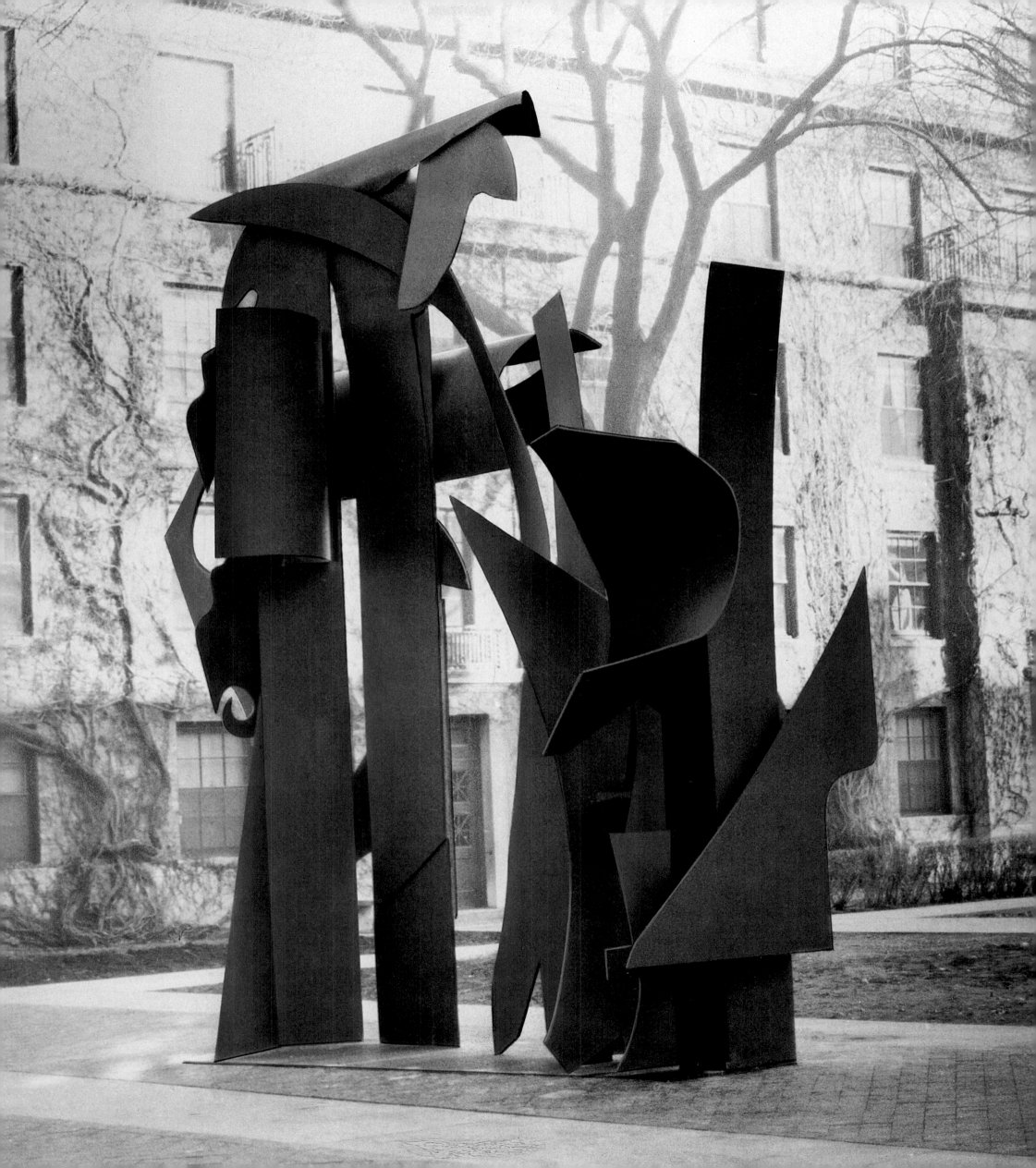

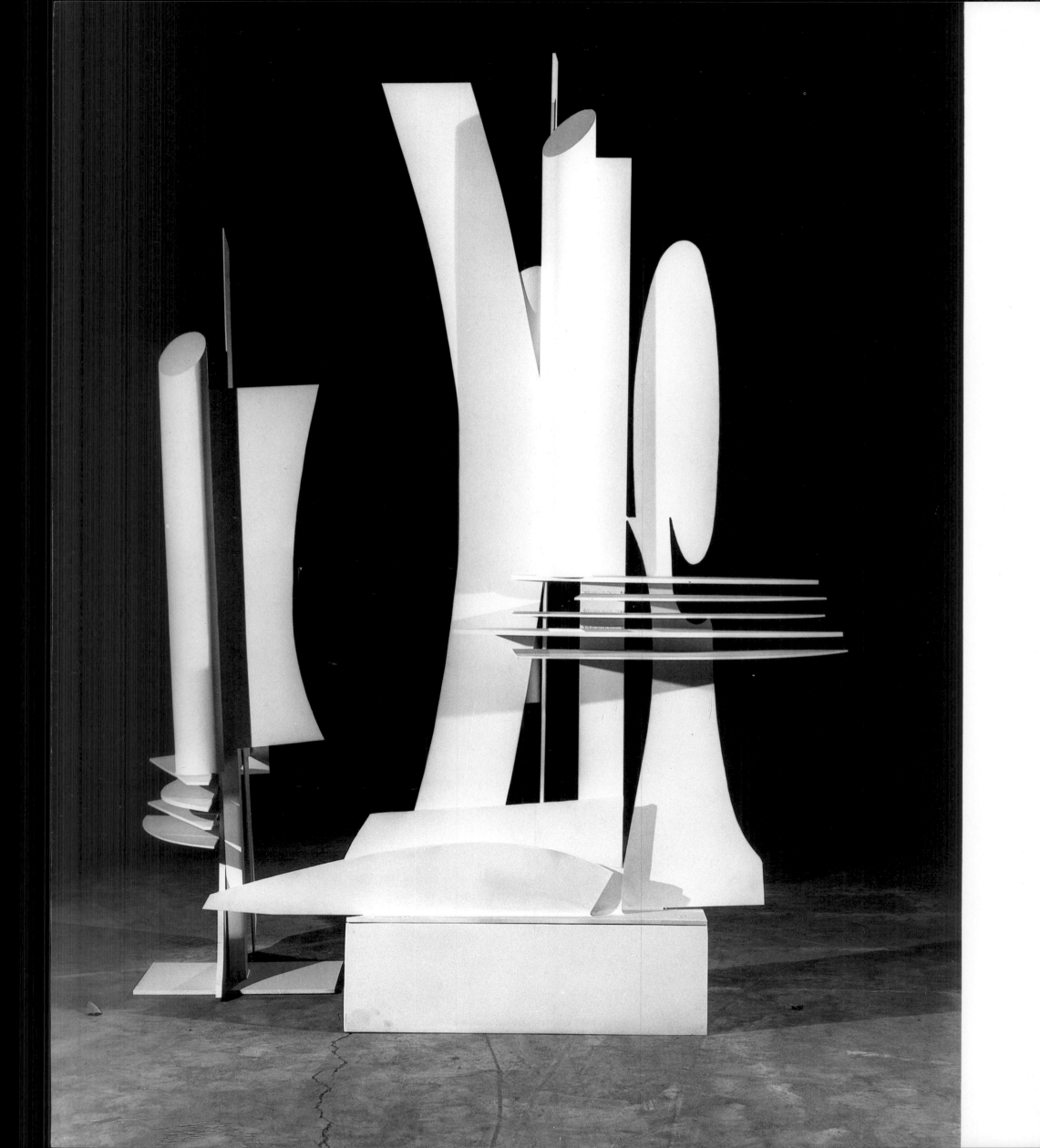

Double Image, *1976*

*I found that in my
hands and in my way
of thinking at this
point, it was
almost like butter—
like working with
whipped cream
on a cake.*

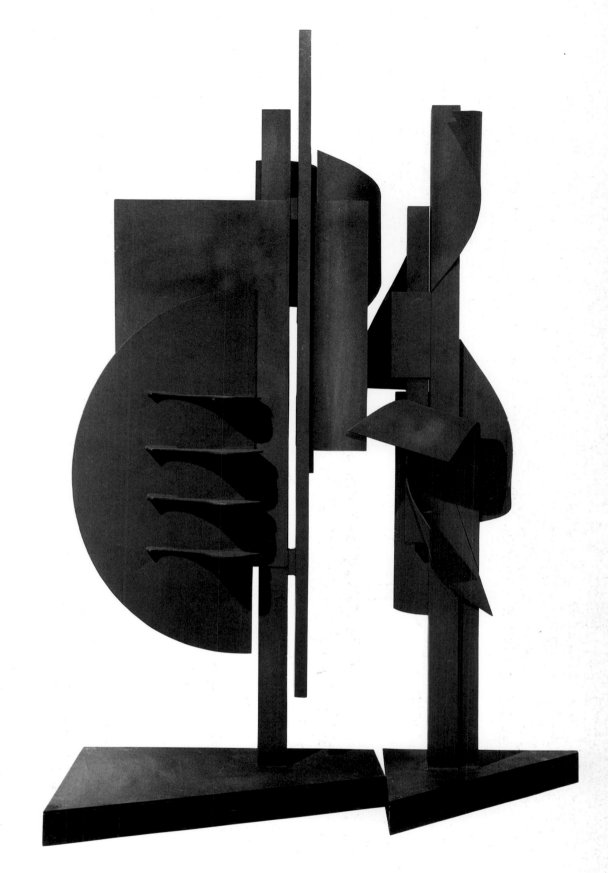

Sky Landscape II, *1976*

*I just don't have any trouble.
I feel maybe somebody will say, how cocksure
she is. . . . So I restrain myself from saying it.
But I am cocksure. Let's face it.*

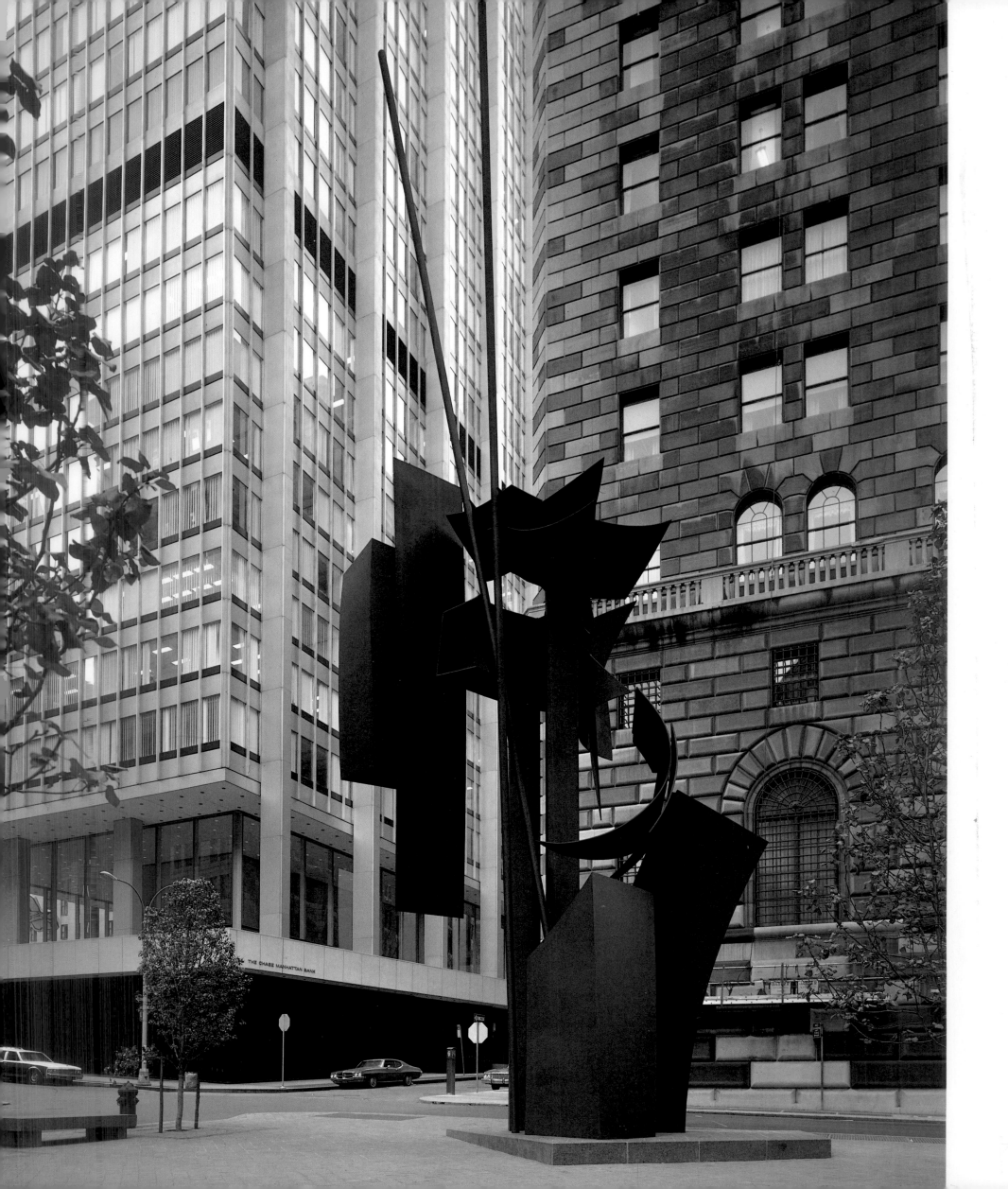

Shadows and Flags, *1977–78*

Working in metal has allowed me to fulfill myself as an environmental architect.

Sky Tree, *1976*

The space [for my sculpture] must be more architectural than romantic.

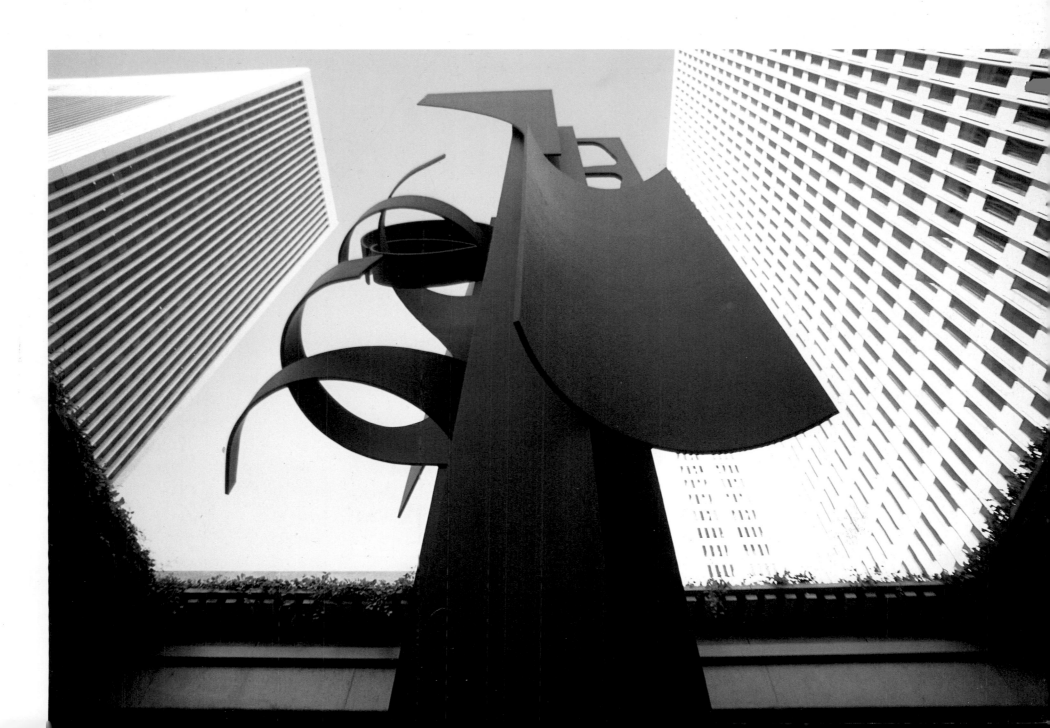

WORKS
ON PAPER

*Of course, I have never left
two dimensions because I've
always been doing etchings
and lithographs and drawings.*

The drawings, prints, and collages shown on the following pages are samples of a large body of work that has been an important interest of the artist for most of her life. As a teenager she did a number of modest landscape and interior watercolors. She cared enough about these schoolgirl works to keep them, and she recently gave them to the Archives of American Art. Her thousands of figurative pencil and ink drawings, spanning more than fifty years, are complex and sophisticated; she has given a group of twenty-one of these to the Whitney Museum. Though the delicate drawings seem at first glance the extreme opposite of Nevelson's powerful sculptures, a second look makes it clear that some of her lifetime interests as an artist began here. The overlapping of forms and the curvilinear rhythms were to become major aspects of much of her sculpture and also of some prints and collages. A spare skeleton of drawing seems to lie behind each of Nevelson's works, lavishly built up much in the spirit of the collages and collage-prints she has been making in recent years. Nevelson has said this herself: that there is *drawing* in all her work, and that the way she thinks is *collage*.

The King and Queen, *1953–55, etching*

The figure is architecture.

Her interest in printmaking intensified with the etchings she did from 1953 through 1955 at Stanley William Hayter's Atelier 17 in New York. (She had first studied printmaking at Atelier 17 and had begun making etchings there in 1947.) In a work like *The King and Queen* one can see a clear relationship between her graphics and her sculpture. The linear network defines the boxlike areas, occupied by massive fragments of figures in much the way that her sculpture boxes contain fragments of found wood. In 1963 she was granted a fellowship at the Tamarind Lithography Workshop in Los Angeles, and in six weeks completed twenty-six editions of lithographs that combine hand-drawn elements with printed lace and cloth. Nevelson returned to Tamarind four years later to make a series of sixteen editions titled *Double Imagery*. Since that time graphics have become an increasingly important part of Nevelson's work.

Nevelson's approach to printmaking has been particularly innovative in content and technique. She has explored a broad range of the possibilities inherent in several graphic media, frequently with spectacular results. Among the most interesting of these experiments is a series of six lead-relief prints that were executed by Sergio and Fausta Tosi of Milan in 1970–73. For these Nevelson made thin maquettes of wood. The printer then made a steel plate of each element in the maquette, embossed the lead, put the blocks together, and bonded them to heavy rag paper. The cast-paper reliefs she did a while later are equally sculptural. Once again she worked directly with maquettes of wood, but this time a rubber mold was made, and wet paper pulp was pressed into it and left to dry.

In 1977 Nevelson created an unusual series of etchings which she titled *Essences*—a word she often uses in speaking of her work and ideas. ("I've arrived at essences of some sort," or, again, "[The work] is right down to the essence of life.") These prints reflect much the same preoccupations as the

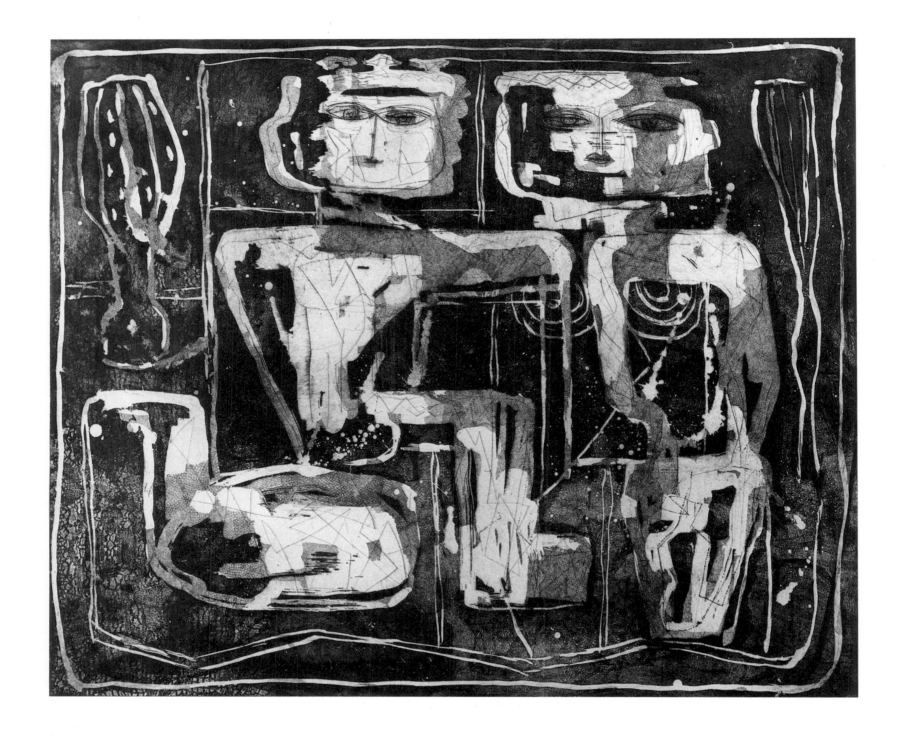

sculptures. What makes them unique is the use of a "soft" ground (varnish) in the preparation of the plate—a method that allowed her to reproduce the shapes and textures of materials like lace by pressing them into the ground before exposing the plate to the acid. With this technique, as Gene Baro observed, she "can be thought to be both building and drawing with the materials."

The lace motif in the *Essences* prints is related to one of the earlier Tamarind series of lithographs as well as to the *Tonalities* series of 1981—yet each of

these is quite different. Nevelson frequently makes use of the same ideas and materials, motifs and techniques, but each time she revises and revitalizes them. She has said, "I don't let anything escape from me. You don't throw out a thing, you reorient a thing."

Lace has been an important element in much of Nevelson's work. She has used it as the basis of pieces that range from the subtle textures of the *Tonalities* etchings to the monumental forms of *Frozen Laces*, a series of sculptures made of Cor-ten steel. And she once remarked with satisfaction that one of her huge wood wall sculptures looked "like black lace carved into the wall." There is in the "lace" prints, as in all of her work, deliberate drama—often the result of a startling juxtaposition of the most delicate and most powerful compositional ideas. The solid dark element in *Essences #6* seems related to shapes in the steel sculptures or the rugged chunks of old wood that Nevelson has incorporated in her wall sculptures.

Nevelson had been exploring collage since 1959. In the early seventies she began to make series of large collages using wood, paper, and other materials to create works that were just a step removed from her low-relief wall sculptures. (In much the same way that Alexander Calder kept a whole studio for his gouaches, which he called the Gouacherie, Nevelson has set aside several large rooms in her house for the creation and storage of her collages. Hundreds of them are stacked in tiers around the walls, on tables, and even piled high—but carefully—on couches and chairs, and covered with dropcloths.) In 1979 she carried the collage idea still further with her *Celebration* series of collage-prints in strong colors that revealed a whole new direction in her work. In 1983 Nevelson made a series of etchings titled *Reflections* which combine color collage designs related to those of the *Celebration* prints with elements of delicate lace collage that she had originated for the *Essences*. The *Reflections* prints—etchings with aquatint—appear as a daring summation of two totally different creative moods. As in her sculpture, the bold combination of opposites contributes to the challenging ambiguity and tension that make her work so exciting. The title of her 1983 show at Pace, *Cascades Perpendiculars Silence Music*, makes it clear that a rich summation rather than a single style is Nevelson's deliberate, consistent choice.

Where the *Essences* etchings seem to move back into space, like the boxes, the collage-prints appear to build forward, like the wall sculptures. In a conversation I had with Richard Solomon, the director of Pace Editions, he discussed the *Celebration* series as a significant example of how closely her work relates to her personality and her life:

The bold color and dynamic compositions seem to state a new confidence, even a new vitality, a joyous celebration at eighty. This was a very original print project. She tore up, for part of the collages, some proofs of etchings done about 1977 that had never been editioned, and she bought and tore up sheets of colored papers. She assembled them almost as if she were making instant sketches. What you see in the prints done from this collage series is tremendous energy, speed, supreme confidence—born of all her years as an artist—and joy. The process of making collages seemed to trigger more and more energy and exhilaration as she worked. This session was an unforgettable demonstration of total creative control; she worked with no hesitation, no second thoughts. And in the final prints there are so many of the formal elements of Nevelson's prior work as a printmaker—such as the mirror image, which is related to the *Double Imagery* prints of the sixties, the Cubist approach to composition, the complexity of the parts, and overall order.

Louise's entire creative life is very much a collage, an accumulation of various activities arranged in a very personal harmony. Each type of creative activity occupies a different area of her two connected houses and garage. She once said to me that "the more space I have" —she keeps adding to her house like a collage, too—"the more room I have to fill up with work." And when it was full the work overflowed—at various times into a rented garage, a nearby empty house, an abandoned pizzeria.

She is absolutely indefatigable. Louise will have a print project under way in one room and collages of varying kinds in other rooms. She assembles her large sculptures downstairs in the garage and her smaller "end of day" pieces in rooms on the upper levels of the house. A constant flow of energy follows her various activities from room to room.

It is worth noting that the prints and collages are a more important part of Nevelson's oeuvre than has generally been assumed. The collages, little known because few have been exhibited, stand out in a survey of her lifework with surprising strength, undoubtedly because the concept of collage has been at the root of Nevelson's sculptural style, and even her life style. She has said this many times, in many ways.

Looking back to previous chapters, the variety of work that adds up to the Nevelson oeuvre may be briefly appraised in concluding this text. The various kinds of early work are fascinating progenitors of the great series of sculptural and graphic work to come, and a few extraordinarily fine examples of black wood sculpture stand out from the rest. But it is the later wood constructions and environments that mark Nevelson's place as a great sculptor. And while there are a number of masterpieces in the white and gold wood series, the dazzling transparent sculptures, and the impressive painted metal and Cor-ten works, it is the monumental black wood assemblages—from the landmark *Sky Cathedrals* of the 1950s through the current multitude of imaginative and innovative works—that are the supreme peak of Nevelson's majestic achievement as one of the greatest artists of our time.

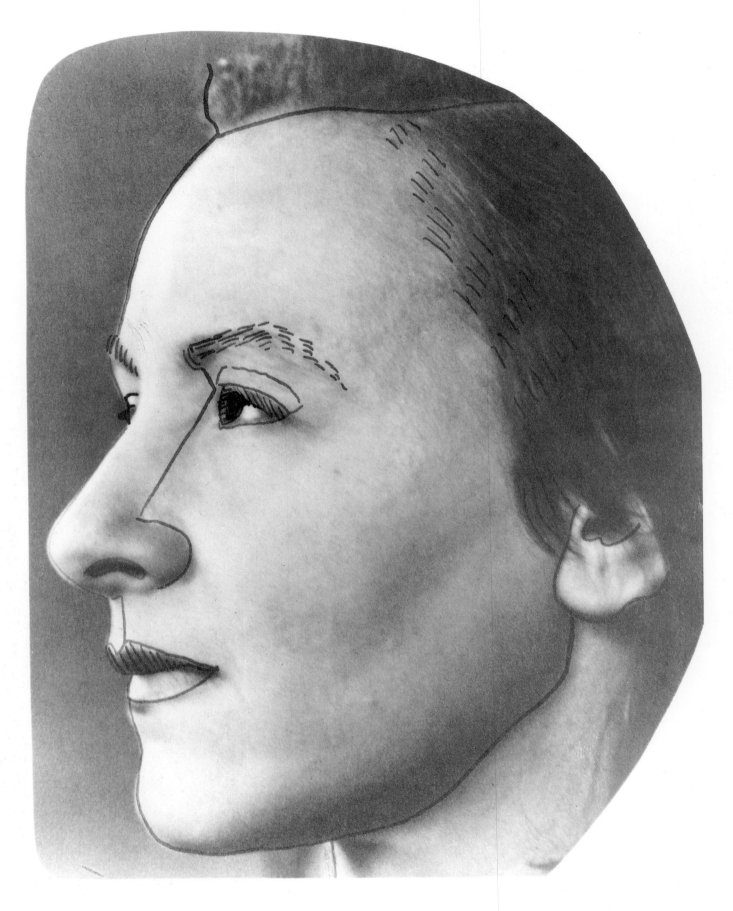

Lotte Jacobi's photograph of Nevelson, which the artist altered

I'm drawing all the time.

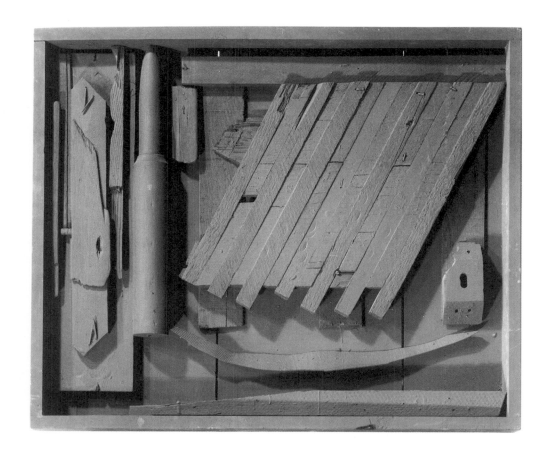

One section of
Sky Presence II, *1960*

*Where they're dented—
that's a drawing, or
where it sucks up space
and becomes darker....*

Gatescape, *1958* ▷

*When I take these old woods
that have nails in them or are
scratched and have texture,
that to me is drawing.*

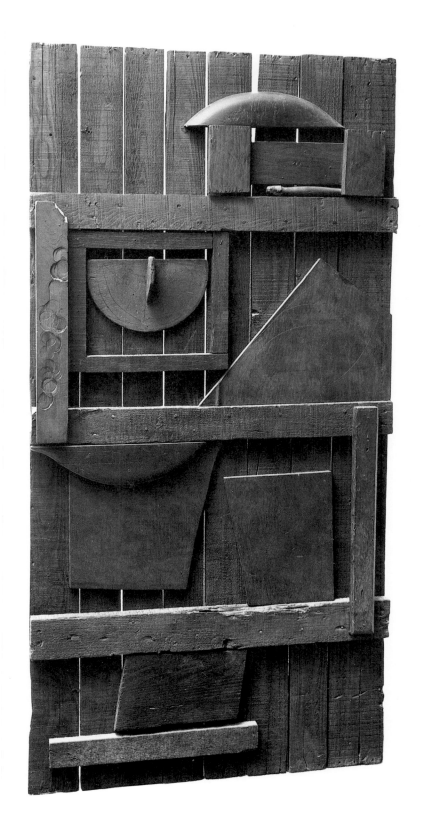

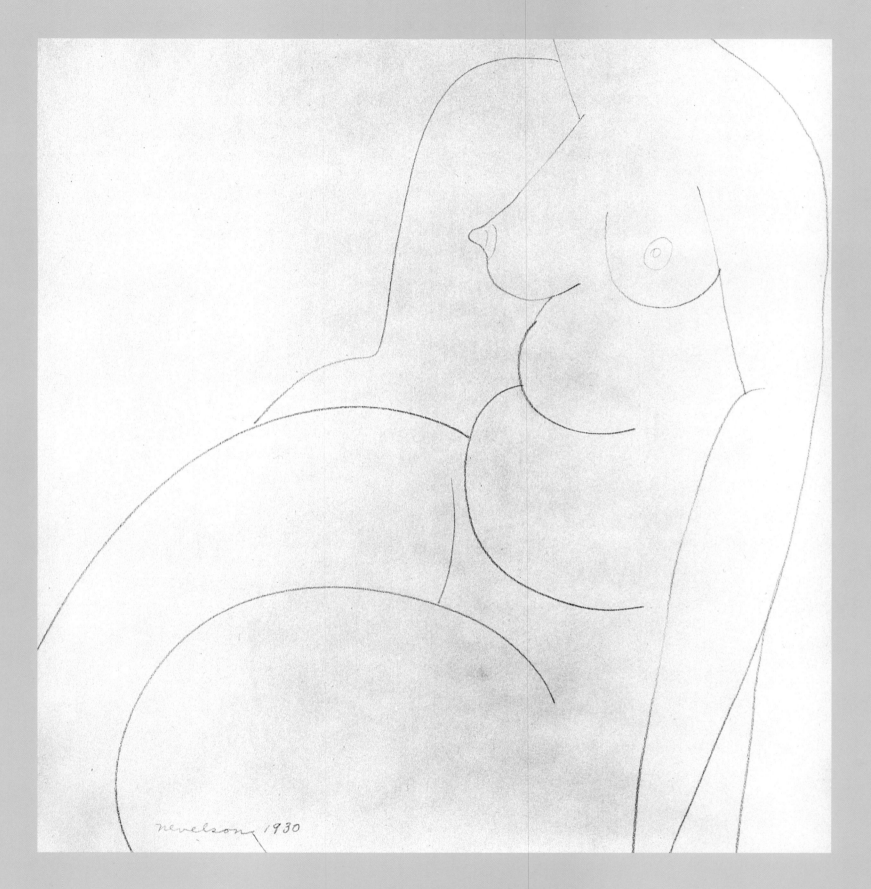

nevelson 1930

Untitled drawing, 1930

_It was a time of searching
and finding myself as an artist._

Untitled drawing, 1932

In the twenties and thirties,
I was a marvelous draftsman.

Untitled drawing, 1930

Searching for that one line that would hold everything.

Two Seated Nudes, *about 1930*

When I used a line, it was like a violin.

Untitled lithograph, 1963

I found material that looks like frozen lace.

For me the immediacy of the material was like fire-engine speed.

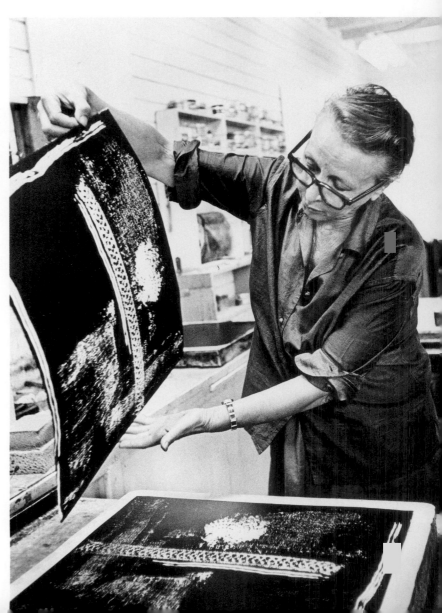

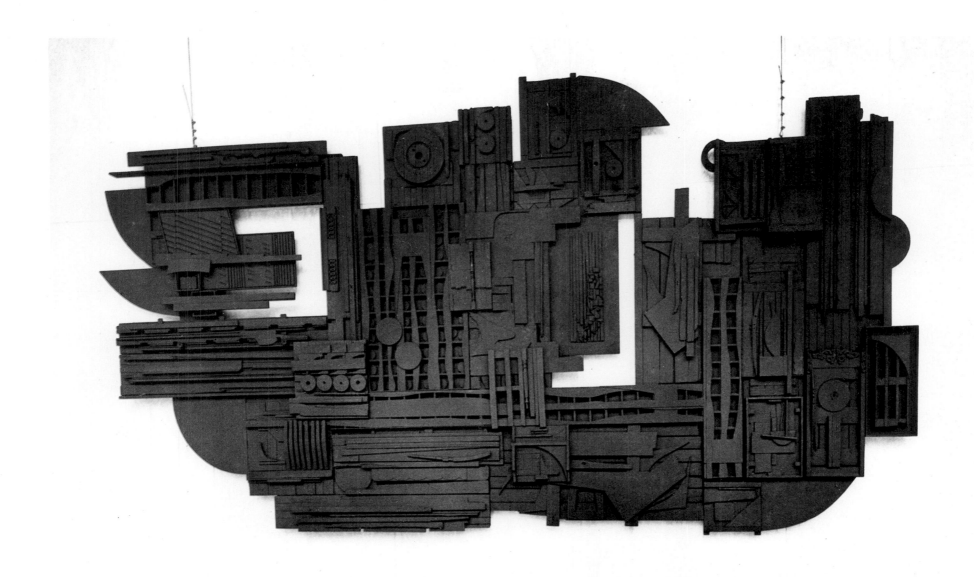

Sky Gate—New York, *1977–78*

*It looks like it's etched
in there—almost like black lace
carved into the wall.*

Frozen Laces—One, *1979–80*

*I've found that through my long
career I've used lace a great deal.*

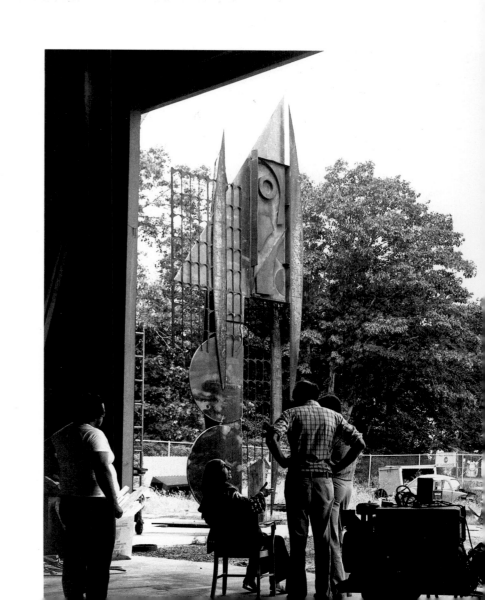

Tonality II, ▷
1981,
etching with
aquatint

Color is a
mirage.

Essences #6, 1977, *soft-ground etching*

I have learned more through my
collections, say, handling old lace that
I have used in my first etchings,
than any formal training could give me.

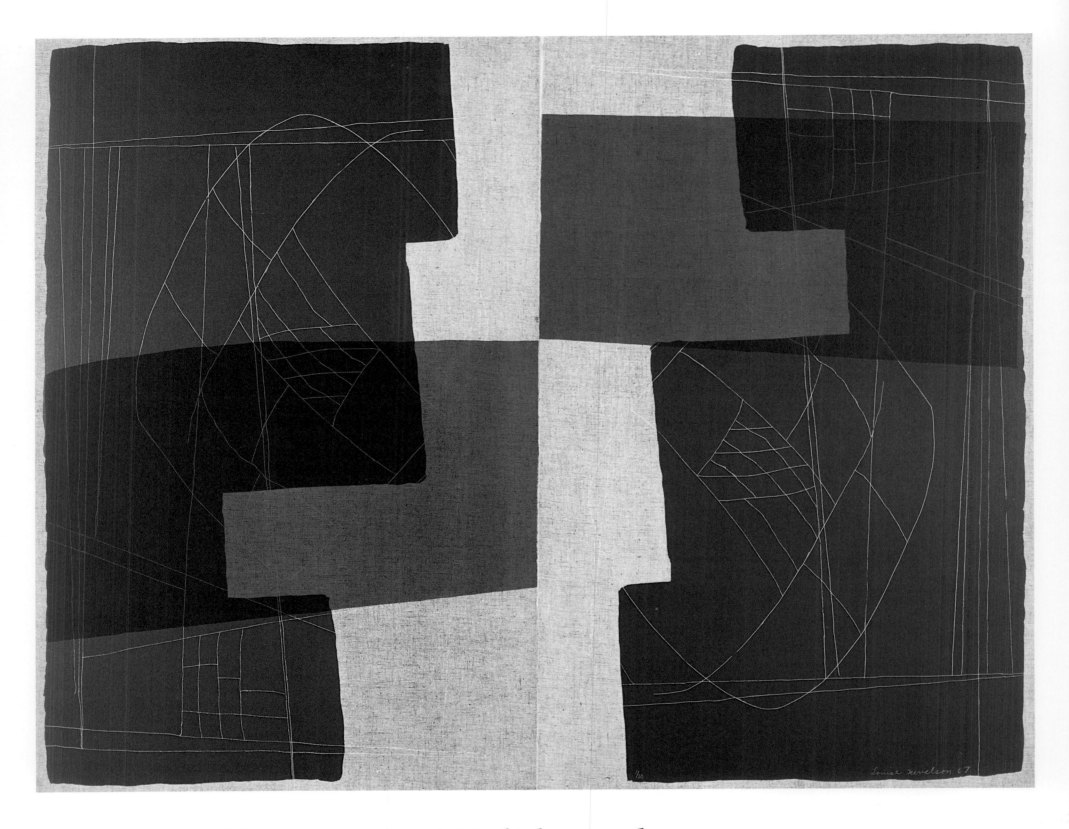

Double Imagery, *1967, lithograph*

When I saw my things looking like lithography, I blacked them out. I didn't want to make lithography. I wanted to make an image that was natural to me.

Thru A–Z + , *1970, lithograph*

I really deal with shadow and space.

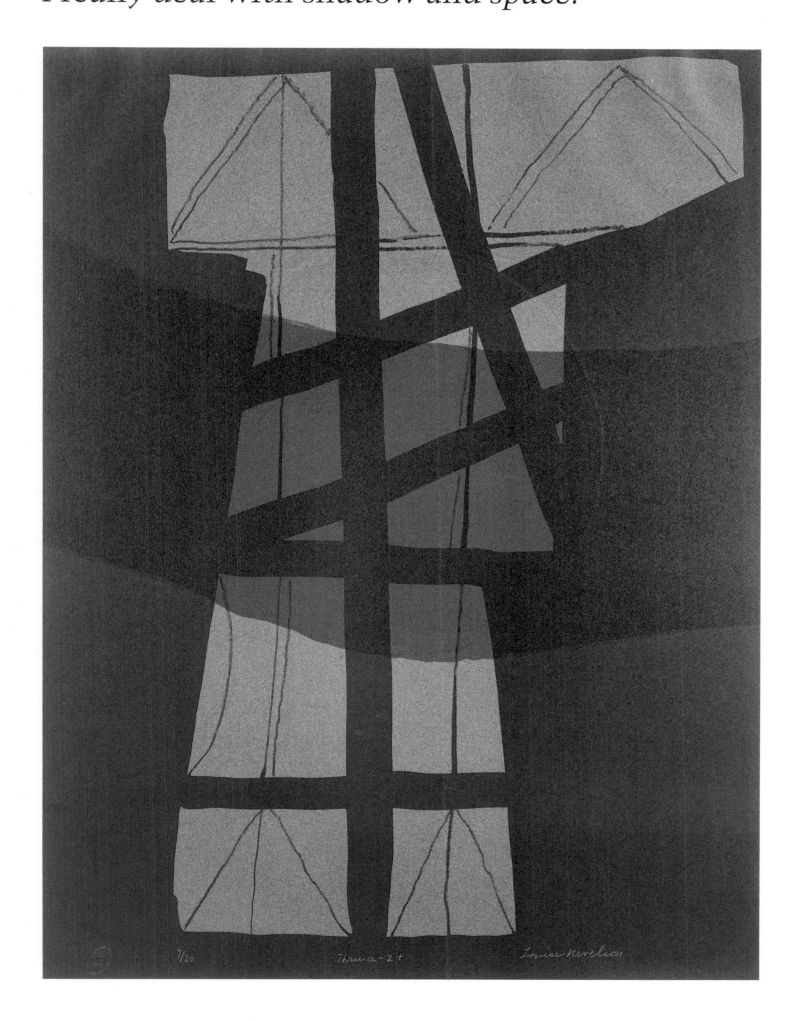

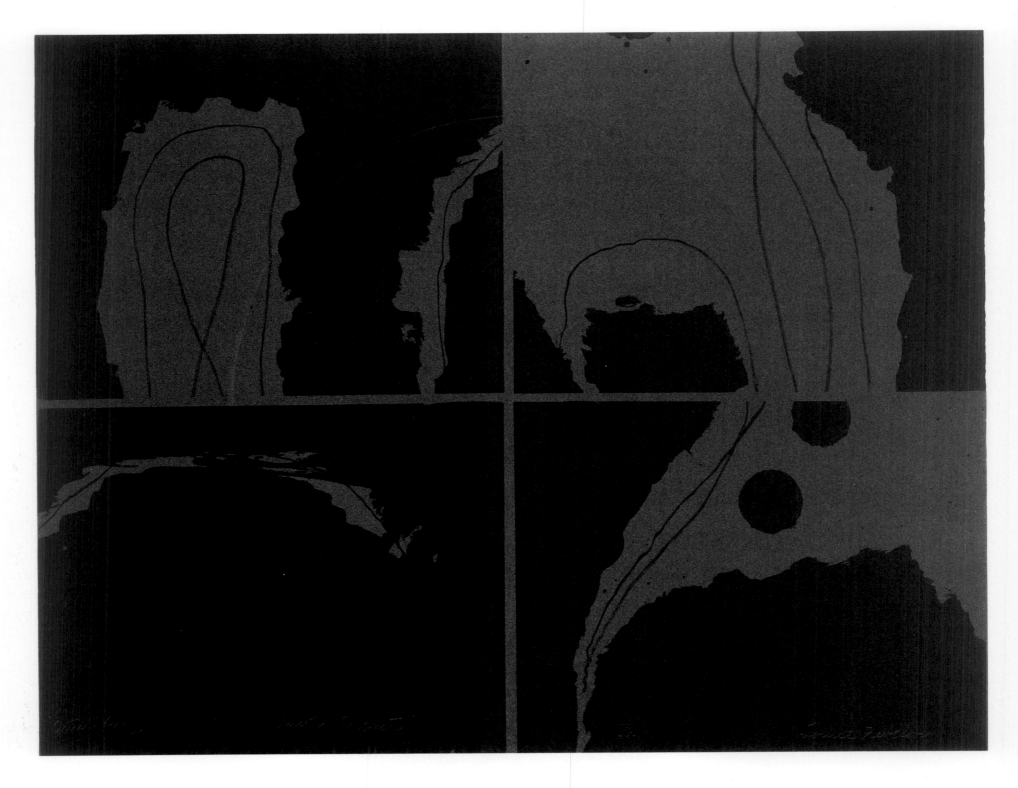

<u>Dusk in August</u>, *1967, lithograph*

Illusion permits anything, reality stops everything.

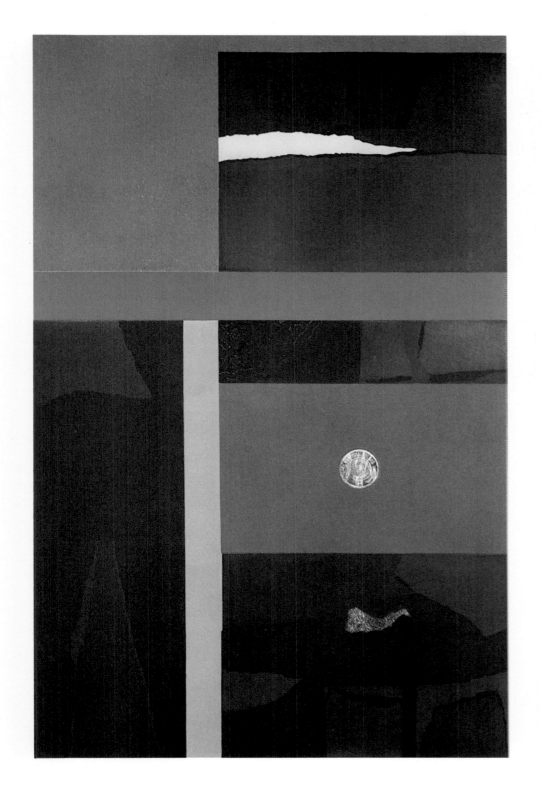

Untitled aquatint, 1973

*The strong, vivid colors are
the strong, vivid emotions.*

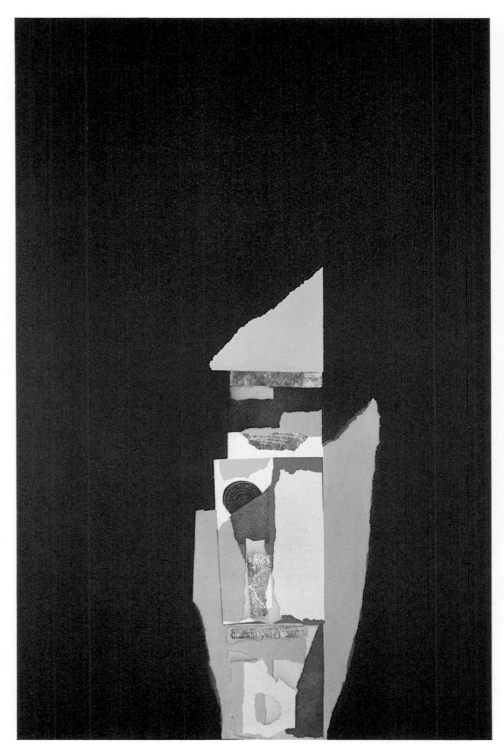

Untitled aquatint, 1973

*If I didn't gamble,
I couldn't do it.*

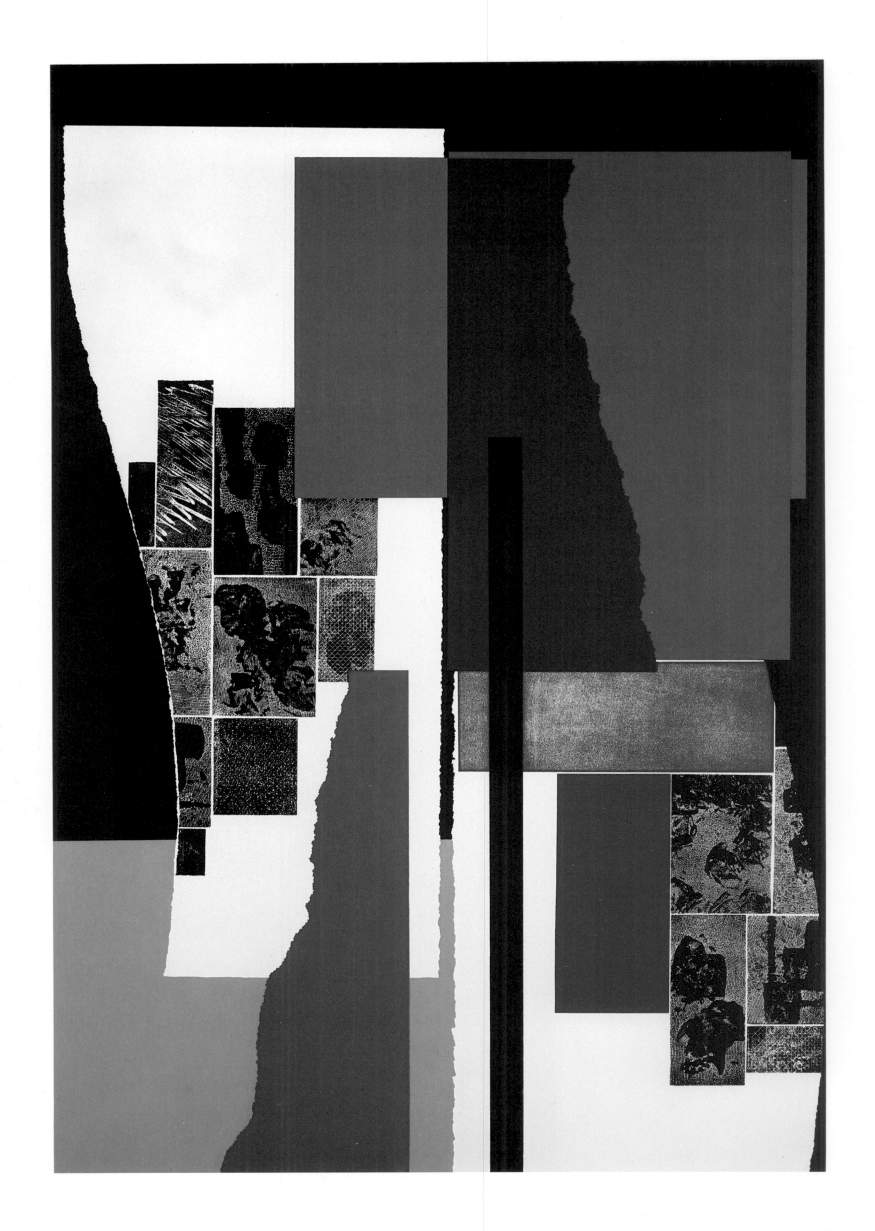

198

◁ Celebration 4, *1979,*
etching with aquatint

*Celebration was
the mood of that time.*

Reflections, *1983,*
etching with aquatint

*I really don't vary in the
work. . . . It's always
kind of virginal to me.
And it's always a surprise.*

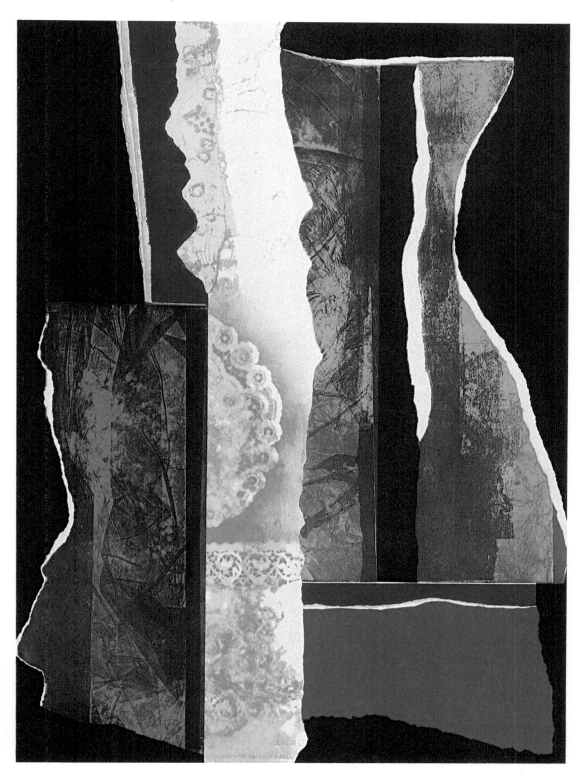

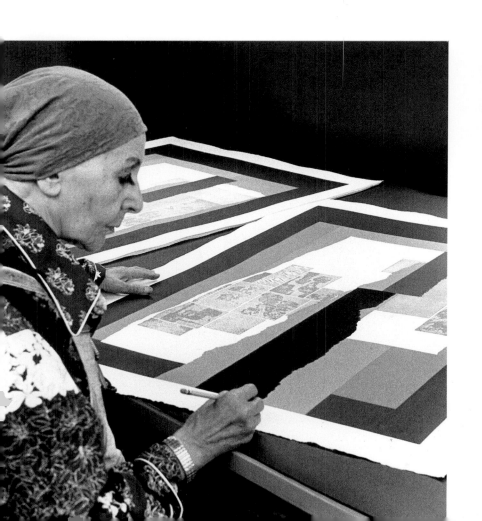

Signing lithographs
Completion is great.

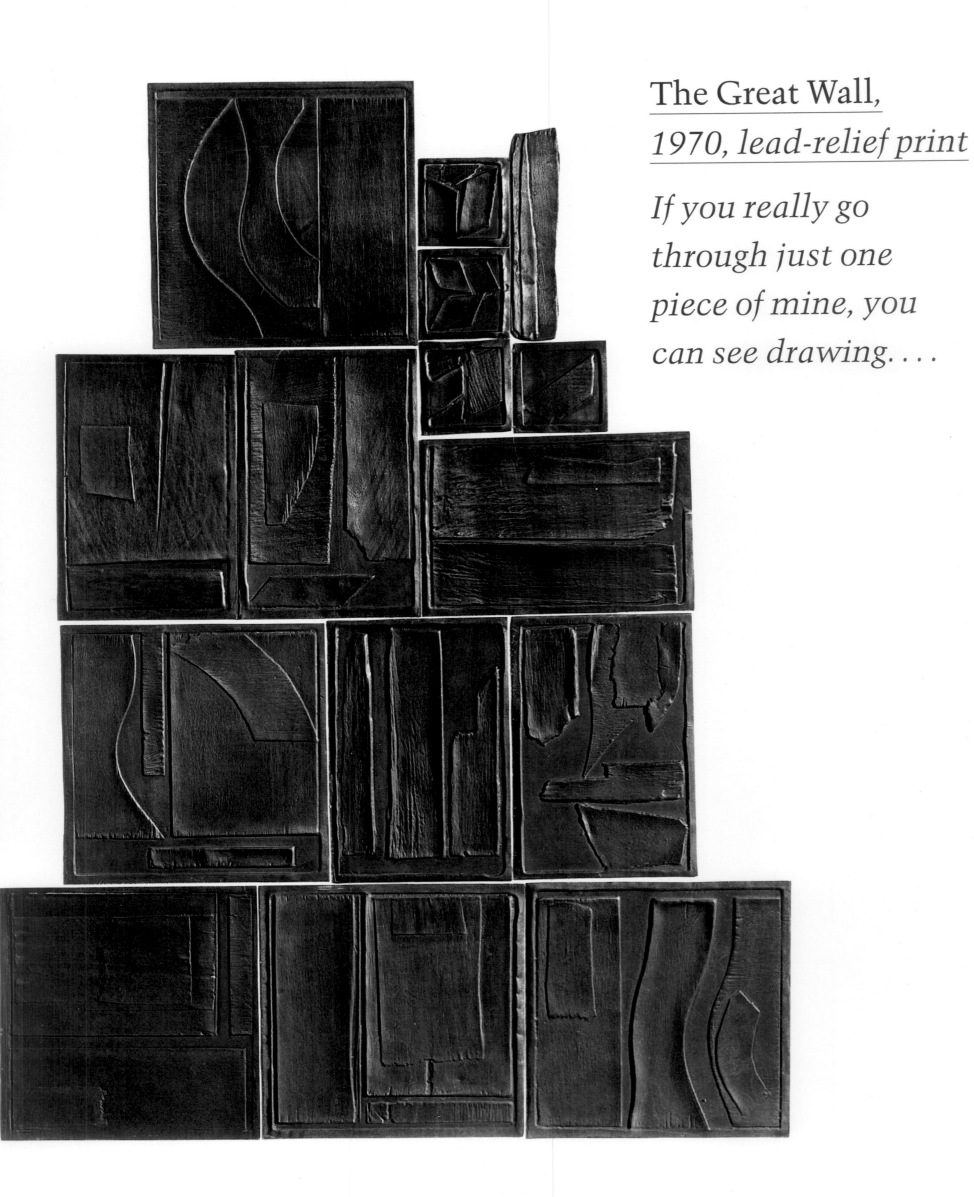

The Great Wall,
1970, lead-relief print

If you really go through just one piece of mine, you can see drawing....

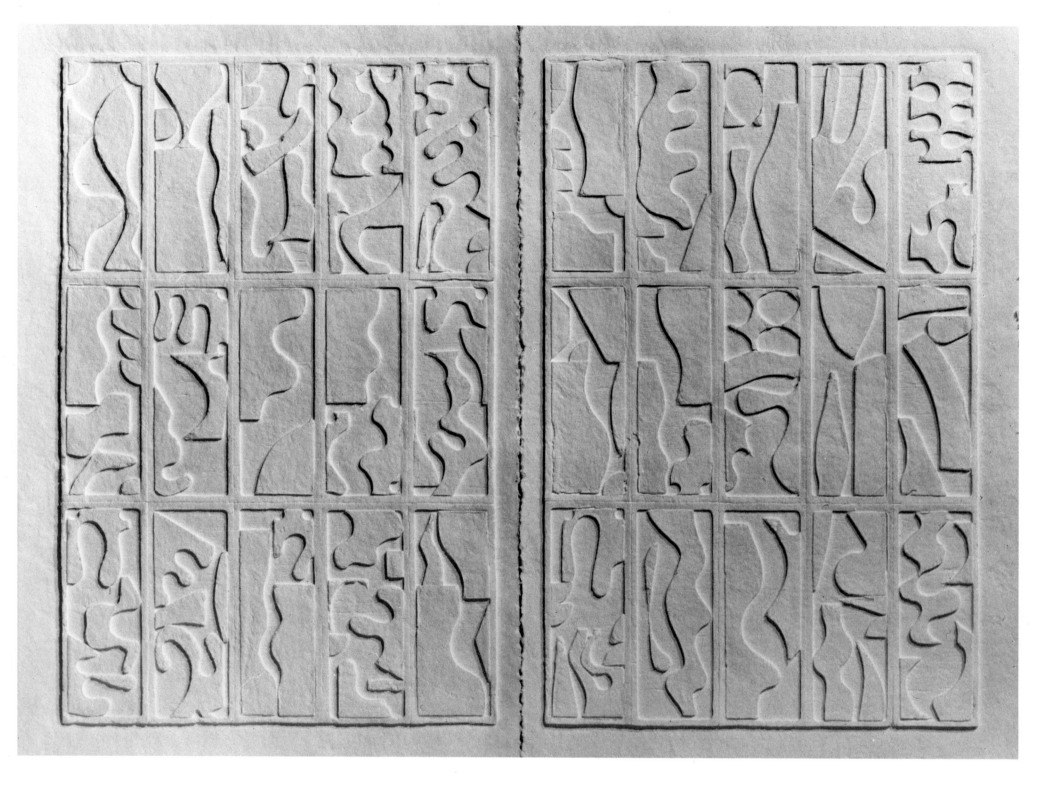

Morning Haze, *1978, cast-paper relief print*

It seems I make all my work just to draw.

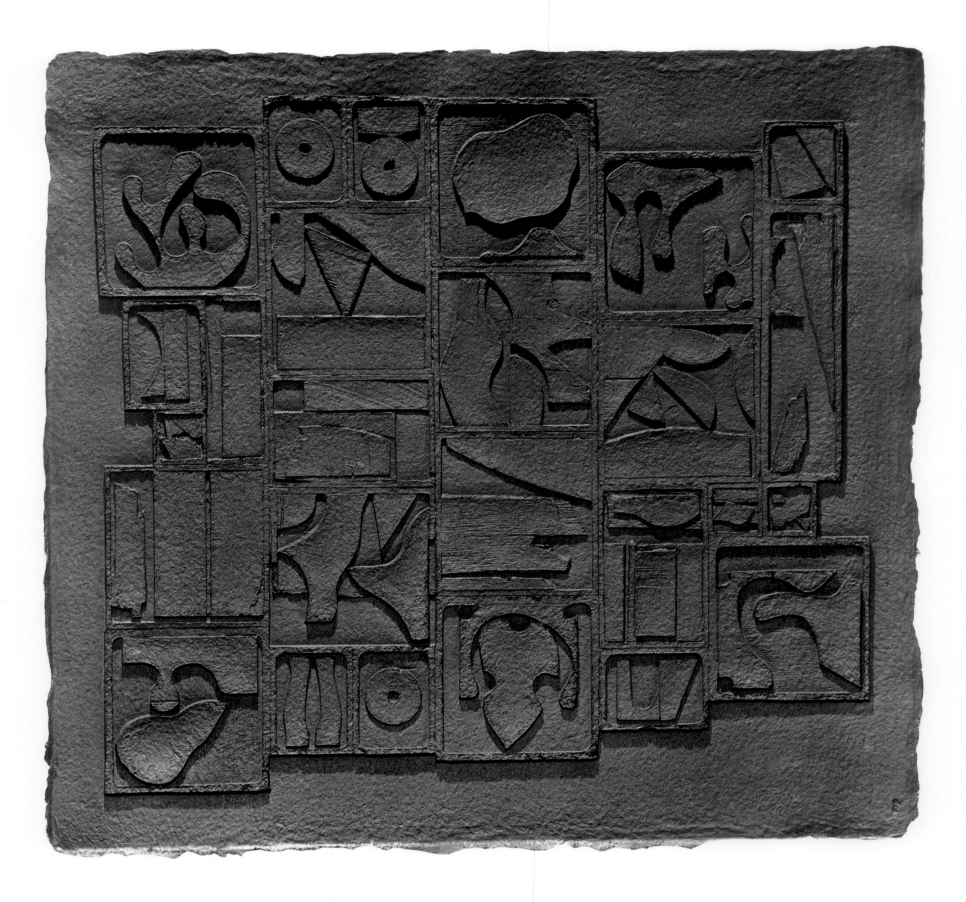

Nightscape, *1975, cast-paper relief print*

When you encompass an object, you are making a visual drawing. . . .

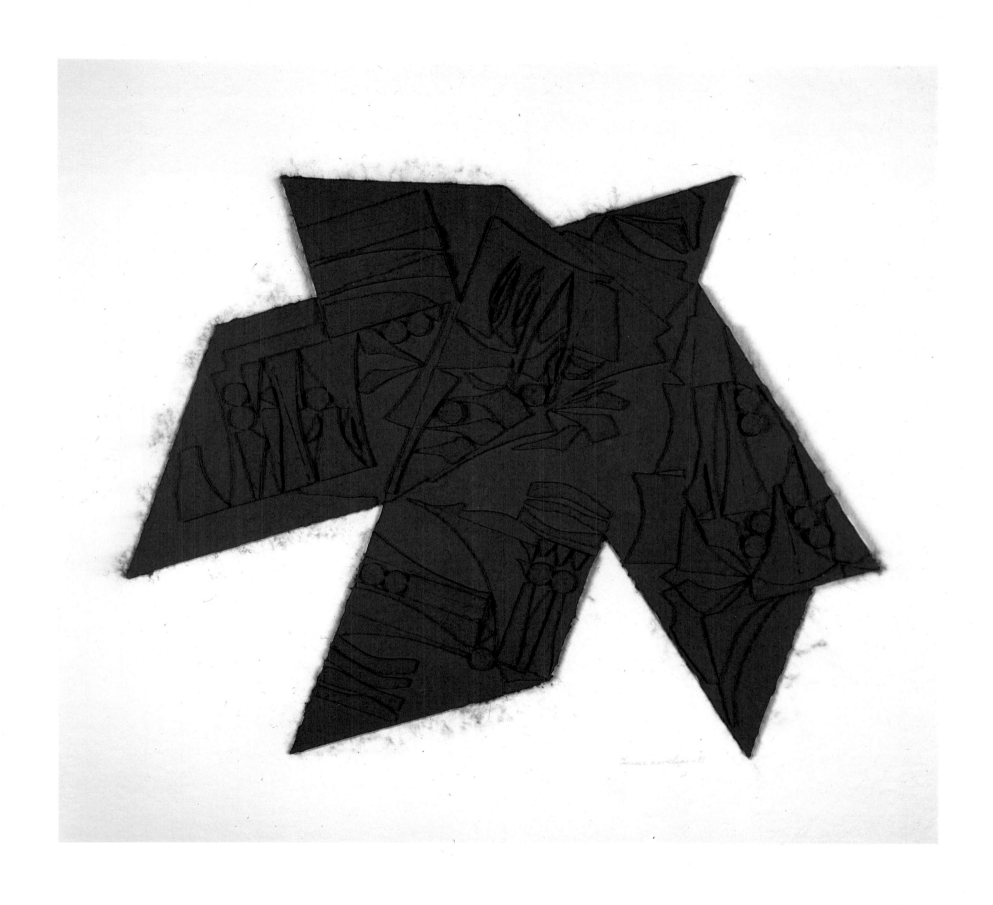

Night Star, *1981, cast-paper relief print*

With your eye you are drawing to define that object.

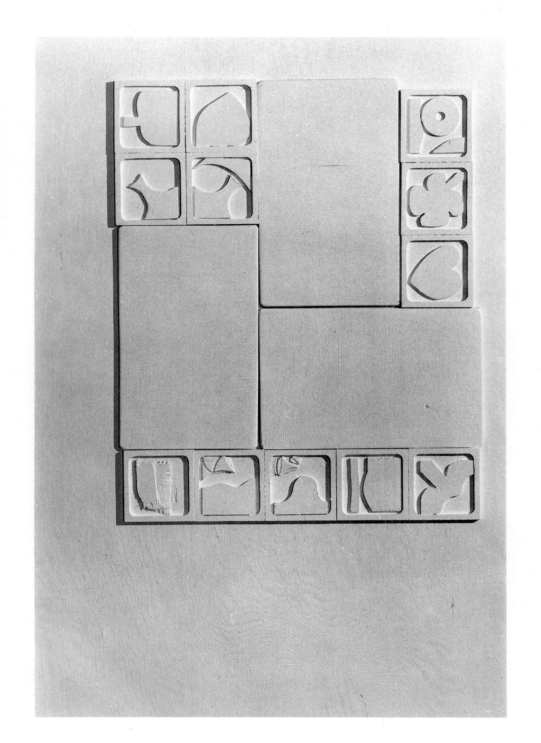

Southern Shores I, *1966,*
wood collage

Collage has become a
contemporary language....
It has come into its own.

Untitled collage, 1974 ▷

I've done sculpture, paintings, drawings, graphics,
everything visual. Now even the collages. I brought
in natural wood, colored glass, old etchings....
I've covered so many facets.

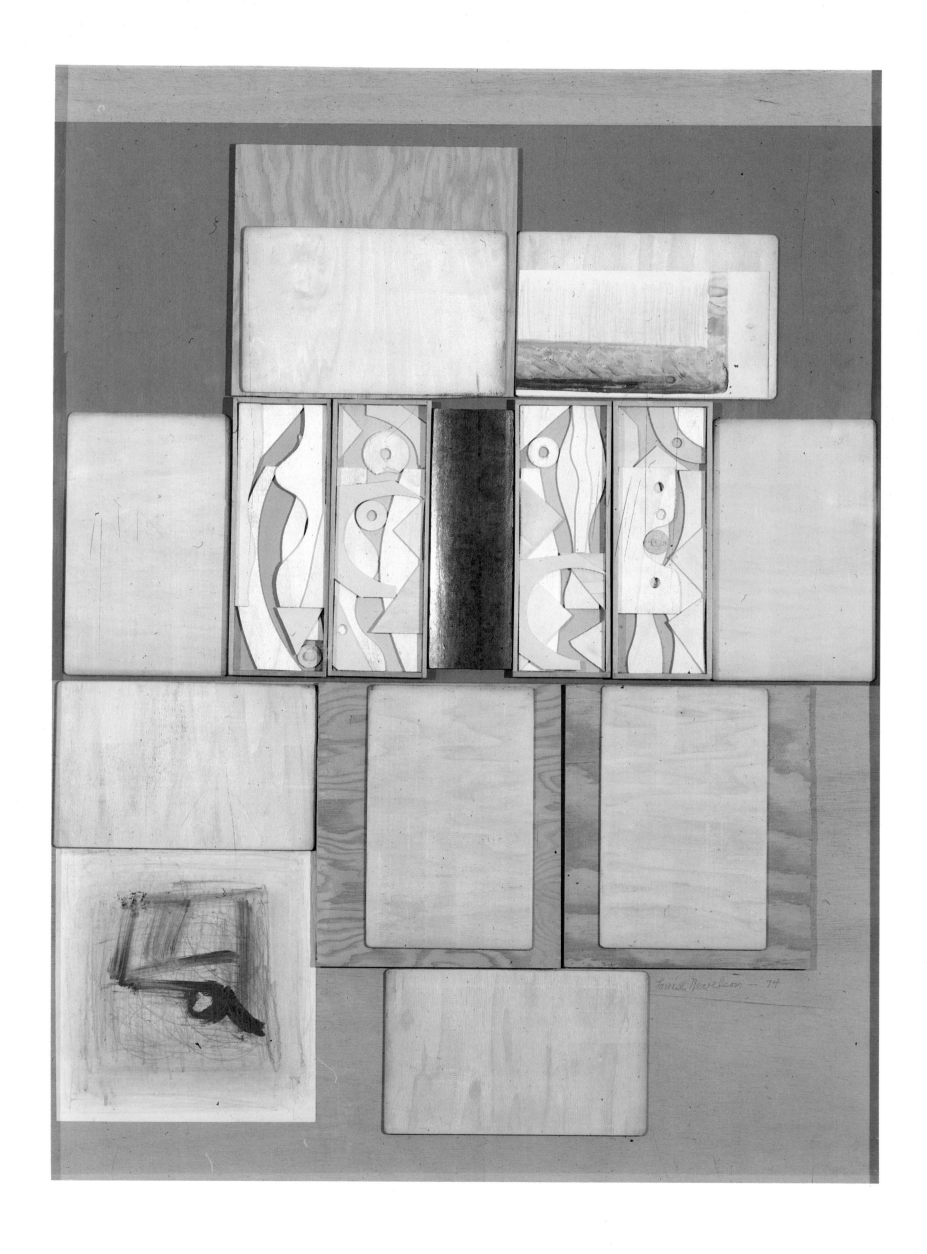

*I love to
put things
together.*

*I've come
to recognize
that the
way I think
is collage. . . .*

Untitled collage,
1972

I'm a collagist.

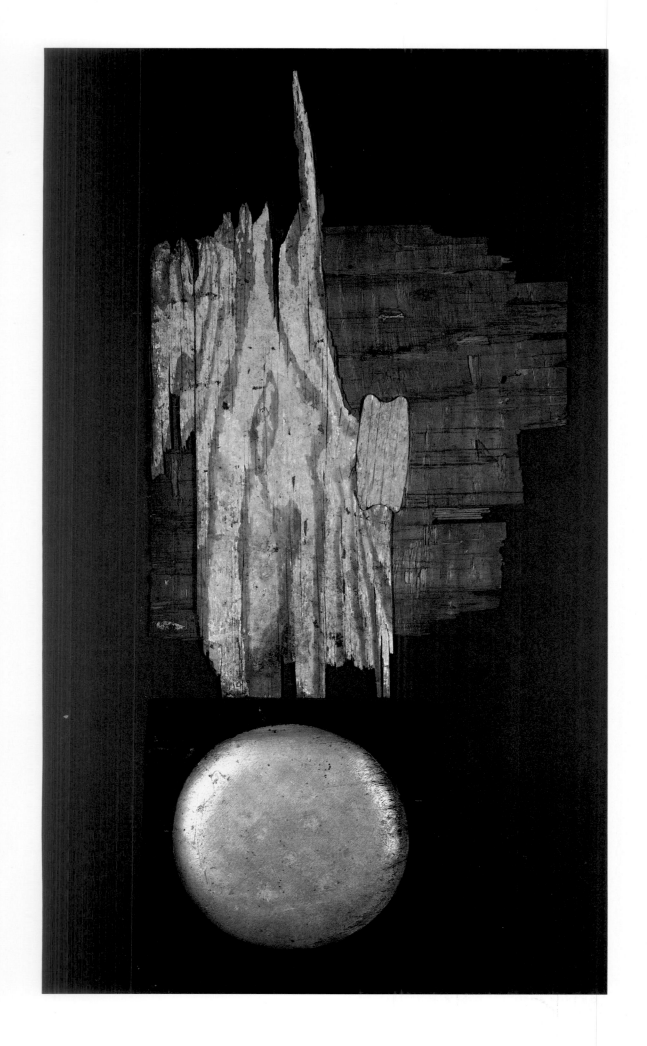

Untitled collage, 1981

The early 1980s were vintage years for collages.

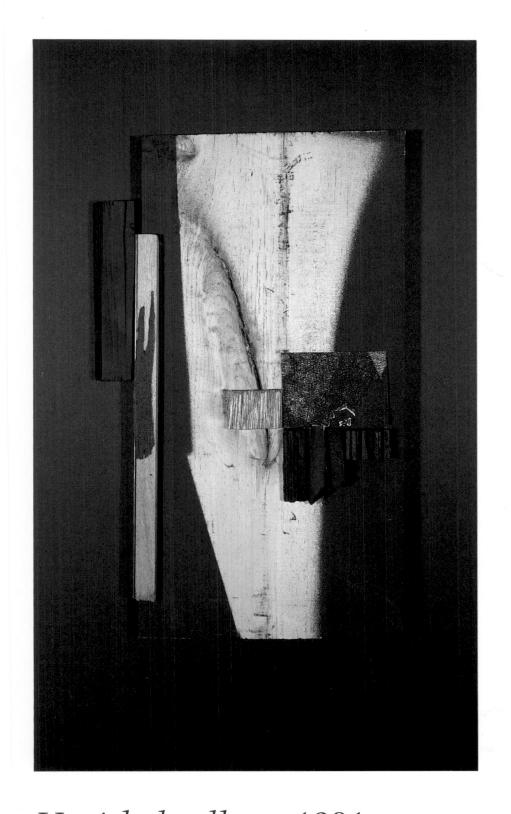

Untitled collage, 1981

Every piece that I make becomes a very living thing to me, very living.

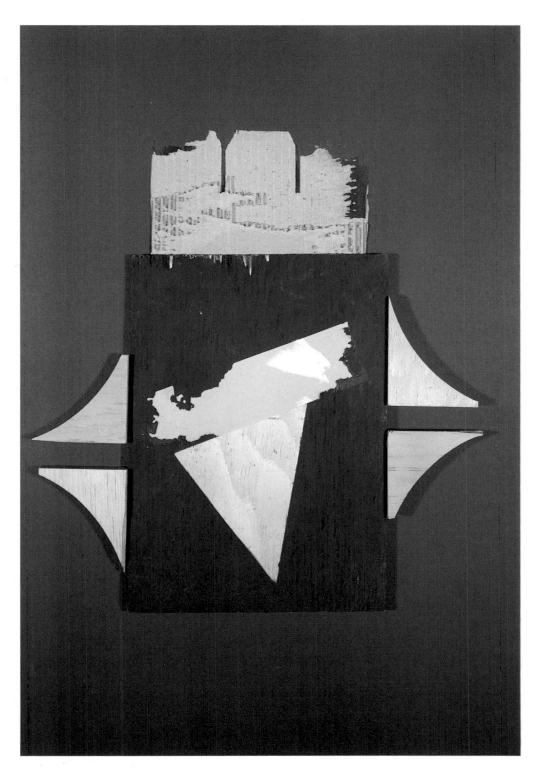

Untitled collage, 1981

When I work I'm not searching for perfection. I'm searching for life.

AFTERWORD: NEW YORK AS MY WORLD

by LOUISE NEVELSON

My world is New York. . . .
The city and I have a lot
in common.

I've LIVED in New York 60 years — my
WHOLE adult Life, mainly the year
around.
I Have fulfilled much of my
world here.
In Retrospect I feel gladdened
that the years + the place — New
York as I feel it permitted me
a fuller scope —

My world is New York City
My awareness — New York
is the reflection of my
world
My intentions are. to stay
here to the very end.

East River City Scape, 1965

When I look at the city from my point of view, I see New York City as a great big sculpture.

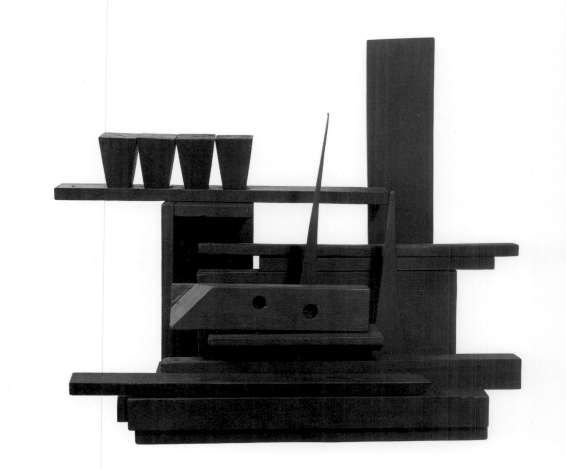

City Reflection, 1972

I visited Georgia O'Keeffe—the mountains are her landscape. Well, New York City is mine.

Celebration II,
1976

*Many of my works
are real reflections
of the city.*

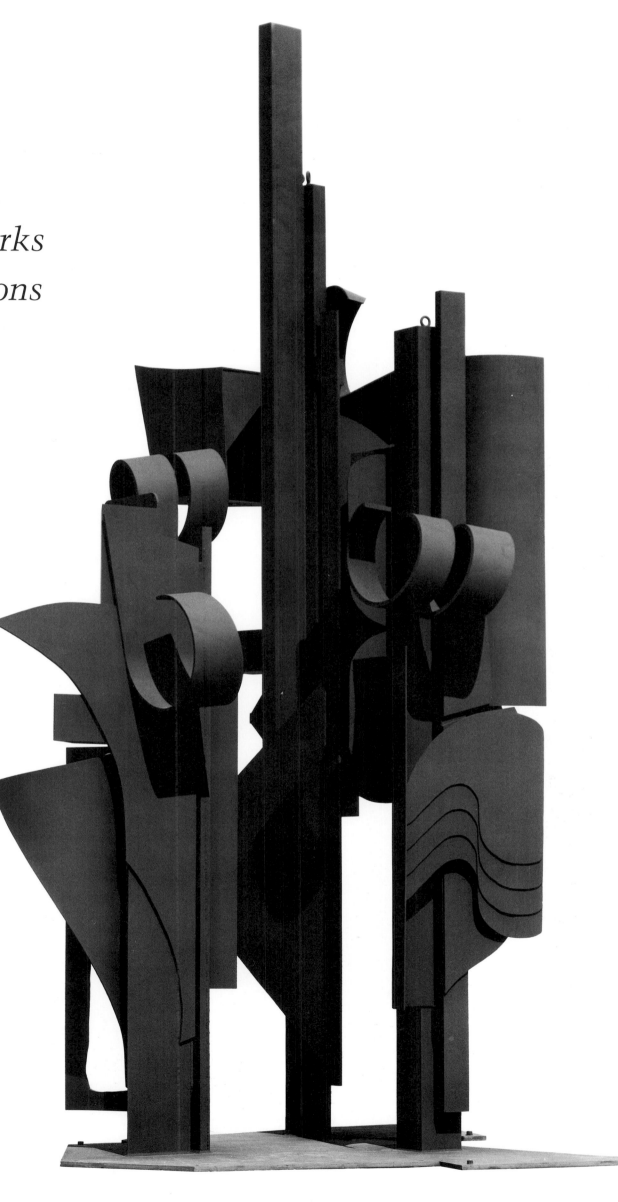

REFERENCE
MATERIAL

CHRONOLOGY

This summary of Nevelson's life in her eighty-fifth year focuses on major events. For further details about exhibitions, interviews, publications, and films, consult the Selected Bibliography, which follows this section.

1899 Born in Kiev, Russia, to Isaac Berliawsky and Minna Ziesel Smolerank.

1902 Father immigrates to America.

1905 Louise and her family—mother, older brother Nathan, and younger sisters Anita and Lillian—leave Russia to join her father in Rockland, Maine. Her father buys woodland, establishes a lumberyard, and becomes a contractor. Louise attends grammar school and high school in Rockland.

1918 Graduates from Rockland High School. Meets Charles Nevelson, a shipowner from New York, and becomes engaged to him.

1920 Marries Charles Nevelson in Boston and moves to New York. They travel to New Orleans and Cuba on two honeymoon trips.

During the twenties in New York, studies painting and drawing with Theresa Bernstein, William Meyerowitz, and the Baroness Hilla Rebay. Also studies drama in Brooklyn at a school founded by Princess Matchabelli and Frederick Kiesler, and studies voice with Metropolitan Opera coach Estelle Liebling. From this time on she tries to educate herself in all the arts, as well as philosophy and comparative religion.

1922 Son Myron (Mike) is born.

1929 Begins classes at the Art Students League of New York, which she takes through the next year. Studies with Kenneth Hayes Miller and Kimon Nicolaides.

1931 Separates from her husband and travels to Munich to study with Hans Hofmann at his academy. Takes daily drawing classes, but political upheavals in Germany force Hofmann to close the school six months after her arrival.

She travels to Berlin and Vienna, where she works as an extra in several films.

Visits Italy and then Paris, where she stays for several weeks, spending a great deal of time in

the Louvre, and at the Musée de l'Homme, where she is fascinated by the African sculpture.

Begins to write poetry.

After returning to New York, resumes classes at the Art Students League.

1932 Meets Diego Rivera through a mutual friend and becomes an assistant for his series of twenty-one murals, *Portrait of America*, in the New Workers' School on 14th Street.

Begins to study modern dance with Ellen Kearns (which she continues, with Kearns and other teachers, into the fifties).

Goes to Paris for six weeks during the summer.

Takes classes at the Art Students League, studying drawing and painting with Hans Hofmann, now living in New York, and painting with George Grosz.

1933 Exhibits several paintings at the Secession Gallery, New York, her first gallery showing.

1934 Exhibits small figurative sculptures (polychromed plaster, tattistone, terra-cotta, bronze) in several New York galleries.

1935 One of her terra-cotta figures is included in the exhibition *Young Sculptors* at the Brooklyn Museum, her first museum showing.

1936 Exhibits five wood sculptures in an A.C.A. Gallery competition judged by Yasuo Kuniyoshi, Stuart Davis, and Max Weber. Receives an honorable mention; art critic Emily Genauer (*New York World Telegram*) writes that she "is the most interesting of the contest winners."

1937 Works at painting and sculpture under the Works Progress Administration, and teaches sculpture at the Educational Alliance School of Art in New York as part of the WPA program.

1941 Begins seven-year affiliation with the Nierendorf Gallery, New York, with her first one-artist exhibition, which includes paintings and sculpture, mostly done under the WPA. Though none are sold, there is praise from the press: Emily Genauer (*New York World Telegram*) and Carlyle Burroughs (*New York Herald Tribune*).

1942 Second one-artist show at Nierendorf. At this time she begins to use found objects in her work.

1943 Her first exhibition of sculpture organized around a theme, *The Circus: The Clown Is the Center of His World*, held at the Norlyst Gallery, New York, at the same time that she exhibits paintings and drawings at Nierendorf. After these exhibitions, she destroys about two hun-

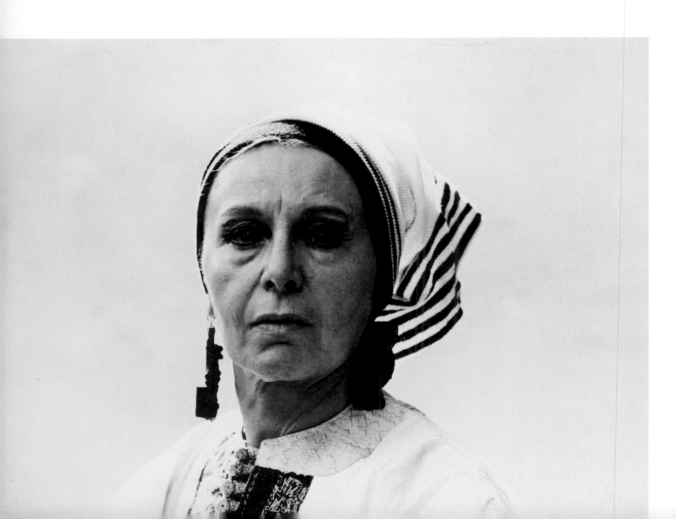

My thinking is to bring the world together, and our time is right for this performance.... I think in our time you recognize that it really is one world.

dred paintings and sculptures because of a lack of storage space.

Buys a four-story house on East 30th Street, New York, made possible by an inheritance from her father; moves from a loft on East 10th Street, and lives there until 1959. For the garden, black painted wood scraps and found objects are combined in an assemblage which she calls *The Farm*. At various times the house becomes a gathering place for artists and organizations such as the Federation of Modern Painters and Sculptors, the Sculptors' Guild, and the Four O'clock Forum— this last organized in 1952 by Will Barnet and Steve Wheeler as a forum for aesthetic ideas.

1944 First exhibition of abstract wood assemblages, *Sculpture Montages*, is held at Nierendorf.

1945 Has one-artist exhibition at Nierendorf.

1946 Show at Nierendorf titled *Ancient City*.

Included in the Whitney Museum of American Art Annual for the first time (and included frequently thereafter).

1947 Studies printmaking for the first time with English artist Stanley William Hayter at his New York workshop, Atelier 17. Begins a series of etchings.

1948 Karl Nierendorf dies.

She travels to England, France, Italy, and Central and South America.

1949 Stops working in wood and produces a series of terra-cotta and marble sculptures, all done at the Sculpture Center, New York.

1950 Her first show of etchings, *Moonscapes*, is held at the Lotte Jacobi Gallery.

During the spring, takes a short trip to Mexico with her sister Anita, visiting the museums in Mexico City.

1951 Makes a second trip to Central America with her sister, visiting archaeological sites on the Yucatán peninsula and Mayan ruins at Quiriguá, Guatemala.

1952 Included in the National Association of Women Artists annual exhibition for the first time (and included frequently thereafter).

1953 Returns to work at Atelier 17 and finishes the series of prints begun in 1947—thirty editions in all.

1954 One-artist shows in New York at the Lotte Jacobi Gallery (etchings) and Marcia Clapp Gallery.

1955. An exhibition called *Ancient Games and Ancient Places* is held at the Grand Central Moderns gallery, New York; some etchings are shown in connection with the sculpture. (This gallery, directed by Colette Roberts, represents her work through 1958.) Reviewing the show for *Art News*, Fairfield Porter writes that it "illustrates that art is for her a possibility that she sees in everything."

1956 A show titled *The Royal Voyage (of the King and Queen of the Sea)* is held at Grand Central Moderns. The Whitney Museum acquires *Black Majesty* from this exhibition—the first museum acquisition of her work.

1957 *The Forest*, a black wood sculpture show at Grand Central Moderns, is notable for its dramatic installation and a masterpiece, *Indian Chief*.

A large black wood sculpture, *First Personage* (the King from *The Royal Voyage*), is acquired by the Brooklyn Museum.

Elected president of the New York chapter of Artists' Equity, a position which she holds for two years.

Begins enclosing wood reliefs in boxes and creates her first wall pieces.

Sky Cathedral, the first Nevelson wall sculpture on view to the public, is made for her brother's Thorndike Hotel in Rockland, Maine.

1958 *Moon Garden + One* at Grand Central Moderns, her first environmental exhibition, uses blue lighting for the black wall sculptures which she calls *Sky Cathedrals*. Parker Tyler in *Art News*: "Divided between stark austerity and a 'Gothic' lyricism, these works proclaim the

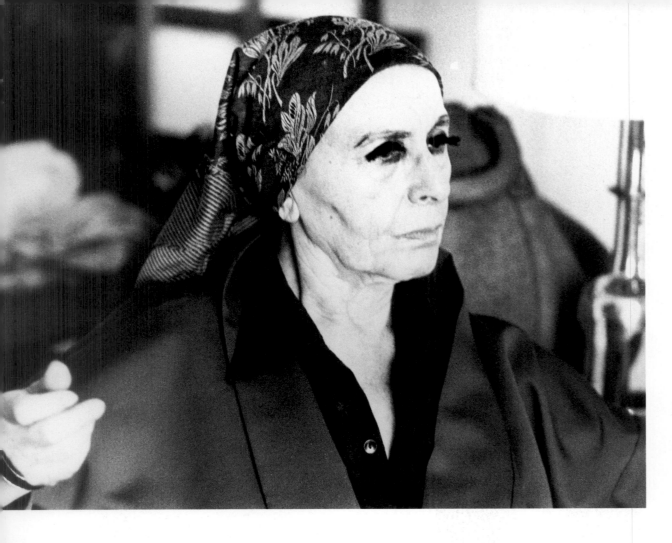

*I feel that the times,
the new materials,
and my maturity
have allowed me
to actually fulfill
a sense of grandeur
that I have had
all my life.*

dexterity of a rare formal passion." Nevelson: "It was not really for an audience, it was for my visual eye. It was a feast—for myself." The Museum of Modern Art, New York, acquires a large *Sky Cathedral* from this show.

A group of works shown at the Galerie Jeanne Bucher introduces Nevelson to the Paris art scene; enthusiastic review by Michel Ragon.

Has show of prints and drawings at the Esther Stuttman Gallery, New York.

Works are acquired by prominent private collectors, including Governor Nelson Rockefeller, Philip Johnson, and Mr. and Mrs. Burton Tremaine.

Included in the biennial Pittsburgh International Exhibition, Carnegie Institute (and included frequently thereafter).

Hilton Kramer publishes a major article, "The Sculpture of Louise Nevelson," in *Arts*, a landmark for critical appreciation of her oeuvre.

1959 She sells her house on East 30th Street

and moves to the house at 29 Spring Street, where she still lives.

The Martha Jackson Gallery, New York, now representing her work (and continuing to do so until 1962), shows *Sky Columns Presence*. She also exhibits at the Galerie Daniel Cordier in Paris.

Creates *Dawn's Wedding Feast*, her first white environment, for the exhibition *Sixteen Americans* at the Museum of Modern Art. Robert Coates writes about the sculptures in *The New Yorker*: "Spaced about as they are, and colored a uniform white, they give the room they are in an overwhelming feeling of cathedral silence and calm."

From this point on her work rapidly increases in quantity, is more frequently exhibited and reviewed in America and abroad, and is acquired by many institutions and private collectors.

Awarded Grand Sculpture Prize at *Art USA*, New York Coliseum, and the Logan Prize in Sculpture at the *63rd American Exhibition*, the Art Institute of Chicago.

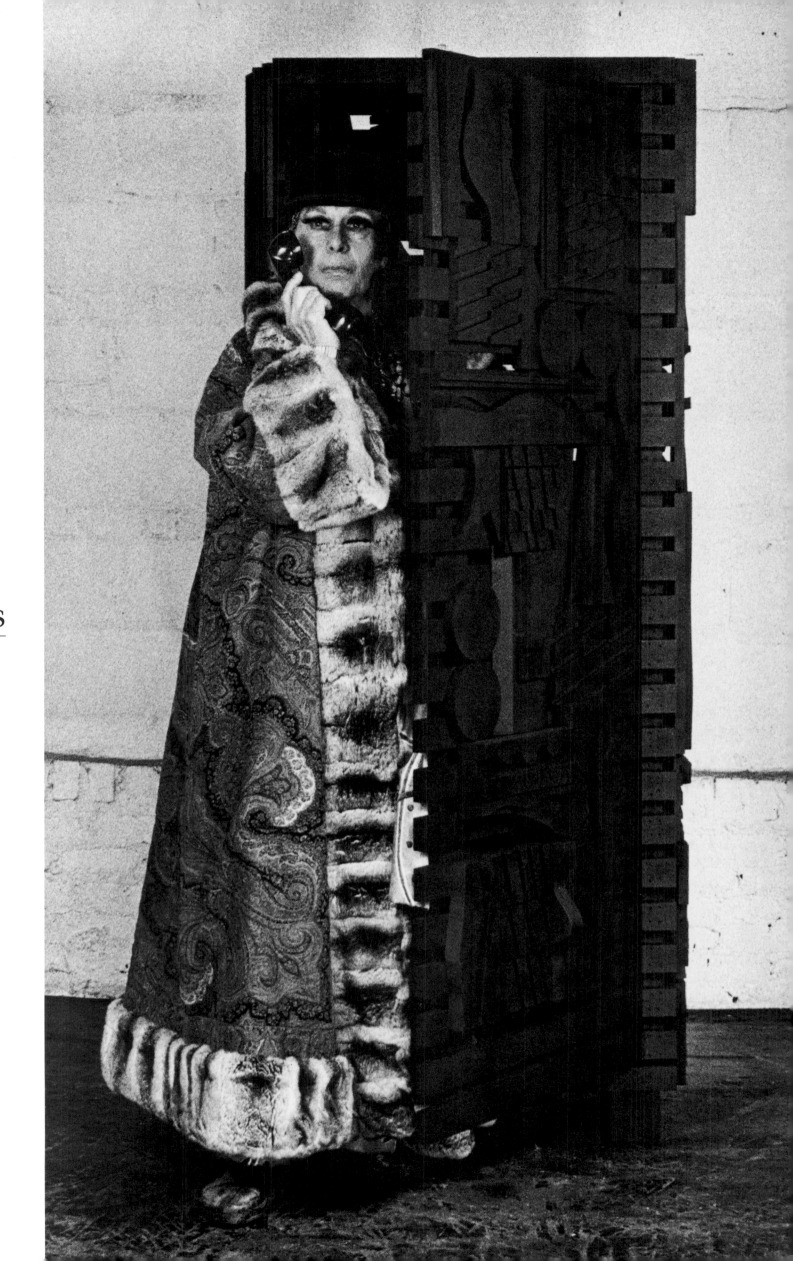

Photographed in 1973 for the Whitney Museum's Artists Address Book *with the black wood telephone booth she constructed for the photograph*

I'm dramatic, it seems.

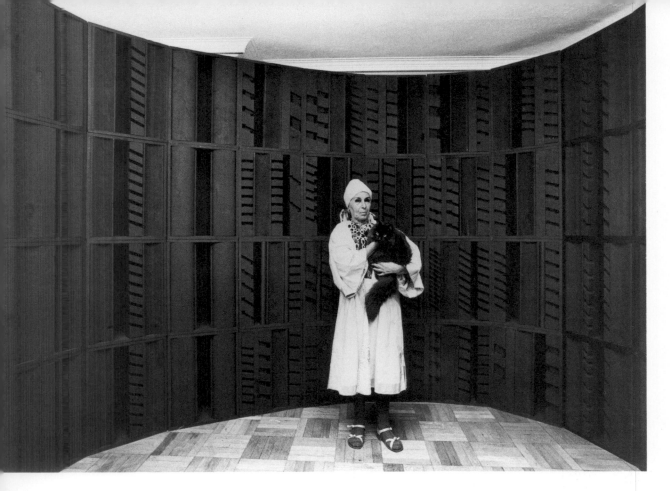

To have an empire,
dear, you have
to build it. . . .
I have built a
whole reality
for myself.

Begins to make collages, which she continues to do into the 1980s.

1960 Shows work in many group and one-artist exhibitions in museums, including the Art Institute of Chicago; Munson-Williams-Proctor Institute, Utica, New York; Rome-New York Foundation, Rome; and the Musée des Arts Décoratifs, Paris. Also shows in a number of galleries: David Herbert and Martha Jackson in New York; Ferus, Los Angeles; Devorah Sherman, Chicago; and Daniel Cordier, Paris (where black, white, and gold constructions are shown together for the first time).

Jean Arp writes a poem about Nevelson and her work, published in *XXᵉ Siècle*.

1961 *The Royal Tides*, her first gold sculptures, are exhibited at Martha Jackson. *Royal Tide I* is then shown at the Museum of Modern Art's *The Art of Assemblage* exhibition and featured in the catalogue by William C. Seitz.

Other important exhibitions that year include a white assemblage at the Pittsburgh International, wall constructions at the Staatliche Kunsthalle of Baden-Baden, Germany (sent by

the U.S.I.S.), and the Museum of Modern Art, New York.

Art News publishes one of her untitled poems ("Queen of the black black").

Dore Ashton writes about Nevelson's work for the French quarterly *Cimaise*: "Nothing exists for her that is unrelated to something else and when it is all added together, it is a total environment of which she is queen."

1962 Begins affiliation with the Sidney Janis Gallery, New York, the first woman and first American sculptor represented by the gallery.

Elected vice-president of the Federation of Modern Painters and Sculptors. Selected by the Museum of Modern Art as one of four artists (with Jan Müller, Loren MacIver, and Dimitri Hadzi) to represent the United States at the XXXI Biennale Internazionale d'Arte, Venice—official recognition of her stature as a major American artist. Creates black, white, and gold environments for three rooms in the United States Pavilion.

Wins Grand Prize of $3,000 in the First Sculp-

ture International at the Torcuato di Tella Institute's center of visual arts, Buenos Aires.

First woman elected president of National Artists' Equity.

1963 Ends affiliation with Sidney Janis Gallery.

First London exhibition at Hanover Gallery, and in New York shows etchings at the Balin-Traube Gallery and sculpture at Martha Jackson.

Receives a Ford Foundation grant to work at the Tamarind Lithography Workshop in Los Angeles. Produces twenty-six editions of prints.

1964 Begins affiliation with the Pace Gallery of New York, which represents her from this time on and mounts frequent exhibitions of her current work. Also exhibits abroad in Bern, Kassel, London, Turin, and Zurich.

Nevelson by Colette Roberts published by Editions Georges Fall, Paris.

1965 Diana MacKown, a young painter and photographer, succeeds Theodore Haseltine, Nevelson's assistant since 1952, and moves into the Spring Street house. Over the next eighteen years MacKown makes series of tapes, photographs, and films of Nevelson.

Participates in the National Council on Arts and Government in Washington.

Exhibits at the Pace Gallery, New York; David Mirvish Gallery, Toronto; and Galerie Schmela, Düsseldorf.

Works at the Hollander Graphic Workshop in New York to produce, through the following year, two editions of lithographs and twelve of etchings.

1966 First metal sculptures are fabricated from aluminum.

Elected vice-president of the International Association of Artists.

Exhibits at the Pace Gallery, New York; Ferus-Pace Gallery, Los Angeles; and Harcus/Krakow Gallery, Boston.

Produces a portfolio of twelve serigraphs titled

Facade—photographic collages of her sculpture silkscreened on paper—in homage to Edith Sitwell; published by Harry N. Abrams, New York, in collaboration with Pace Graphics (name changed later to Pace Editions).

Gives the Archives of American Art (a branch of the Smithsonian Institution, Washington, D.C.) her personal archive, which she continues to add to over the years. It now contains about 21,000 items, including early watercolors, original essays and poetry, scrapbooks, correspondence, interviews, photographs, reviews, dealers' records, and catalogues.

The Archives commissions Ugo Mulas to take a series of photographs of Nevelson, her house, and her collection.

1967 First major retrospective exhibition held at the Whitney Museum. Catalogue by curator John Gordon.

The Whitney Museum publishes *Portfolio "9"* (lithographs by nine artists), printed at the Hollander Workshop, New York. Nevelson's print is titled *Dusk in August.*

Art in America publishes a feature article, "The Artist Speaks: Louise Nevelson," by Dorothy Gees Seckler, an important record of and acute critical commentary on Nevelson's ideas and attitudes at that time.

Small Plexiglas sculptures are begun and made in multiples through the next year. Other multiples are produced in the following years, in editions of one hundred to one hundred fifty, in black and clear Plexiglas, bronze, wood, and polyester resin.

Begins a series of clear Plexiglas works titled *Transparent Sculpture,* completed during the following year.

Returns to the Tamarind Lithography Workshop and produces a series of sixteen print editions titled *Double Imagery.*

One-artist shows at Galerie Daniel Gervis, Paris, and the Rose Art Museum, Brandeis University, Waltham, Massachusetts.

Decides she wants an "empty house." Disposes of almost all her collections.

1968 Exhibits at the Arts Club of Chicago and the Dunkelman Gallery, Toronto.

A film, *The Look of a Lithographer*, is produced by June Wayne, director of the Tamarind Lithography Workshop.

1969 She is awarded a MacDowell Colony Medal.

Atmosphere and Environment X, the first large-scale Cor-ten steel sculpture, is commissioned by Princeton University.

The Juilliard School of Music at Lincoln Center for the Performing Arts, New York, acquires a forty-seven-foot black wood wall, *Nightsphere-Light*.

One-artist exhibitions are held at the Rijksmuseum Kröller-Müller, Otterlo, The Netherlands; Museo Civico, Turin, Italy; Galerie Jeanne Bucher, Paris; the Pace Gallery, New York; the Museum of Fine Arts, Houston; the University of Texas, College of Fine Arts, Austin; and the Akron Art Institute, Ohio.

1970 Begins a series of lead-relief prints which continues through the next three years. A total of six print editions are produced in the workshop of Sergio and Fausta Tosi in Milan.

Pace Graphics publishes her series of cast-paper relief prints (in black and in white).

Produces two lithographs at the Hollander Workshop, New York, for a television film called *Making a Lithograph*. The lithographs are titled *Thru A–Z* and *Thru A–Z +*.

A fifty-five-foot white wood wall is commissioned by Temple Beth-El, Great Neck, New York.

An exhibition is held at the Whitney Museum, *Louise Nevelson: New Acquisitions*—sculpture, prints, and early drawings and paintings given to the museum by the artist and the Howard and Jean Lipman Foundation.

1971 The Whitney Museum acquires a black wood wall, *Young Shadows*, the Whitney's first purchase (previous acquisitions were gifts of the artist or her family).

A group of sculptures, *Seventh Decade Garden*, made from welded aluminum scraps, is exhibited at Pace.

Receives the Creative Arts Award in Sculpture from Brandeis University and the Skowhegan Medal for Sculpture.

Shows sculpture at the Makler Gallery, Philadelphia, and the Richard Gray Gallery, Chicago; prints at Pace Graphics, New York.

A color film, *Louise Nevelson*, is aired by WCBS/Channel 2, New York.

1972 Continues to create large outdoor Cor-ten steel sculptures. *Night Presence IV* is installed on Park Avenue at 92nd Street, New York, a gift of the artist to the city. *Atmosphere and Environment XIII: Windows to the West* is commissioned by the city of Scottsdale, Arizona.

Publication of *Louise Nevelson*, by Arnold Glimcher (Praeger Publishers; revised and enlarged edition, E. P. Dutton, 1976).

Exhibits at the Richard Gray Gallery, Chicago; Dunkelman Gallery, Toronto; and Pace Graphics, New York, where collages are shown for the first time.

First tapestry, *Sky Cathedral* (black wool with metallic thread image), is produced by Gloria F. Ross based on a maquette made of wood.

1973 The Walker Art Center, Minneapolis, organizes a retrospective exhibition of wood sculpture with a major catalogue by director Martin Friedman. The exhibition travels to five museums in the United States.

Has exhibition at Studio Marconi, Milan, which travels to the Moderna Museet, Stockholm.

Receives commission for Cor-ten steel sculpture, *Sky Covenant*, from Temple Israel, Boston.

Portfolio of six prints, aquatint and collage, published by Pace Editions.

1974 One-artist shows in Brussels, Paris, Berlin, San Francisco, Dallas, Atlanta, Kansas City, Missouri, Columbus, Ohio, Philadelphia, and New York.

1975 *Bicentennial Dawn*, the artist's largest wood sculpture to date, commissioned for the James A. Byrne Federal Courthouse, Philadelphia.

Transparent Horizon, Cor-ten steel painted black, is commissioned by I. M. Pei for the Massachusetts Institute of Technology, Cambridge.

Has one-artist shows in Boston, Cleveland, Tokyo, Florence, and Turin.

1976 Publication of *Dawns + Dusks*, transcripts of Nevelson's conversations with Diana MacKown (Charles Scribner's Sons).

A television film called *Nevelson in Process*, made for WNET/Channel 13, is shown in New York and then aired nationally.

Exhibits pieces from *Moon Garden + One* at the Venice Biennale. Her work is prominently featured in the exhibition *200 Years of American Sculpture* at the Whitney Museum.

Sky Tree, Cor-ten steel painted black, is installed in the Embarcadero Center in San Francisco.

1977 Pace Editions publishes a series of etchings titled *Essences*.

A group of 1976 steel sculptures, painted black or white, is shown at the Neuberger Museum, SUNY, College at Purchase, New York.

Creates a white sculpture interior for the Chapel of the Good Shepherd in Saint Peter's Church, New York; also designs vestments for the attending clergymen.

Mrs. N's Palace, a black wood house environment, 1964–77, is shown at Pace. Hilton Kramer reviews this major work for the *New York Times*: "Physically constructed of wood that is painted black, it is visually an intricate structure of shadow and light.... A continually absorbing anthology of Mrs. Nevelson's characteristic forms."

1978 Legion Memorial Square, in the Wall Street area of Manhattan, is renamed Louise

Queen of the black black
In the valley of all all
With one glance sees the King.
mountain top
The climb
The way
Restless winds
midnight blooms
Tons of colors
Tones of waterdrops
Crystal reflections
Painting mirages
Celestial splendor
Highest grandeur
Queen of the black black
King of the all all.

Louise Nevelson 1961

Nevelson Plaza. Seven large black sculptures of painted Cor-ten steel, *Shadows and Flags*, are installed there.

Sky Gate—New York, wood painted black, is made for the World Trade Center, New York.

Receives honorary degree from Boston University.

Gives (with Mike Nevelson) a collection of thirty-four early American samplers to the Museum of American Folk Art, New York.

Begins a series of gifts of Nevelson-made jewelry, designer clothing, and Indian costumes and jewelry to the Costume Institute of the Metropolitan Museum of Art, New York, the Heard Museum in Phoenix, and the Costume Institute of the Phoenix Art Museum.

1979 A group of three large black sculptures of painted Cor-ten steel, *The Bendix Trilogy*, is made for the Bendix Corporation Headquarters in Southfield, Michigan.

Receives the President's Medal of the Municipal Art Society of New York.

Elected to membership in the American Academy and Institute of Arts and Letters. Occupies Chair Two, originally held by Augustus Saint-Gaudens.

Pace Editions publishes a series of colorful collage prints titled *Celebration*.

The Whitney Museum commissions Pedro Guerrero to photograph Nevelson at home and at work for publication in the catalogue for *Louise Nevelson: Atmospheres and Environments*.

1980 To celebrate Nevelson's eightieth birthday, a number of large retrospective exhibitions, with illustrated catalogues including critical essays, are organized by the Farnsworth Library and Art Museum in Rockland, Maine (in 1979); and in 1980 by the Phoenix Art Museum, Arizona; and the Whitney Museum of American Art in New York. The Whitney Museum exhibition, titled *Louise Nevelson: Atmospheres and Environments*, assembles—and publishes in a large-format catalogue (Clarkson N. Potter)—a number

◁ *With Diana MacKown* <u>*at 29 Spring Street*</u>

How I wish people could retain the indefinable urge for self-expression that seems to be a child's inheritance that so many of us shed for the more material things of life.

<u>*Stills from*</u> Geometry + Magic *by Diana MacKown*

Diana has made a film about me in which she superimposed images like a collage.

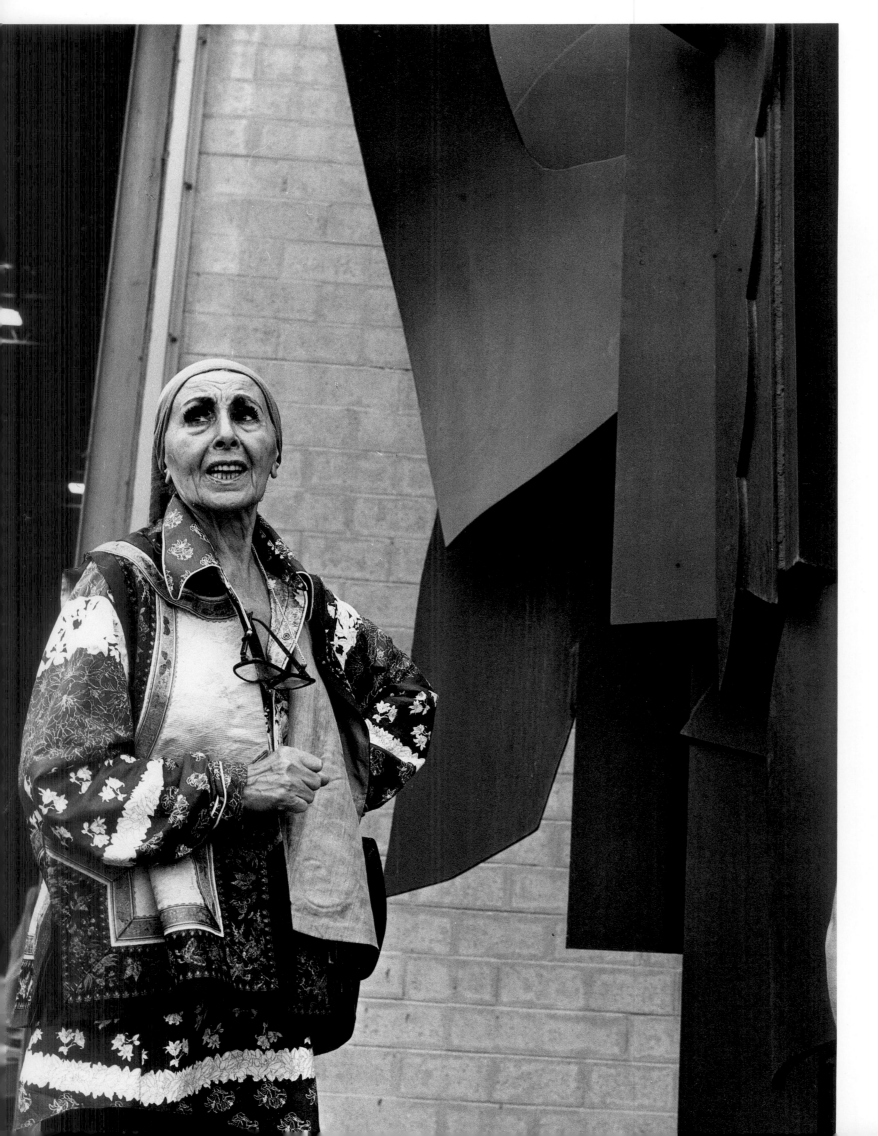

*The essence
of living is
in doing,
and in doing
I have made
my world.*

of the major black, white, and gold sculptures shown from 1955 to 1961; *Mrs. N's Palace*, first shown at Pace in 1977, is also included.

An important two-part exhibition is held in New York at the Pace and Wildenstein galleries (maquettes for monumental sculpture at Pace, wood sculpture and collages at Wildenstein). A joint catalogue is published by Pace to document this project. (Daniel Wildenstein had met Nevelson in Paris in 1931 and expressed interest in her work when she was still a student of Hans Hofmann.)

Begins a large series of mixed-media collages which continues through the next years. (She says the eighties are "vintage years" for her collages.)

Voyage I, a black-painted Cor-ten steel sculpture thirty feet high, is fabricated in an edition of three. Two are installed, one in the Hallmark Center, Kansas City, Missouri, one at the University of Iowa, Iowa City.

1981 Important exhibitions are held at Wildenstein, London, and the Galerie de France, Paris. Nevelson travels to both openings, which are attended by distinguished audiences. Also exhibits at the Pace Gallery, Columbus, Ohio, and the Makler Gallery, Philadelphia.

Dawn's Presence—Two (1969–75), a large white wood assemblage, is acquired for the office of Schlumberger Limited, New York, sponsor of the 1980 Whitney retrospective.

Pace Editions publishes a series of prints—etching and aquatint—titled *Tonalities*.

Travels to Yucatán with Diana MacKown.

Gives collections of santos and Southwest Indian baskets to the Millicent Rogers Museum in Taos, New Mexico.

1982 Diana MacKown's film about Nevelson, *Geometry + Magic*, is shown in New York at the fall Cooper Union Forum.

Nevelson goes to Japan for the opening of her exhibition *Nevelson at Wildenstein Tokyo*.

1983 An exhibition of recent sculpture, *Cascades Perpendiculars Silence Music*, is held at the Pace Gallery.

A two-person retrospective, with Georgia O'Keeffe, is held at the Nassau County Museum of Fine Art, Roslyn Harbor, New York. The Grey Art Gallery and Study Center, New York University, shows works in the university collection.

Begins work on stage sets and costumes for Gluck's opera *Orfeo ed Euridice*, to be performed by the Opera Theater of Saint Louis in 1984.

Makes a series of cloth collages framed in Plexiglas that she calls *Valentines*.

The print series *Reflections*, five different images in editions of fifty each, is produced by Pace Editions. The media are etching and aquatint, using collage directly on the plates.

Dawn Shadows, a large steel sculpture painted black, commissioned for Madison Plaza in Chicago, is completed at the Lippincott foundry in North Haven, Connecticut.

Sky Landscape, a steel sculpture painted black, is commissioned by the American Medical Association and installed in front of their new headquarters building in Washington, D.C.

Double Image, a 1976 aluminum sculpture painted white, is featured in the inaugural installation of the sculpture court at the Whitney Museum's midtown branch in New York—the Whitney Museum of American Art at Philip Morris.

Makes eight sculptures, Cor-ten steel painted black, titled *Frozen Laces*, a series that evolved from *Frozen Laces—One* of 1979–80.

SELECTED BIBLIOGRAPHY

Publications preceded by an asterisk include extensive biographical or bibliographical material.

BOOKS

*Baro, Gene. *Nevelson: The Prints*. New York, Pace Editions, 1974.

*Glimcher, Arnold B. *Louise Nevelson*. New York, Praeger Publishers, 1972; revised and enlarged edition, New York, E. P. Dutton & Co., 1976.

*Johnson, Una E. *Louise Nevelson: Prints and Drawings 1953–1966*. New York, The Brooklyn Museum with Shorewood Publishers, 1967.

*Nevelson, Louise. *Dawns + Dusks* (taped conversations with Diana MacKown). New York, Charles Scribner's Sons, 1976.

*Roberts, Colette. *Nevelson*. Paris, Editions Georges Fall, 1964.

*Wilson, Laurie. *Louise Nevelson: Iconography and Sources*. New York and London, Garland Publishing, 1981.

CATALOGUES

*Arts Club of Chicago. *Louise Nevelson*, 1968.

David Herbert Gallery, New York. *Louise Nevelson*, 1960.

Museo Civico, Turin, Italy. *Louise Nevelson, Scultura–Litographie*, 1969.

Galerie Daniel Cordier, Paris. *Exposition de Louise Nevelson, Sculpteur*, 1960.

Galerie Daniel Gervis, Paris. *Louise Nevelson*, 1967.

Galerie de France, Paris. *Nevelson*, 1981.

Galerie Gimpel Hanover, Zurich. *Louise Nevelson*, 1964.

Galerie Jeanne Bucher, Paris. *Louise Nevelson*, 1969.

Hanover Gallery, London. *Louise Nevelson: First London Exhibition*, 1963.

Martha Jackson Gallery, New York. *Nevelson*, 1961.

*The Museum of Fine Arts, Houston. *Louise Nevelson*, 1969.

The Museum of Modern Art, New York. *Sixteen Americans* (Dorothy C. Miller, ed.), 1959.

_____. *The Art of Assemblage* (William C. Seitz), 1961.

Nassau County Museum of Fine Art, Roslyn Harbor, New York. *Nevelson and O'Keeffe: Independents of the Twentieth Century* (Constance Schwartz, ed.), 1983.

Neuberger Museum, SUNY, College at Purchase, New York. *Nevelson at Purchase: The Metal Sculptures*, 1977.

The Pace Gallery, New York. *Nevelson*, 1964.

*_____. *Nevelson: Recent Wood Sculpture*, 1969.

_____. *Nevelson: Sky Gates and Collages*, 1974.

_____. *Nevelson: Dawn's Presence—Two; Moon Garden + Two*, 1976.

_____. *Nevelson: Maquettes for Monumental Sculpture* (David L. Shirey, ed.); *Nevelson: Wood Sculpture and Collages* (Barbaralee Diamonstein, ed.), 1980.

_____. *Nevelson: Cascades Perpendiculars Silence Music*, 1983.

Phoenix Art Museum. *Louise Nevelson: The Fourth Dimension* (Laurie Wilson), 1980.

*Rijksmuseum Kröller-Müller, Otterlo, The Netherlands. *Louise Nevelson, Sculptures, 1959–1969*, 1969.

Staatliche Kunsthalle, Baden-Baden. *Louise Nevelson*, 1961.

*Studio Marconi, Milan. *Nevelson*, 1973.

*Walker Art Center, Minneapolis, with E. P. Dutton & Co. *Nevelson: Wood Sculptures* (Martin Friedman), 1973.

*Whitney Museum of American Art, New York, with Praeger Publishers, Inc. *Louise Nevelson* (John Gordon), 1967.

*Whitney Museum of American Art, New York, with Clarkson N. Potter, Inc. *Louise Nevelson: Atmospheres and Environments* (introduction by Edward Albee), 1980.

Wildenstein, London, with the Pace Gallery, New York. *Louise Nevelson: Sculptures and Collages* (Carter Ratcliff, ed.), 1981.

*William A. Farnsworth Library and Art Museum, Rockland, Maine. *Louise Nevelson*, 1979.

MAGAZINE ARTICLES

Arp, Jean. "Louise Nevelson." *XXᵉ Siècle*, June 1960, p. 19.

Ashton, Dore. "U.S.A.: Louise Nevelson." *Cimaise*, April–June 1960, pp. 26–37.

Coates, Robert M. "The Art Galleries." *The New Yorker*, 2 January 1960, p. 61.

Garrison, Gene. "Louise Nevelson: The Fourth Dimension." *Carefree Enterprise*, February 1980, pp. 6–7.

Glimcher, Arnold. "Nevelson: How She Lives, Works, Thinks." *Art News*, November 1972, pp. 69–73.

Hess, Thomas B. "U.S. Art: Notes from 1960." *Art News*, January 1960, pp. 24–29.

Hughes, Robert. "Art: Night and Silence, Who Is There?" *Time*, 12 December 1977, pp. 59–60.

Kozloff, Max. "Art." *The Nation*, 10 April 1967, pp. 477–78.

Kramer, Hilton. "Month in Review." *Arts*, January 1957, pp. 44–47.

_____. "The Sculpture of Louise Nevelson." *Arts*, June 1958, pp. 26–29.

K[roll], J[ack]. "Reviews and Previews: Louise Nevelson." *Art News*, May 1961, pp. 10–11.

Melville, Robert. "Exhibitions: The Venice Biennale." *Architectural Review*, October 1962, pp. 285–86.

[Nevelson]. "Nevelson on Nevelson." *Art News*, November 1972, pp. 66–68.

_____. Untitled poem, "Queen of the black black" (in Philip Pearlstein, "The Private Myth"). *Art News*, September 1961, p. 45.

Pincus-Witten, Robert. "Louise Nevelson, Whitney Museum." *Artforum*, May 1967, p. 5.

P[orter], F[airfield]. "Reviews and Previews: Louise Nevelson." *Art News*, January 1955, p. 46.

Ragon, Michel. "Constructions Oniriques." *XXᵉ Siècle*, December 1969, p. 113.

Raynor, Vivien. "Art of Assemblage." *Arts Magazine*, November 1961, pp. 18–19.

_____. "Louise Nevelson at Pace." *Art in America*, January–February 1973, pp. 114–15.

R[iley], M[aude]. "Irrepressible Nevelson." *Art Digest*, April 1943, p. 18.

Roberts, Colette. "L''Ailleurs' de Louise Nevelson." *Cahiers du Musée de Poche*, May 1960, pp. 76–84.

Rosenblum, Robert. "Louise Nevelson." *Arts Yearbook 3: Paris/New York*, 1959, pp. 136–39.

Schwartz, M. D. "Sixteen Americans at the Museum of Modern Art." *Apollo*, February 1960, p. 50.

Seckler, Dorothy Gees. "The Artist Speaks: Louise Nevelson." *Art in America*, January–February 1967, pp. 32–43.

[Seiberling, Dorothy]. "Weird Woodwork of Lunar World." *Life*, 24 March 1958, pp. 77–80.

Smith, Dido. "Louise Nevelson." *Craft Horizons*, May–June 1967, pp. 44–49, 74–79.

T[yler], P[arker]. "Reviews and Previews: Louise Nevelson." *Art News*, January 1958, p. 54.

Wilson, Laurie. "Bride of the Black Moon: An Iconographic Study of the Work of Louise Nevelson." *Arts Magazine*, May 1980, pp. 140–48.

NEWSPAPER REVIEWS

Newspapers throughout the country, as well as some abroad, have published reviews of Nevelson exhibitions since the mid-1930s. The most frequent and important reviews have been published in three New York newspapers:

The *New York Herald Tribune* carried perceptive early commentaries by Carlyle Burroughs and Emily Genauer.

The *New York Times* published reviews of most of the important Nevelson museum and gallery exhibitions. Critics who reviewed the shows include Dore Ashton, John Canaday, Howard Devree, Edward Alden Jewell, Hilton Kramer, James R. Mellow, and Stuart Preston.

The *New York World Telegram* featured reviews by Emily Genauer through three decades, starting in the 1930s.

MICROFILMS

Archives of American Art, Smithsonian Institution, Washington, D.C. (duplicated in five regional offices: Boston, Detroit, Houston, New York, San Francisco).

This collection contains approximately 21,000 items (21 cubic feet of papers), most now on microfilm, given by Nevelson since 1966. Categories include: exhibition catalogues and announcements; clippings (with reference to her exhibitions, talks, activities in professional organizations, honorary degrees and awards, etc.); dealers' records and inventories; interviews—including an important series from the Archives Oral History Program by Dorothy Gees Seckler (1964 and 1965), Colette Roberts (1968), and Arnold Glimcher (1973); original essays, poetry, statements, and a group of early watercolors by the artist; scrapbooks; photographs (art works and personal); slides; press releases; reviews.

FILMS

Geometry + Magic: Louise Nevelson. A twenty-eight-minute color film by Diana MacKown. Produced by Iron Crystal Films, camera, sound, and editing by Rawn Fulton. Nevelson in her environment, 1970–82, featuring superimposed collage-like images. First viewing in New York at the fall 1982 Cooper Union Forum.

The Look of a Lithographer. A forty-five-minute black-and-white film, 1968, produced and written by June Wayne, narrated by Mark Jordan, photographed by Ivan Dryer and Jules Engel. Distributed in 1968 by Tamarind Institute, University of New Mexico, Albuquerque.

Louise Nevelson. A twenty-five-minute color film directed by Fred Pressburger, distributed by Spectra Films, Inc. Aired by WCBS/Channel 2, New York, in 1971.

Making a Lithograph. A television film, 1970, produced by the Hollander Workshop, New York, in which Nevelson makes two lithographs.

Nevelson in Process. A twenty-eight-minute color film coproduced and codirected by Susan Fanshel and Jill Godmilow for WNET/Channel 13, New York. First televised in New York in 1976, then shown on other channels across the country. Focus is on Nevelson working on large-scale metal sculptures.

Portrait de Louise Nevelson. A fifty-minute color film made for Swiss television, directed by Pierre Koralnek. Aired in Switzerland in 1980, then shown in various parts of Europe. An English version was shown at the Whitney Museum as part of Nevelson's eightieth birthday celebration.

TRANSCRIPTS OF TAPED INTERVIEWS WITH LOUISE NEVELSON

Belloli, Jay. Walker Art Center, Minneapolis, 1971.

Braun, Barbara (with Paul Anbinder and Jean Lipman). Given by *Publishers Weekly* to the Archives of American Art, Smithsonian Institution, Washington, D.C., 1982.

Glimcher, Arnold. Oral History Program, Archives of American Art, Smithsonian Institution, Washington, D.C., 1973.

_____. Arnold Glimcher Papers, New York, 1970 (two interviews) and 1971.

Jacobowitz, Arlene. Brooklyn Museum Library, New York, 1965.

Kissell, Howard. New York, 1972. Given by the artist to the Archives of American Art, Smithsonian Institution, Washington, D.C.

K. O. Given by the artist to the Archives of American Art, Smithsonian Institution, Washington, D.C., 1963.

Lerner, Gwen; Solomon, Richard; and Swanson, Dean. Walker Art Center, Minneapolis, 1973.

Rago, Laurie Elliot. New York, 1958 and 1959. Given by the artist to the Archives of American Art, Smithsonian Institution, Washington, D.C.

Roberts, Colette. Oral History Program, Archives of American Art, Smithsonian Institution, Washington, D.C., 1968.

_____. Arnold Glimcher Papers, New York, 1964.

Seckler, Dorothy Gees. Oral History Program, Archives of American Art, Smithsonian Institution, Washington, D.C., 1964 and 1965.

Streeter, Tal. Given by the artist to the Archives of American Art, Smithsonian Institution, Washington, D.C., 1959.

Waterman, Edward C. New York, 1960. Given by the artist to the Archives of American Art, Smithsonian Institution, Washington, D.C.

Wilson, Laurie. Laurie Wilson Files, New York, 1976 (three interviews) and 1977.

TAPED INTERVIEWS ABOUT NEVELSON

Diamonstein, Barbaralee. *Louise Nevelson: A Conversation with Barbaralee Diamonstein*. Pace Gallery Publications, New York, 1980.

Roberts, Colette, with Arnold Glimcher. Arnold Glimcher Papers, New York, 1970.

Wilson, Laurie. Laurie Wilson Files, New York, 1976–77 (forty taped interviews with Nevelson's family and friends, museum curators, gallery directors, artists, and others).

ARTIST'S STATEMENTS

Archives of American Art, Smithsonian Institution, Washington, D.C. (microfilms).

Whitney Museum of American Art Library, Artist's File (handwritten statement 1957).

LIST OF WORKS

high. Collection of Barrett N. Linde, Washington, D.C.

page 59

First Personage, *1956. Wood painted black, 94 inches high. The Brooklyn Museum, New York; Gift of Mr. and Mrs. Nathan Berliawsky.*

BLACK WORKS

pages 62–63

Tide I Tide, *1963. Wood painted black, 108 inches high. The Albert A. List Family Collection, Byram, Connecticut.*

page 65

Sky Cathedral, *1957. Wood painted black, 12 feet long. Collection of Howard and Jean Lipman, New York.*

page 67

Sky Cathedral—Moon Garden Wall, *about 1956–59. Wood painted black, 86 inches high. The Cleveland Museum of Art; Gift of the Mildred Andrews Fund.*

pages 68–69

Sky Cathedral Presence, *1957–64. Wood painted black, 16 feet 8 inches long. Walker Art Center, Minneapolis; Gift of Mr. and Mrs. Kenneth M. Dayton.*

page 70

Sky Cathedral, *1958. Wood painted black, 11 feet 3 inches high. The Museum of Modern Art, New York; Gift of Mr. and Mrs. Ben Mildwoff.*

page 71

Sky Cathedral Variant, *1959. Wood painted black, 100 inches high. Collection of Howard and Jean Lipman, New York.*

page 72

Sky Cathedral—Moon Garden + One, *1957–60. Wood painted black, 109 inches high. Collection of Milly and Arnold Glimcher, New York.*

page 73

Black Cord, *1964. Wood painted black, 102 inches high. Whitney Museum of American Art, New York; Promised 50th Anniversary Gift of Joel and Anne Ehrenkranz.*

page 74

Rain Forest Column VII, *1962–64. Wood painted black, 96 inches high. Whitney Museum of American Art, New York; Gift of the artist.*

page 75

Sky Columns Presence, *1959. Wood painted black, each column 78 inches high. International Minerals and Chemicals, Skokie, Illinois.*

page 77 top

Standing Wave, *1955. Wood painted black, 28 inches high. Courtesy of The Pace Gallery, New York.*

page 77 bottom

Dark Reflections, *1959. Wood painted black, 20 inches high. Private collection, New York.*

page 78

Tropical Garden, *1960. Wood painted black, 10 feet 13 inches long. Grey Art Gallery and Study Center, New York University Art Collection; Anonymous gift.*

page 79

Mirror Image I, *1969. Wood painted black, 17 feet 6 inches long. The Museum of Fine Arts, Houston; Gift of the Brown Foundation.*

page 80

Night—Focus—Dawn, *1969. Wood painted black, 117 inches long. Whitney Museum of American Art, New York; Gift of the Howard and Jean Lipman Foundation.*

page 81

Homage to 6,000,000 II, *1964. Wood painted black, 19 feet 6 inches long. The Israel Museum, Jerusalem.*

pages 82–83

Homage to the World, *1966. Wood painted black, 28 feet 8 inches long. The Detroit Institute of Arts; Founders Society Purchase, Friends of Modern Art Fund.*

page 83 right

Young Shadows, *1959–60. Wood painted black, 10 feet 6 inches long. Whitney Museum of American Art, New York; Gift of the Friends of the Whitney Museum of American Art and Charles Simon.*

pages 84–89

Nightsphere-Light, *1969. Wood painted black, 47 feet long. Juilliard Theater Lobby, Lincoln Center for the Performing Arts, New York; Gift of Howard and Jean Lipman.*

page 90

Moon Gardenscape XIV, *1969–77. Wood painted black, 94 inches high. Whitney Museum of American Art, New York; Gift of the American Art Foundation and the Howard and Jean Lipman Foundation.*

page 91

Rain Garden Spikes, *1977. Wood painted black, 80 inches high. Collection of Gerald Luss, New York.*

17 x 22 inches. Whitney Museum of American Art, New York; Gift of Louise Nevelson in memory of Marcel Duchamp.

page 197 left

Untitled, *1973. Aquatint, 37 x 26 inches. Courtesy of Pace Editions Inc., New York.*

page 197 right

Untitled, *1973. Aquatint, 37 x 26 inches. Courtesy of Pace Editions Inc., New York.*

page 198

Celebration 4, *1979. Etching with aquatint, 44 x 32 inches. Courtesy of Pace Editions Inc., New York.*

page 199 top

Reflections, *1983. Etching with aquatint, 39½ x 29½ inches. Courtesy of Pace Editions Inc., New York.*

page 200

The Great Wall, *1970. Lead-relief print, 30 x 26 inches. Whitney Museum of American Art, New York; Gift of Pace Editions Inc.*

page 201

Morning Haze, *1978. Cast-paper relief print, 33 x 46 inches. Courtesy of Pace Editions Inc., New York.*

page 202

Nightscape, *1975. Cast-paper relief print, 27 x 31 inches. Courtesy of Pace Editions Inc., New York.*

page 203

Night Star, *1981. Cast-paper relief print, 35 x 39 inches. Courtesy of Pace Editions Inc., New York.*

page 204

Southern Shores I, *1966. Wood collage painted white, 30 x 20 inches. The Pace Gallery, New York.*

page 205

Untitled, *1974. Mixed-media collage, 40 x 30 inches. Courtesy of Wildenstein & Co., Inc., New York.*

page 207

Untitled, *1972. Paper collage, 30 x 20 inches. Whitney Museum of American Art, New York; Promised gift of Howard and Jean Lipman.*

page 208

Untitled, *1981. Mixed-media collage, 40 x 30 inches. Collection of the artist.*

page 209 left

Untitled, *1981. Mixed-media collage, 30 x 20 inches. Collection of the artist.*

page 209 right

Untitled, *1981. Mixed-media collage, 30 x 20 inches. Collection of the artist.*

page 210

Untitled, *1981. Mixed-media collage, 40 x 30 inches. Collection of the artist.*

page 211

Untitled, *1981. Mixed-media collage, 40 x 30 inches. Collection of the artist.*

AFTERWORD

page 214 top

East River City Scape, *1965. Wood painted black, 31 inches long. Weatherspoon Art Gallery, University of North Carolina, Greensboro.*

page 214 bottom

City Reflection, *1972. Wood painted black, 10 feet 4 inches high. The Pace Gallery, New York.*

page 215

Celebration II, *1976. Cor-ten steel painted black, 28 feet high. Pepsico Inc., Purchase, New York.*

INDEX

CREDITS

SPECIAL THANKS

First of all, to Louise Nevelson and her assistant Diana MacKown, who helped us in dozens of ways during the past two years.

To her dealers, Arnold B. Glimcher, president of the Pace Gallery, and Richard Solomon, director of Pace Editions Inc., whose records and photo files were made available for this publication; and to Margi Conrads at Pace and Georgette Balance at Pace Editions.

To Christopher Colt, director of the David Anderson Gallery, who made available files and photographs from the Martha Jackson Gallery, one of Nevelson's earlier dealers.

To the Whitney Museum of American Art, especially Tom Armstrong, director; Doris Palca, head of publications and sales; Anita Duquette, rights and reproductions; and James Leggio, copy editor.

To Garnett McCoy, senior curator of the Archives of American Art, and Didi Croll and Colleen Hennessey, archives assistants.

I must also gratefully acknowledge the many authors and interviewers who first recorded the Nevelson remarks that I have quoted in the text and which accompany the illustrations. The most important of these sources are the conversations that made up Diana MacKown's *Dawns + Dusks*, Arnold B. Glimcher's *Louise Nevelson*, and the Archives of American Art interviews

PHOTOGRAPHS

The majority of the photographs are from the files of the Pace Gallery, Pace Editions Inc., and the David Anderson Gallery (formerly the Martha Jackson Gallery). The numbers following the photographers' names refer to pages on which their photographs are reproduced.

Oliver Baker, *185 left*
Ferdinand Boesch, *55 bottom, 99, 102, 148, 149, 166*

Rudolph Burckhardt, *54, 56, 58, 71, 75, 96 bottom, 112–13, 116–17, 120 bottom, 121, 136, 151 left, 185 right*
Geoffrey Clements, *46, 47, 48 top, 74, 80, 83 right, 90, 103 top left, 125, 142, 161 bottom, 186, 187, 188, 190 top, 195, 196, 200, 222*
Tom Crane, *104–6*
Jean Dubout, *77 top*
Roxanne Everett, *170*
Bill Finney, *50 bottom, 120 top*
giacomelli-venezia, *124*
Lynn Gilbert, *22*
Pedro Guerrero, *20, 36 top, 36 bottom, 37, 76 top, 76 bottom, 84, 171, 191 bottom, 206 top, 208, 209 left, 209 right, 210, 211, 226 top, 226 bottom, 228*
Ara Guler, *206 bottom*
Howard Harrison Studio, *167*
Koppes Photography, *65, 159, 165*
Werner Krüger, *220*
Diana MacKown, *30, 34, 51, 169*
Diana MacKown © Iron Crystal Films, Inc., *130, 227*
Robert E. Mates and Mary Donlon, *100–101*
Allen Mewbourn, *53 top, 79*
George H. Meyer, *128–29*
Bill Molemore Photo, *155 left*
Al Mozell, *69 top, 91, 92, 93, 94, 103 top right, 103 bottom, 175, 180, 195, 204, 214 bottom*
Ugo Mulas, *143*
Hans Namuth, *frontispiece*
Otto E. Nelson, *55 top*
Pach Brothers, *19*
Eric Pollitzer, *70*
George Roos, *192, 215*
John D. Schiff, *53 bottom, 77 bottom, 146, 151 right, 214 top*
Marvin Schwartz, *221*
Buckley Semley, *48 bottom*
Bill J. Strehorn, *78*
Eric Sutherland, *111*
William Suttle, *38, 39, 85–89, 155 right, 157, 172*
Jerry L. Thompson, *73, 118*
Reinhart Wolf, *133*